CUBE
BOOK

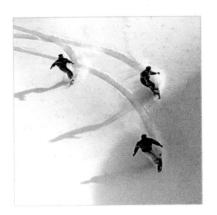

WHITE STAR PUBLISHERS

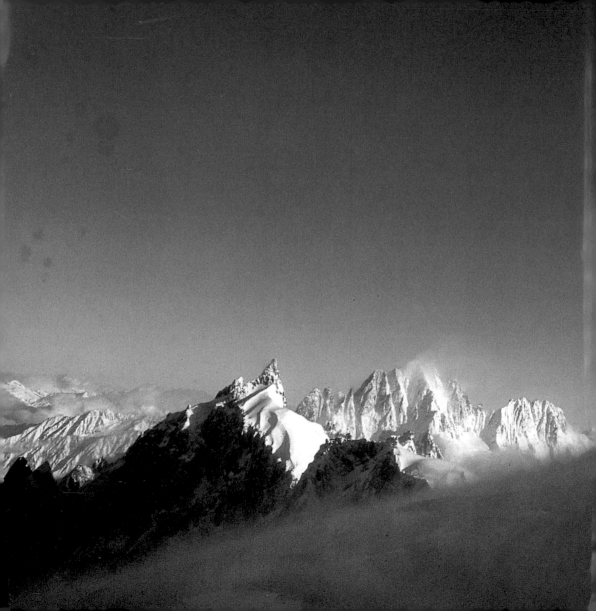

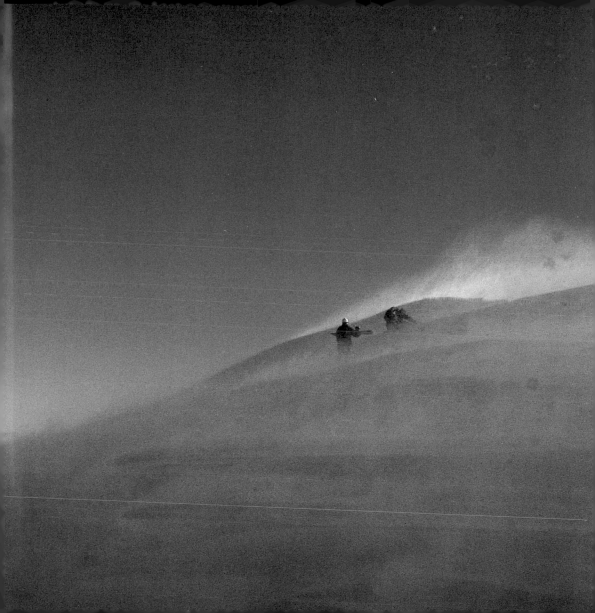

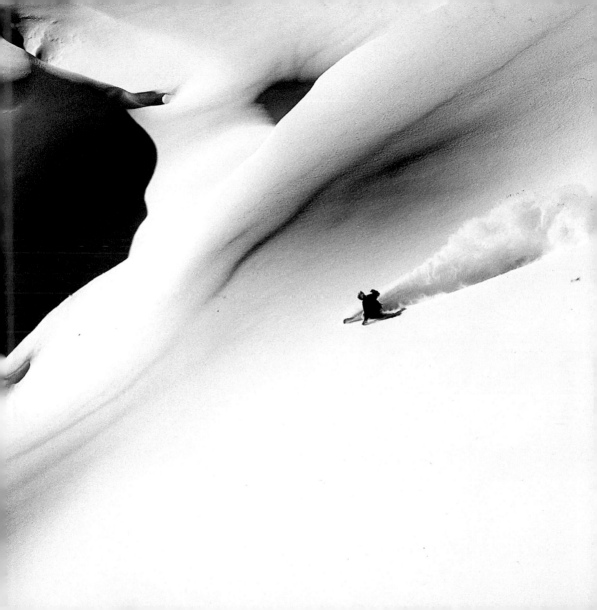

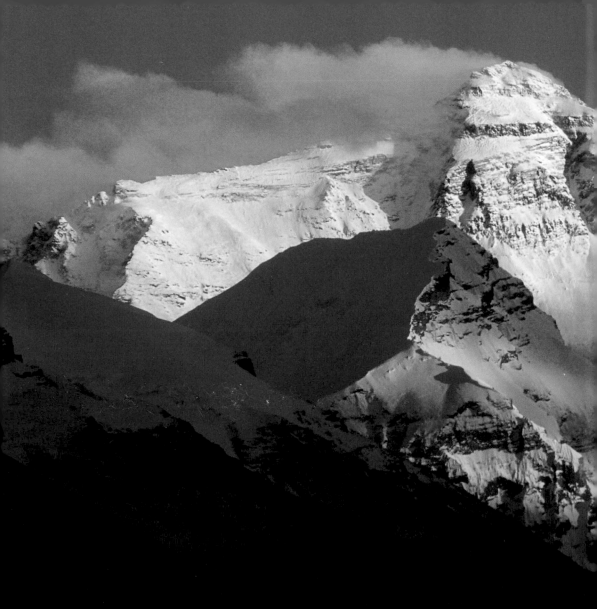

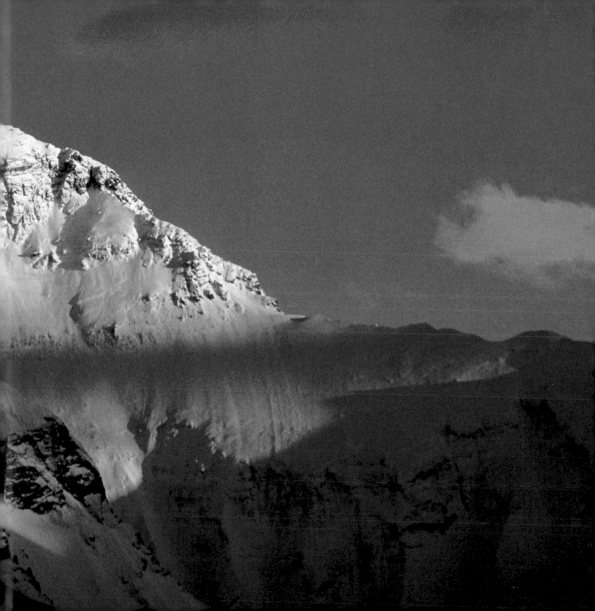

TEXTS BY

STEFANO ARDITO

ENRICO CAMANNI

ERMINIO FERRARI

ROBERTO MANTOVANI

LUCA MERCALLI

FRANCESCO PETRETTI

LUIGI ZANZI

editorial director
VALERIA MANFERTO DE FABIANIS

editorial staff
GIADA FRANCIA

graphic design
CLARA ZANOTTI

translation
AMY CHRISTINE EZRIN

© 2005 WHITE STAR S.p.A.
VIA CANDIDO SASSONE, 22-24
13100 VERCELLI - ITALY
WWW.WHITESTAR.IT

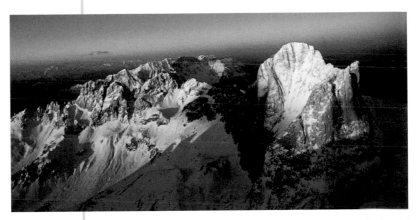

• Trentino-Alto Adige (Italy) - Towers of the Vajolet (Catinaccio Chain).

ISBN 88-544-0075-0

REPRINTS:
1 2 3 4 5 6 09 08 07 06 05

Printed in Singapore

CONTENTS

MOUNTAINS

1 • Colorado (USA) - Three athletes test their abilities on an off-trail descent with their snowboards.

2-3 • Mont Blanc (Chamonix, France) - A windy day makes the ascent to the top of the Aiguille du Midi difficult. In the background, the Aiguille du Plan and the Aiguille Verte.

4-5 • Chamonix (France) - The risky descent of a snowboarder down the face of the glacier of Enverse du Plan on the Aiguille du Midi.

6-7 • Tibet (China) - The north side of Mount Everest.

11 • California (USA) - A captivating image of Mono Lake at the base of the granitic wall of El Capitan.

12-13 • Tibet (China) - Dawn on Mount Kawa Karpo.

14-15 • Upper Savoy - (France) Two climbers on Aiguille Verte.

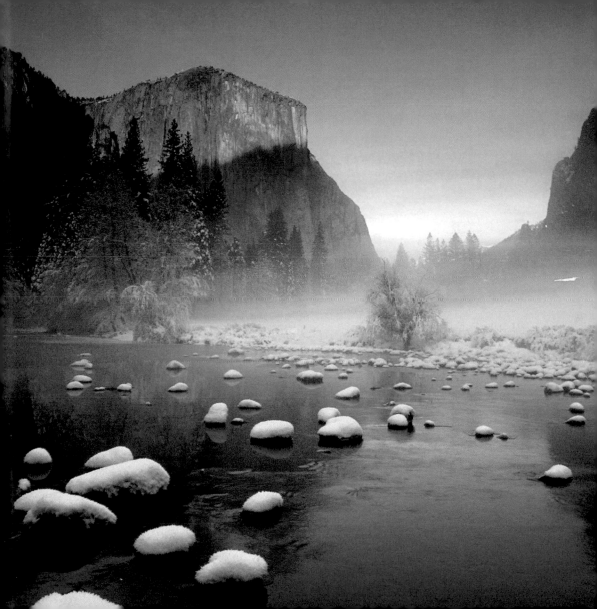

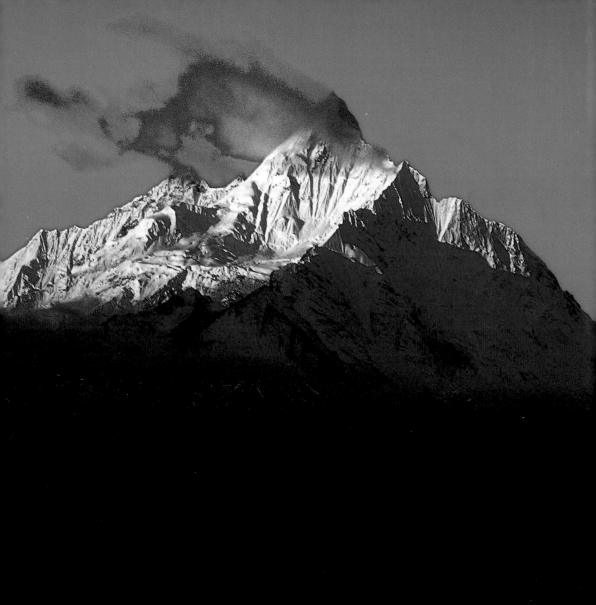

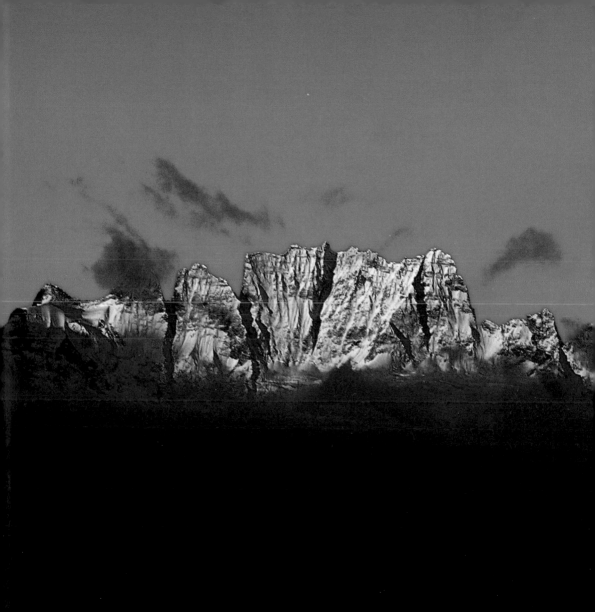

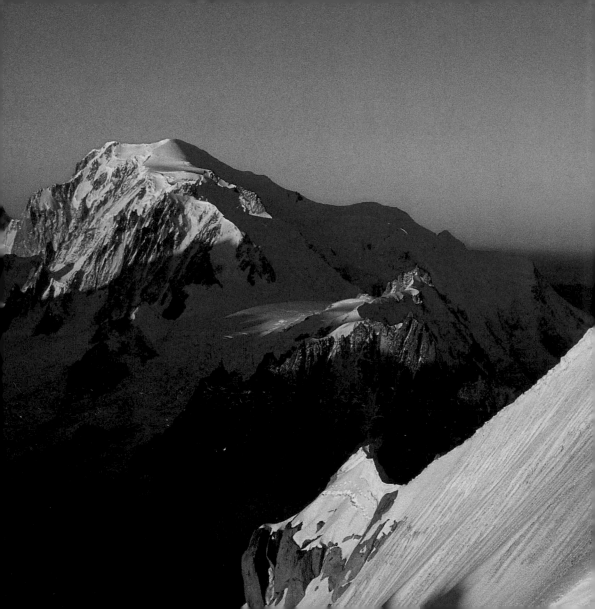

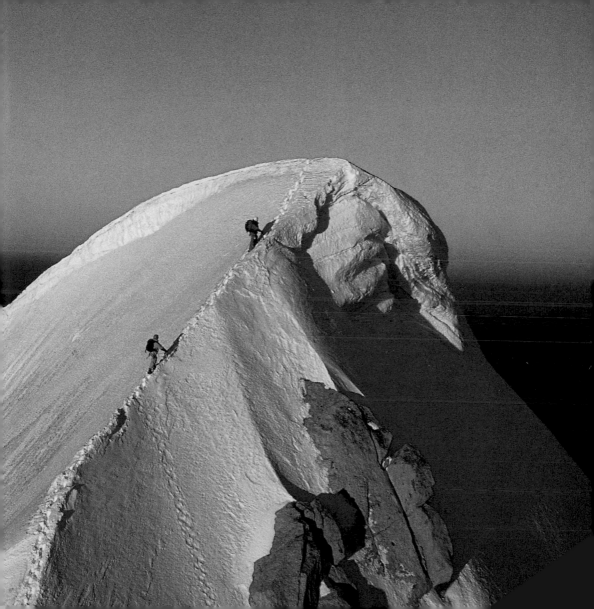

Introduction

by Roberto Mantovani

SCHOOLBOOKS DISPENSE WITH THE MATTER IN THE SIMPLEST WAY. THE MOUNTAINS, THEY SAY, ARE WRINKLES IN THE GEOCOSMOS, CAUSED BY THE LIFTING OF THE EARTH'S CRUST. TOO LITTLE. THE INFINITE VARIETY OF THE VERTICAL LANDSCAPE – SPIRES, TOWERS, PYRAMIDS, DOMES, BIG AND SMALL WALLS, PILLARS, ANGLES, AND CRESTS – HAS LED MAN, SINCE ANCIENT TIMES, TO SEEK EXPLANATIONS FOR THOSE MYSTERIOUS PRESENCES THAT STAND OUT ON THE HORIZON. OVER THOUSANDS OF YEARS, FOR THE INHABITANTS OF THE LOWLANDS, THE GREAT PEAKS OF THE PLANET BECAME SPRINGBOARDS FOR THE IMAGINATION, HAVENS FOR THE MIND AND SPIRIT, SYMBOLS OF THE SUPERNATURAL ABOVE, OPEN SEASON FOR FANTASIES, AND METAPHORS FOR

● China, Pakistan - Base camp at the foot of K2 (28,251 feet),
the second tallest mountain in the world.

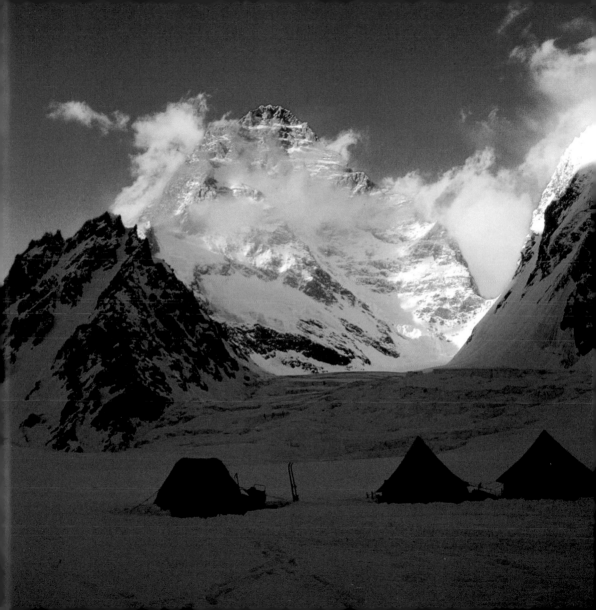

Introduction

ALL INDESCRIBABLE EVENTS. IN MODERN TIMES, THAT UN-STOPPABLE TENDENCY OF THE HUMAN SPIRIT TO INSIST UP-ON TRACING THE UNKNOWN BACK TO THE KNOWN HAS GEN-ERATED AN URGENT NEED TO EXPLORE THE TERRACES OF THE EARTH TO THE LAST. NATURALISTS, SCIENTISTS, TRAVEL-ERS, AND MOUNTAIN CLIMBERS AND HIKERS HAVE CLIMBED AN ENDLESS NUMBER OF PEAKS FROM WHICH POUR VAL-LEYS, GLACIERS, GORGES, AND RAVINES. THEY HAVE GIVEN A NAME TO THE MATERIAL OF WHICH THE MOUNTAINS ARE MADE, PLACED MORPHOLOGIES SEEMINGLY LACKING ANY SIGNIFICANCE ON FILE, AND CATALOGUED THE PLANT TYPES THAT DRAW NOURISHMENT FROM THE SHEEREST SLOPES. CULTURE HAS DESTROYED FANCIFUL, PRE-SCIENTIFIC LEG-ENDS AND CREATED NEW CERTAINTIES AND THEORIES. YET,

Introduction

CARRIED AWAY BY THE SURGE IN THE *LIBIDO IMAGINARUM* THAT THIS BOOK'S PHOTOGRAPHS MANAGE TO UNLEASH, IT IS DIFFICULT TO SEE THE MOUNTAINS AS JUST MONUMENTS OF ROCK, SNOW, AND ICE. COLOR, IN THE MOUNTAINS, IS EVERYWHERE, IN EVERY TONE, HUE, AND SHADE. SPLASHES, SPOTS, AND BRUSH STROKES PAINT THE CHROMATIC WEAVE IN THE WARP OF THE LANDSCAPE: FROM THE COBALT BLUE OF THE SKY AT HIGH ALTITUDES TO THE MUTED COLORS OF THE PASTURES AT THE BEGINNING OF THE SEASONS; FROM THE WHITE-BLUE OF THE FACE OF THE GLACIERS TO THE INFI-NITE TONES OF GREEN IN THE WOODS AND THE OPEN PAS-TURES; FROM THE SPRAY OF THE WATERFALLS TO THE BRIGHT WHITE OF THE LAST PATCHES OF SNOW RESISTING THE SUMMER HEAT. THEN, THERE ARE THE HUES THAT UNEX-

Introduction

PECTEDLY LIGHT UP AT SUNDOWN, SETTING THE MOUNTAIN WALLS AFLAME WITH WARM, DEEP-RED COLORS: THE DOLOMITE'S *ENROSADIRA* THAT REVIVES THE LIMESTONE WALLS WITH A BREATHTAKING GLOW IN EARLY EVENING OR THE SOFT AND EVANESCENT BRUSH STROKES THAT CARESS SNOWFIELDS AND GLACIERS UPON MORNING'S FIRST RAYS OF SUN. FURTHERMORE, THERE ARE THE INTENSE COLORS DICTATED BY THE PASSING OF THE SEASONS: FLOWER BLOSSOMS BETWEEN SPRING AND EARLY SUMMER RUN FROM THE BOTTOM OF THE VALLEY UP TO THE HIGHEST MEADOWS; THE CHROMATIC BLAZE OF AUTUMN, WITH THE YELLOW OF THE BEECH AND CHESTNUT TREES, THE RED OF THE WILD CHERRY TREES AND FIELDS OF BLUEBERRIES, THE GOLD OF THE LARCHES, AND THE ORANGE OF THE GRASSES, HEDGES, AND

Introduction

BUSHES. THEN, THERE ARE THE OVER-STUFFED CLOUDS THAT APPEAR ON DAYS WITH BAD WEATHER, WHEN THE MIST GETS STUCK IN THE WOODS, CREATING FAIRY-TALE SETTINGS. HOWEVER, THIS IS NOT EVERYTHING, BECAUSE COLOR IS AL-SO REVEALED IN THE DETAILS. IT IS FOUND ON THE FOREST FLOOR, AMONG THE ROCKS SPREAD HAPHAZARDLY ON THE PEBBLY FLOOR OF A STREAM, AROUND THE BANKS OF A POND, IN A PILLOW OF MOSS, OR IN A BUNCH OF PIONEER PLANTS AT THE EDGE OF A SCREE. THEY ARE HUMBLE AND DISCREET PALETTES, OF A CERTAIN SIMPLICITY THAT IS BARE-LY APPARENT. JUST A QUICK STOP AT THE SIDE OF A PATH IS ENOUGH TO REALIZE THAT IT IS NOT ALWAYS NECESSARY TO LOOK FAR: AT YOUR FEET EXTENDS A SMALL-SCALE UNIVERSE OF A THOUSAND COLORS. THE NATURAL SPECTACLE, THE AN-

Introduction

CESTRAL FORCE OF THE SYMBOLS, THE WONDER, AND THE BEAUTY ARE ABLE TO MAR EVEN THE MOST PRECISE COSMOGRAPHY OF THE MOUNTAINS, GIVING WAY TO INTERNAL JOURNEYS. IN THE PREASSENCE OF THE PEAKS, WOODS, AND GLACIERS, ENTIRE CONTINENTS OF THOUGHTS BLOSSOM AND UNDERGROUND, WIDESPREAD BONDS WITH THE WORLD OF THE GREAT HEIGHTS ARE STRENGTHENED. PAGES ENLIVENED BY A CONTINUOUS NARRATIVE WEAVE WEBS OF MOVING ECHOES AND BRING CERTAINTY OF NEW MENTAL SPACES IN DIFFERENT FORMS OF CONSCIOUSNESS. THIS IS THE ANSWER TO THE "TOO LITTLE" OF THE SCHOLASTIC MOUNTAINS.

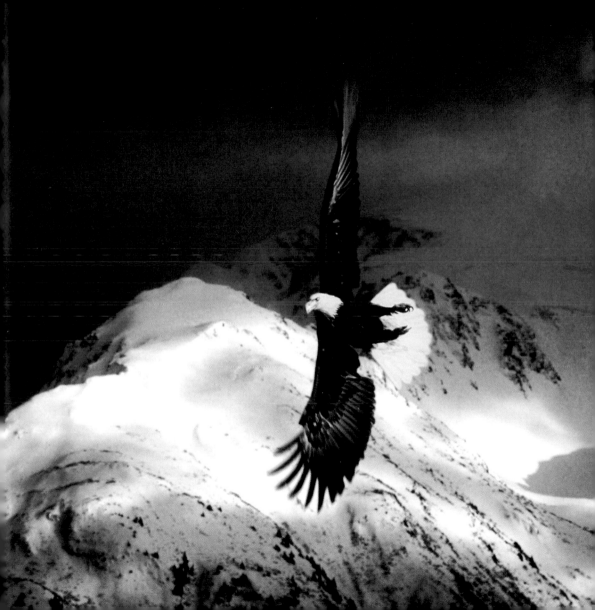

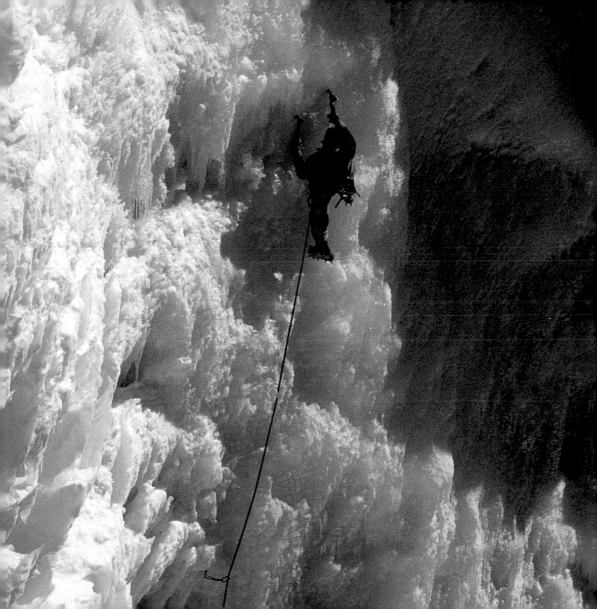

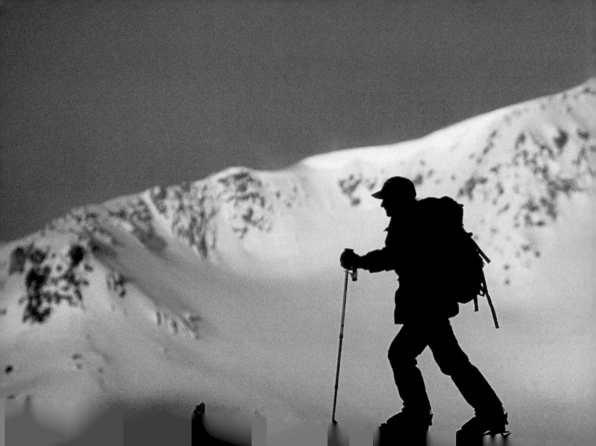

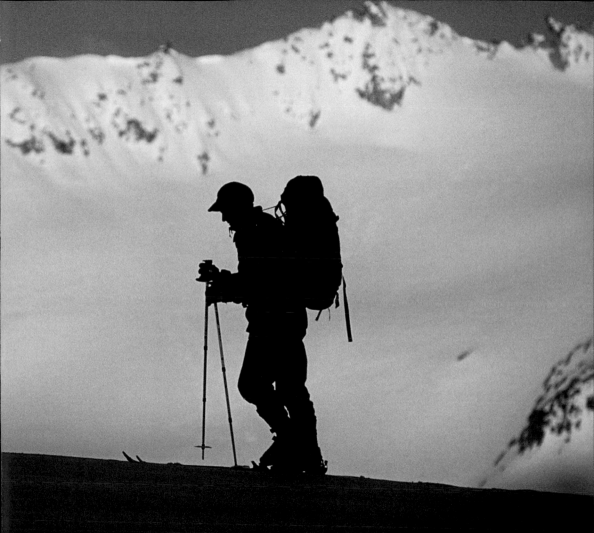

GIANTS

ROBERTO MANTOVANI

Nepal - Nuptse Peak at sunset.

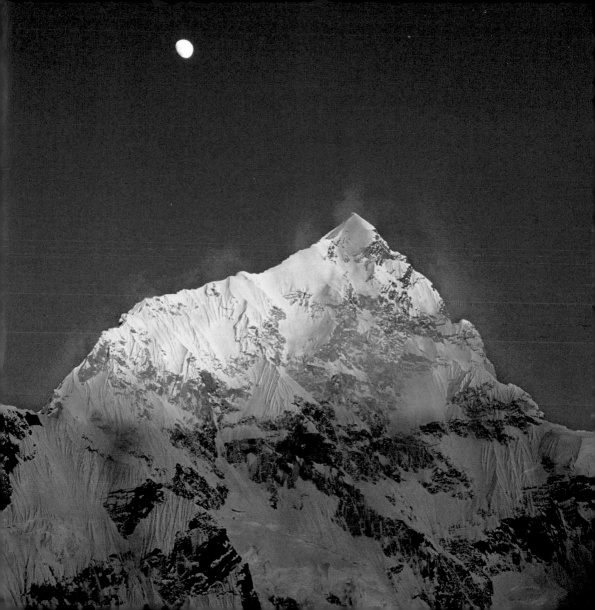

INTRODUCTION Stone Giants

The mountains do not have only one face; they possess thousands, each one different from the other. The environmental variety hinges on the presence of different elements – altitude, the diversity of the rocks, the presence of ice and water, the morphology of the valley gorges, the forest mantle, the pasture-land lining – that compete to build architectural settings, backgrounds, curtains, and foregrounds, like a stage. Thus, for example, the world of the Dolomites is a total flourish of spires, towers, and vertical walls that seem to defy the force of gravity, whereas, elsewhere, taller mountains feature giant frozen walls, cascades of seracs,

INTRODUCTION Stone Giants

PILLARS OF SOLID ROCK, AND CRESTS THAT FORM LACE CURTAINS OF CRYSTAL. ON THE GREAT MOUNTAIN CHAINS OF THE GLOBE, THE PEAKS THAT SEEM TO TOUCH THE SKY ARE NOT ALWAYS THE MOST BEAUTIFUL. THE FORMS THAT PEAK OUR FANTASY THE MOST, APART FROM A FEW SPLENDID EXCEPTIONS, ARE OFTEN FOUND AT LOWER ALTITUDES: THEY APPEAR IN SHAPES OF SLEN-DER SILHOUETTES, ROCKY PIKES LIKE GIANT TRIANGULAR VEILS, AND SOMETIMES LIKE IMPOSING PYRAMIDS AR-MORED IN ICE – THE PARADIGM AND ARCHETYPE OF IN-ACCESSIBLE PEAKS. HOWEVER, THERE IS MORE. THE MOUNTAINS NEVER EXHAUST THEIR LANDSCAPE VALUE JUST IN THE CRESTS. AT THE BASES OF PEAKS STRETCH HIGH-ALTITUDE PRAIRIES, PASTURE LANDS, AND, GRADU-

Stone Giants
Introduction

ALLY, ON THE SIDES OF THE VALLEYS, WOODS AND FARMS. THESE LANDSCAPES ARE OFTEN FAMOUS FOR THEIR PANORAMIC VIEWS, THEIR PRESENCE IN PHOTO-GRAPHIC BOOKS, AND THEIR POPULARITY AS TREKKING AND WALKING DESTINATIONS AND PLACES TO VISIT THAT FEATURE RURAL LIFESTYLES. ENVIRONMENTS THAT SEEM SHAPED BY NATURE OFTEN OWE THEIR EXISTENCE TO THE SILENT WORK OF MEN WHO, GENERATION AFTER GENERATION, USING KNOWLEDGE ACQUIRED OVER THE CENTURIES, HAVE REDESIGNED THE PHYSIOGNOMY IN A MASTERFUL WAY, LEVELING THE GROUND, MANIPULAT-ING THE FLOW OF RAINWATER, CARING FOR PASTURES AND WOODS, AND CREATING PATHS AND TERRACES.

- Piedmont (Italy) - Margherita Hut, located at 14,942 feet up Mount Rosa.

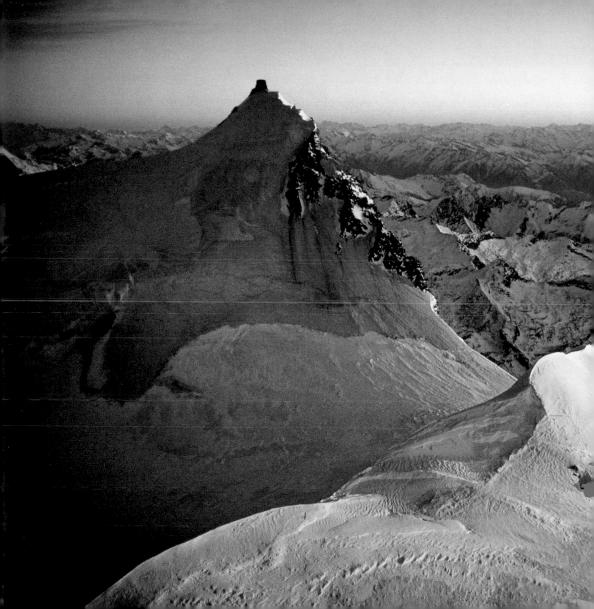

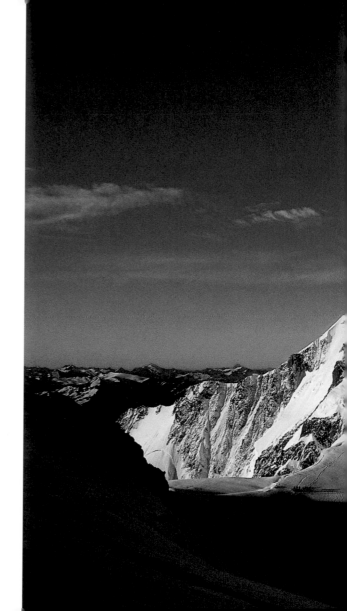

Europe

- Val d'Aosta (Italy) -
The top of Mont Blanc.

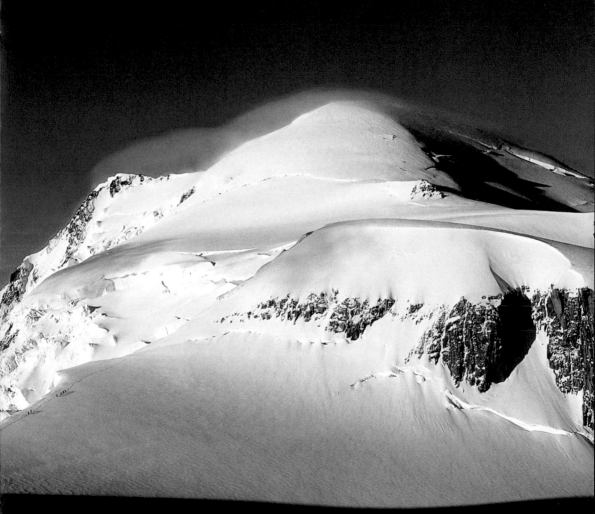

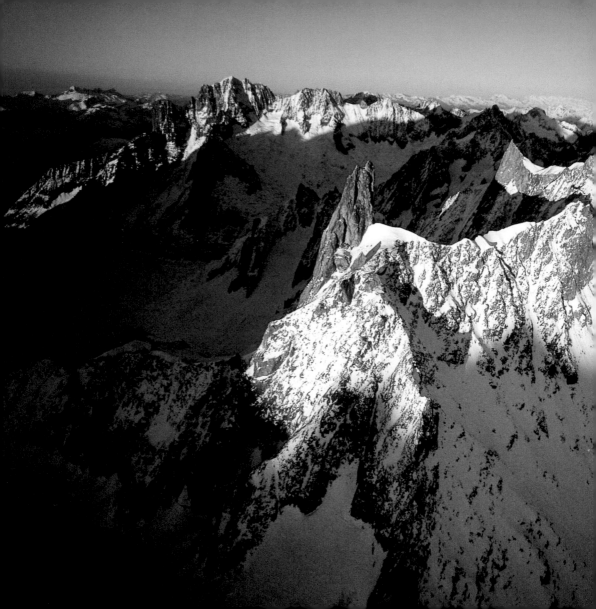

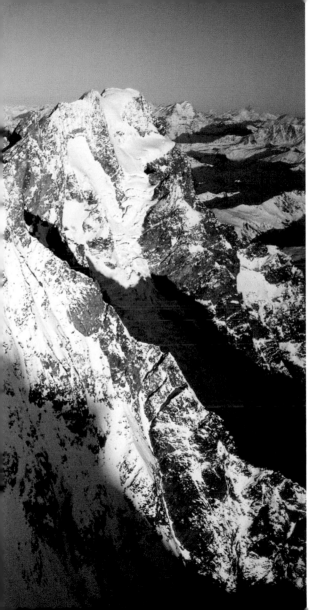

36-37 • Val d'Aosta (Italy) - The sun lights up the pinnacle of the Giant's Tooth (Dent du Geant), on the left, and the Grandes Jorasses, on the right.

37 • Val d'Aosta (Italy) - Dawn on the Grandes Jorasses.

38-39 • Val d'Aosta (Italy) - A panoramic view of the Mont Blanc Chain.

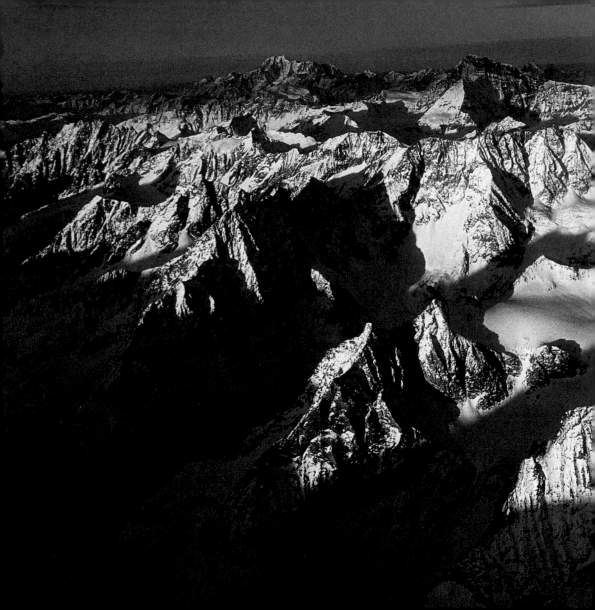

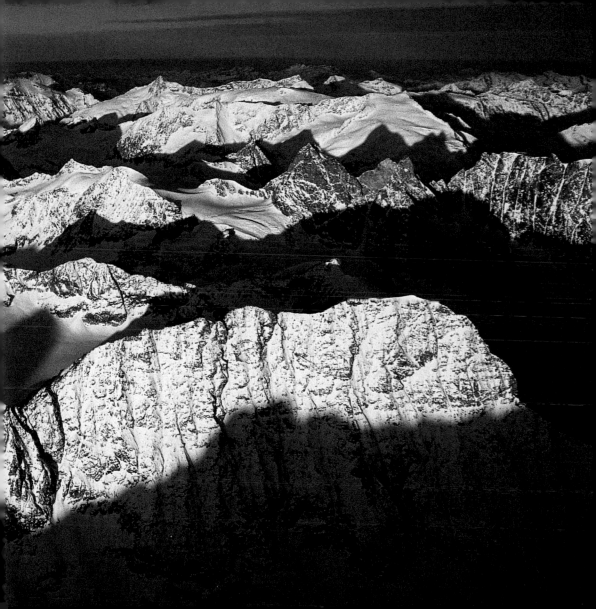

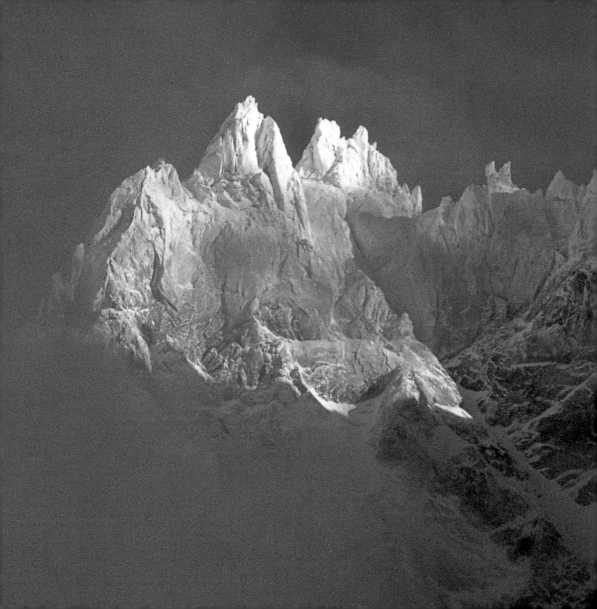

Upper Savoy (France) - The western face of Aiguille de Blaitière.

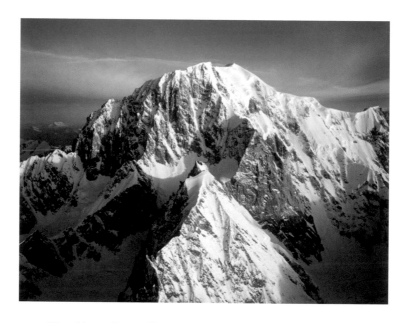

42 • Upper Savoy (France) - Aerial view of the face of Brenva.

43 • Upper Savoy (France) - The Mont Blanc watershed, along the border between France and Italy.

44-45 • Upper Savoy (France) - Sunset over the Grandes Jorasses.

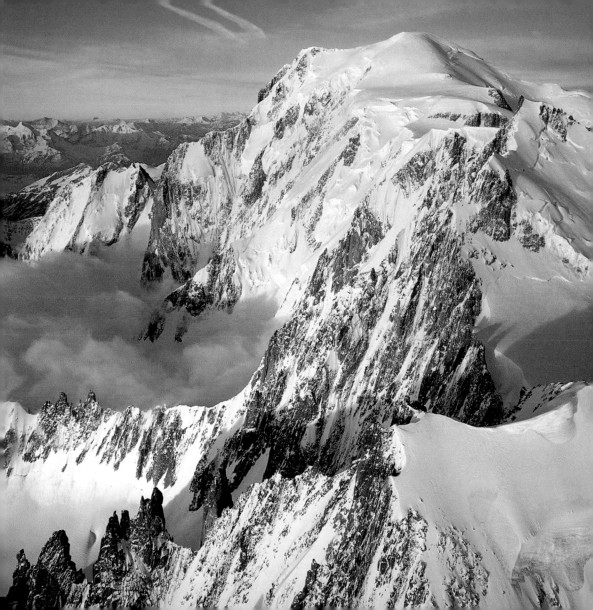

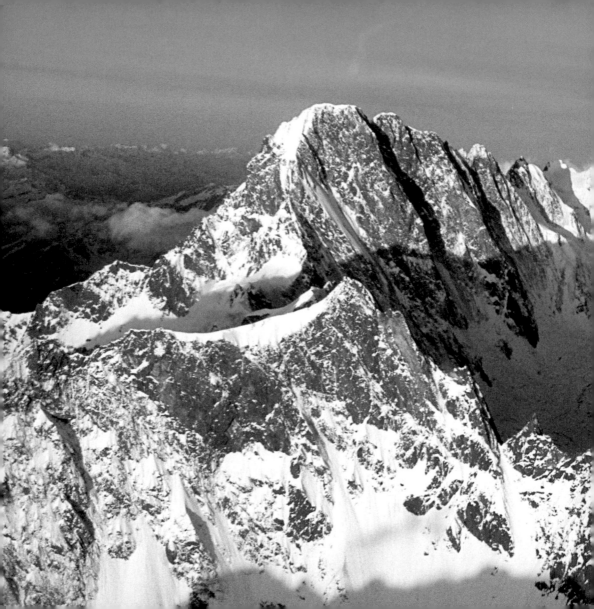

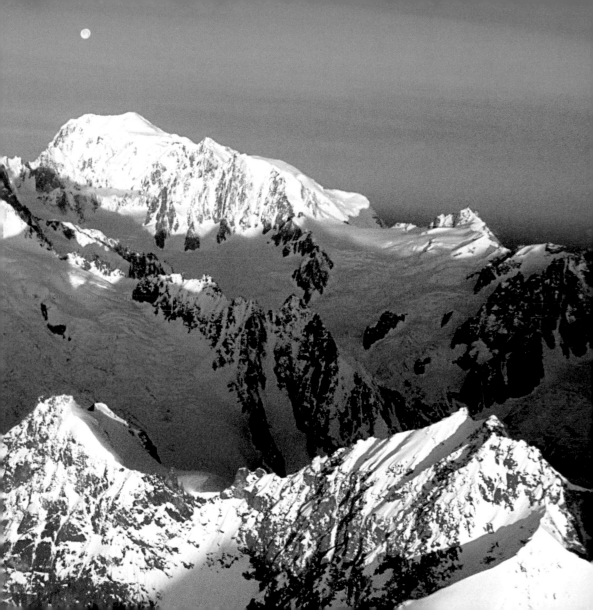

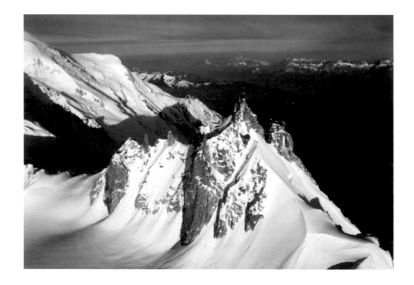

46 • Upper Savoy (France) - Aiguille du Midi.

47 • Upper Savoy (France) - The north face of Aiguille Verte.

48-49 • Upper Savoy (France) - View of the Aiguille du Midi Massif's snowy crest.

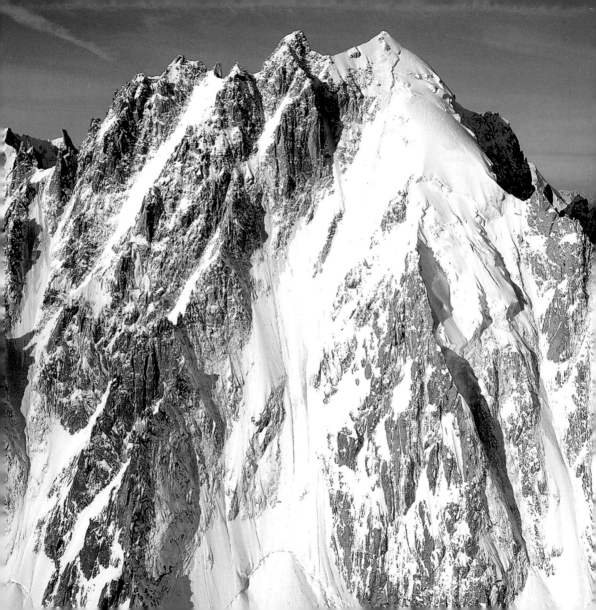

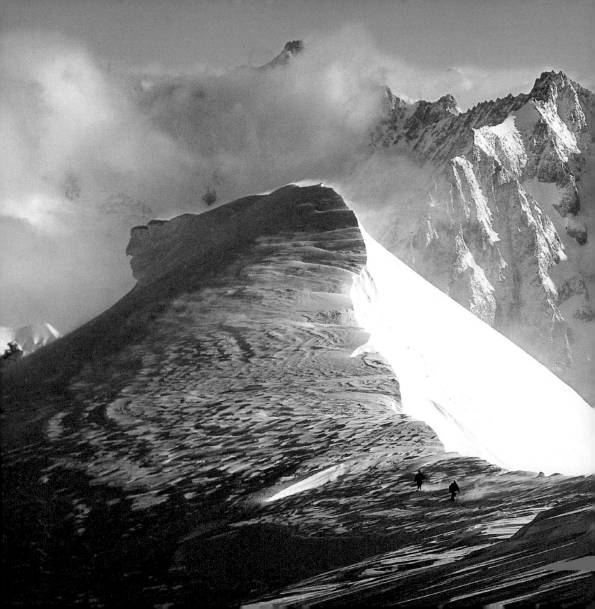

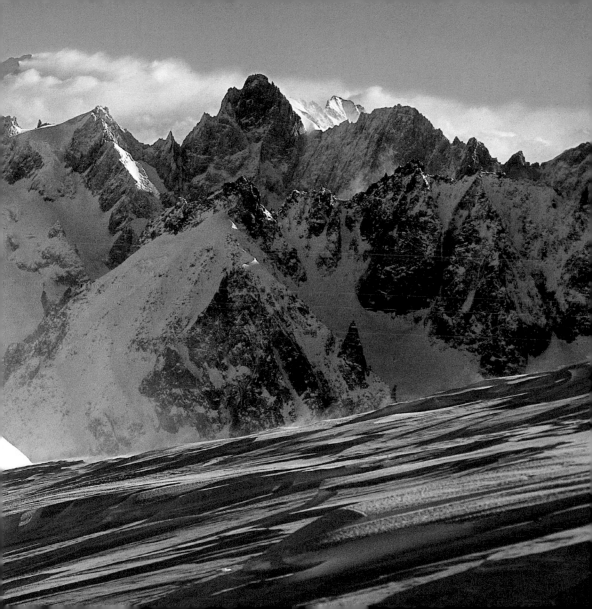

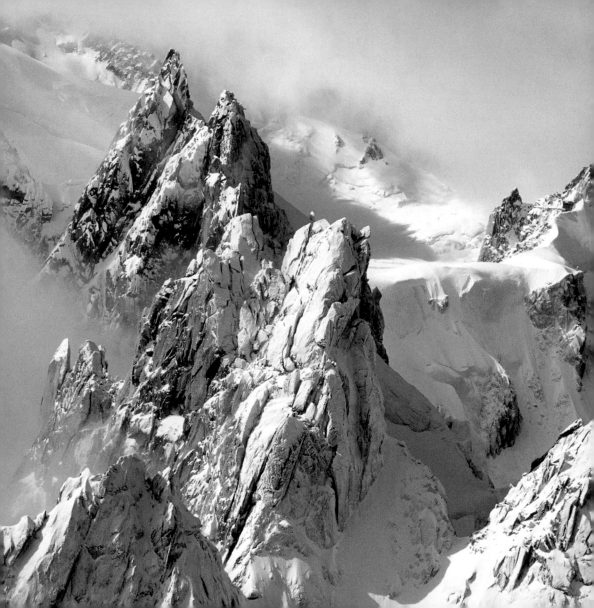

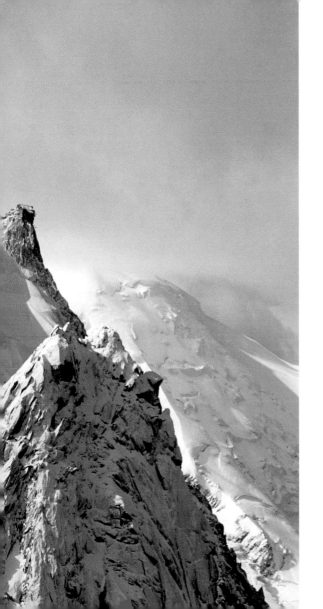

50-51 • Upper Savoy (France) - Aiguille du Midi, center, and Aiguille du Plan, on the left.

51 • Upper Savoy (France) - Aerial view of two satellite peaks of the Aiguille du Midi.

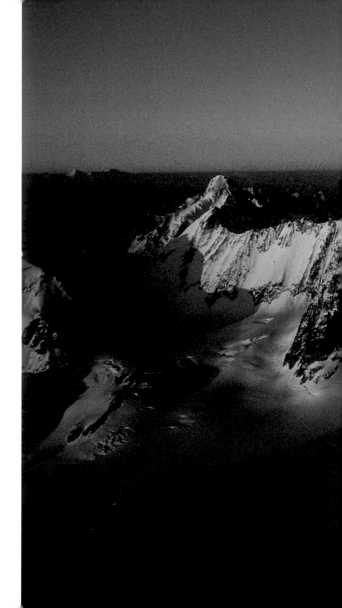

● Upper Savoy (France) - The Argentière Glacier encircled by Aiguille du Chardonnet, Aiguille d'Argentière, Tour Noir (Black Tower), Mont Dolent, and Aiguille de Triolet.

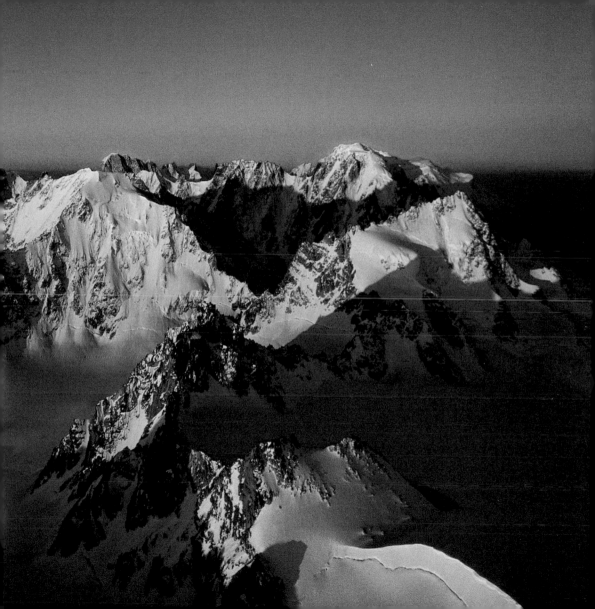

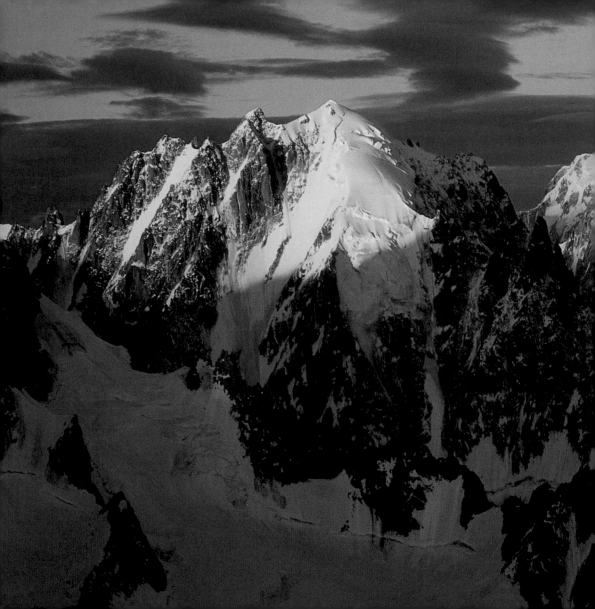

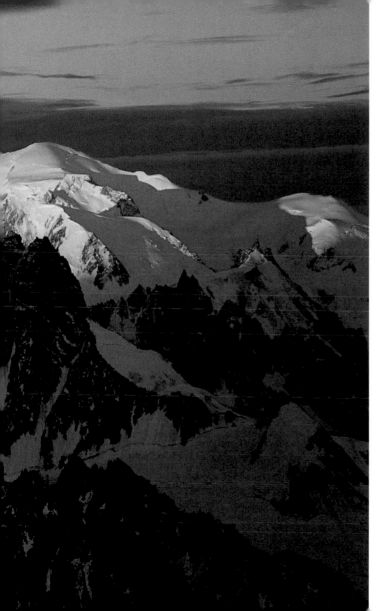

Upper Savoy (France) -
The last light of day on the
Aiguille Verte (left) and the
peak of Mont Blanc (right).

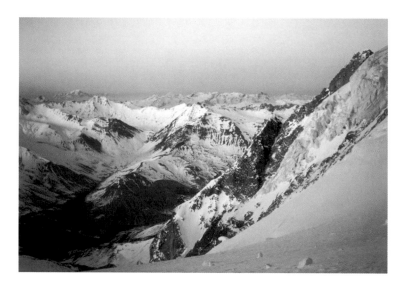

56 • Oisans (France) - The Meije Glacier, in the National Park of the Ecrins.

57 • Dauphiné (France) - The square profile of Mont Aiguille.

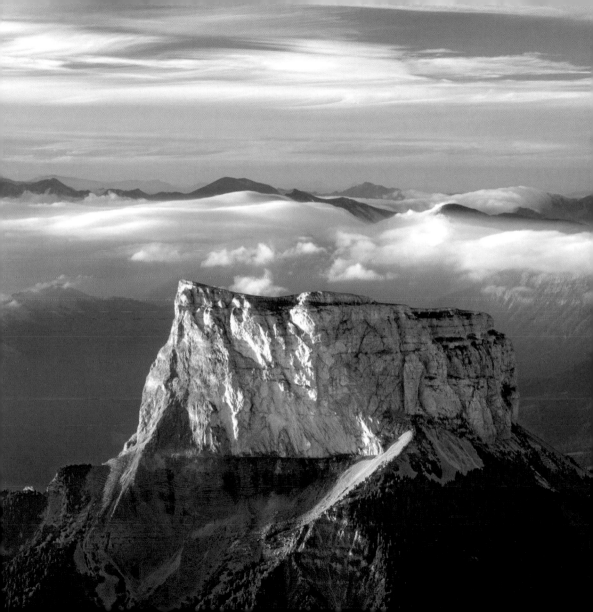

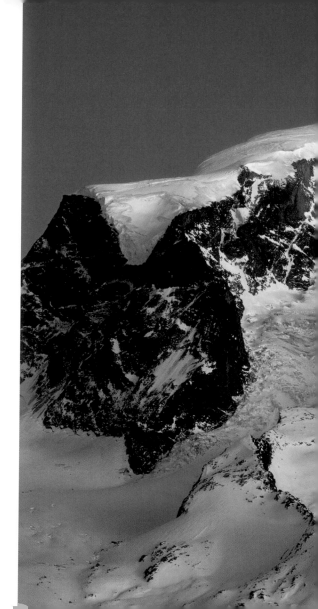

58 • Oberland (Switzerland) - The north
face of Mount Monch.

58-59 • Valais (Switzerland) - Mounts
Rosa and Lyskamm.

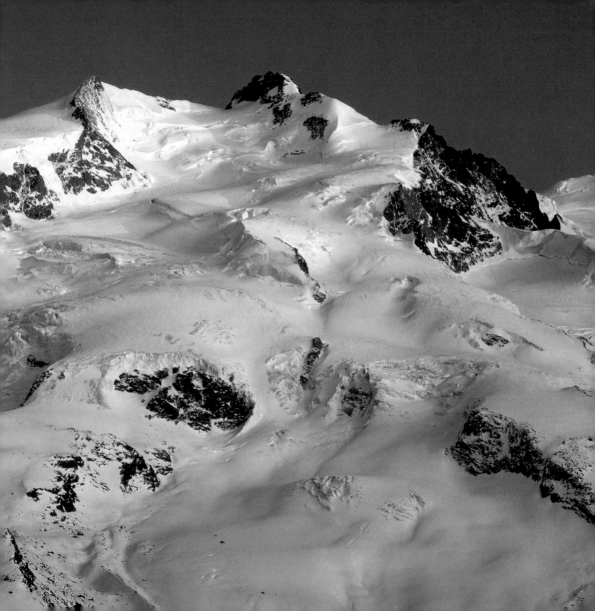

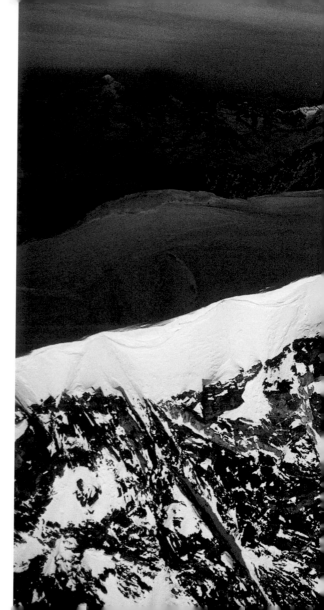

60 • Piedmont (Italy) - View of Mount Rosa.

60-61 • Piedmont (Italy) - Margherita Hut, on Mount Rosa, is the highest hut in Europe.

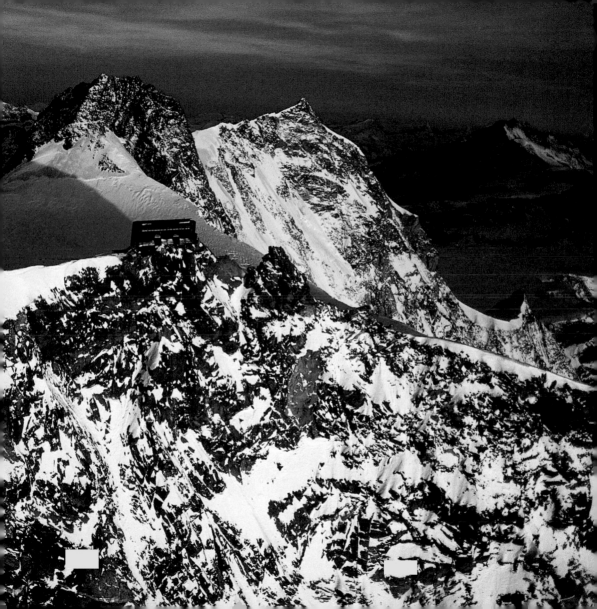

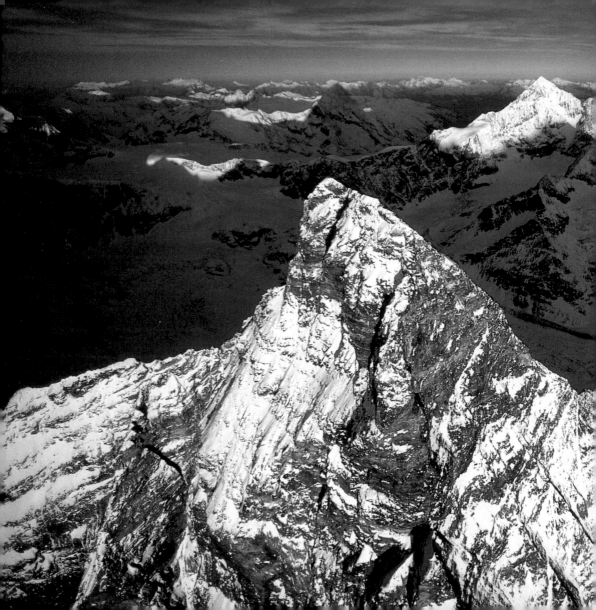

Val d'Aosta (Italy) -
The Matterhorn's
pyramid.

64 • Valais (Switzerland) - The Matterhorn's peak overlooks a sea of ice.

65 • Valais (Switzerland) - The Matterhorn is 14,692 feet tall.

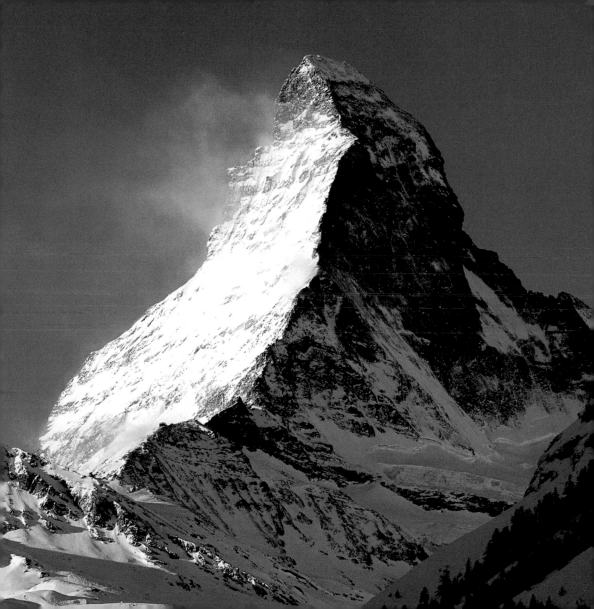

Oberland (Switzerland) -
Dawn on Finsteraarhorn
from Agassizhorn Peak.

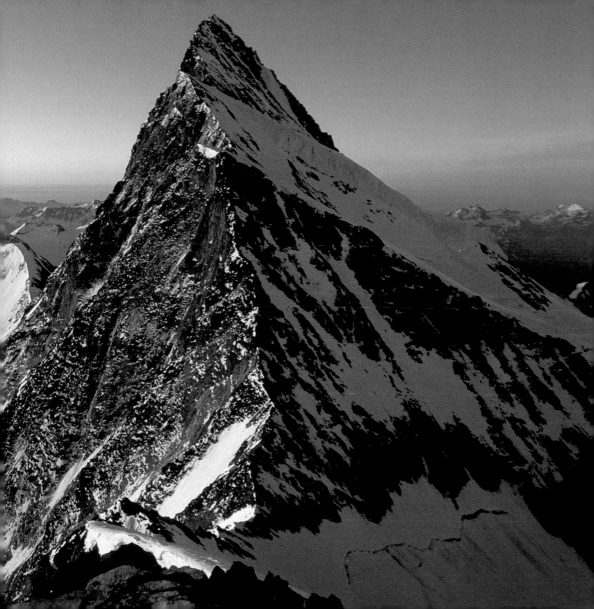

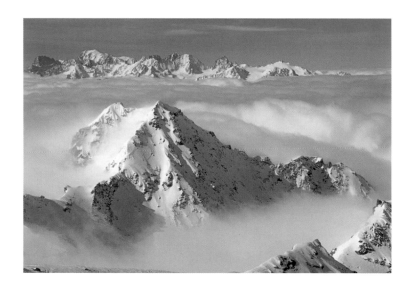

68 • Valais (Switzerland) - Aerial view of the Verbier Alps.

69 • Valais (Switzerland) - Mount Obergabelhorn seen from the top of Blanc de Moming.

70-71 • Oberland (Switzerland) - Dawn on mounts Monch and Eiger.

72-73 • Graubunden (Switzerland) - Sunset on Piz Medel.

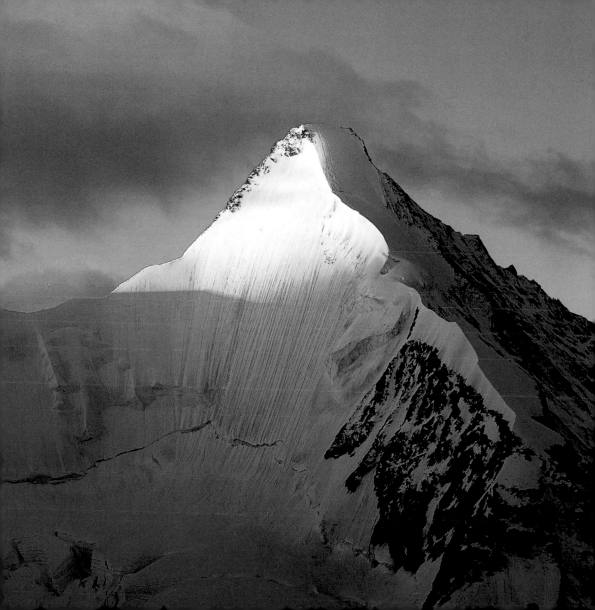

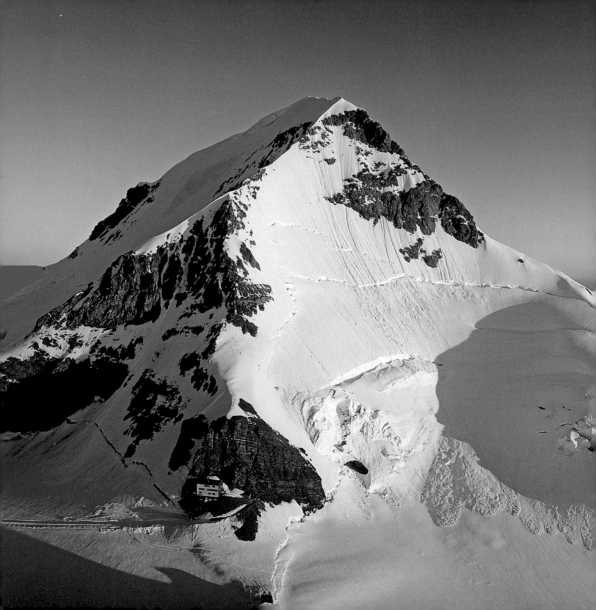

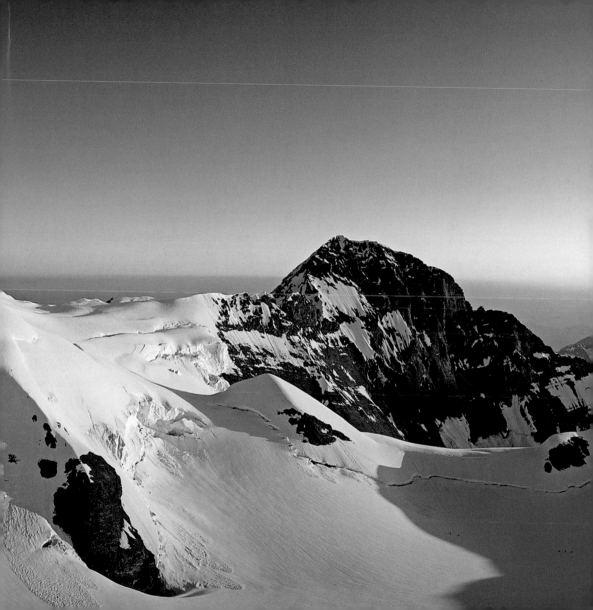

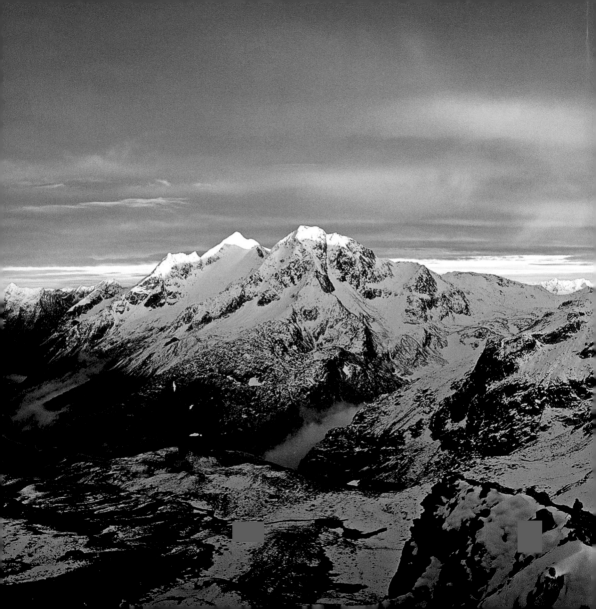

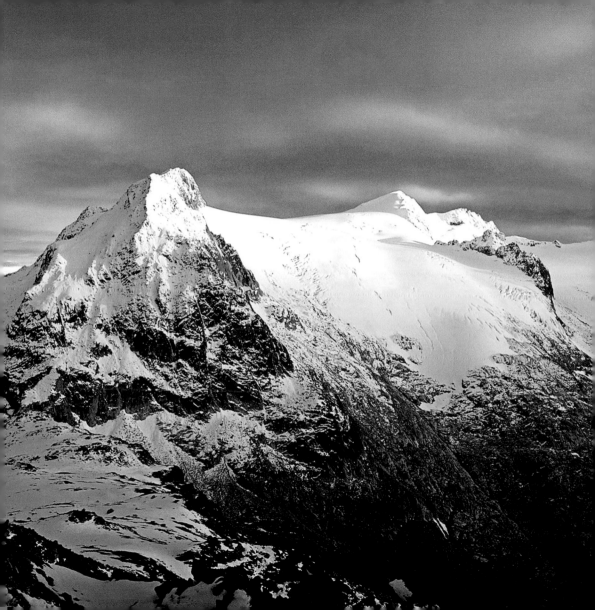

74 • Trentino-Alto Adige (Italy) -
Towers of the Sella.

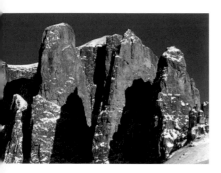

74-75 • Trentino-Alto Adige
(Italy) - Panorama over Piz Boé.

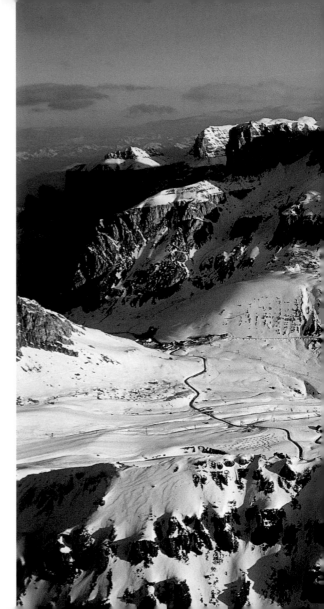

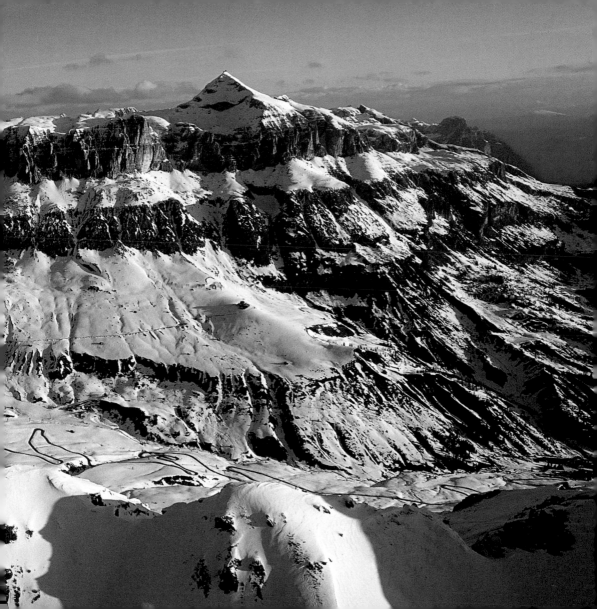

Trentino-Alto Adige (Italy) - Two
aerial views of the Brenta
Dolomites.

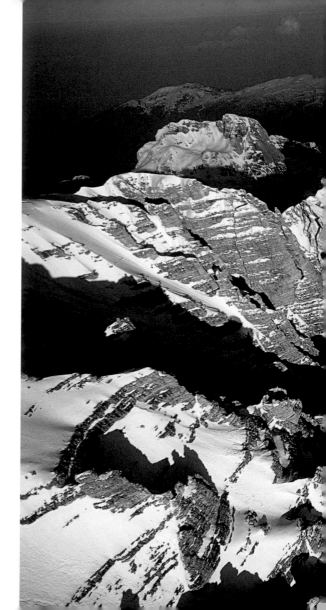

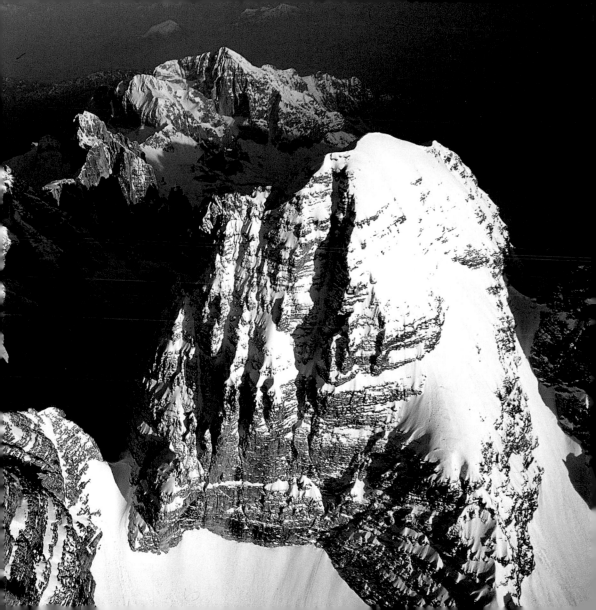

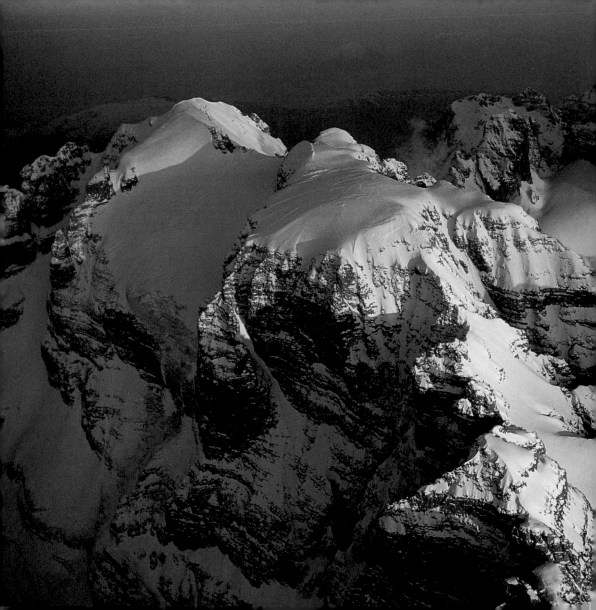

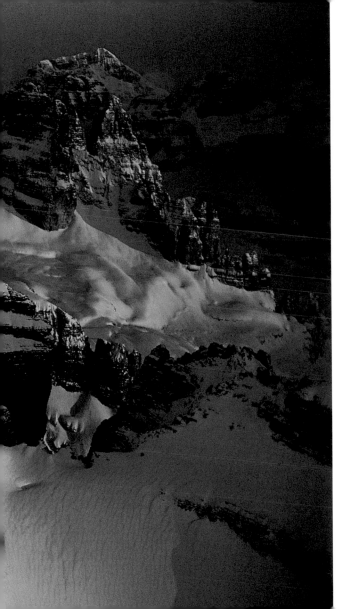

● Trentino-Alto Adige
(Italy) · Snowy Cima
Tosa pops up from the
Brenta Dolomites.

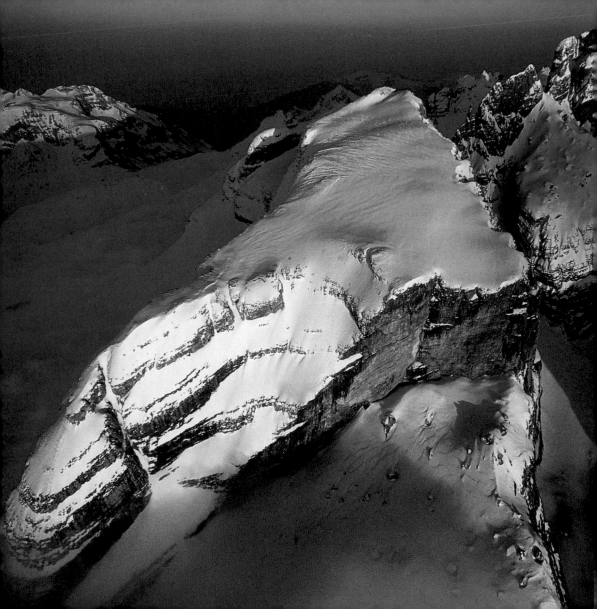

80-81 • Trentino-Alto Adige (Italy) - The Brenta Chain is found in the westernmost Dolomites.

81 • Trentino-Alto Adige (Italy) - The Sfulmini Chain, in the Brenta Chain.

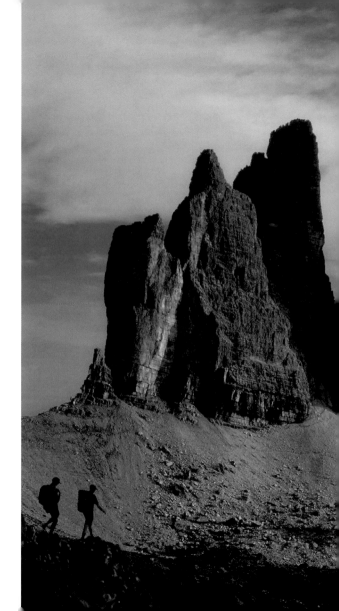

Trentino-Alto Adige
(Italy) - The Three Peaks
of Lavaredo are part of
the Sesto Dolomites.

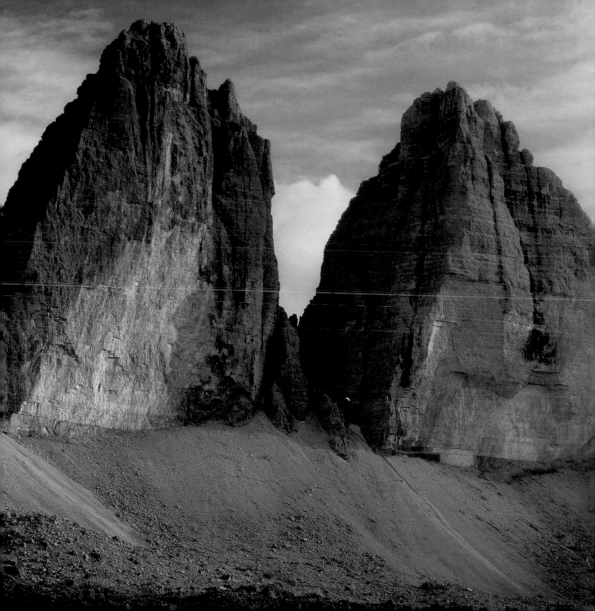

84 ● Trentino-Alto Adige (Italy) - Cima dei Bureloni, in the Pale di San Martino.

84-85 ● Trentino-Alto Adige (Italy) - Mount Pelmo.

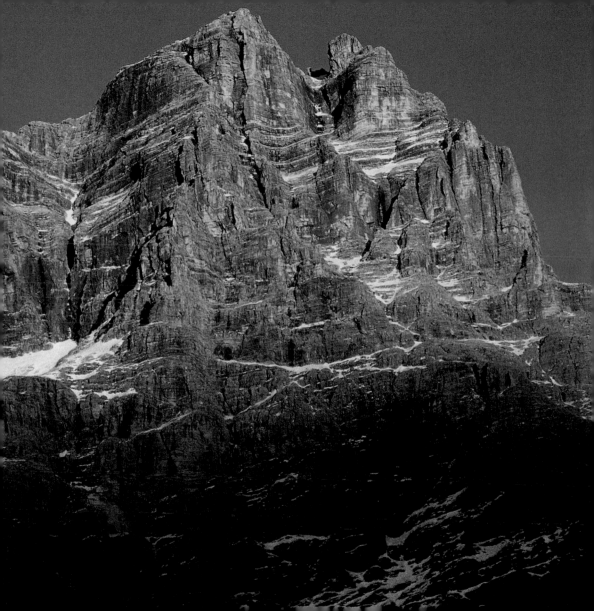

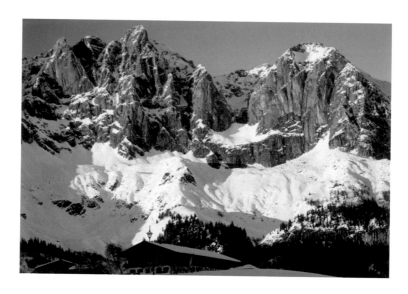

86 • Tyrol (Austria) - A hut at the base of Wilder Kaiser.

87 • Tyrol (Austria) - Grossglockner towers over the Heiligenblut Valley.

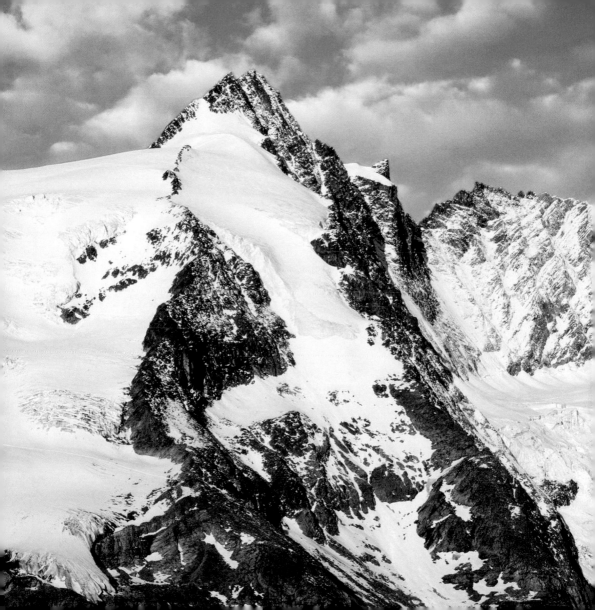

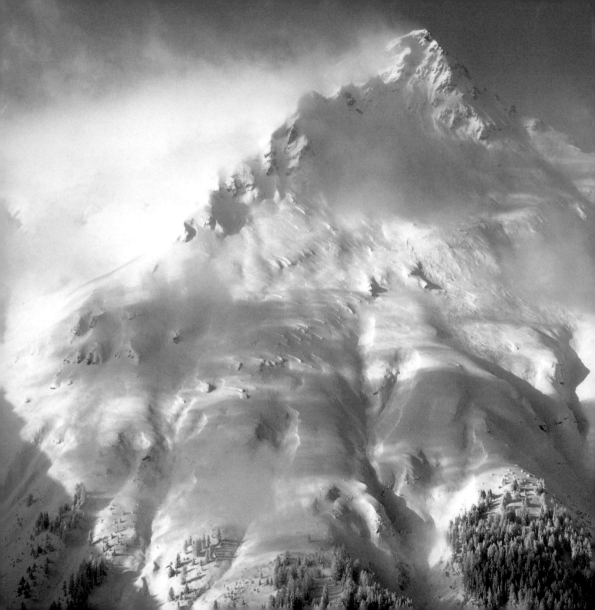

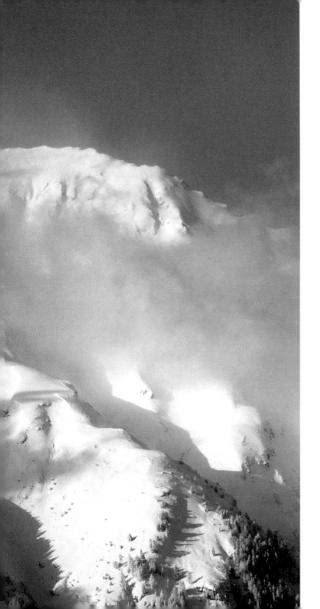

88-89 • Tyrol (Austria) - Ortler seen from Nauders Valley.

89 • Tyrol (Austria) - A snowslide has marred the side of this mountain, in the Alps on the border with Engadina.

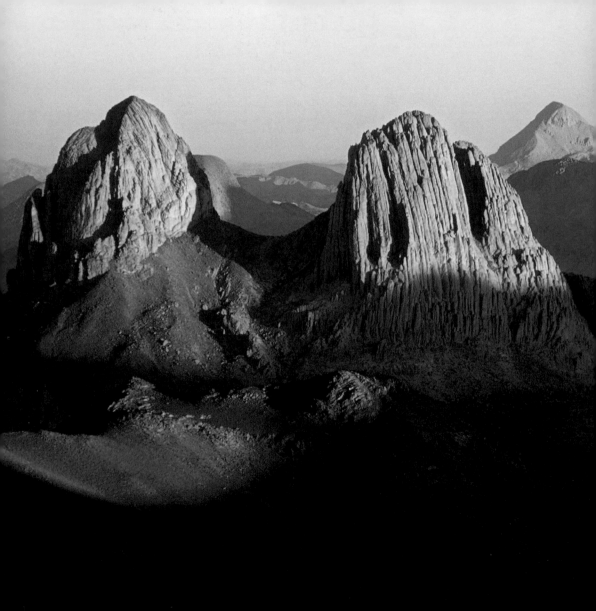

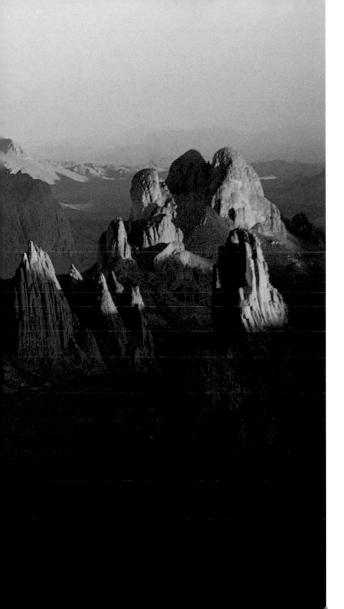

Africa

90-91 • Algeria - The warm light of sunset envelops the Saharan Atlas Mountains.

92-93 • Tanzania - Kilimanjaro is the background for a group of antelopes.

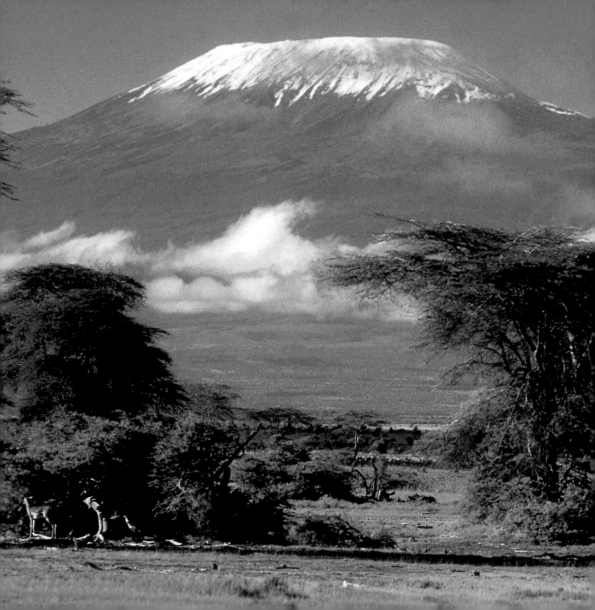

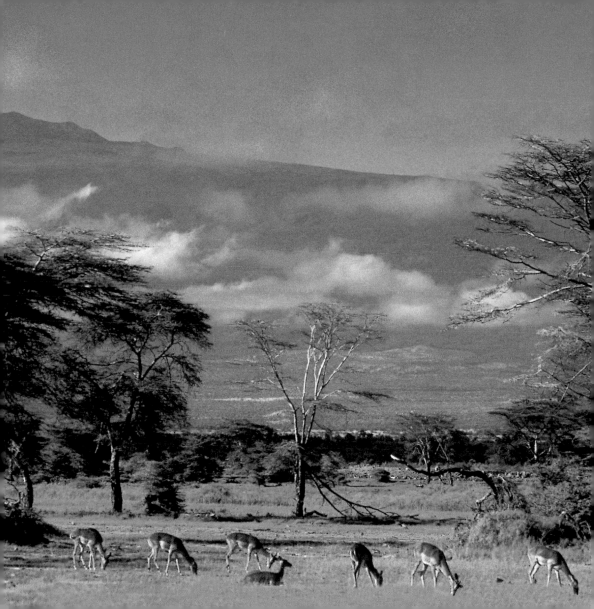

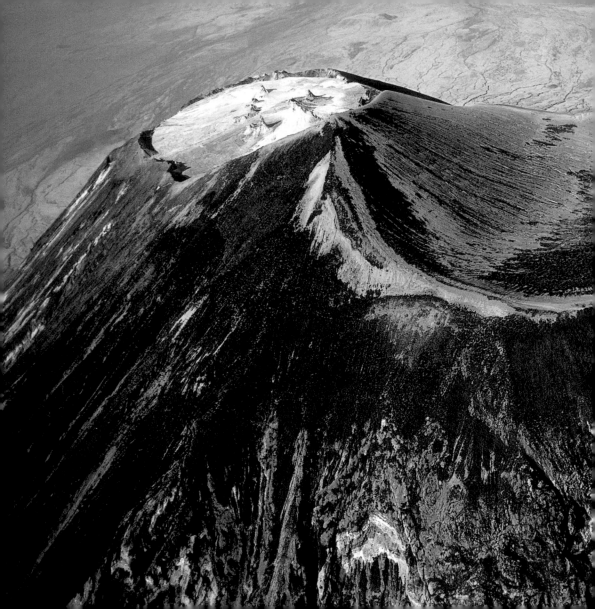

Tanzania - The immense crater of Ol Doinyo Lengai and rivers of petrified lava.

Asia

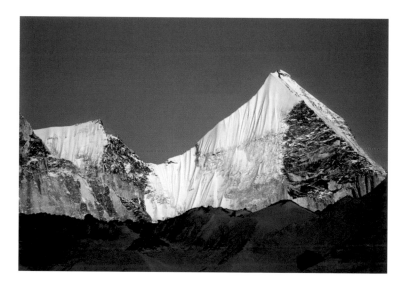

Uttar Pradesh (India) - The Ganges River originates from Bagirathi Peak, near the Gaumukh Glacier.

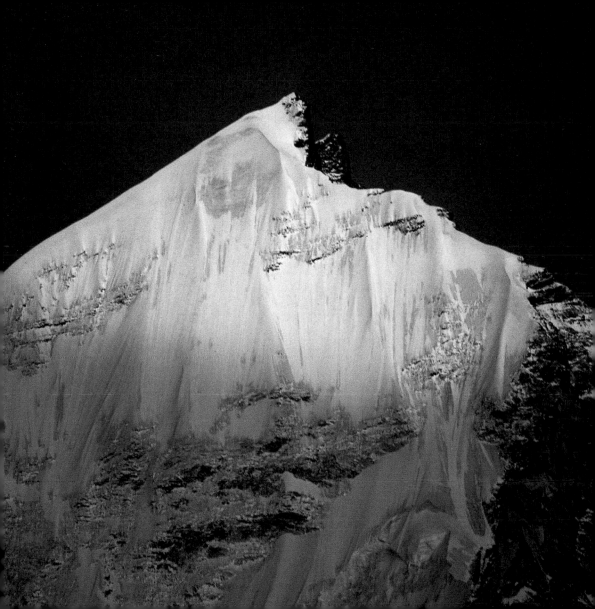

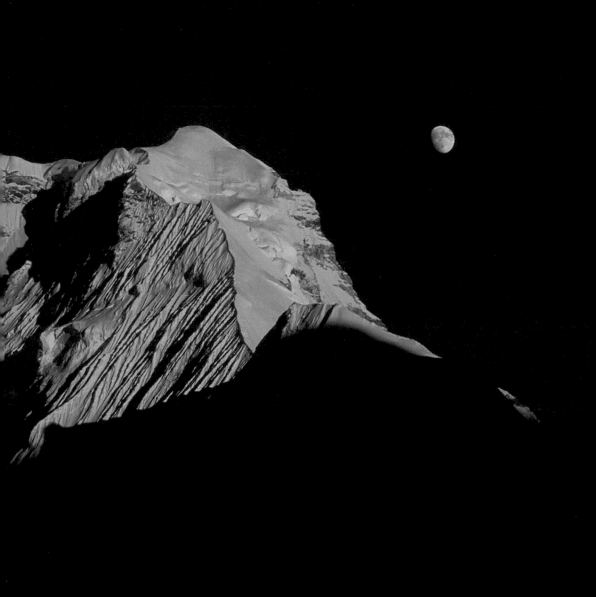

98-99 • Nepal - The moon looks like the end of the line for Dorje Lakpa, in the Himalayas.

100-101 • Nepal - The massif of Annapurna exceeds just over 26,000 feet.

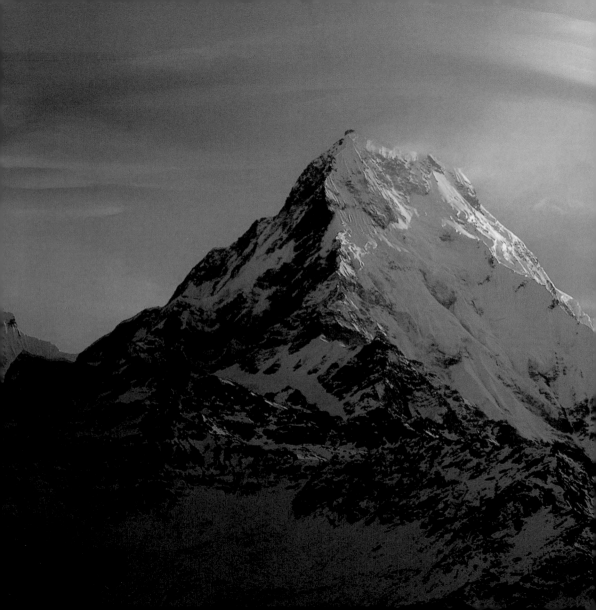

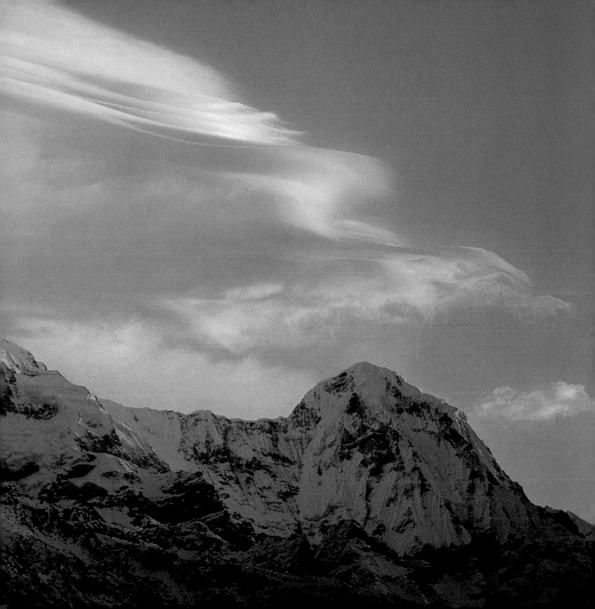

102 • Nepal - The peak of Ama Dablam at sunset.

102-103 • Nepal - Ama Dablam: its name means "mother and her necklace."

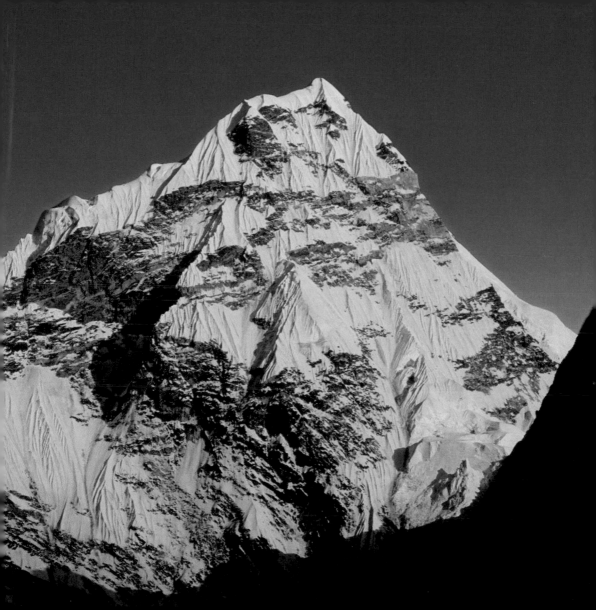

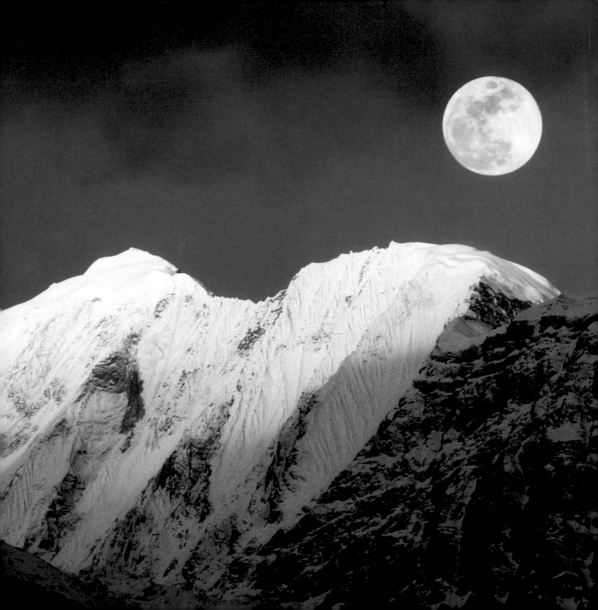

104-105 • Nepal - The last light of evening on the snows of Cho Oyu.

106-107 • Nepal - The moon's image frames one of the many nameless peaks in the Himalayas.

108-109 • Nepal - The peaks of mounts Everest, Lhotse, and Nuptse seen from Mount Pumori.

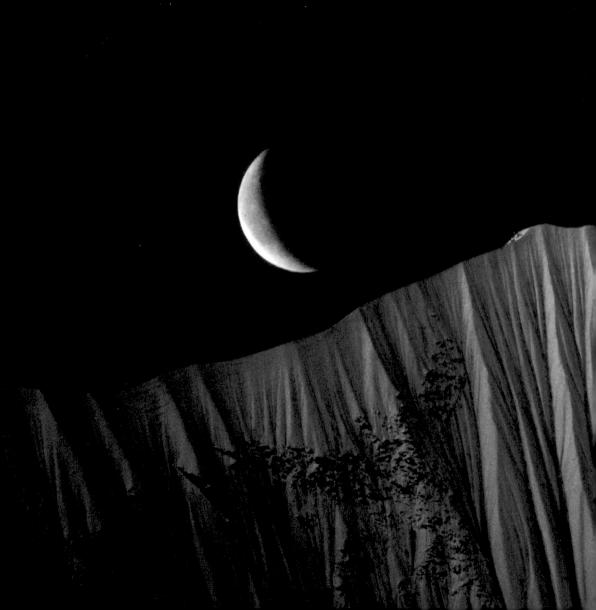

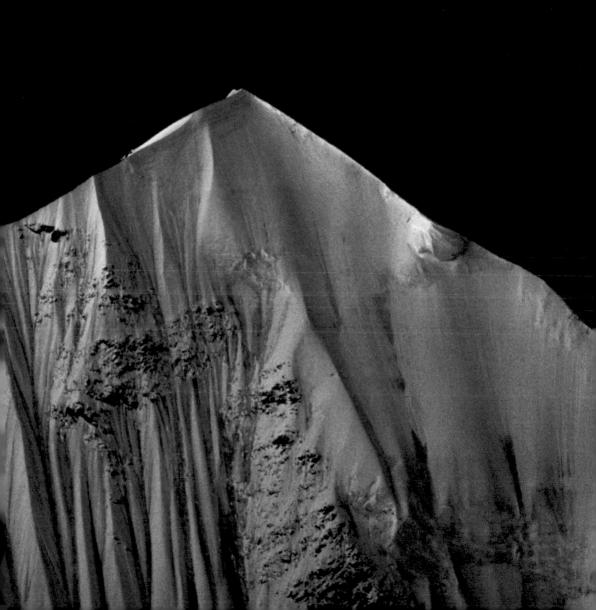

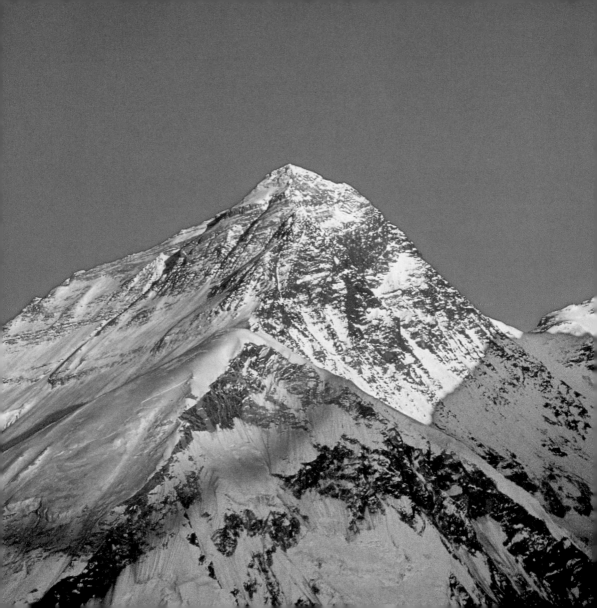

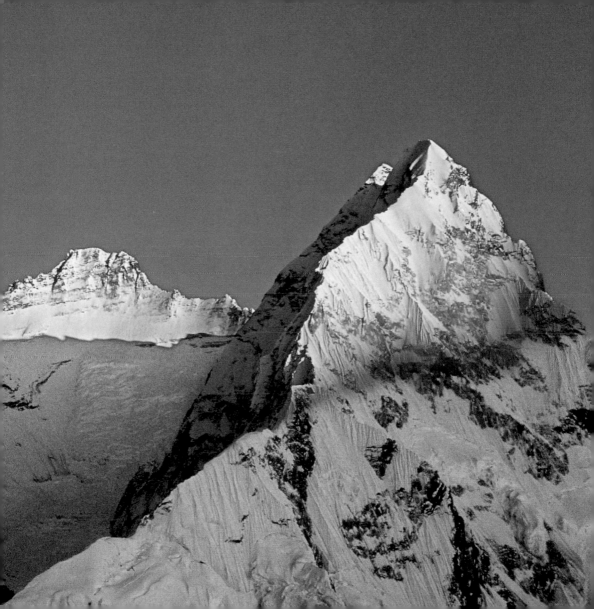

110 ● Nepal - Red clouds cover Everest, on the border between Nepal and Tibet.

111 ● Nepal - The sun at dusk is reflected from the southwestern face of Everest.

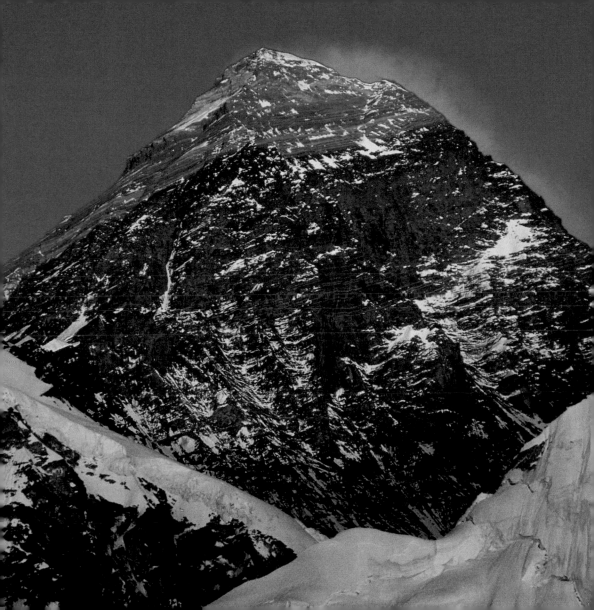

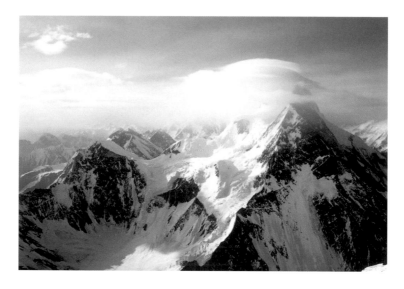

112 • Pakistan - Broad Peak, also known as K3, is seen here from Abruzzi Ridge.

113 • Pakistan - Mount Masherbrum, originally called K1, can be glimpsed among the gray clouds.

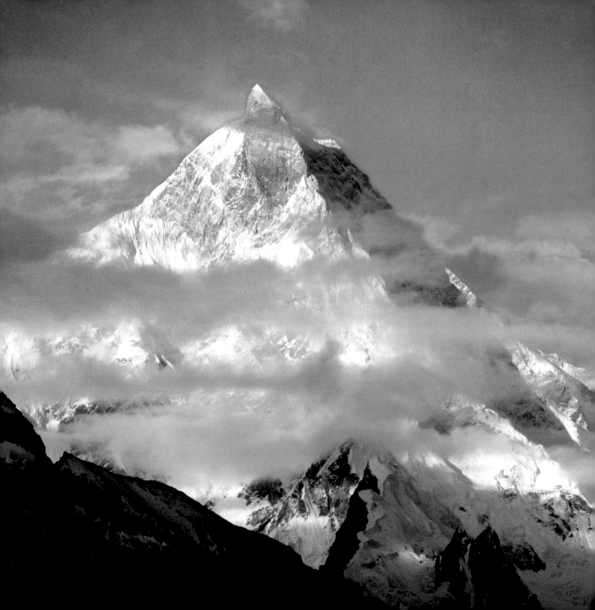

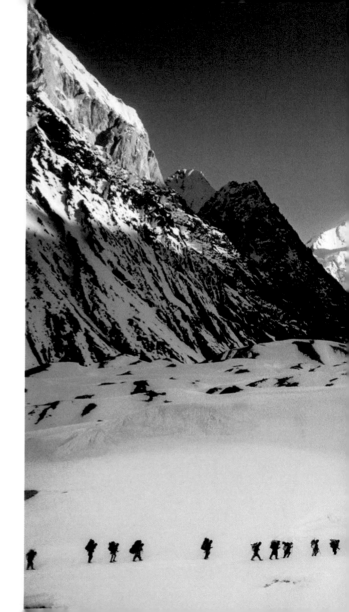

114-115 ● Pakistan - A long line of porters marches across the ice towards the 28,253-foot-high of K2.

116-117 ● Xizang (China) - The Rolwaling Himal is the dividing line between the autonomous Chinese region and Nepal.

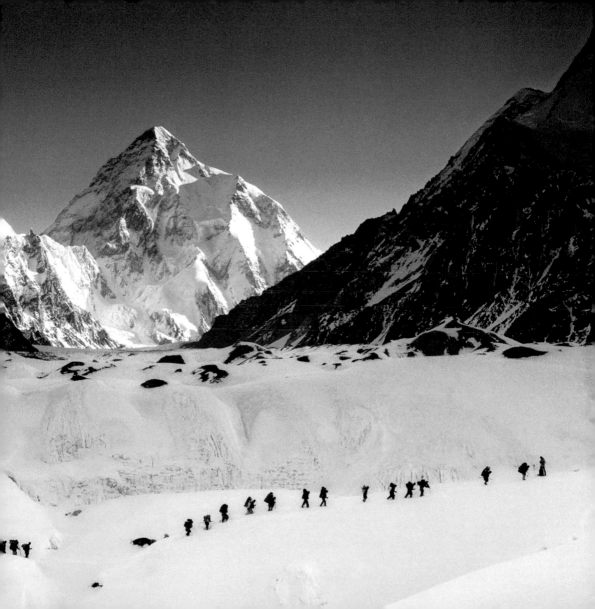

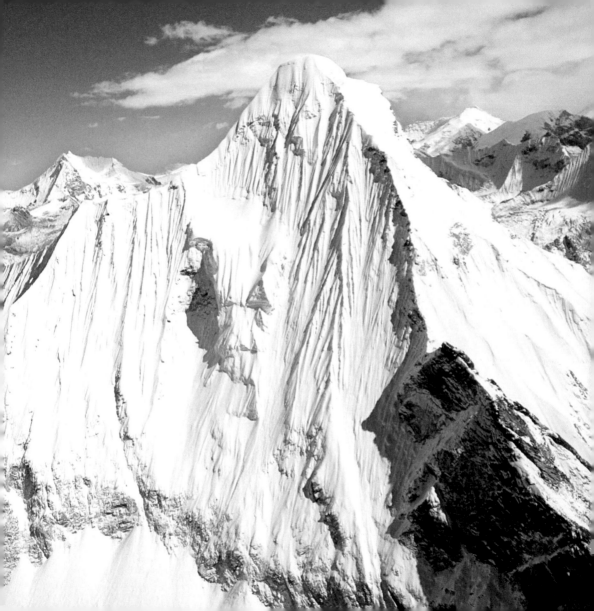

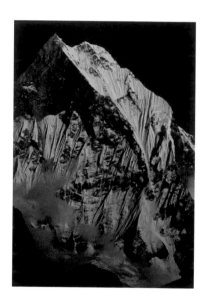

118 • Nepal - Machapuchare rises east of the Annapurna Massif.

119 • Nepal - Gasherbrum IV is part of Karakorum.

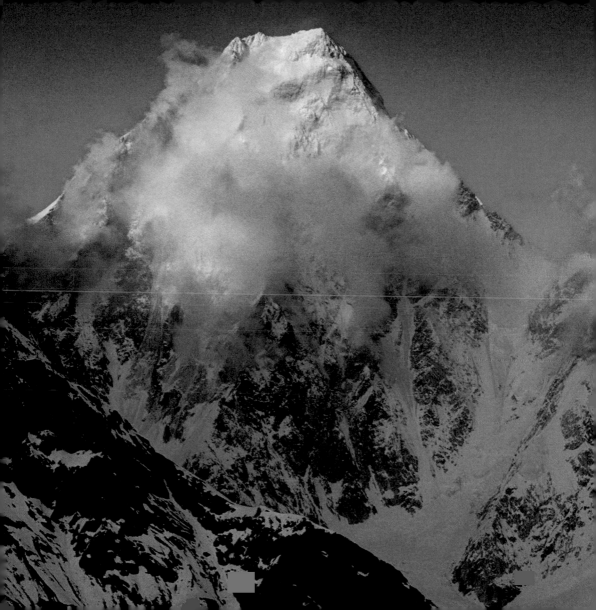

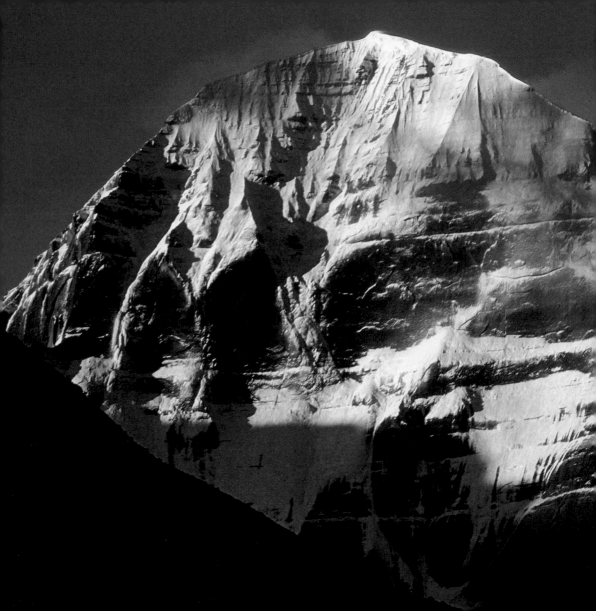

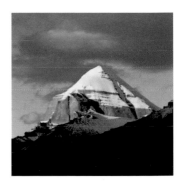

120-121 ● Tibet (China) - The southern face of Mount Kailas, the symbolic sacred mountain of Buddhism and Hinduism.

121 ● Tibet (China) - The peak of Mount Kangrinbog.

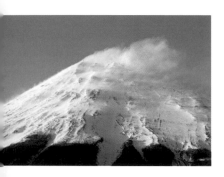

● Japan - Still today, Mount Fuji
continues to exercise a strong
influence over visual Japanese
culture.

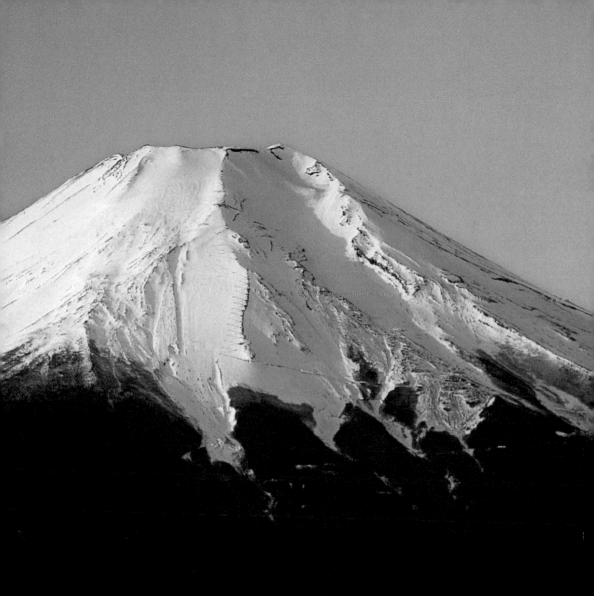

Oceania

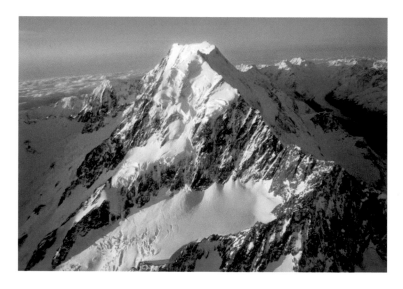

124 • Canterbury (New Zealand) - The southern face of Mount Cook towers over Hooker Valley.

125 • Canterbury (New Zealand) - Mount Cook (12,316 feet) is the tallest peak in New Zealand.

126-127 • Canterbury (New Zealand) - Mounts Cook (left) and Tasman (right).

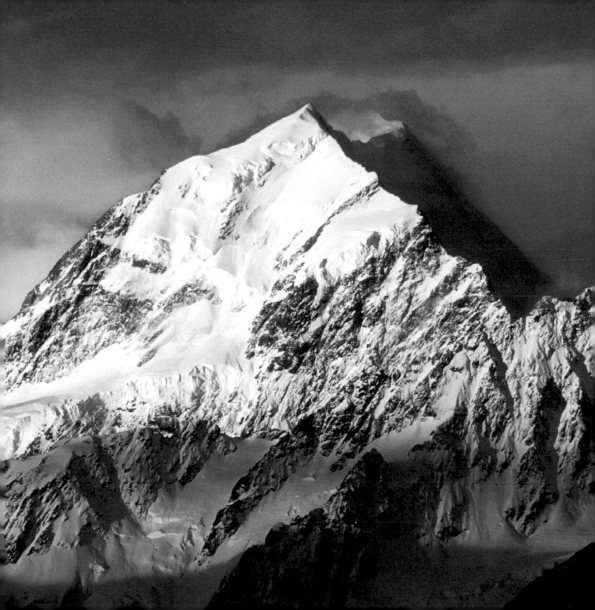

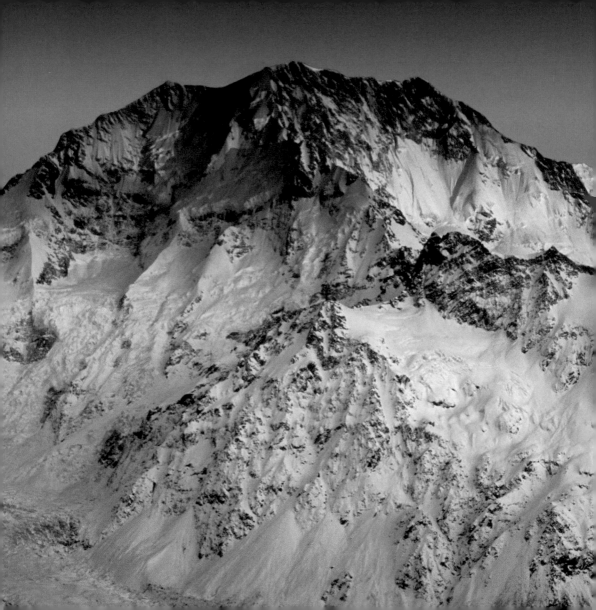

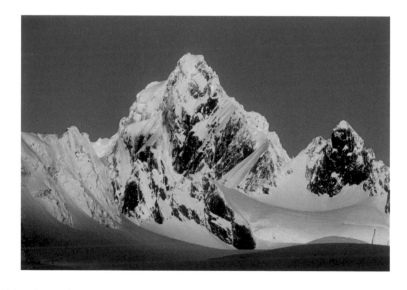

128 • West Coast (New Zealand) - A play of color on mounts Alack and Douglas.

129 • Canterbury (New Zealand) - Dusk at Mount Graceful seen from Murchison Hut.

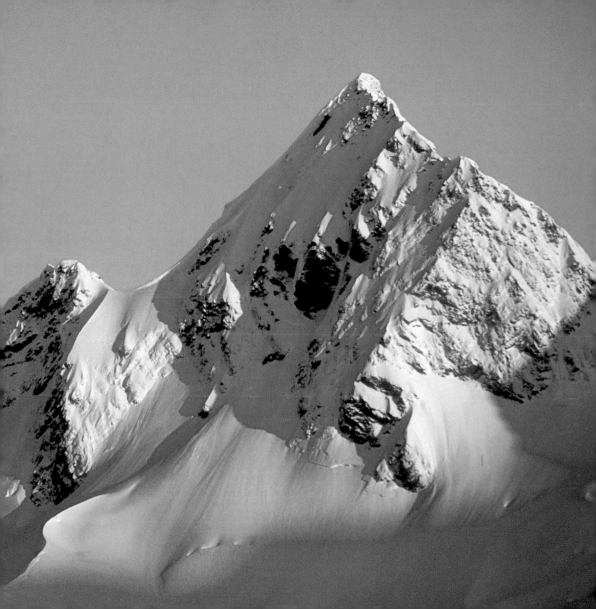

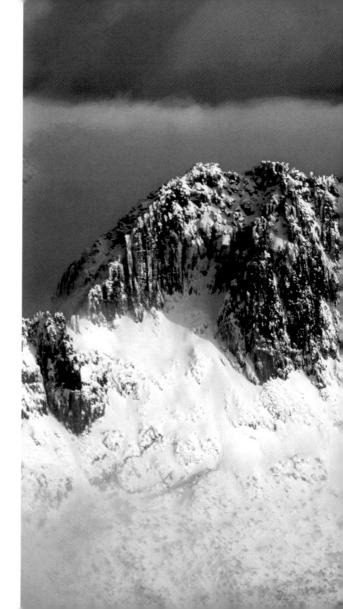

• Tasmania (Australia) - An aerial view of Eldon Bluff, in the Cradle Mountain-Lake St. Clair National Park.

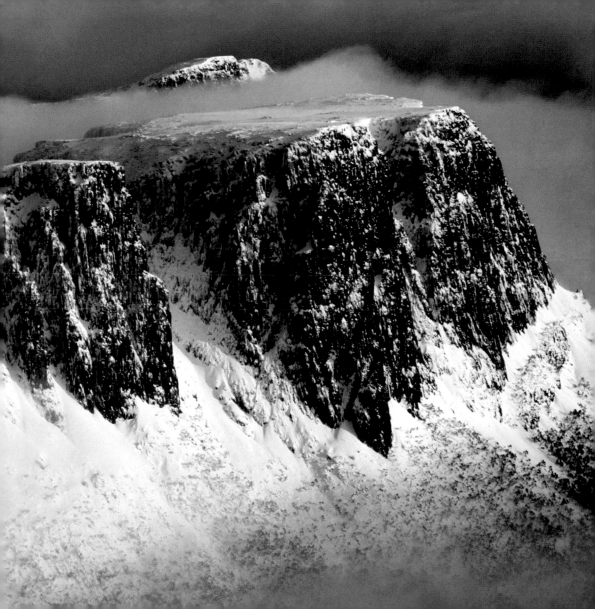

West Coast (New Zealand) - A skier prepares to reach the top of Mount Von Bulow. In the background, Mount Tasman.

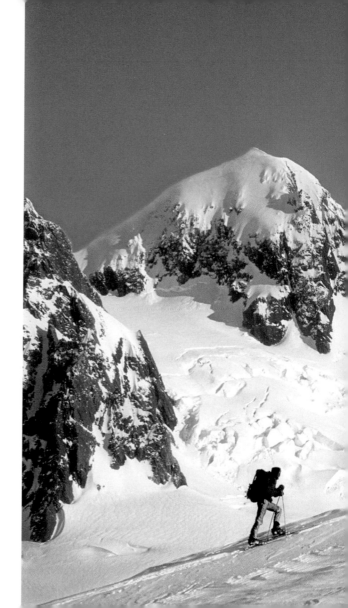

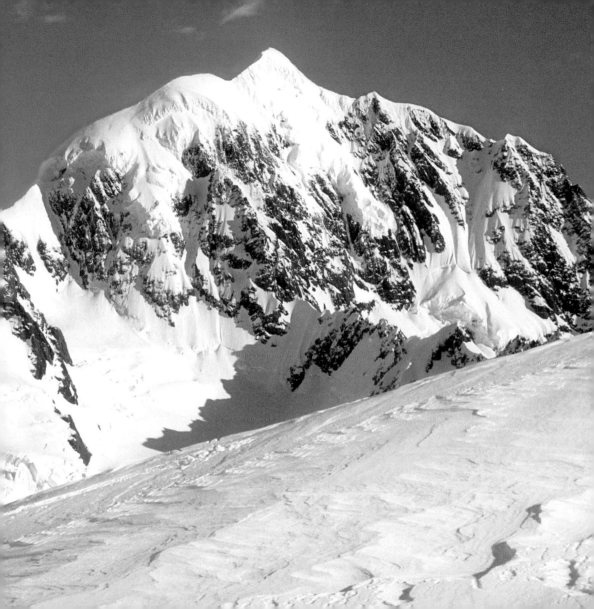

North America

134 • Alaska (USA) - Clouds envelop Mount Foraker, in Denali National Park.

134-135 • Alaska (USA) - Mounts Hunter (14,574 feet) and Foraker (17,402 feet) are among the tallest peaks in the Yukon.

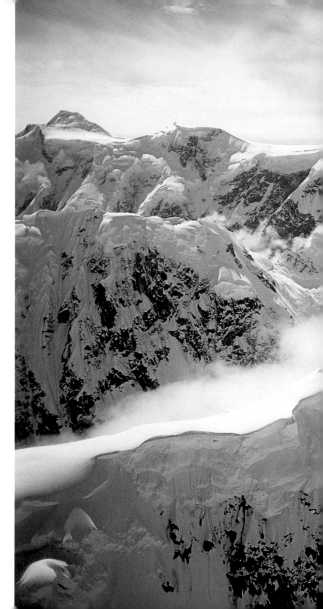

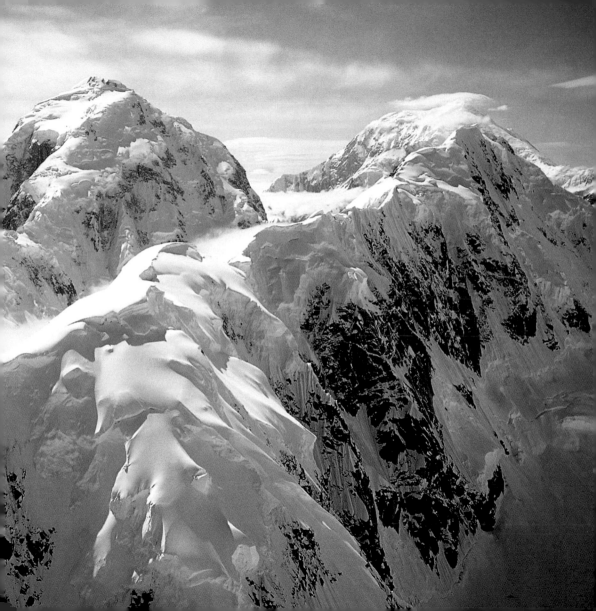

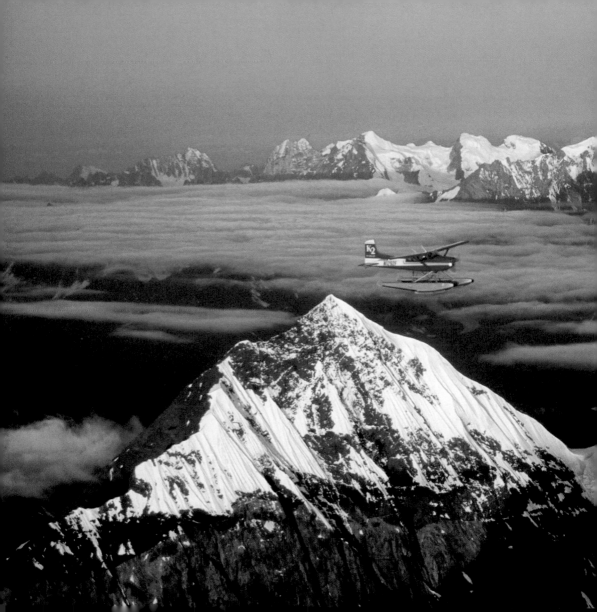

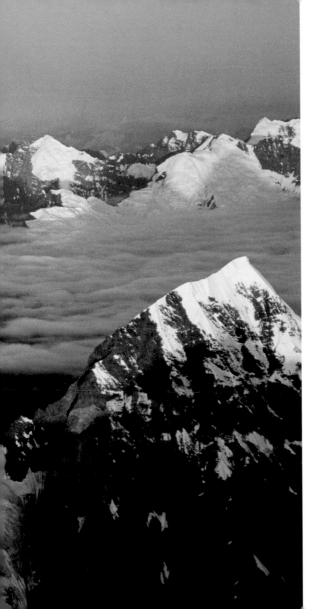

136-137 ● Alaska (USA) - A hydroplane circles the massif of Mount McKinley, in Denali National Park.

137 ● Alaska (USA) - The play of light on Mount McKinley, in Denali National Park.

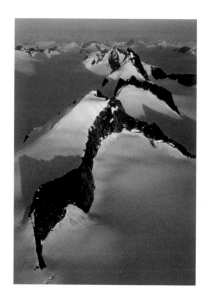

138 and 139 ● Alaska (USA) - Numerous snowy crests connect the peaks of the Juneau Massif, in the southeast of the state.

140-141 ● British Columbia (Canada) - Three Guardsmen Mountain.

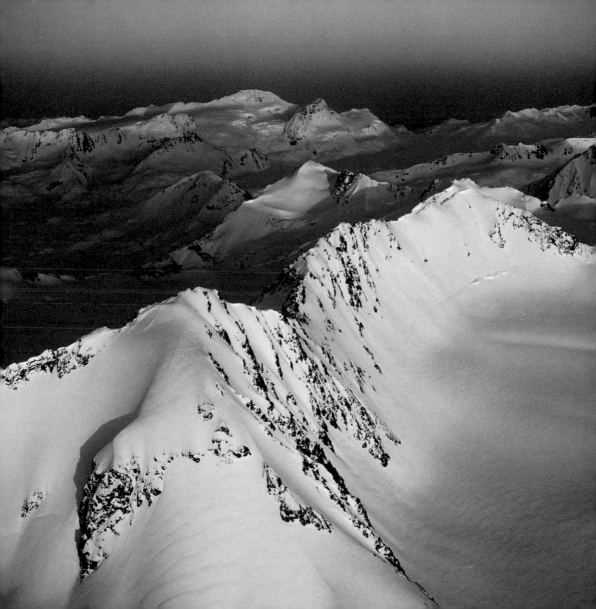

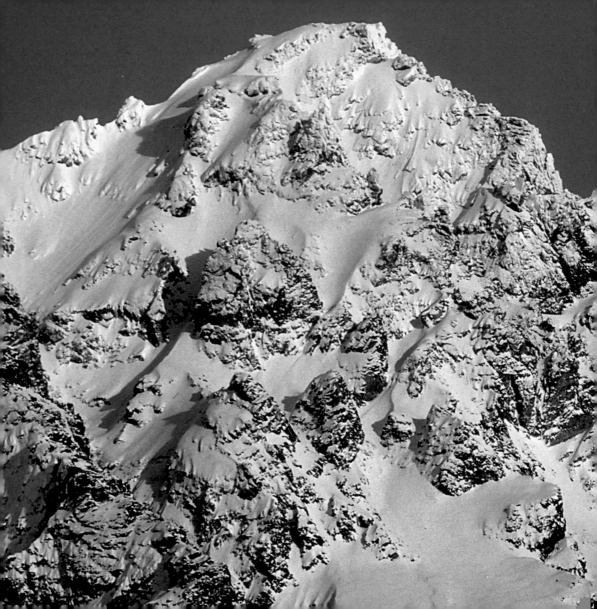

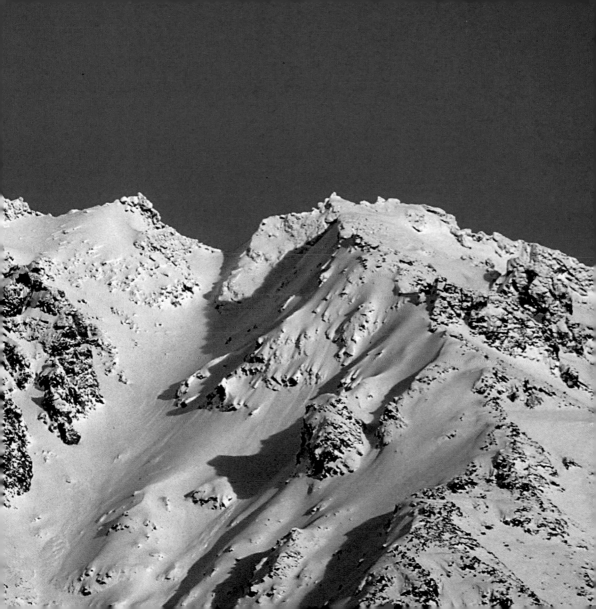

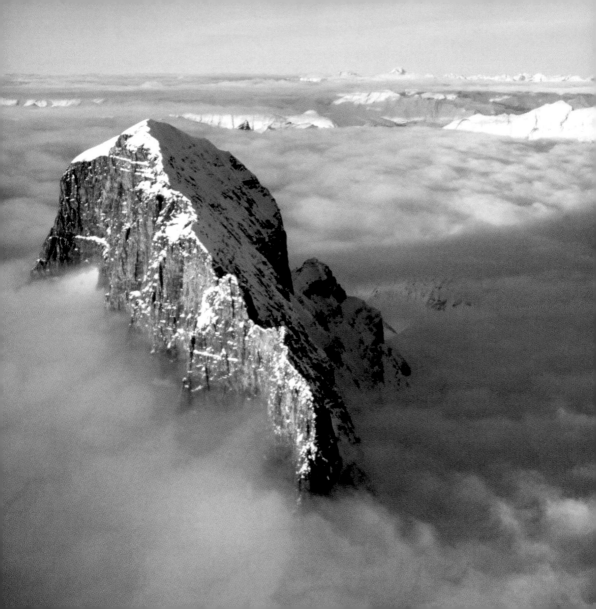

142-143 • British Columbia
(Canada) - The peak of Mount
Assiniboine.

143 • British Columbia (Canada)
- Mount Assiniboine, in the
Canadian Rockies, is a rocky
pyramid 11,870 feet tall.

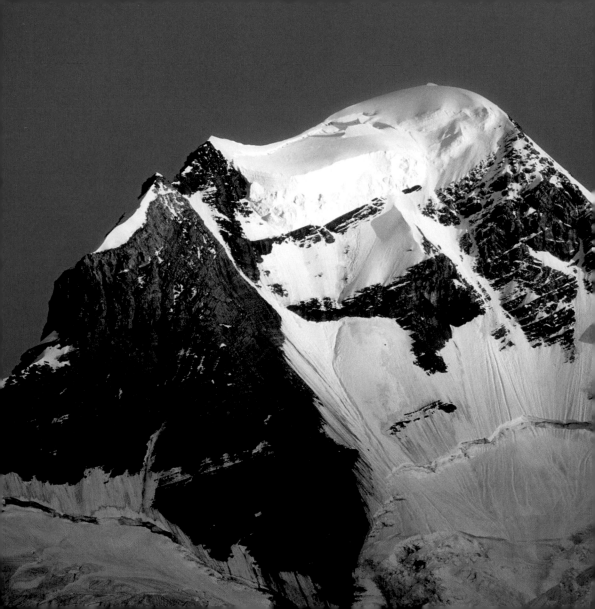

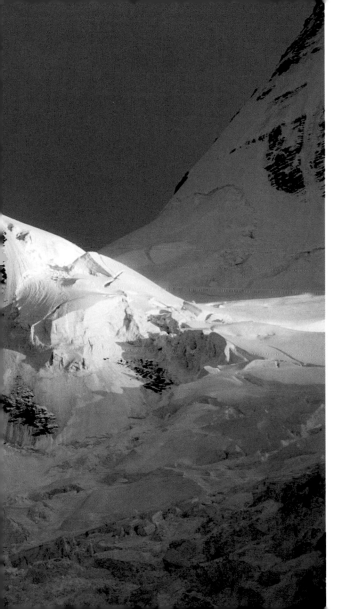

144-145 • British Columbia (Canada) - A winter view of Mount Robson at sunset.

146-147 • Alberta (Canada) - The Canadian Rockies overlook the Canmore area, in Kananaskis County.

148-149 • Washington (USA) - The top of Mount Rainier sticks up over the clouds.

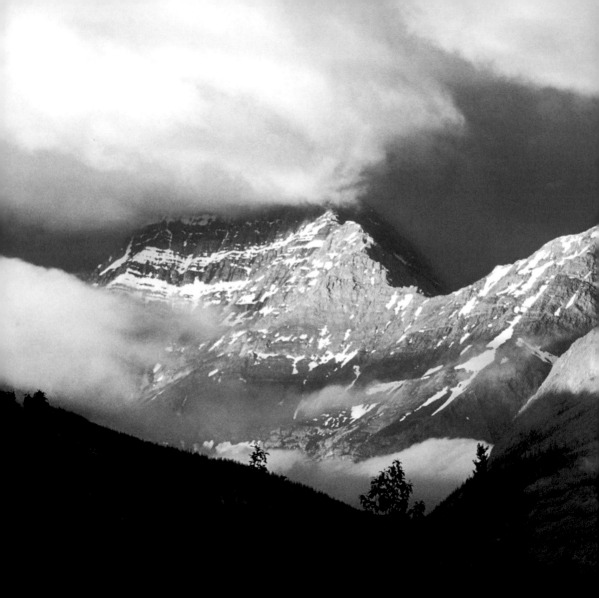

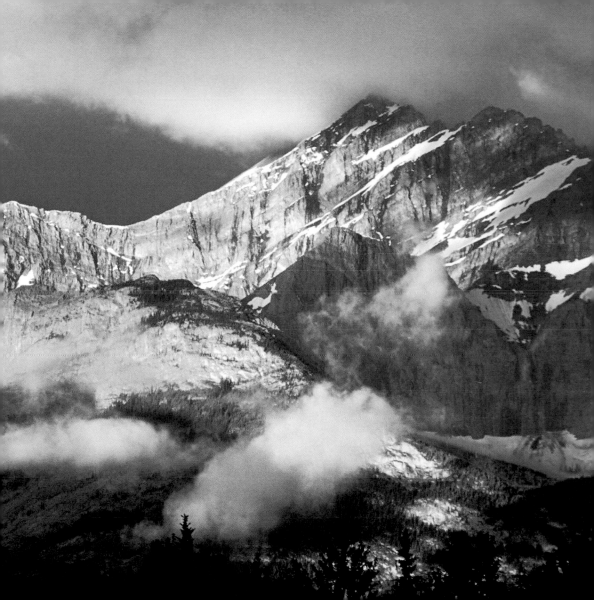

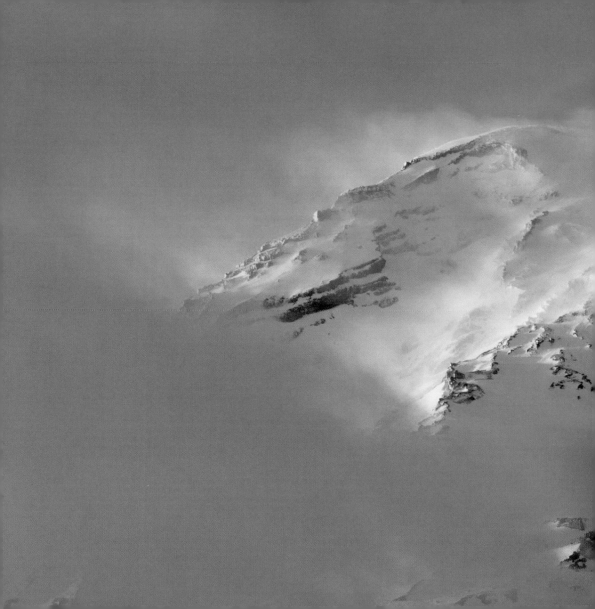

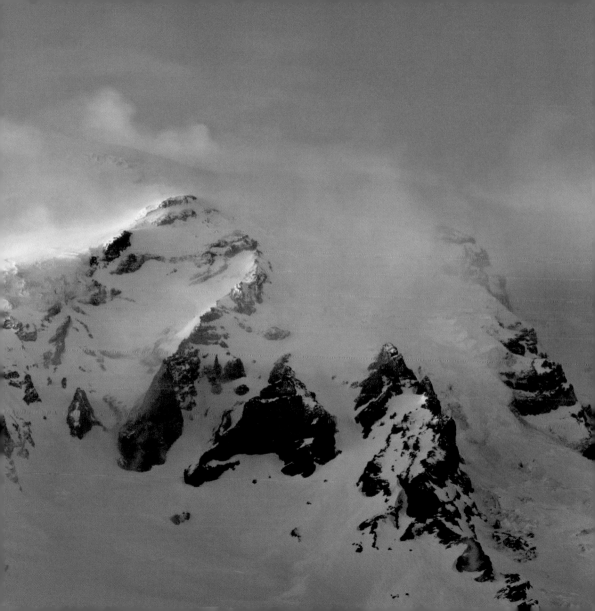

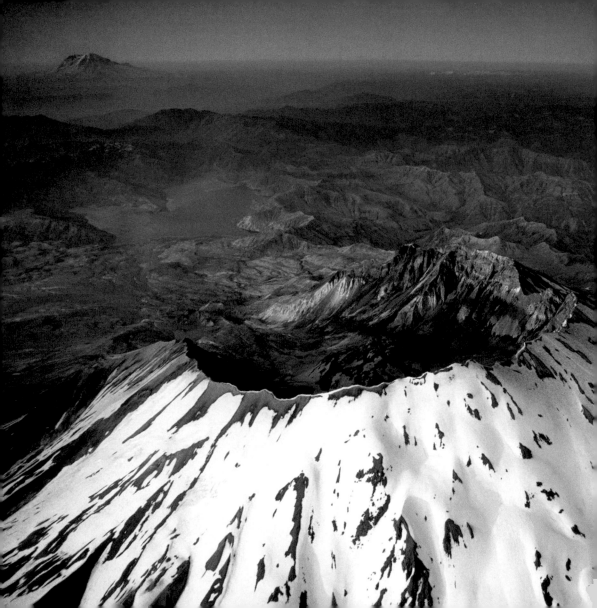

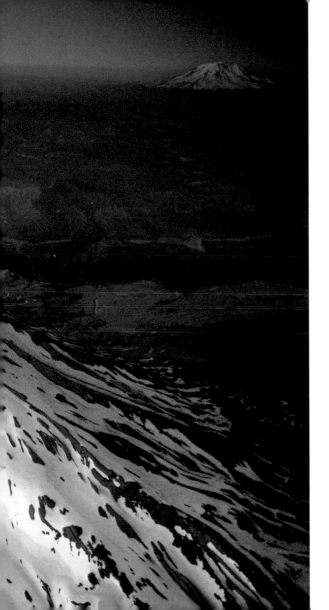

150-151 • Washington (USA) - In the foreground, the crater of Mount St. Helens. In the background on the left, Mount Rainier, and on the right, Mount Adams.

151 • Washington (USA) - The northern face of Mount St. Helens.

California (USA) - Mount Whitney, in the middle, belongs to the Sierra Nevada.

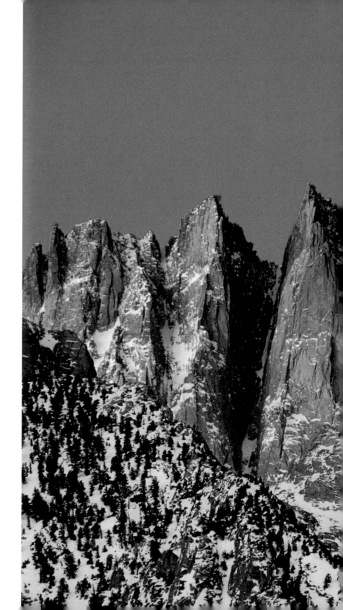

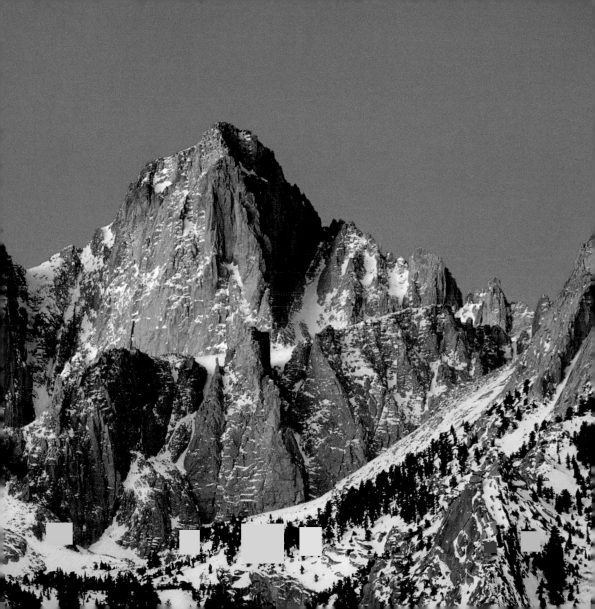

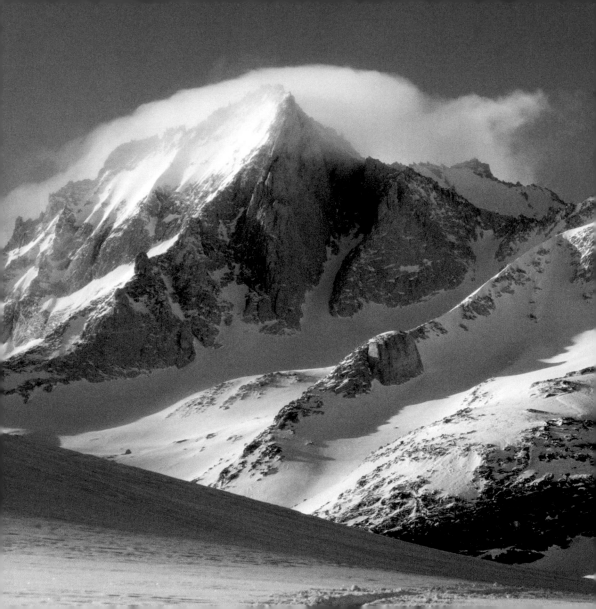

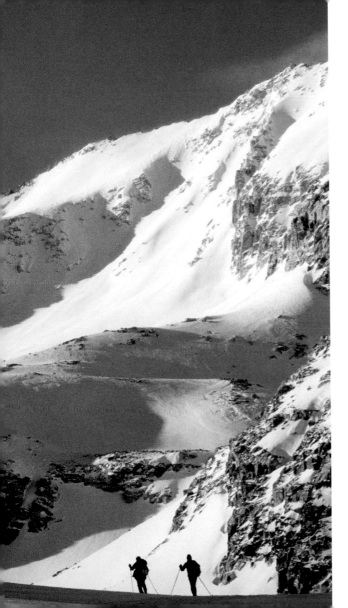

California (USA) - Bear Creek Spire is found in the Rock Creek Region, in the Sierra Nevada.

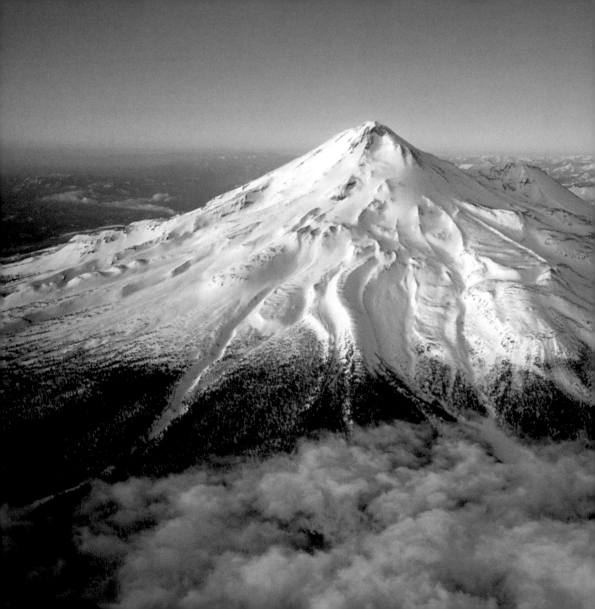

● Oregon (USA) - Mount Hood, a volcano 11,240 feet tall, belongs to the Cascade Range.

California (USA) - Both in winter (left) and in spring (right),
Half Dome is an attraction in Yosemite National Park.

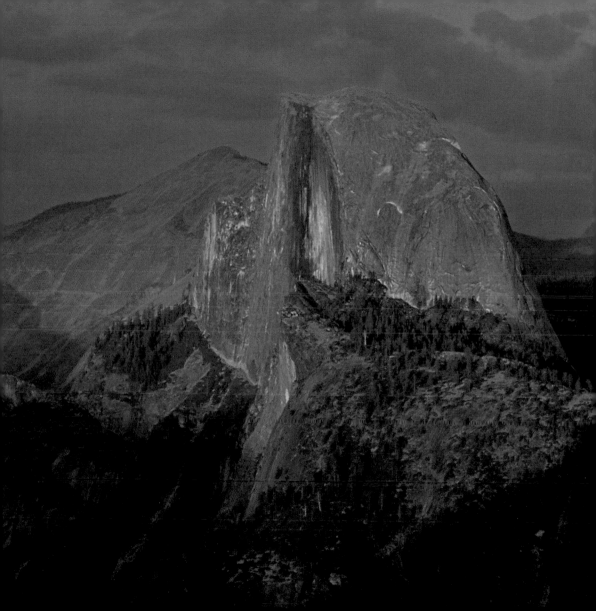

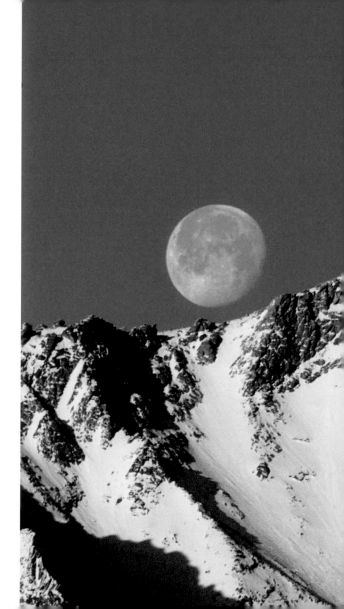

California (USA) - A full moon hangs over the mountains of the Sierra Nevada.

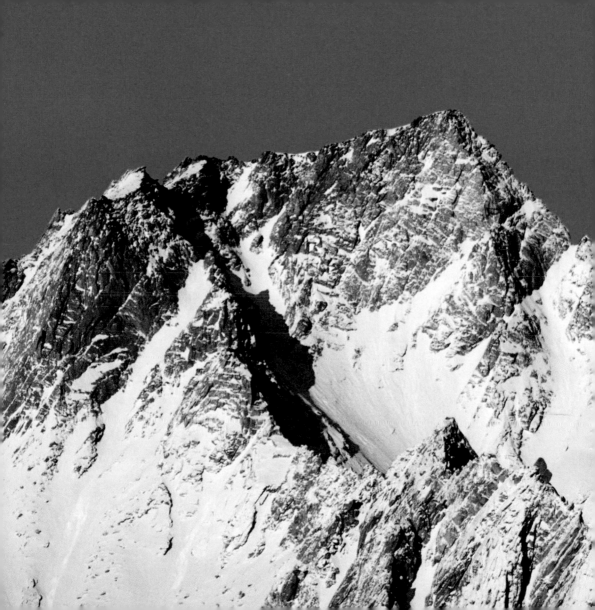

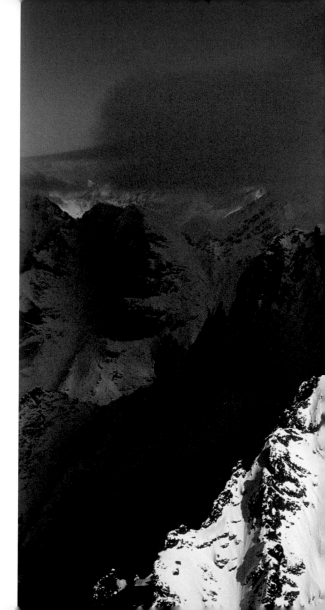

162 • Colorado (USA) - The Sangre de Cristo Range is one of the longest mountain chains in the world, stretching from Poncha Pass in Colorado to Glorieta Pass in New Mexico.

162-163 • Colorado (USA) - Crestone Peak rises from the Sangre de Cristo Range.

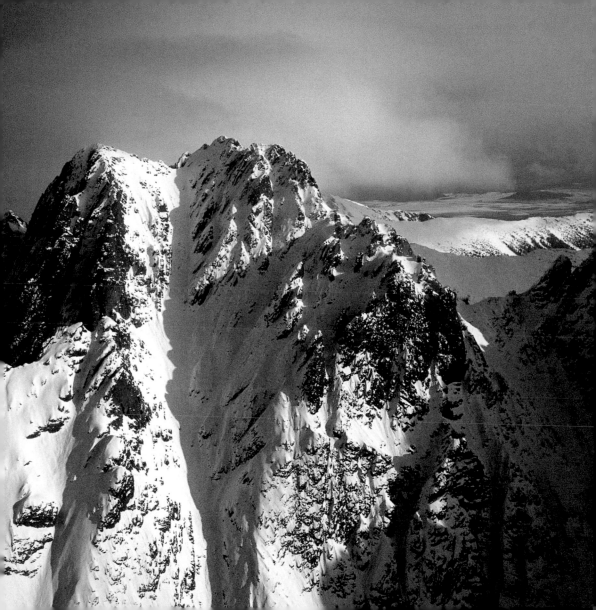

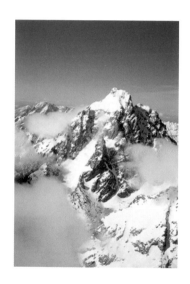

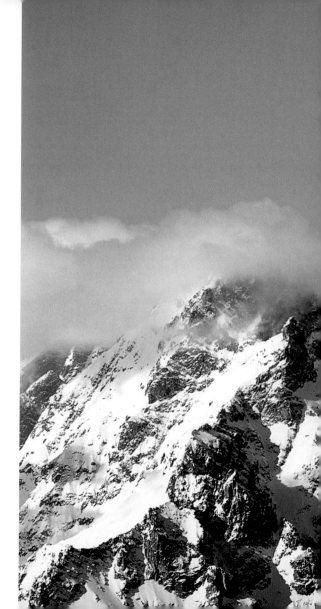

164 • Wyoming (USA) - Grand Teton
Peak reaches up to 13,773 feet.

164-165 • Wyoming (USA) - The Teton
Range contains numerous peaks and
features a front about 40 miles long.

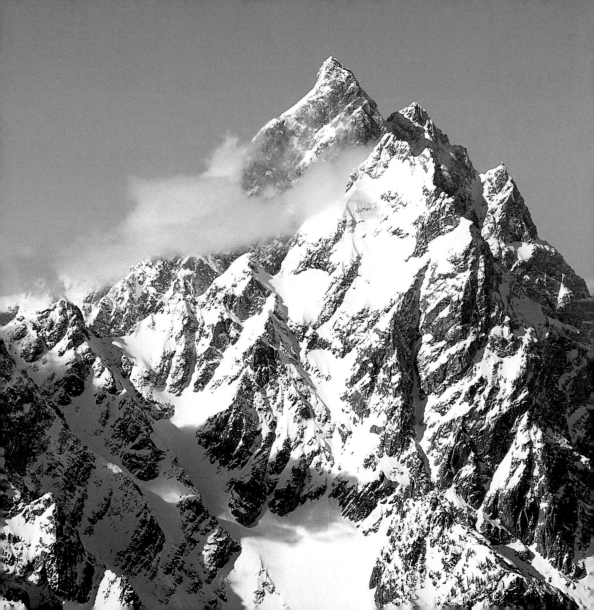

South America

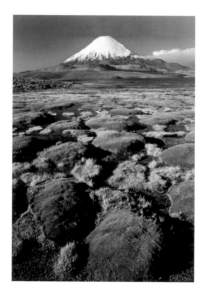

166 • Chile - The volcano Parinacota towers over Lauca National Park from its 20,807 feet.

167 • Ecuador - Perennial snow covers Cotopaxi Volcano.

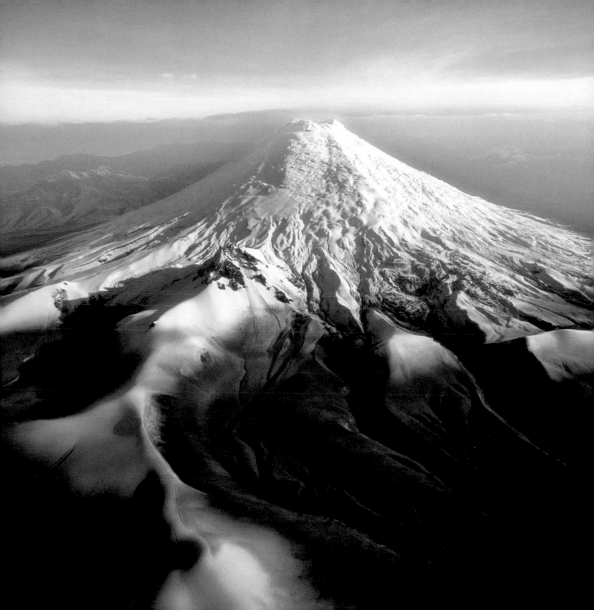

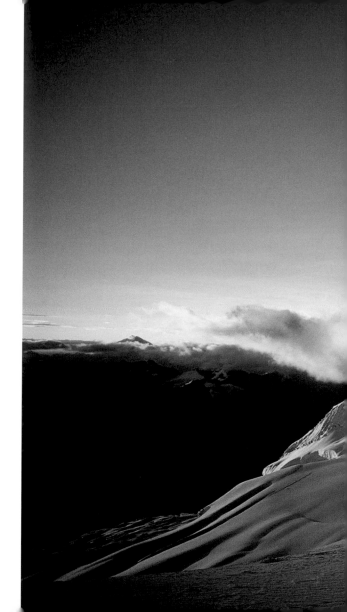

● Peru - Mount Tocllaraju, in the Cordillera Blanca, reaches 19,790 feet.

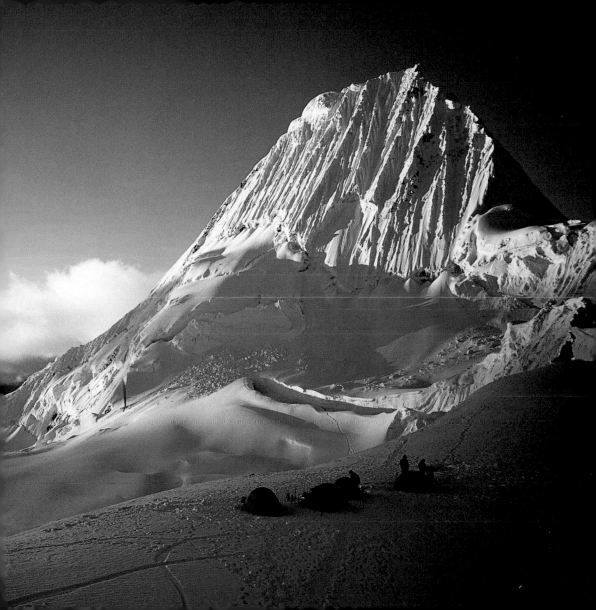

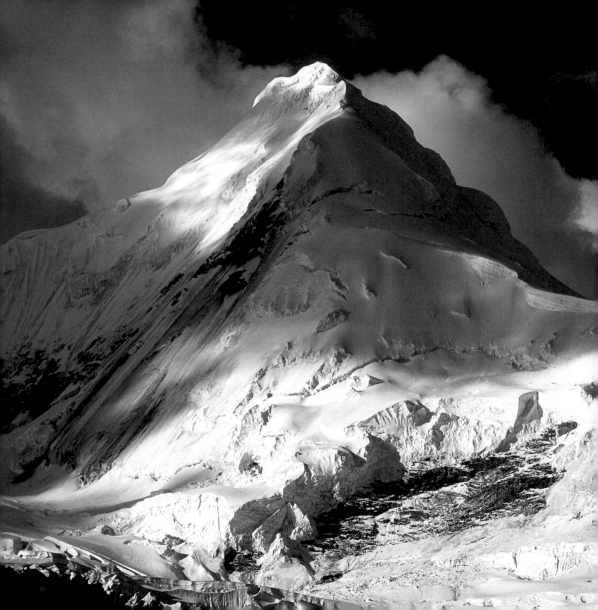

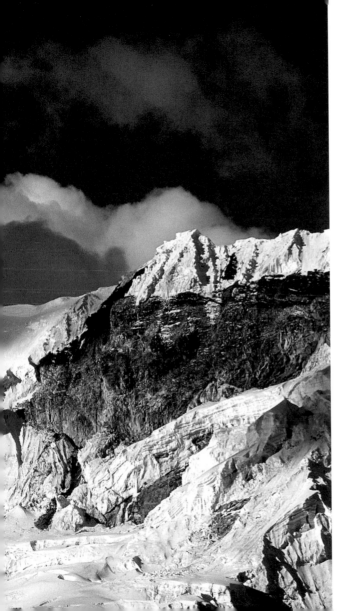

Peru - Snow covers Mount Tocllaraju completely.

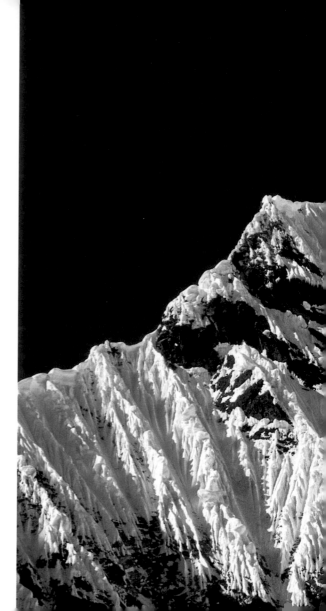

172 • Peru - Massive Nevado Huascaran rises from the Cordillera Blanca.

172-173 • Peru - Massive Ausangate in the Cordillera Vilcanota reaches 20,945 feet.

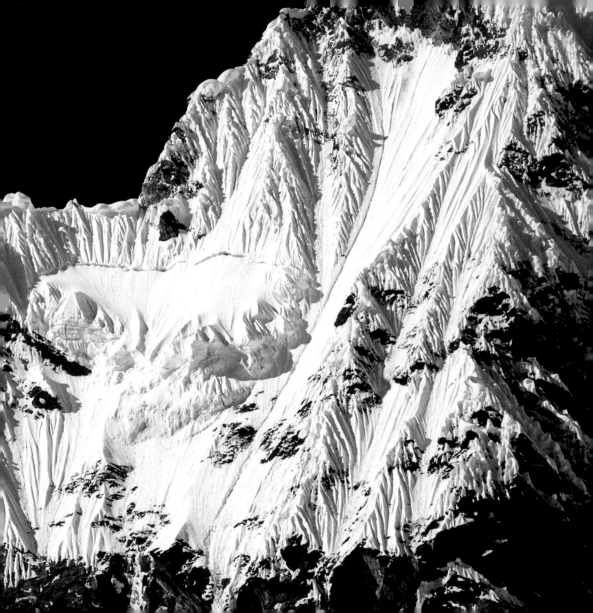

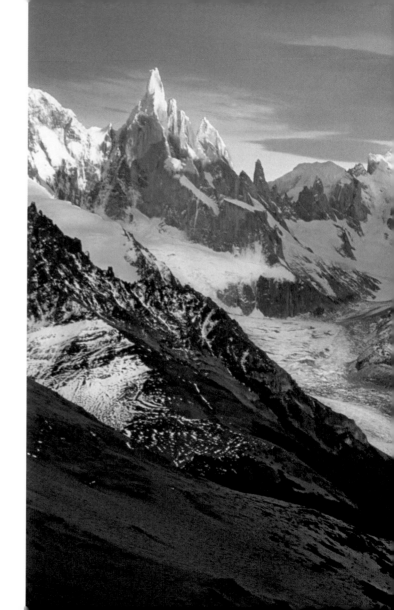

Patagonia (Argentina) - The Cerro Torre, on the left, and the Fitzroy, on the right, belong to the Los Glaciares National Park.

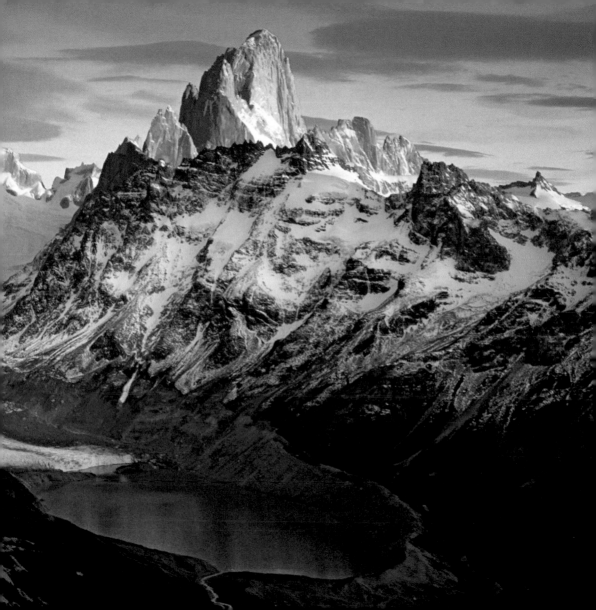

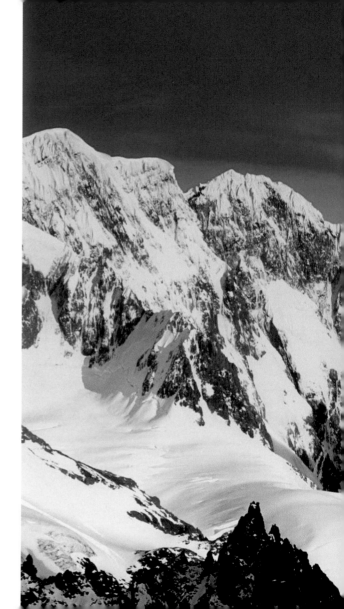

● Patagonia (Argentina) - Cerro Torre (10,279 feet) is one of the best-known peaks in the southern Andes.

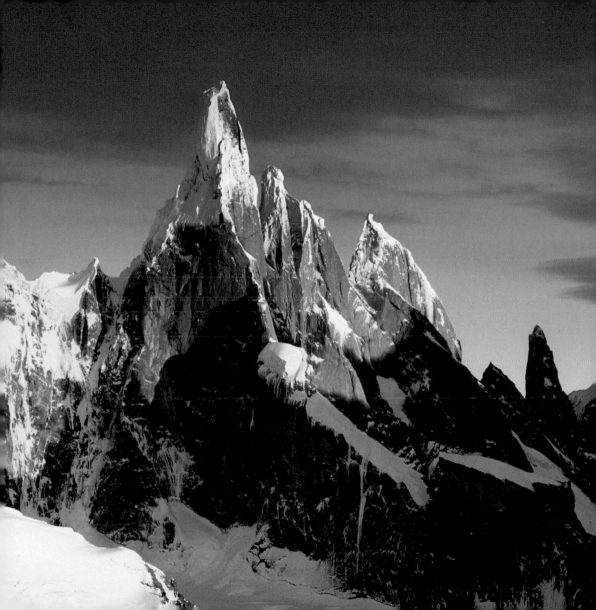

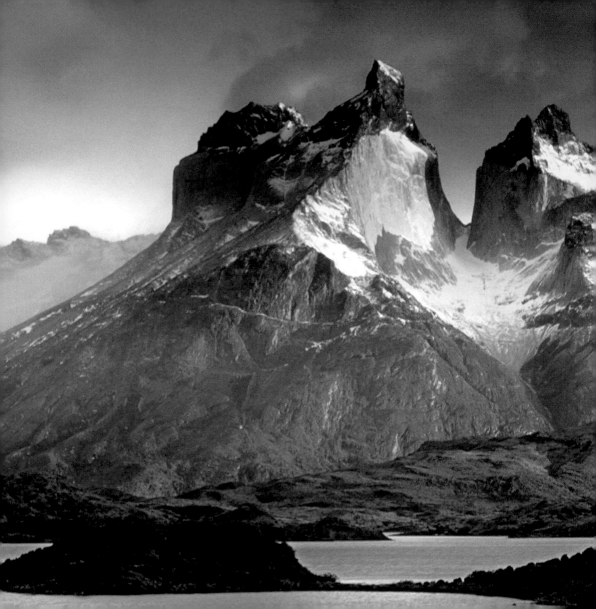

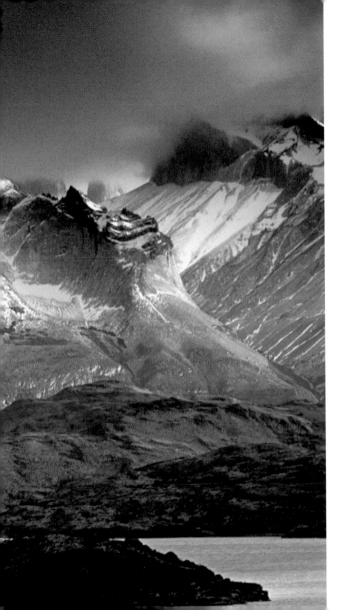

● Chile - Los Cuernos
del Paine can be seen
in the moody lighting of
this photo.

180-181 • Chile - The massif of the Cerro Paine Grande has four peaks and the tallest reaches up to 10,656 feet.

182-183 • Chile - Because of the beauty of its landscapes, the Torres del Paine National Park is included in UNESCO'S World Hertiage List.

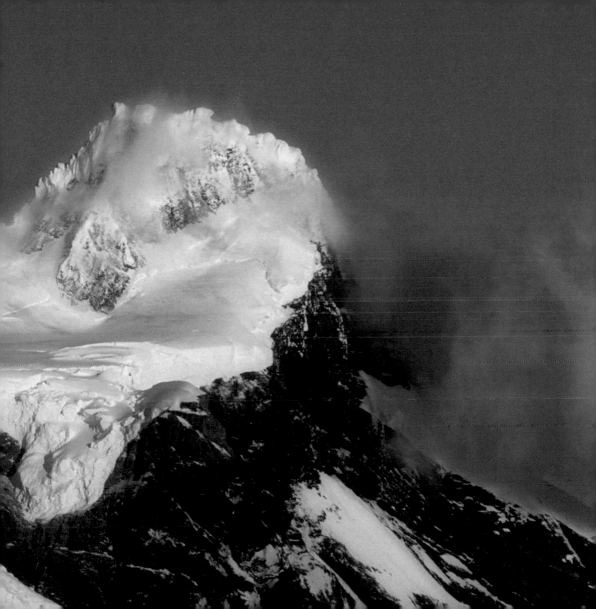

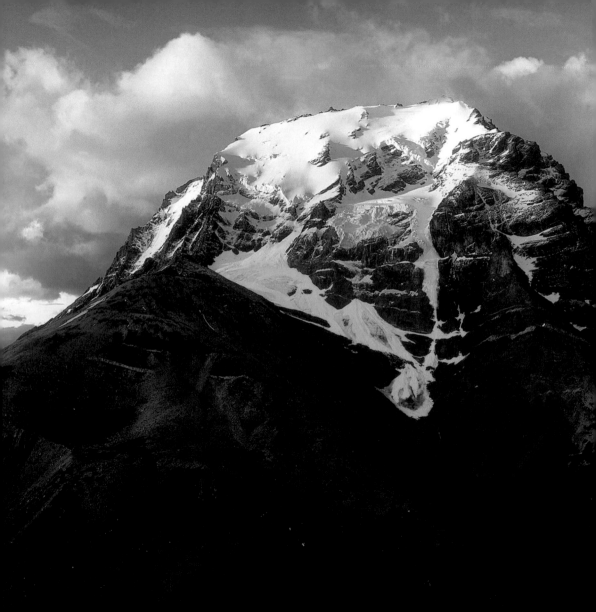

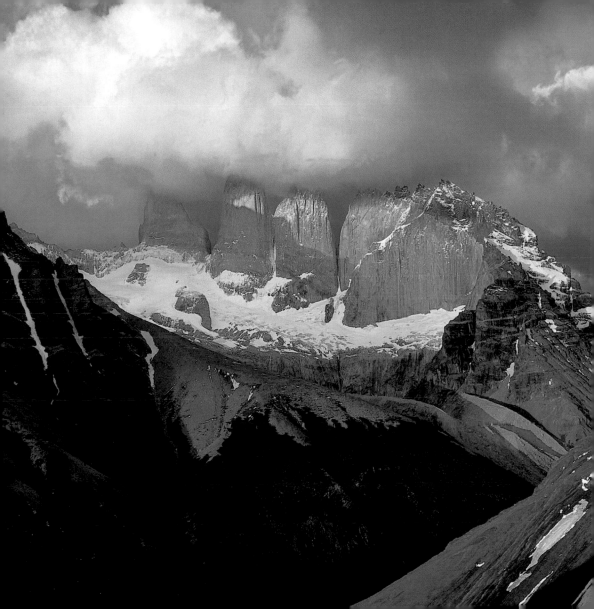

Antarctic

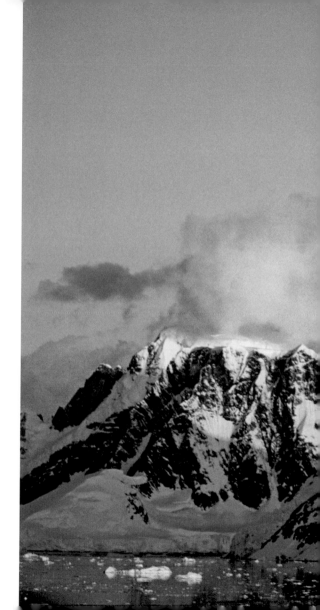

- Antarctic - Surrounded by clouds or illuminated by the midnight sun, Mount Scott dominates the landscape with its 8,927 feet-foot height.

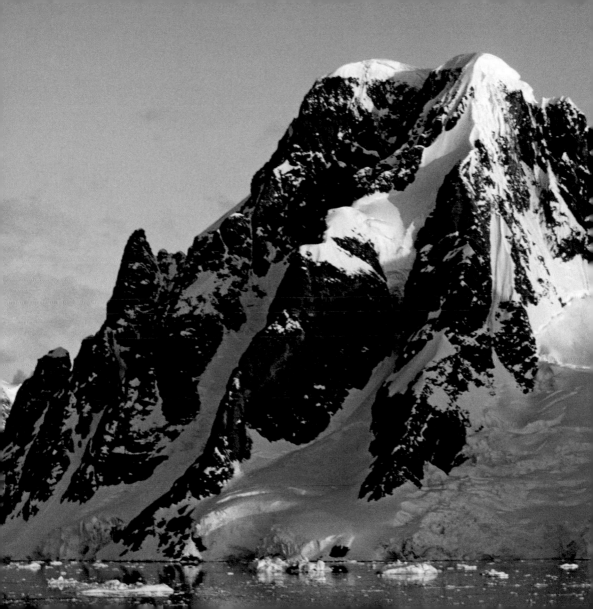

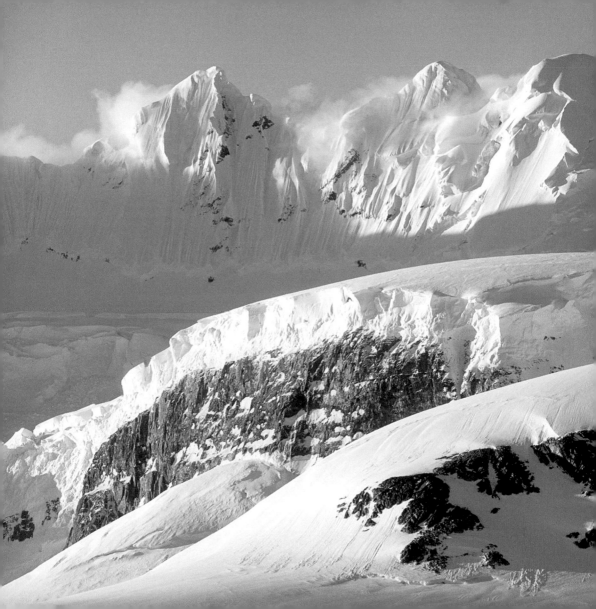

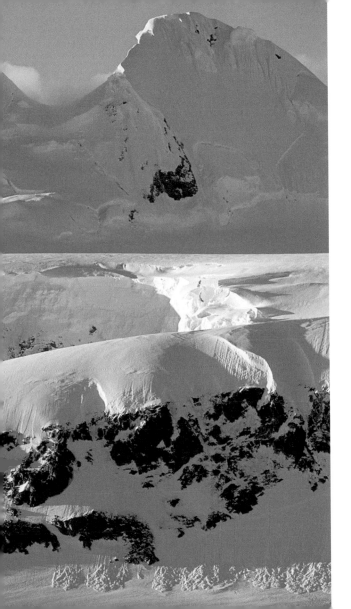

● Wiencke Island (Antarctic) - A wide-angle view of the Fief Range, which contains the so-called Seven Sisters.

RIVERS of ICE

LUCA MERCALLI

Alaska (USA) - A view of the Meade Glacier.

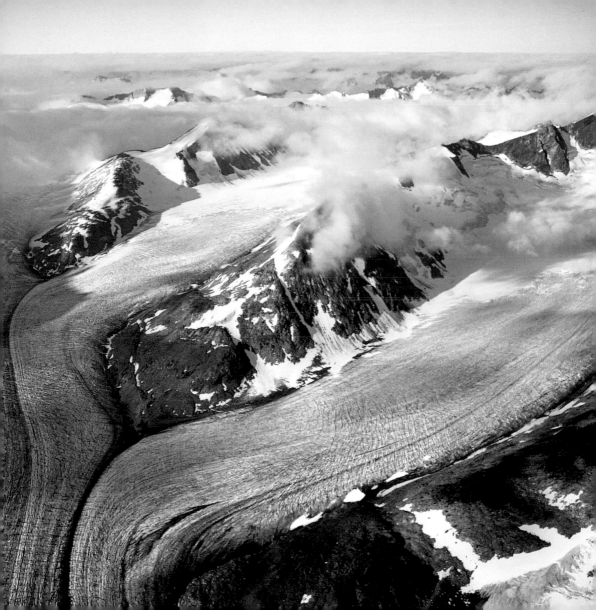

INTRODUCTION Rivers of Ice

With THE EXCEPTION OF THE SEA GLACIERS AT THE POLES, THE REST OF THE WORLD'S GLACIERS ARE ON MOUNTAINS: FROM THE HEART OF THE ANTARCTIC AND GREENLAND AT OVER 10,000 FEET ABOVE SEA LEVEL TO THE PEAKS OF THE ANDES, HIMALAYAS, AND ALPS. THE GLACIERS OF OCEANIA – ON THE NEW ZEALAND ALPS – ARE ALSO ON MOUNTAINS, AS ARE THE SMALL AFRICAN GLACIERS, AT THE TOP OF KILIMANJARO AND RUWENZORI. GLACIERS FORM WHERE THE QUANTITY OF SNOW THAT FALLS IN ONE YEAR IS GREATER THAN THAT WHICH MELTS. SNOW ACCUMULATES, COMPRESSES, EXPELS THE AIR BETWEEN ONE FLAKE AND ANOTHER, AND AFTER A FEW YEARS, BECOMES COMPACT ICE, OVER 50 POUNDS TO THE CUBIC FOOT. STRANGE MATE-RIAL, THAT ICE: BOTH HARD AND PLASTIC. IF YOU HIT IT, IT WILL

INTRODUCTION Rivers of Ice

SHATTER LIKE GLASS, BUT IF SUBJECTED TO HIGH PRESSURE, IT WILL DEFORM LIKE TOOTHPASTE. THUS, THE GLACIERS ARE SLOW RIVERS OF SOLID WATER, ALL CRACKED ON THE SURFACE AND DOTTED WITH TOWERS (THE SERACS, FROM THE SAVOY DIALECT "SÉRAC," WHICH MEANS *RICOTTA* BECAUSE THEY LOOK LIKE THE CHEESE FROM FAR AWAY), BUT UNDERNEATH, NEAR THE ROCKY GROUND, THEY ARE A THICK MASS IN SLOW BUT POWERFUL MOVEMENT, FROM A FEW INCHES TO SEVERAL FEET PER DAY. UNDER ENORMOUS PRESSURE, SAND AND MINERAL FRAGMENTS WILL LEVEL AND GROOVE THE ROCK, WHICH WILL BEAR THE SIGNS OF THE GLACIER'S PASSAGE FOR THOUSANDS OF YEARS. THIS IS THE "MUTTONED" ROCK, WITH THE SOFT PROFILE OF A SHEEP'S RUMP. THE GLACIERS FASCINATE BECAUSE THEY

Rivers of Ice

Introduction

MOVE ON HUMAN TIME: THEY ADVANCE IN COLD PERIODS OF THE YEAR AND RETREAT IN THE WARM PERIODS. HOWEVER, FOR THE LAST HUNDRED YEARS, RISING TEMPERATURES HAVE BEEN MELTING THEM THROUGHOUT THE WORLD, AND ON THE ALPS, 40 PERCENT OF THEIR SURFACE AREA HAS GONE. EVERY YEAR THE GLACIERS DIMINISH BY SEVERAL FEET IN LENGTH AND WIDTH. NEW LAKES DOT THE GLACIERS WHERE BEFORE THERE WAS ONLY SNOW, NEW STREAMS SNAKE DOWN THE ICE TO BE SWALLOWED UP BY RUMBLING WELLS. IF THE TEMPERATURE OF THE EARTH CONTINUES TO RISE, THE BEAUTY OF THE GLACIERS WILL BECOME EVER MORE RARE. THEY WILL RETURN ONE DAY – THERE WILL BE NEW ICE AGES – BUT WE WILL NOT BE HERE TO SEE THEM.

● Valais (Switzerland) - Saas Fee Alpine Glacier.

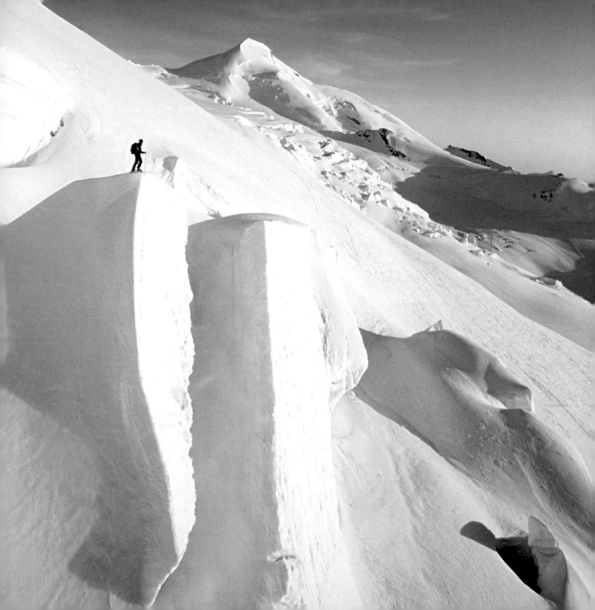

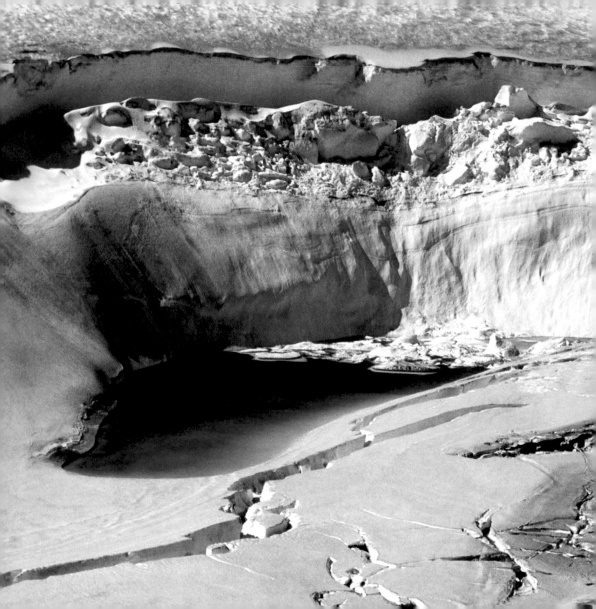

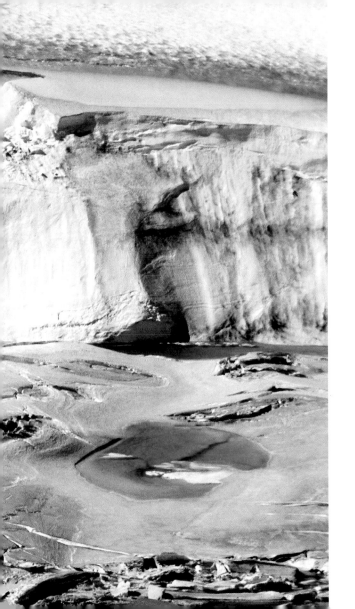

Europe

- Hochland (Iceland) -
A pond at the base of
the Kverkfjoell Glacier.

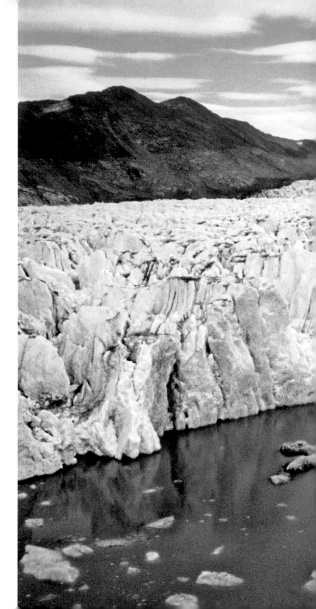

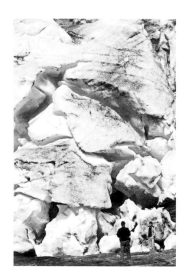

196 ● Norway - Tourists at the base of a glacier at Osterdalsisen, in Saltfjellet-Svartisen National Park.

196-197 ● Svalbard (Norway) - A hollow formed by the sides of the Von Post Glacier.

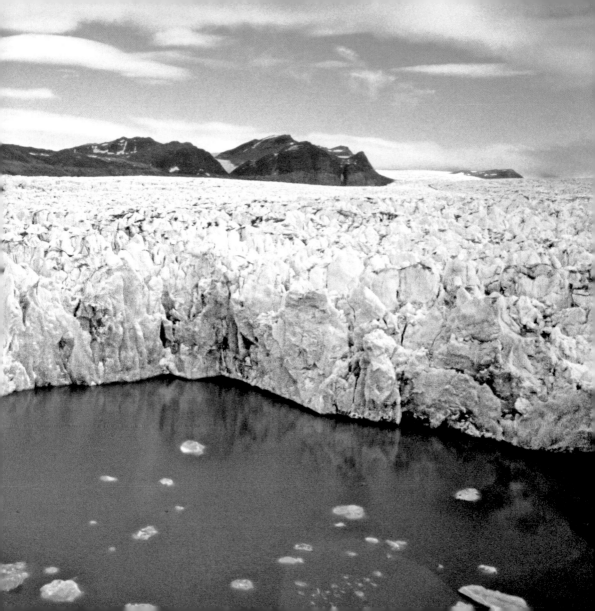

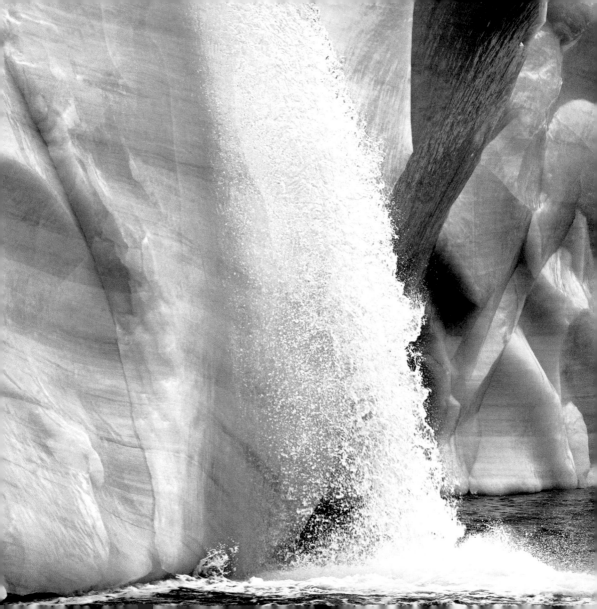

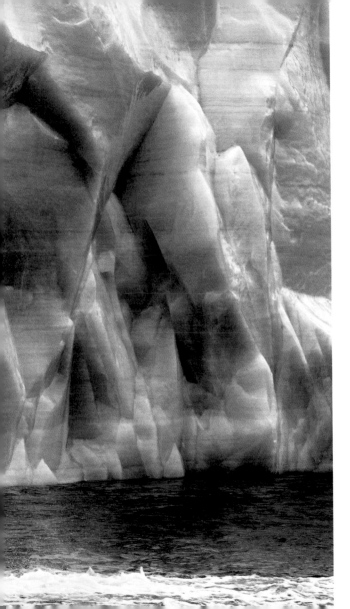

● Spitsbergen (Norway) - A waterfall from the Austfonna Glacier.

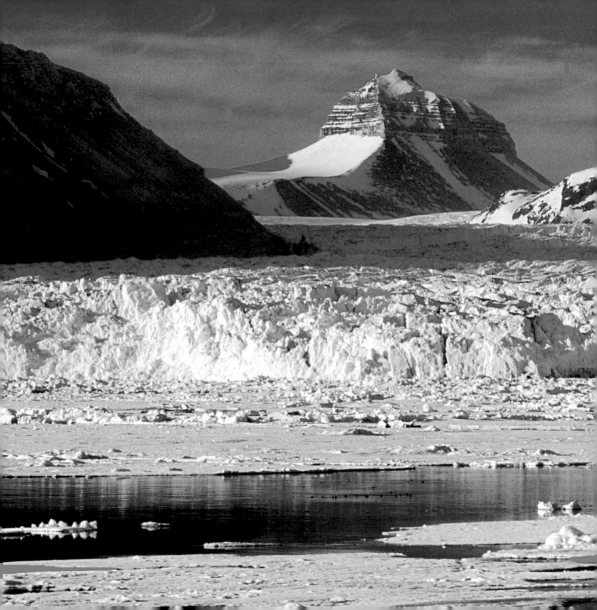

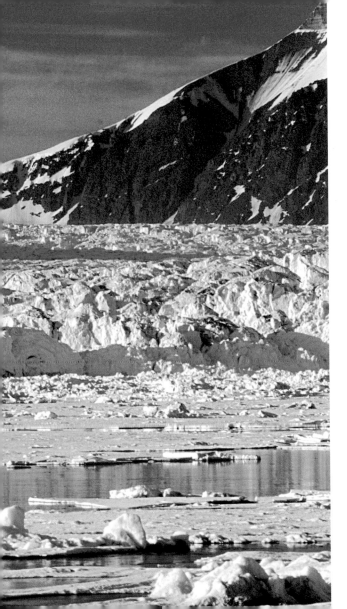

● Svalbard (Norway) -
In the Norwegian
spring, glaciers break
into fragment upon
reaching the sea.

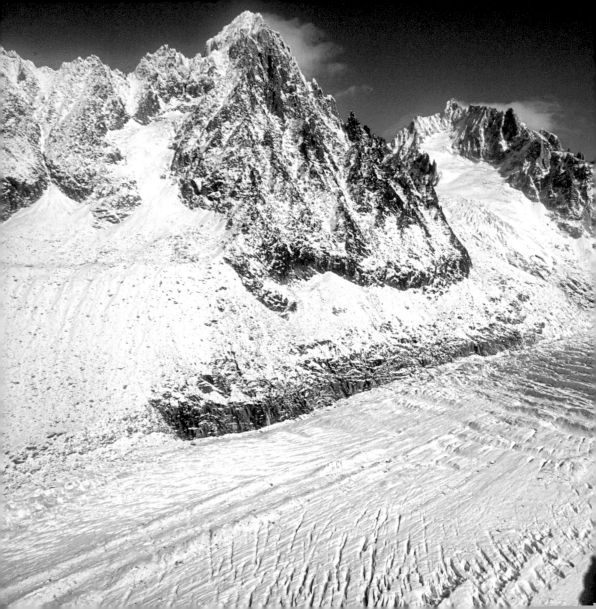

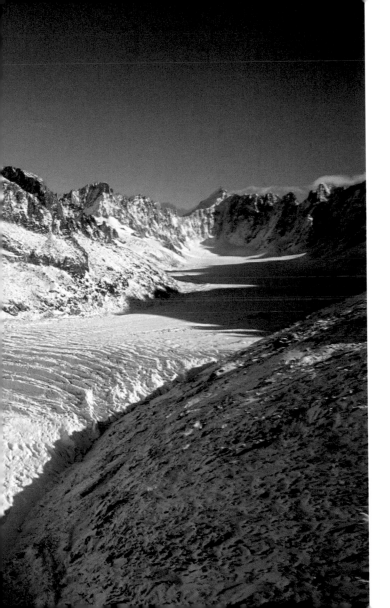

Upper Savoy (France) -
The Argentière Glacier,
on Mont Blanc.

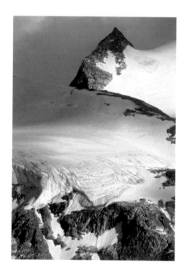

204 • Upper Savoy (France) - A view of the snowy peak of Aiguille Sans Nom.

204-205 • Upper Savoy (France) - The Leschaux Basin hugs the north wall of the Grandes Jorasses on Mont Blanc.

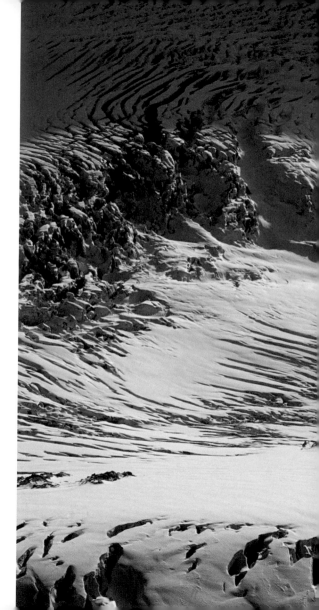

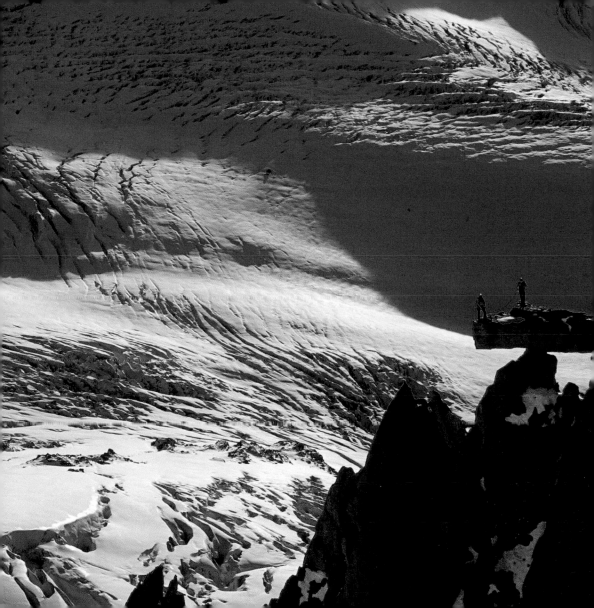

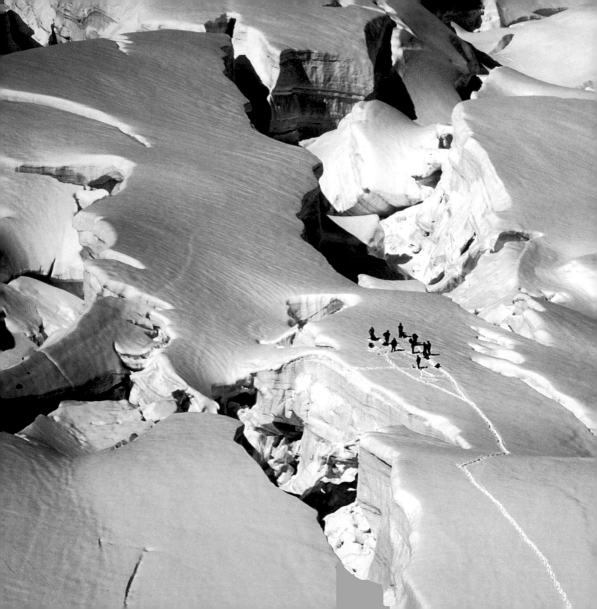

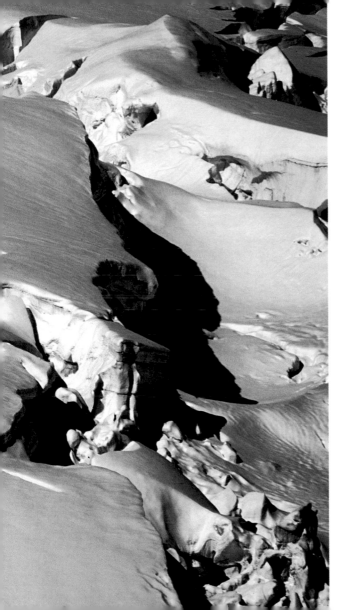

Upper Savoy (Italy) -
The seracs beneath
Mont Blanc at Tacul.

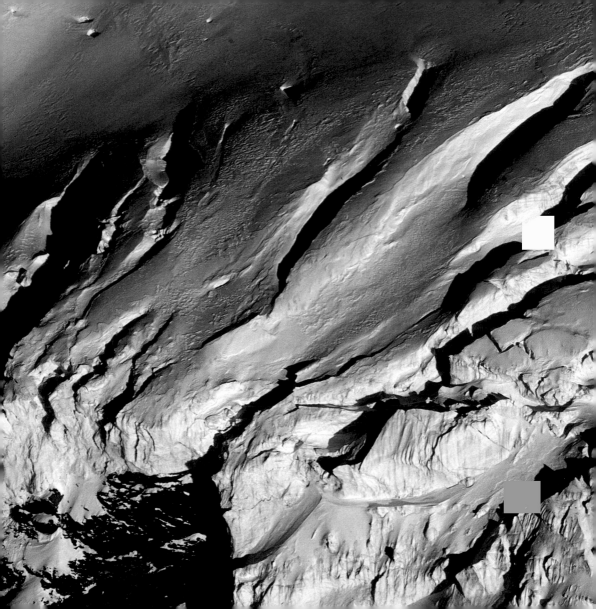

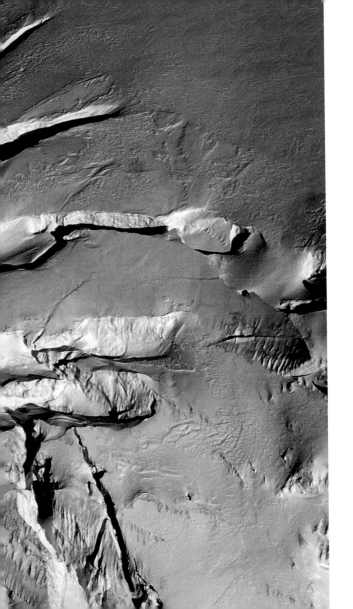

Val d'Aosta (Italy) -
Wind marks and
landslides on a frozen
wall of Mont Blanc.

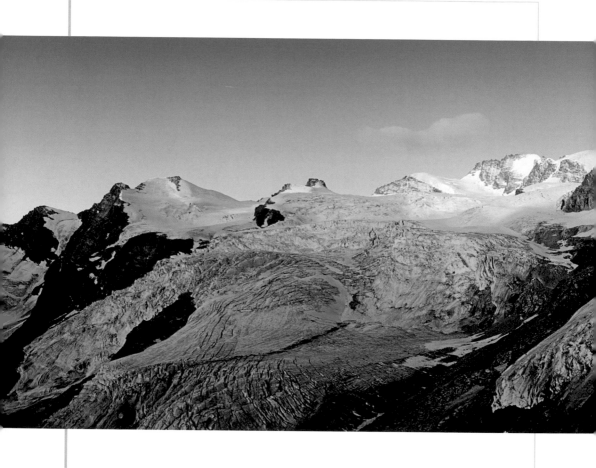

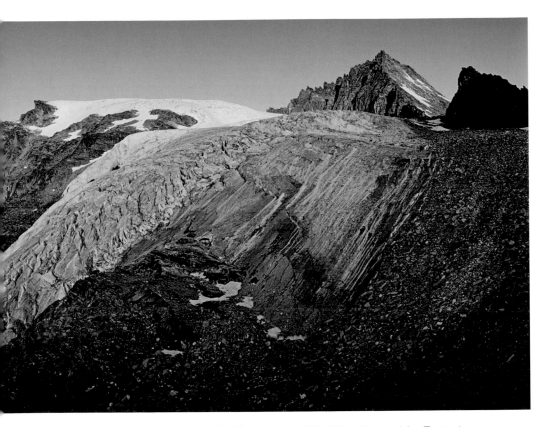

Val d'Aosta (Italy) The glaciers of the Tribulation and the Tsasset,
in Gran Paradiso National Park.

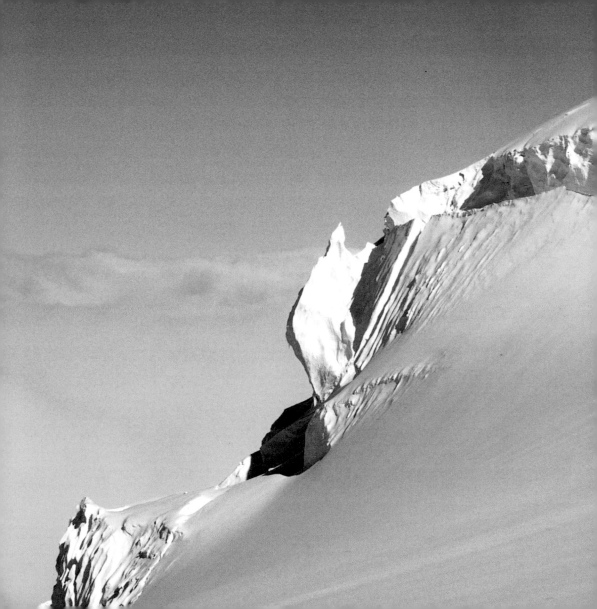

212-213 ● Piedmont (Italy) - The snow seems to slide on the ice in this setting on the peak of Mount Rosa.

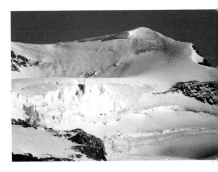

213 ● Piedmont (Italy) Mount Rosa is a massif covered by an enormous glacier.

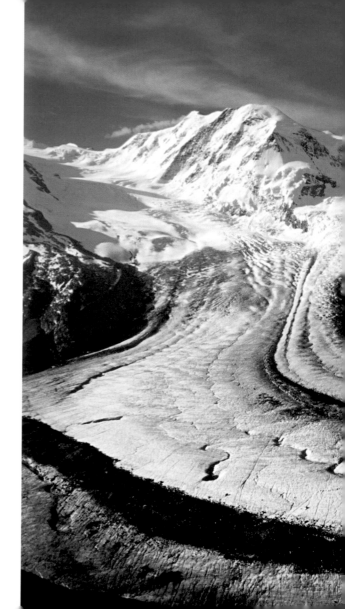

● Valais (Switzerland) -
A view of the Gornerdal
Glacier.

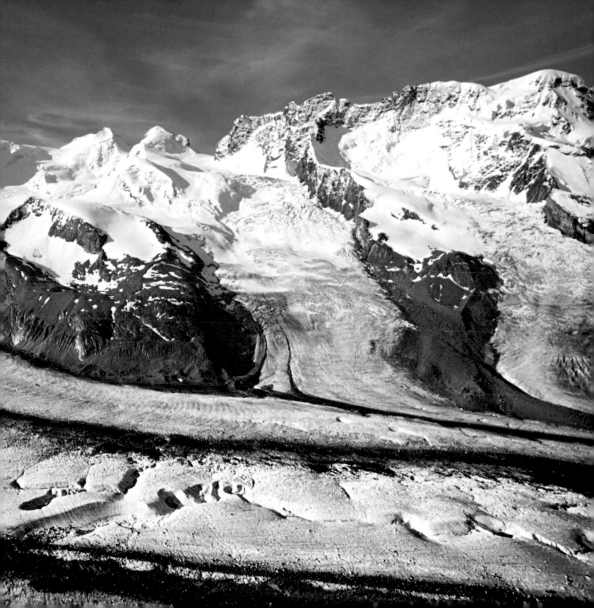

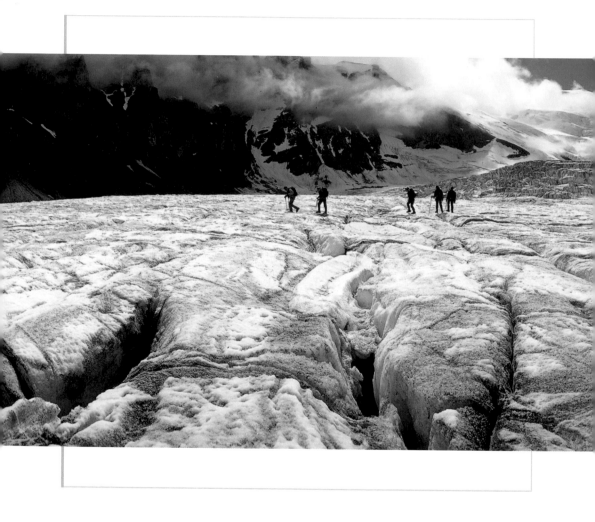

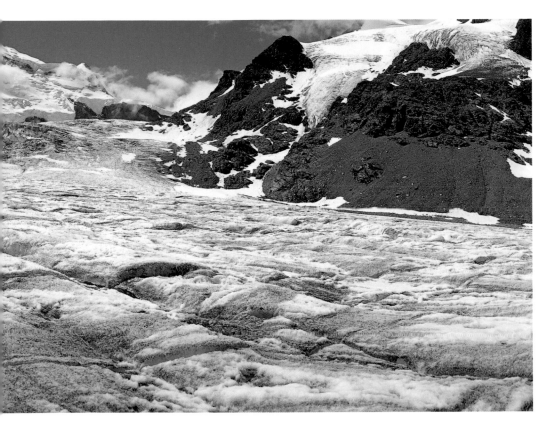

Valais (Switzerland) - The crevasses of the Corbassière Glacier, with Tournelon Blanc (left), Grand Combin (center), and Combin de Corbassière (right) in the background.

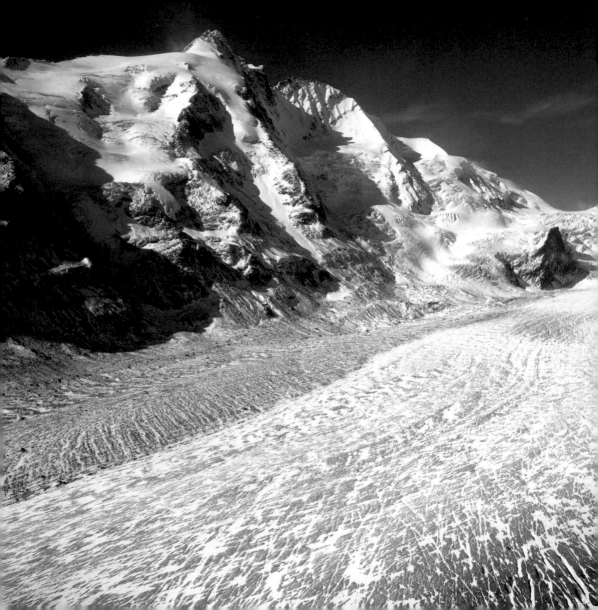

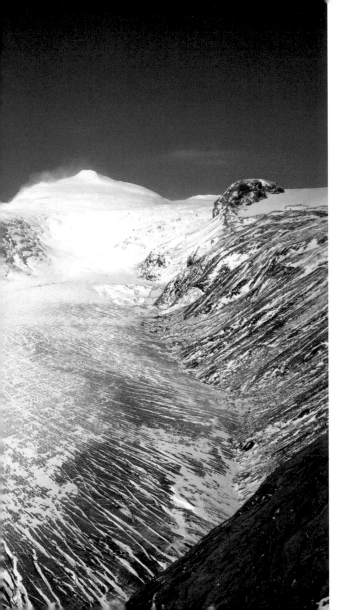

● Corinthia (Austria) -
The Grossglockner and
the Pasternze glaciers
are retreating about
one foot a year.

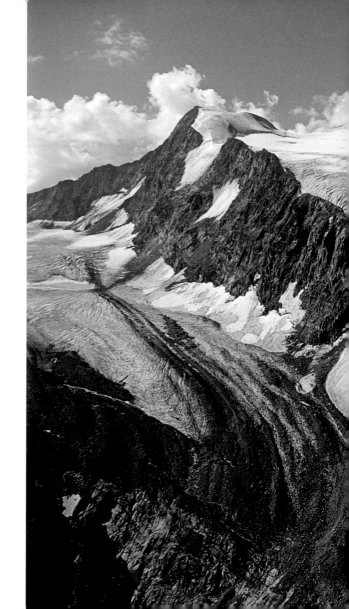

Tyrol (Austria) - A view of the Zuckerhuetl Glacier at Stubaital.

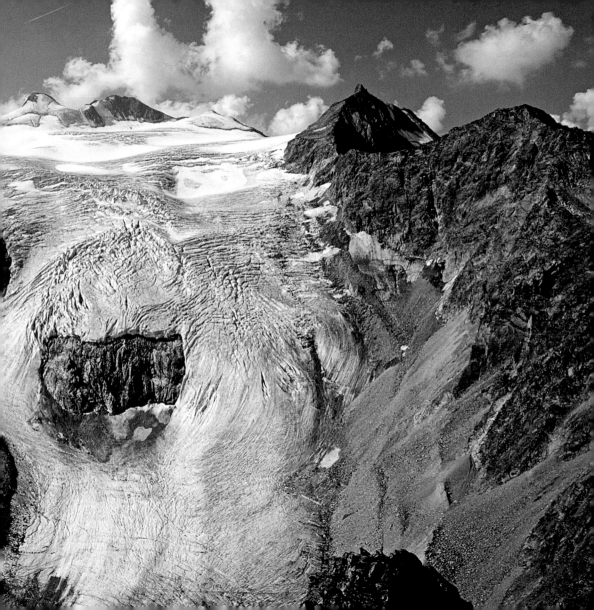

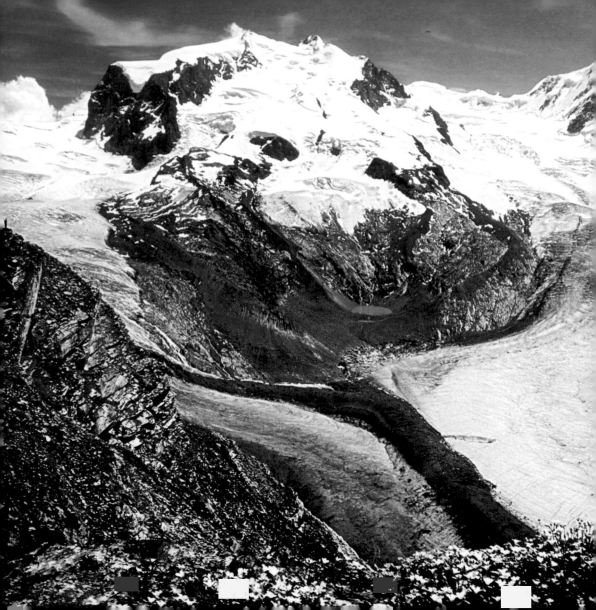

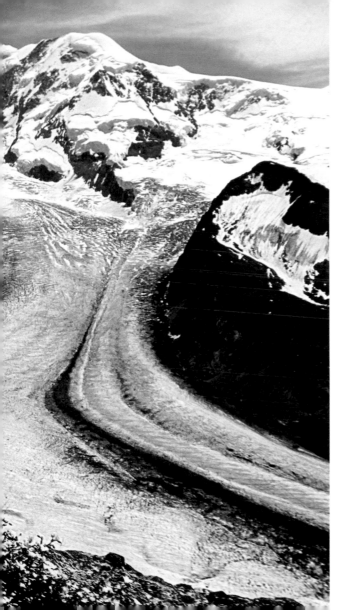

• Switzerland -
The Gornegletscher
with Monte Rosa
on the left and
Lyskamm on the right.

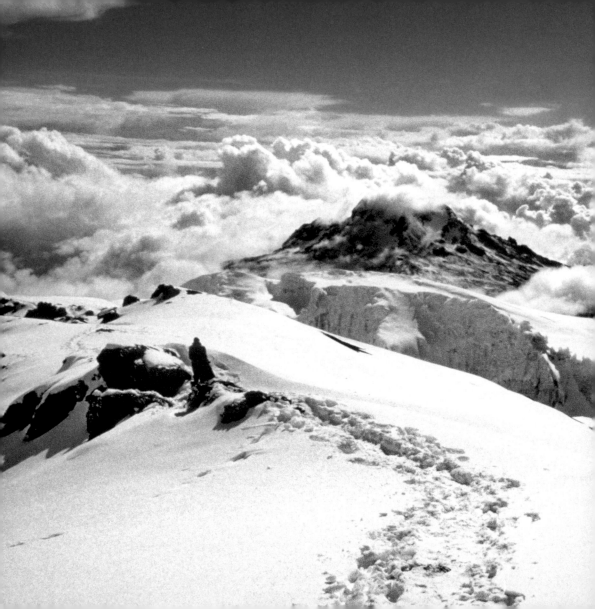

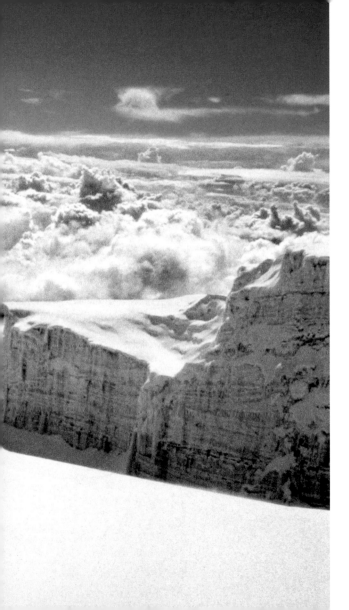

Africa

- Tanzania - A wall of a glacier on Mount Kilimanjaro.

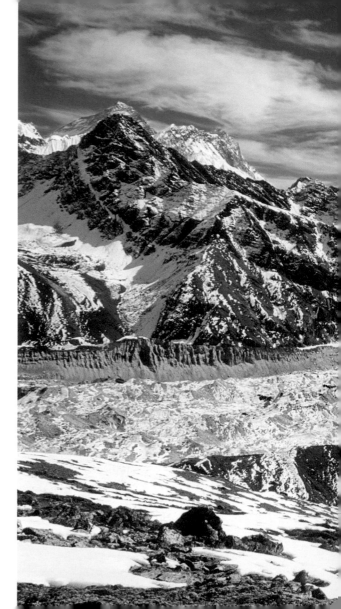

Asia

- Nepal - The Gokyo Valley follows the moraine of the Ngozumpa Glacier, the longest glacier at the base of the Himalayas.

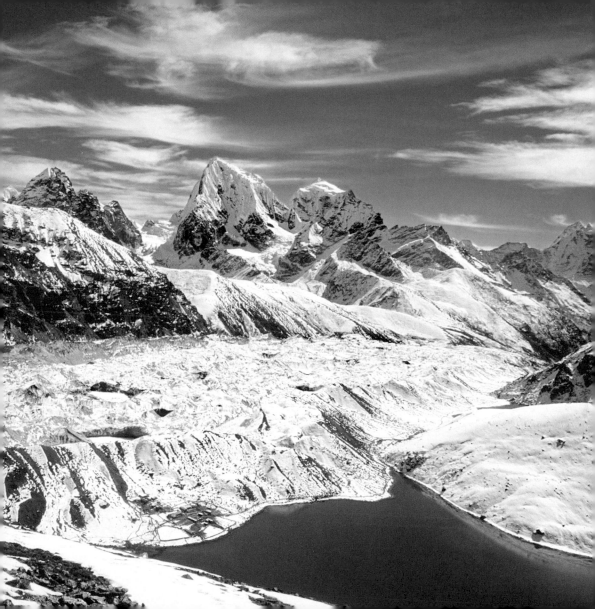

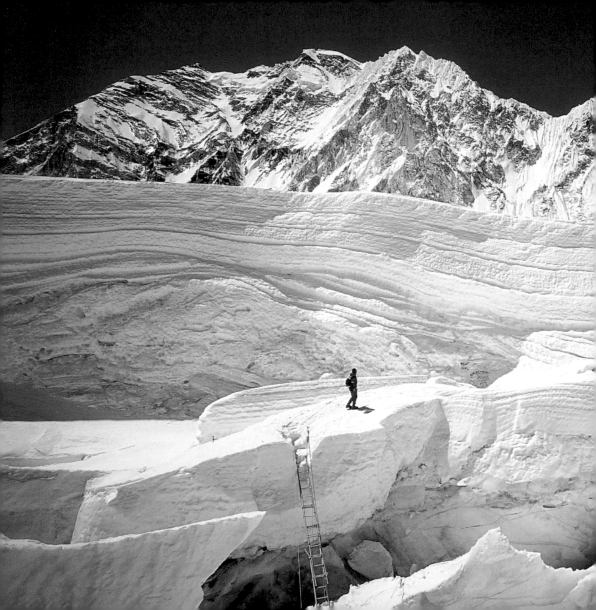

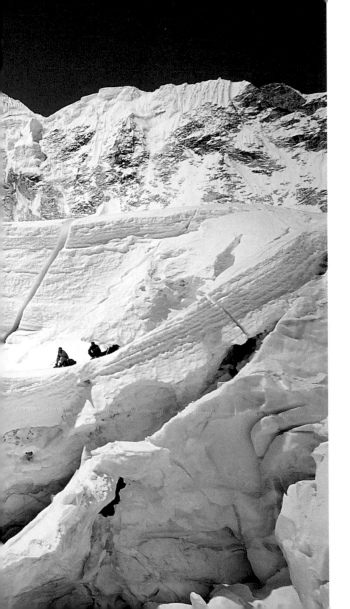

● Nepal - A glacier on Mount Everest.

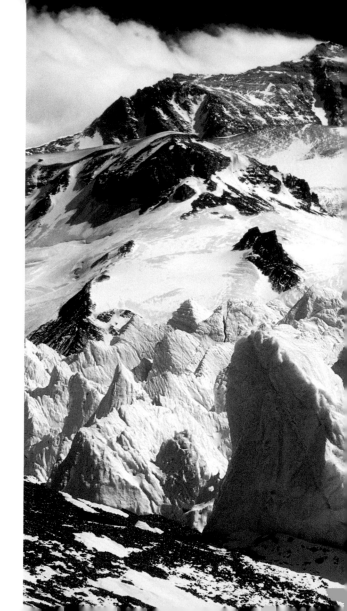

Tibet (China) - The Middle Rongbuk Glacier on Mount Everest.

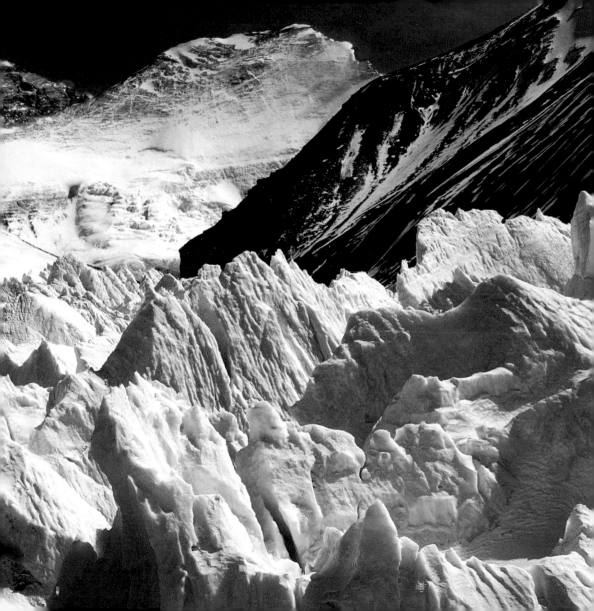

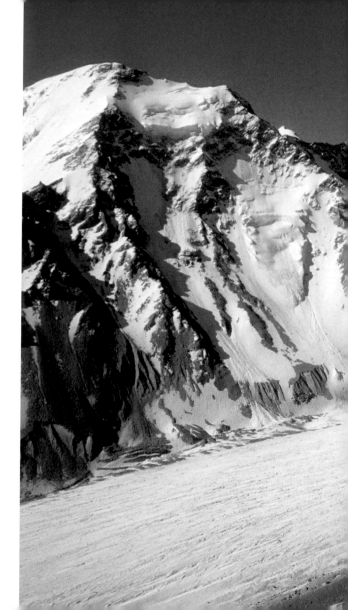

Tibet (China) - This glacier is the source of the Tsangpo River, that is also known by the name of Brahmaputra.

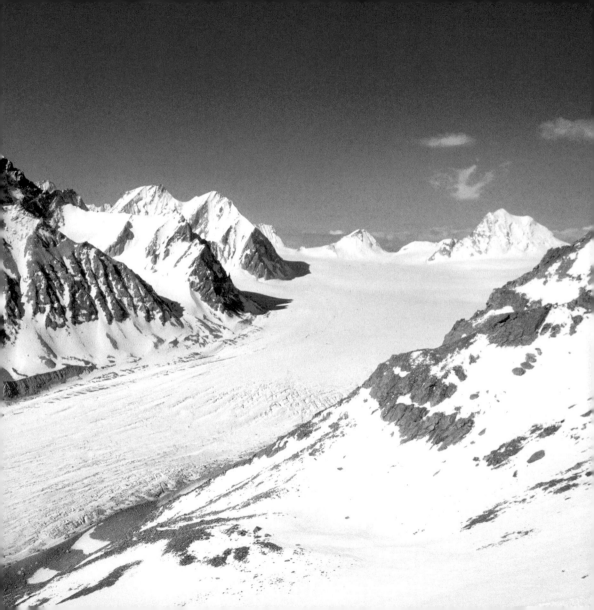

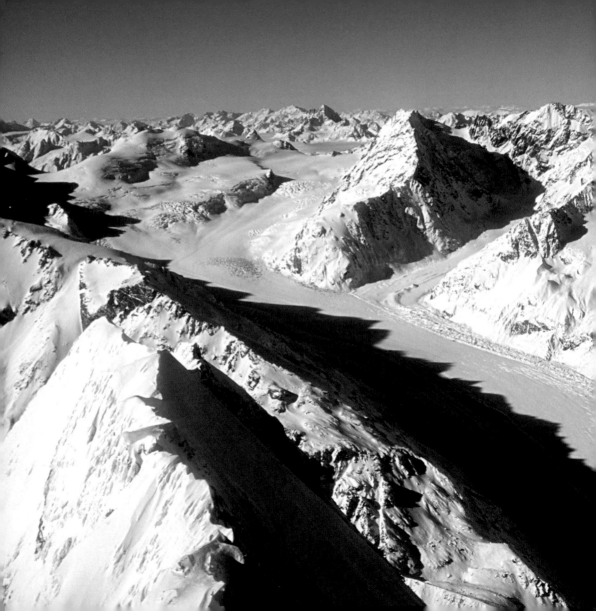

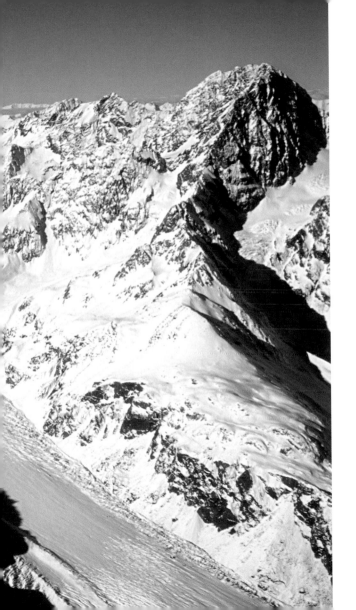

Oceania

- MacKenzie (New Zealand) - Upper Tasman Glacier and the Malte Brun, in Mount Cook National Park, seen from the peak of the Minarets.

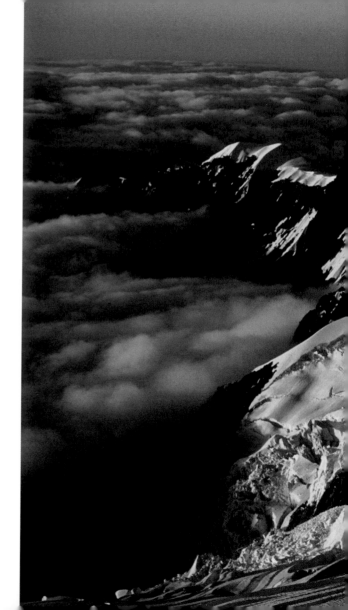

● West Coast (New Zealand) - The Balfour Glacier, in Westland National Park.

ʿ

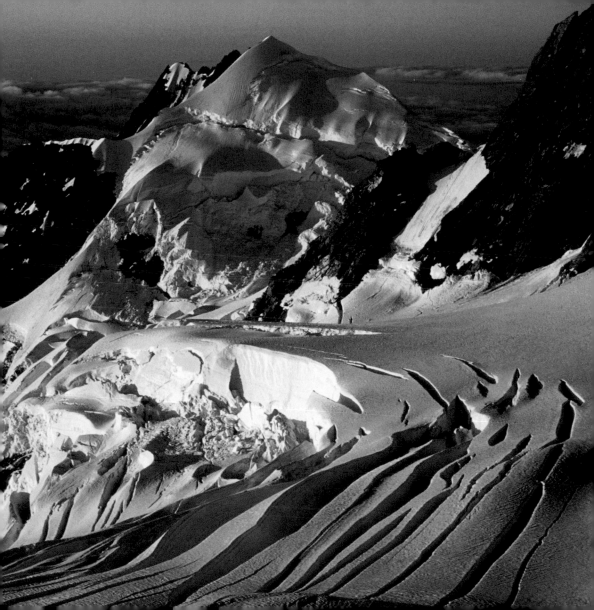

238 • Southern Lakes (New Zealand) - An ice sculpture in the Cardrona Valley.

238-239 • Fiordland (New Zealand) - Hills of snow on Lake MacKenzie, along the Routeburn Track.

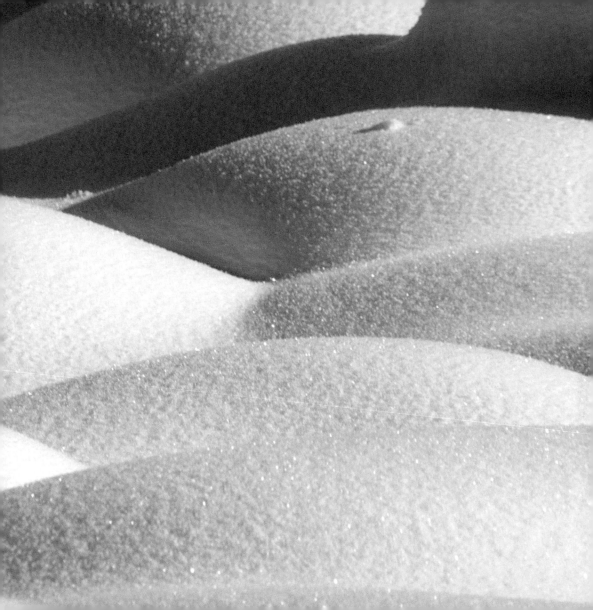

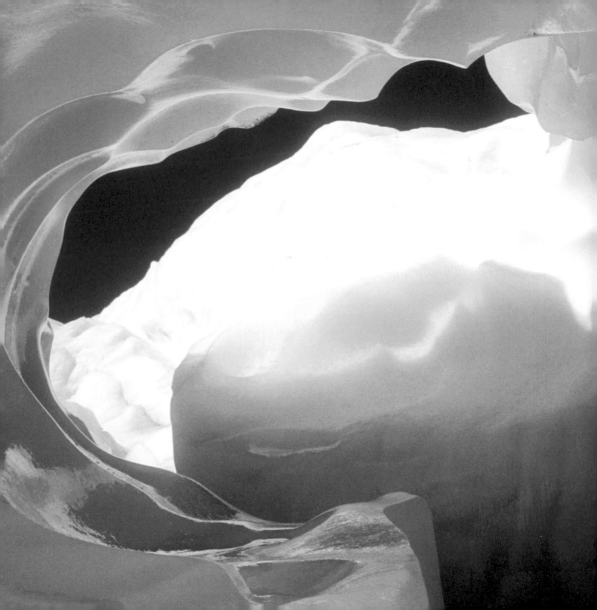

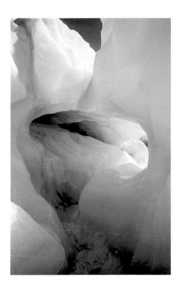

West Coast (New Zealand) - The Fox Glacier in Westland National Park.

North America

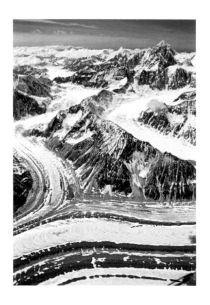

242 • Alaska (USA) - The meeting of glaciers and mountains near Glacier Bay.

243 • Alaska (USA) - A view of Glacier Bay.

244-245 • Alaska (USA) - The front of the Margerie Glacier in Glacier Bay.

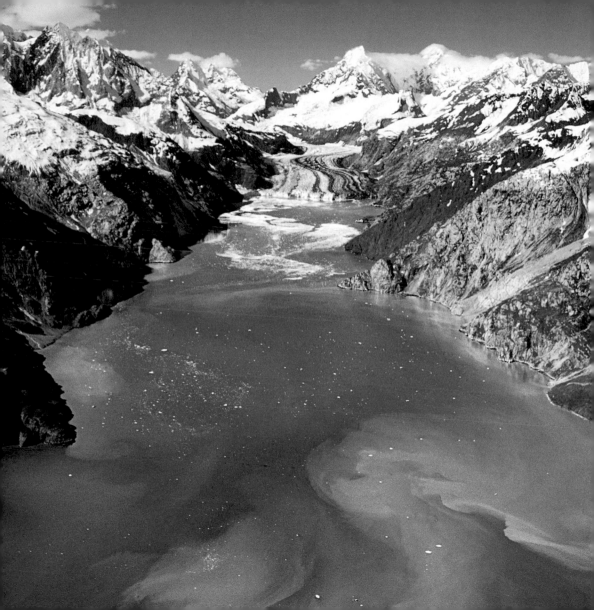

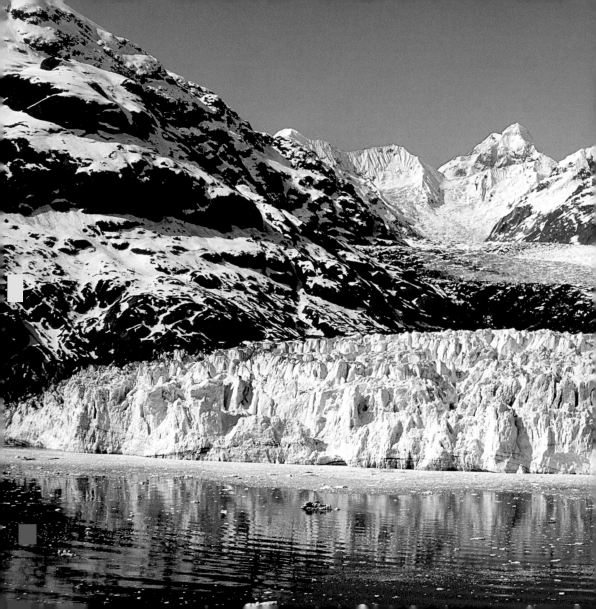

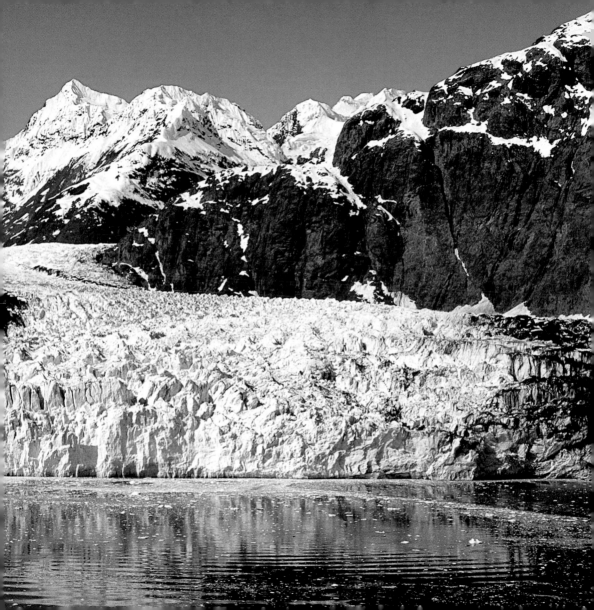

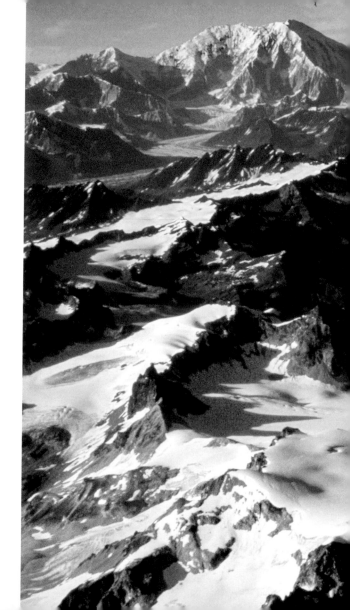

● Alaska (USA) -
The Kahiltna Glacier
traces wide curves
along its course
towards the valley.

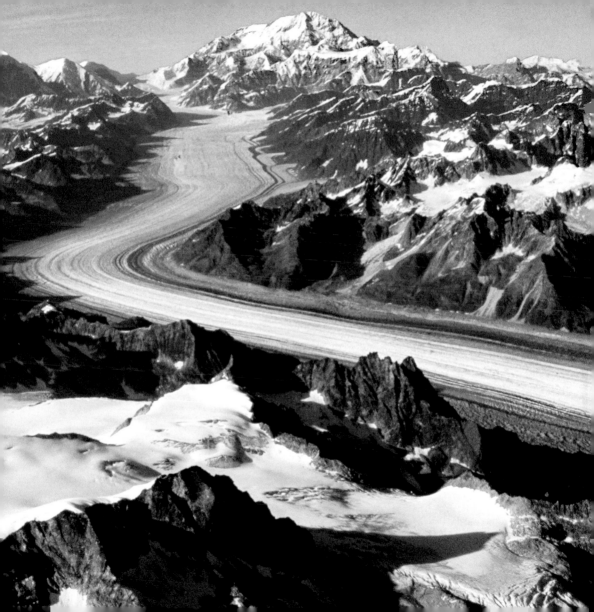

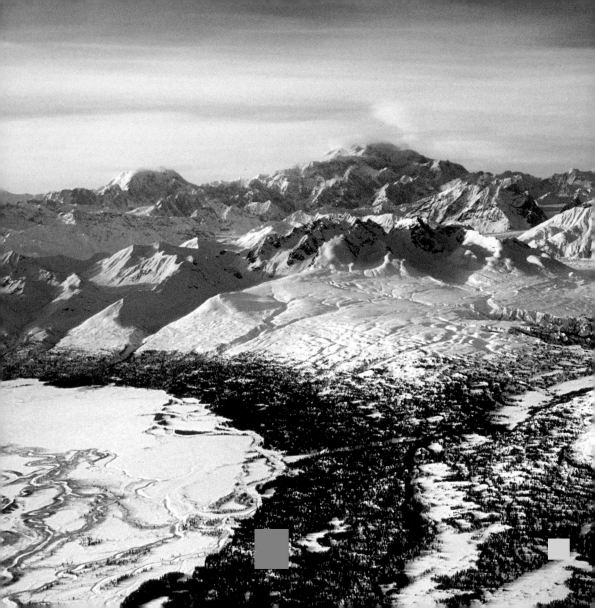

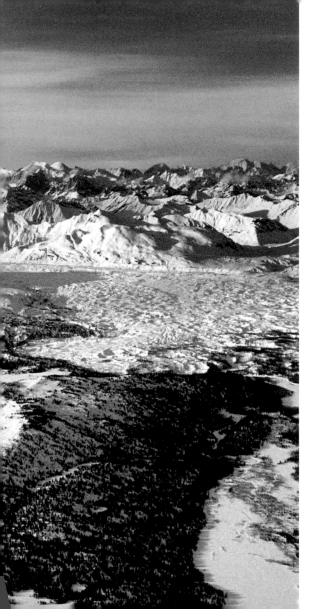

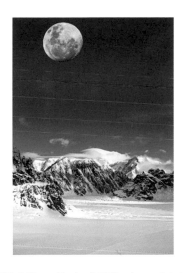

248-249 • Alaska (USA) - An aerial view of the Ruth Glacier in Denali National Park.

249 • Alaska (USA) - A big full moon shines above the natural amphitheater of Ruth Glacier, in Denali National Park.

250-251 ● Alaska (USA)
- The impressive seracs
of the Matanuska
Glacier.

252-253 ● Alaska
(USA) - A vertical visual
of a mantle of snow with
ice patches and small
puddles in Denali
National Park.

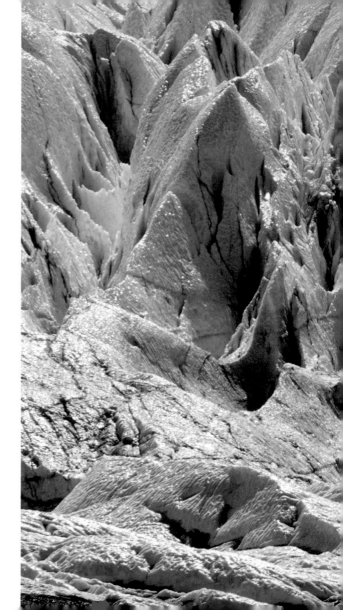

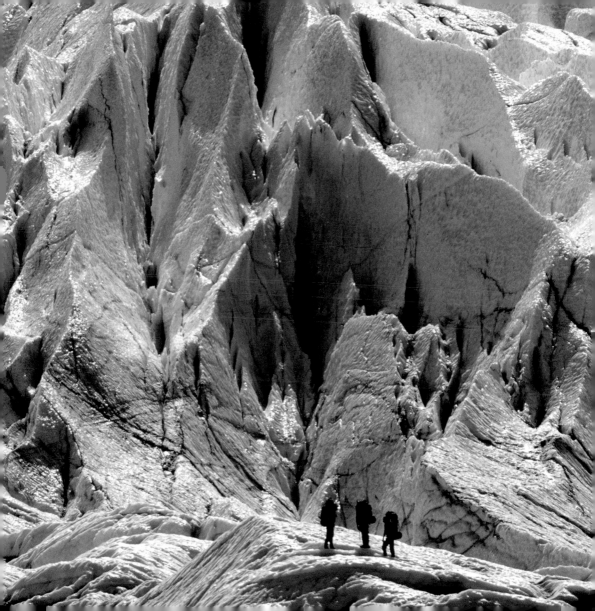

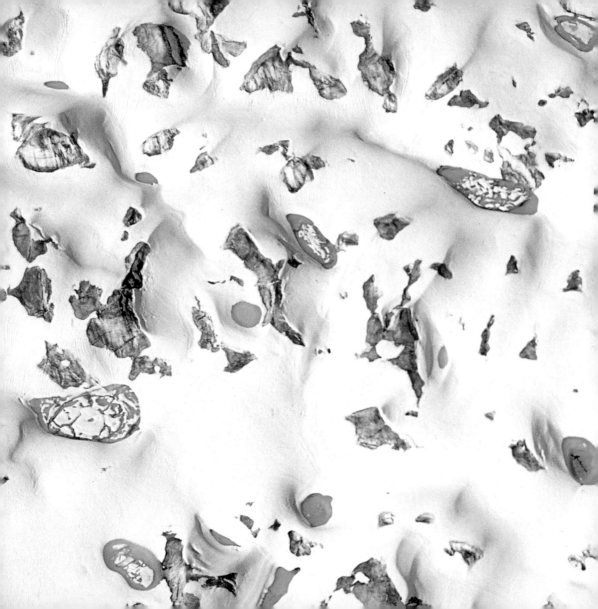

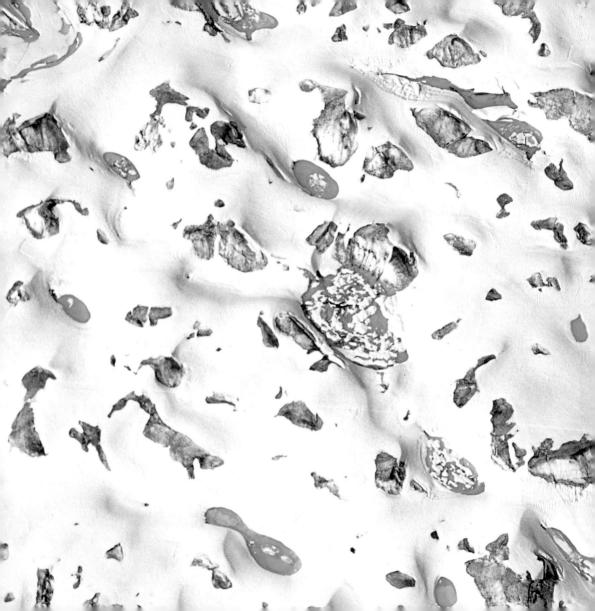

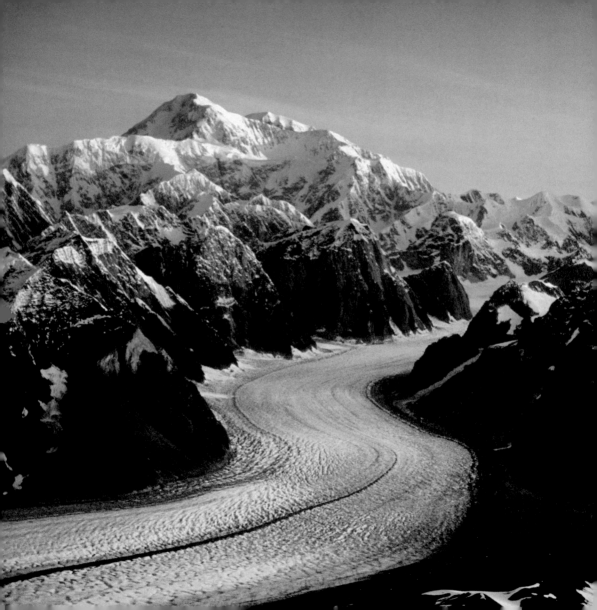

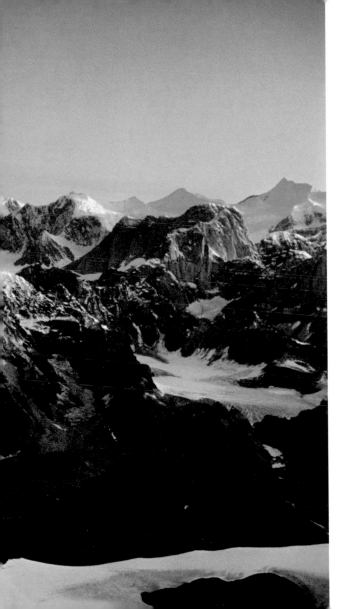

254-255 ● Alaska (USA) - Mount McKinley towers over Ruth Glacier, in Denali National Park,

256-257 ● The two beds of Chitna Glacier, in Wrangell-St. Elias National Park.

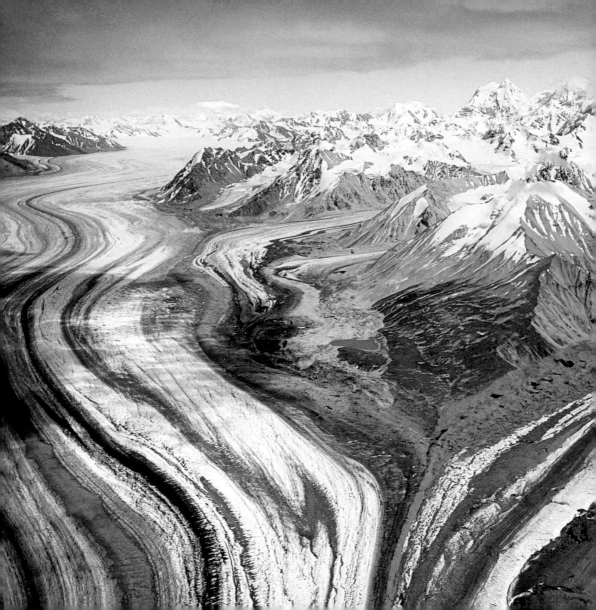

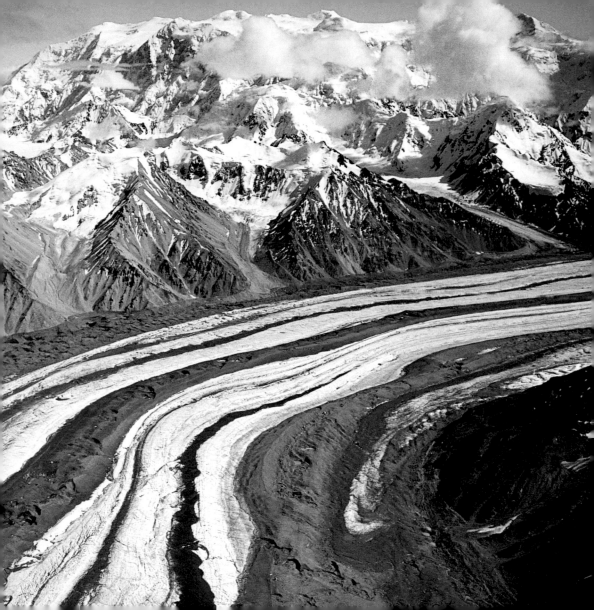

258 • Alaska (USA) - Crevasse on Mendenhall Glacier.

259 • Alaska (USA) - Malaspinas Glacier at Yakuta Bay.

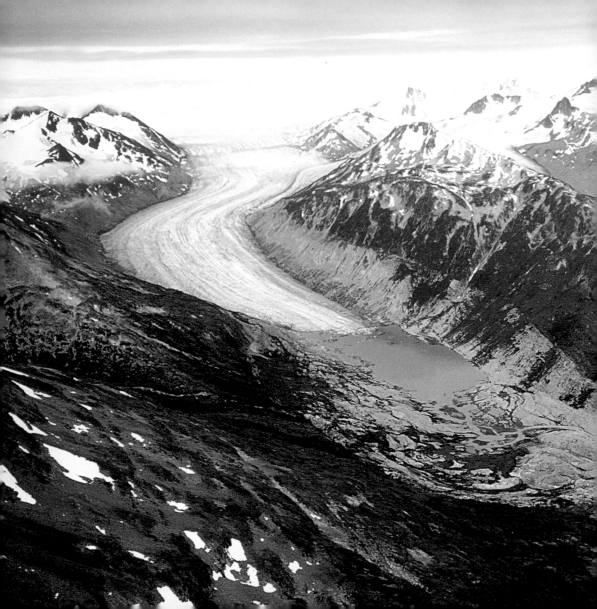

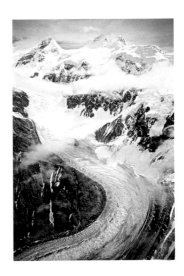

260-261 • Northwest British Columbia
(Canada) - A white serpent designed by
the glacier of Chilkoot Range.

261 • Northwest British Columbia
(Canada) - The curve of the Chilkoot
Range Glacier enveloped by clouds.

262 • Northwest British Columbia (Canada) - Designs created by the wind on the glacier of the Salmons near Stewart.

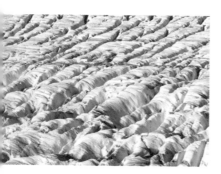

262-263 • Northwest British Columbia (Canada) - A wrinkled river of ice slides down Mount Robson to Lake Berg.

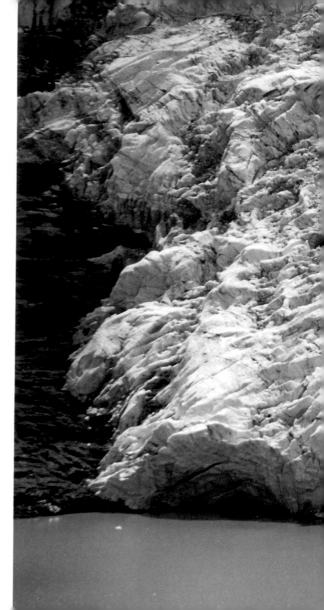

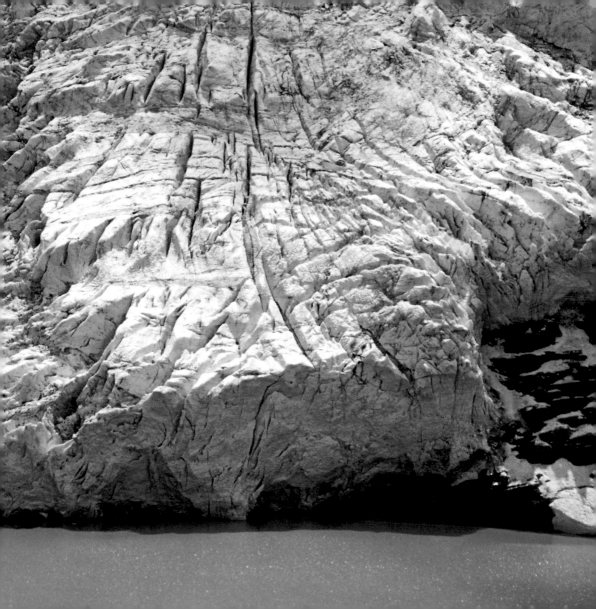

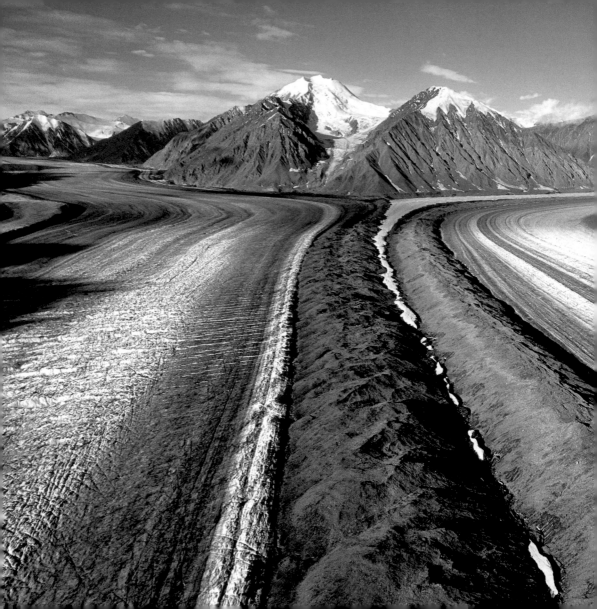

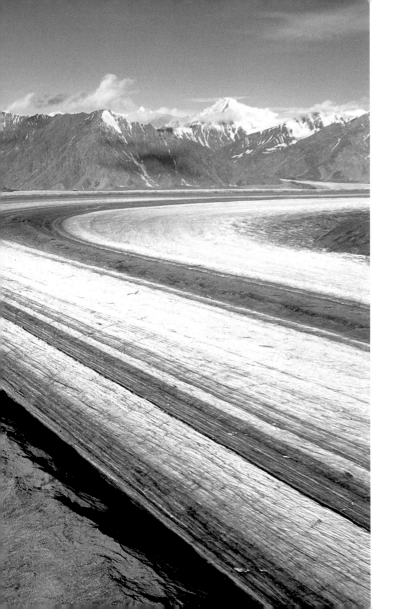

Yukon Territory (Canada) - The Russell and the Moraines glaciers.

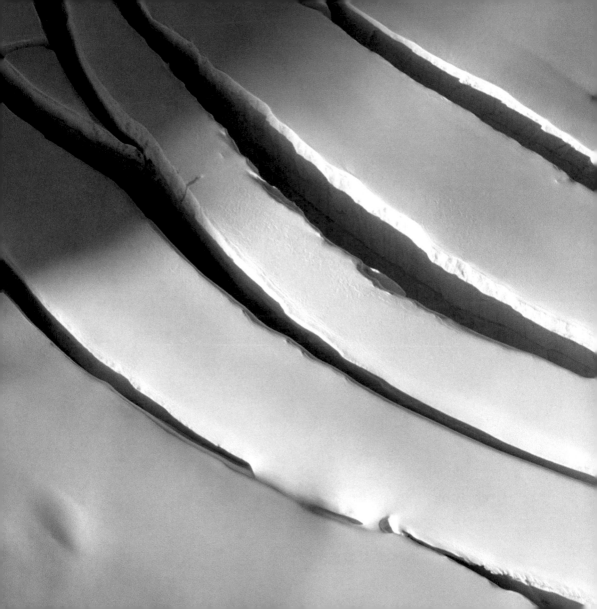

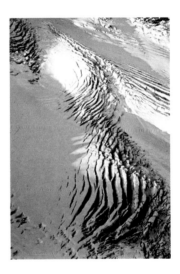

● Washington (USA) Crevasses around
the peak of Mount Rainier, in the national
park of the same name, draw incredible
wrinkles on the mountain face.

Wyoming (USA) - A vertical photo of a glacier on the Wild River Mountains in the Fitzpatrick Wilderness Area.

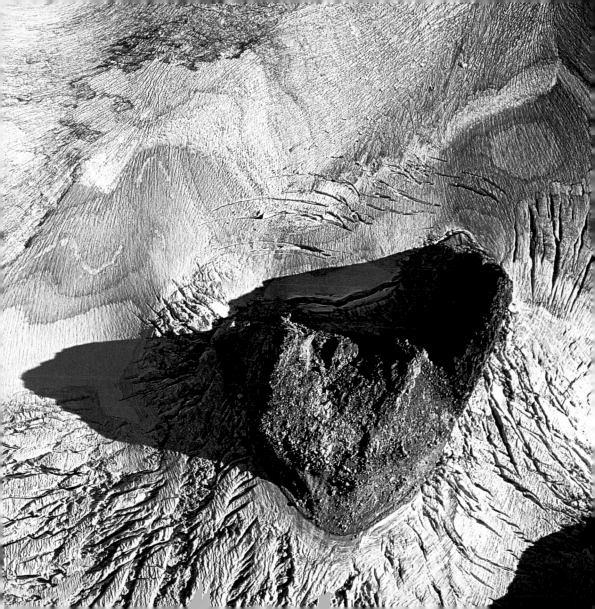

South America

270-271 ● Patagonia
(Argentina) - An aerial
view of Perito Moreno
Glacier and Lake
Argentina near El
Calafate, in Los
Glaciares National Park.

272-273 ● Patagonia
(Argentina) - The front
of Perito Moreno
Glacier.

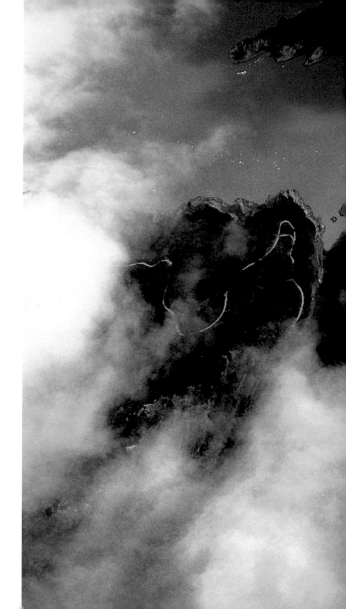

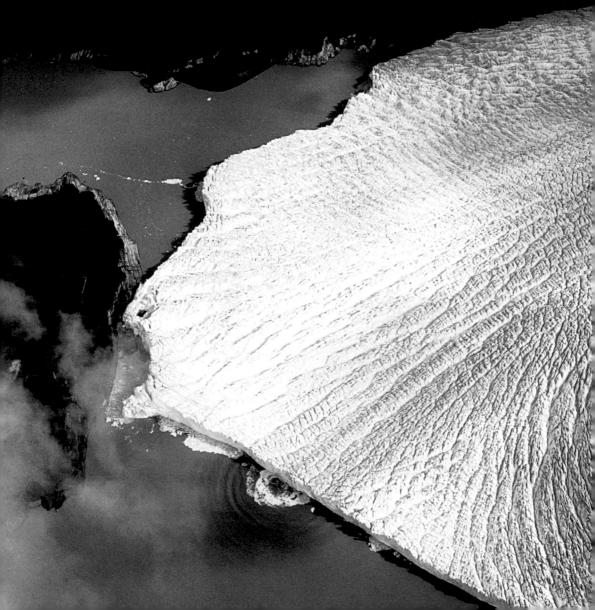

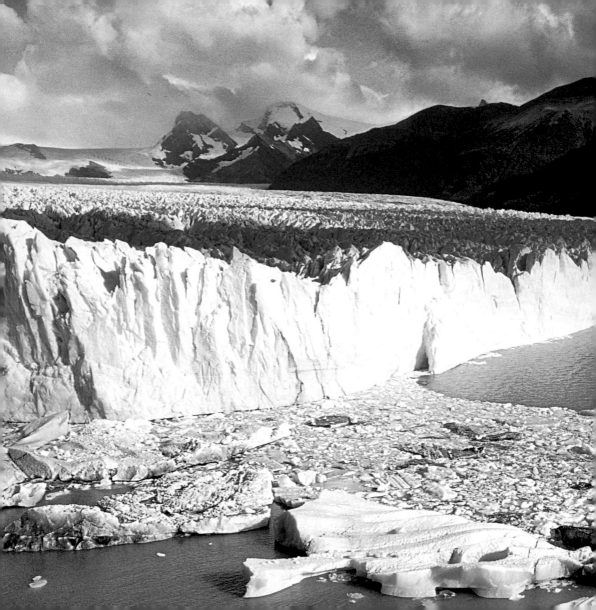

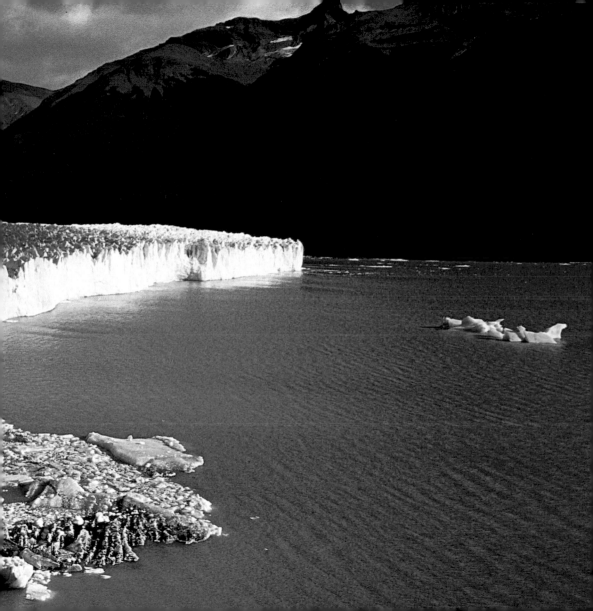

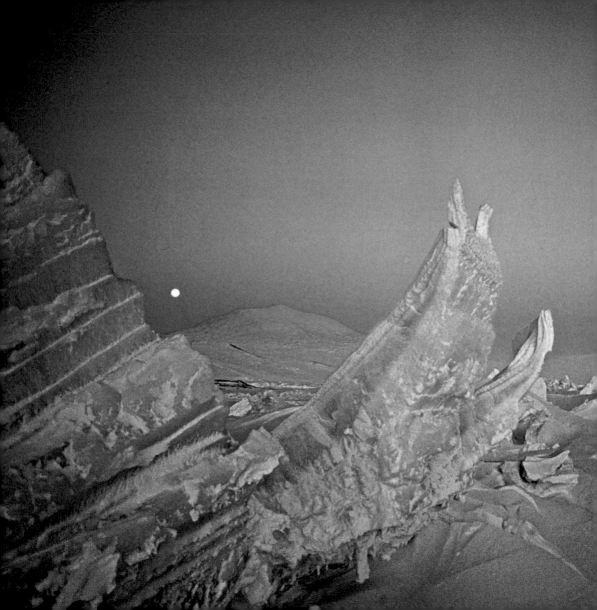

Antarctic

- Antarctic - Mount Erebus on Ross Island.

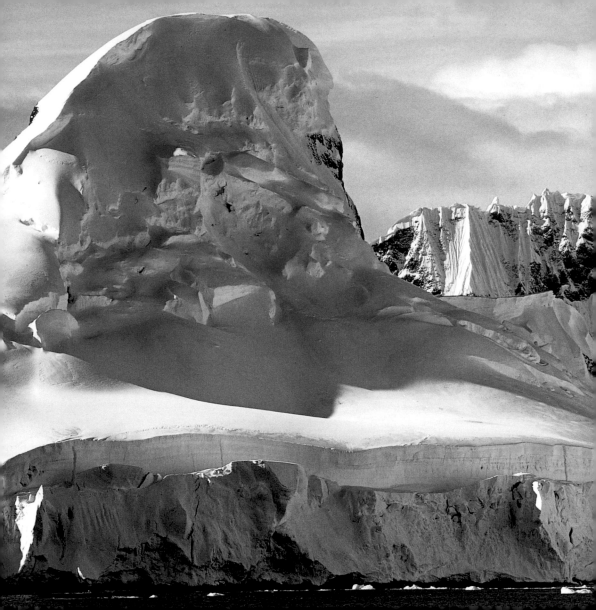

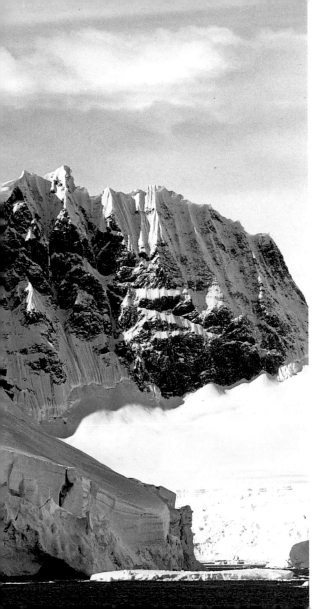

276-277 ● Antarctic - The Lemaire Canal runs between the mainland and Rocky Booth Island.

277 ● Antarctic - Lemaire Canal.

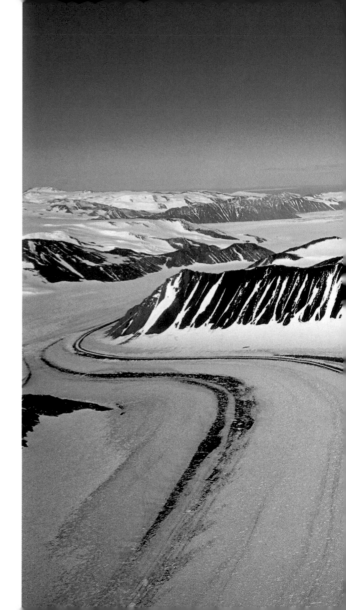

Antarctic - A glacier
and mountains on
Newfoundland.

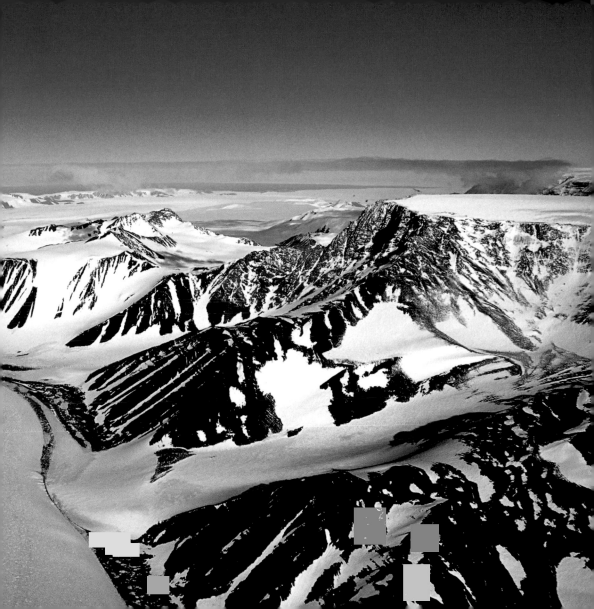

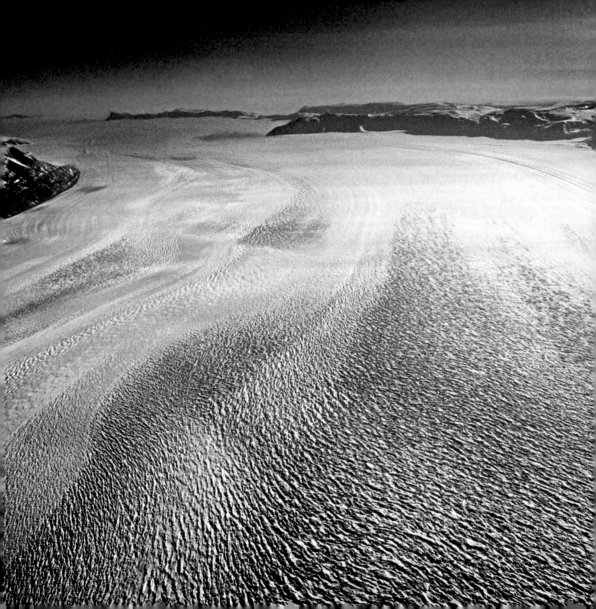

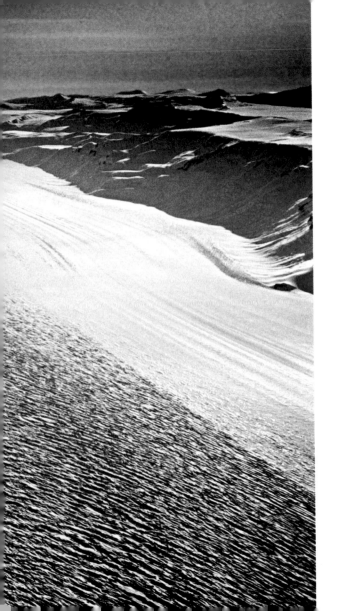

280-281 ● Antarctic -
The Beardmore Glacier on the
Queen Maud Mountains is
considered one of the biggest
glaciers in the world.

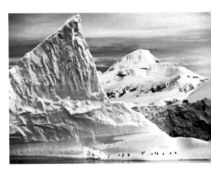

281 ● Antarctic - The imposing
glacier at Paradise Bay.

At the BASE of the MOUNTAINS

ENRICO CAMANNI

- Tyrolese Alps (Austria) - A panoramic view of Kitzbühel.

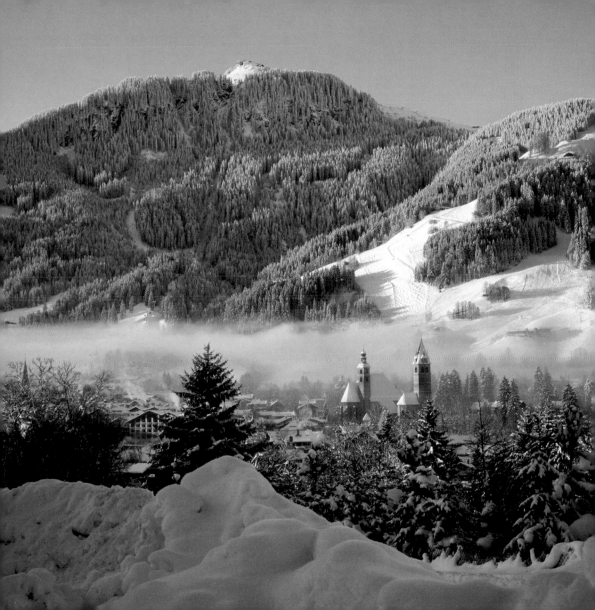

INTRODUCTION At the Base of the Mountains

According to the ethnologist Arnold Niederer, "Mountain pastures hold the same importance for mountain dwellers as the sea for the sailor." Meadows are the sea of the Alps. Pasturelands provide the only guaranteed products for sustenance – milk, cheese, and eggs – and the seasons of the Alps mark the lives of valley dwellers: the springtime climb of the men and animals, their summer stay at high altitudes in search of the best grass, the autumn descent, and the long winter "hibernation" down in the valley while awaiting the next summer. It is the biological rhythm of the mountain, where, contrary to appearances, no one has ever been able to maintain permanent residence.

INTRODUCTION At the Base of the Mountains

PERHAPS REPETITIVE, IT IS CERTAINLY DICTATED BY THE RHYTHM OF THE SEASONS AND THE WHIMS OF THE WEATHER ("NINE MONTHS OF COLD AND THREE OF ICE," THE ABBOT CHANOUX, PRIOR OF THE LITTLE SAINT BERNARD, SAID WITHOUT TOO MUCH IRONY), ALWAYS MOVING IN SEARCH OF THE BEST PLACE AND WEATHER. MOUNTAIN PEOPLE, LIKE ALL OTHER LIVING BEINGS, HAVE HAD TO ADAPT THEIR METHODS AND CUSTOMS TO THE HARSHNESS OF THE ALPINE WORLD, BUT UNLIKE THE PLANTS AND ANIMALS, THEY HAVE MODIFIED THE MOUNTAIN ENVIRONMENT OF THEIR OWN WILL TO MAKE IT MORE LIVABLE. THE LANDSCAPE THAT PROMOTIONAL TOURIST ADVERTISEMENTS RHETORICALLY SELL AS "NATURAL" IS NONE OTHER THAN THE RESULT OF CENTURIES AND CENTURIES OF HUMAN MODIFICATIONS, IN A WEAVE OF NA-

At the Base of the Mountains
Introduction

TURE AND CIVILIZATION THAT IS BY NOW IMPOSSIBLE TO UN-RAVEL. YET AGAIN, THE PASTURELANDS ARE SYMBOLIC OF THOSE MODIFICATIONS, BECAUSE WHERE TODAY WE SEE (AND ENJOY) MEADOWS AND GREEN FIELDS, THERE WAS ONCE ONLY ROCK AND FOREST; AND AS SOON AS THE PAS-TURES AND MEADOWS ARE ABANDONED, THE VEGETATION WILL ADVANCE WITH AN AMAZING PACE, LIKE A SEA SUFFO-CATED BY ALGAE. NOTHING IS CONSTANT AND GUARANTEED, NOT EVEN AT HIGH ALTITUDES. THE SAME PEAKS THAT WE BE-LIEVE TO BE TIMELESS, THOSE GRANITE OR LIMESTONE SPIRES THAT SEEM SYMBOLS OF ETERNITY, ARE BORN OF THE SEA AND DESTINED TO RETURN FROM WHENCE THEY CAME.

287 • Colorado (USA) - Lush fir trees color this gorgeous American valley.

288-289 • Val d'Aosta (Italy) - A winter view of the Ayas Valley.

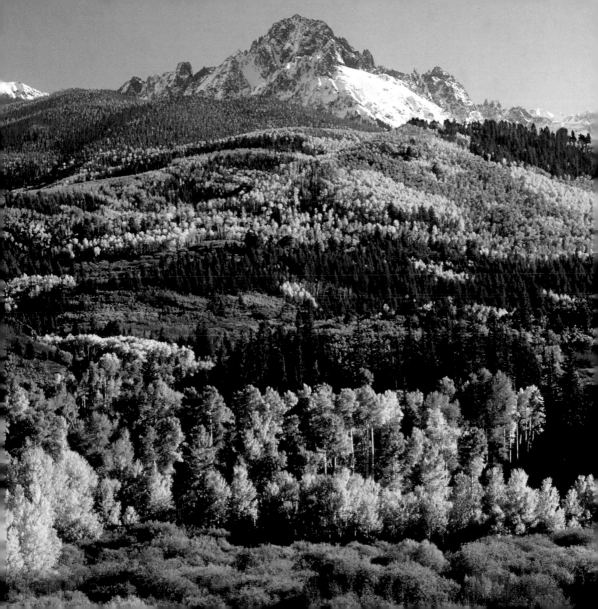

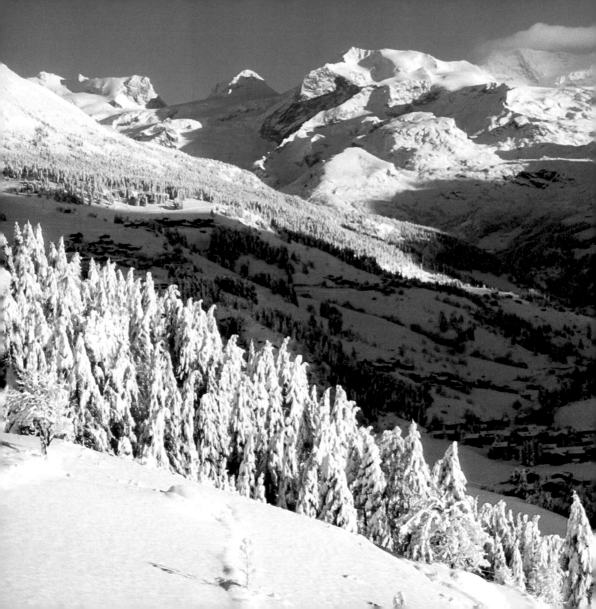

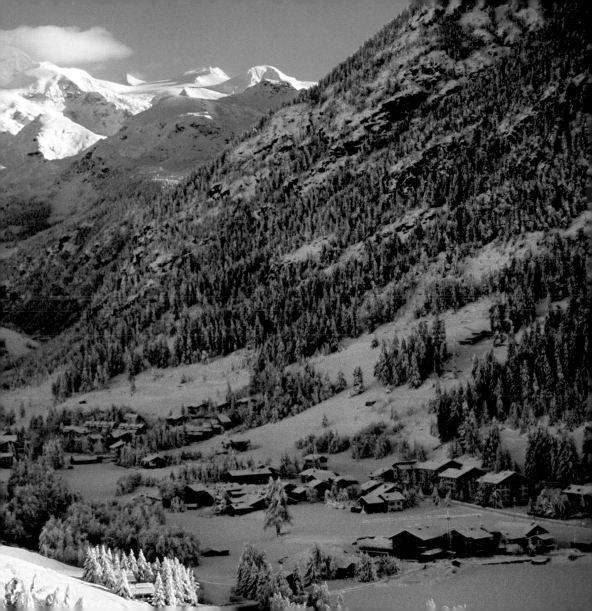

Europe

- Piedmont (Italy) -
Mount Rosa is the end
of the line behind the
clouds in Alagna, in the
Upper Valsesia.

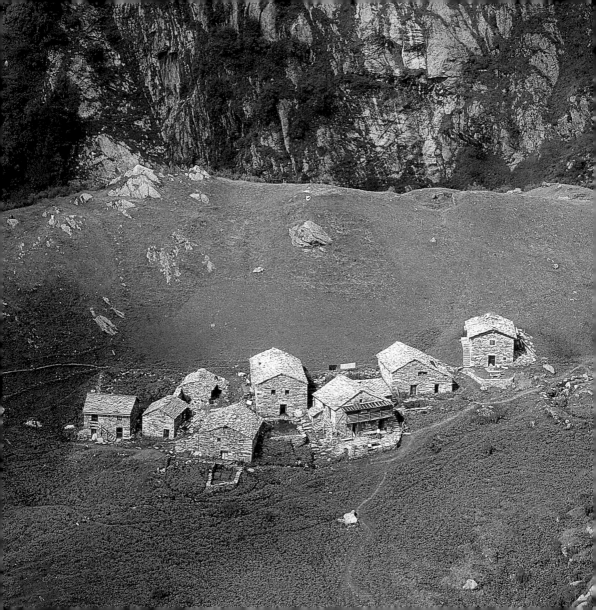

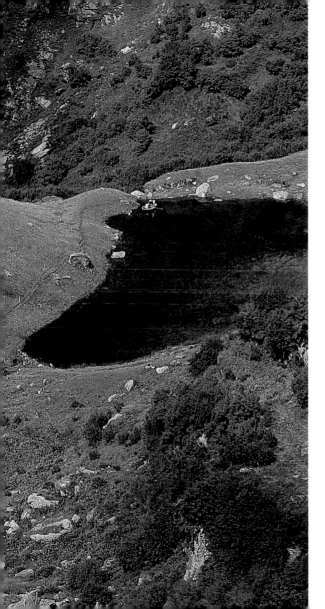

292-293 • Piedmont (Italy) - A summer view of the Campo Alp, in the Upper Valsesia.

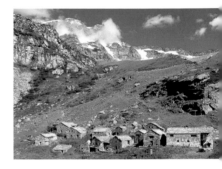

293 • Piedmont (Italy) - An ancient rural settlement on the Bors Alp, in the Upper Valsesia.

● Piedmont (Italy) - Walser
chalets in the villages around
Alagna, in the Upper Valsesia.

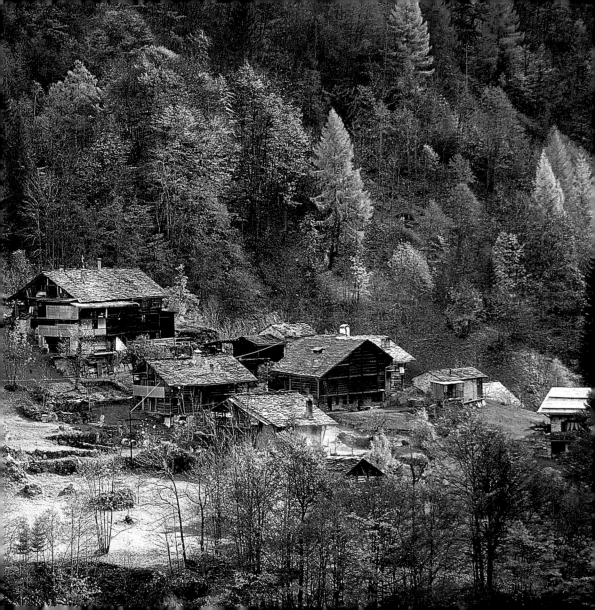

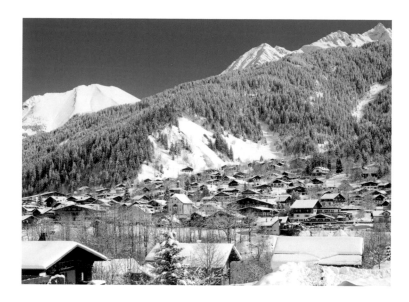

296 • Upper Savoy (France) - The village of Les Contamines, at the base of Mont Blanc.

297 • The Julia Alps (Slovenia) - The town of Podkoren, in the Triglav National Park.

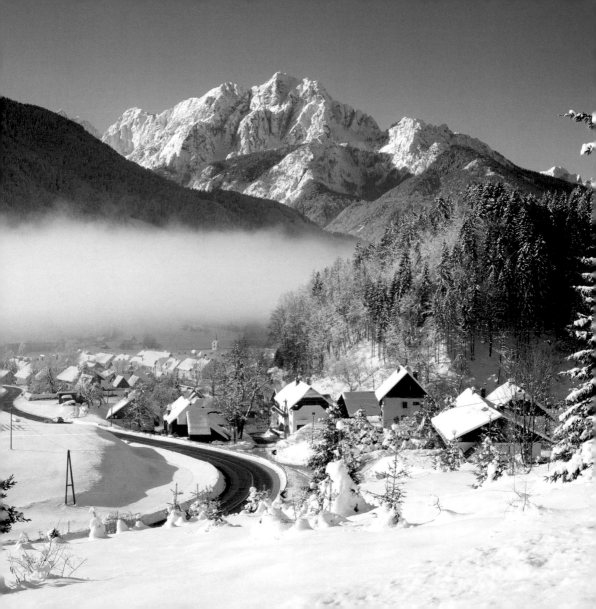

Trentino-Alto Adige (Italy) - The town of Corvara and the hamlet of Colfosco, in the Upper Val Badia.

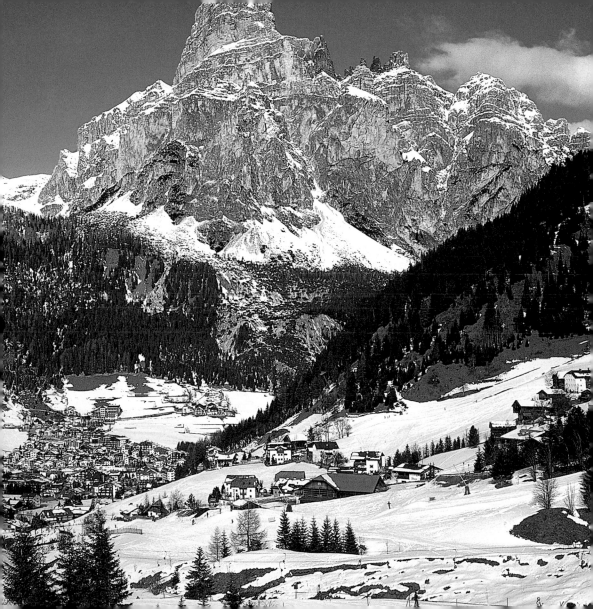

300 • Trentino-Alto Adige (Italy) - The Horn of Fana and the San Silvestro Valley, in the Upper Val Pusteria.

300-301 • Trentino-Alto Adige (Italy) - The Odle and Santa Maddalena, in Val di Funes.

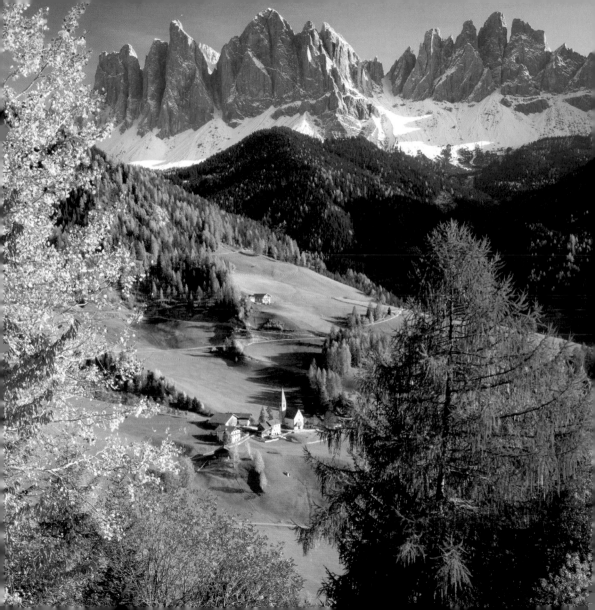

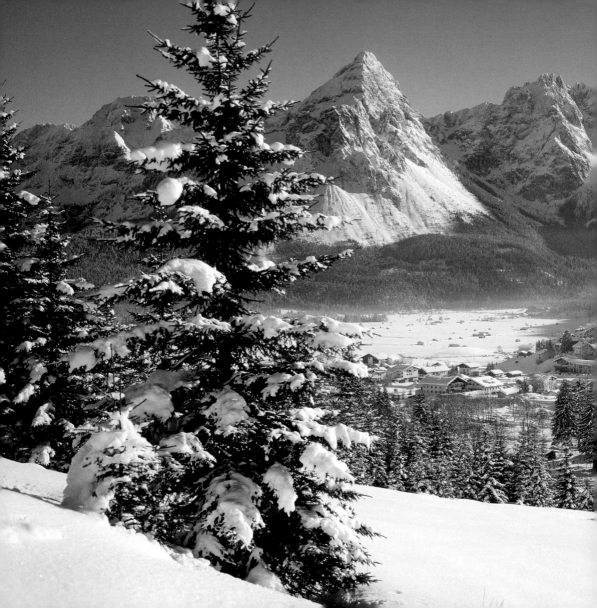

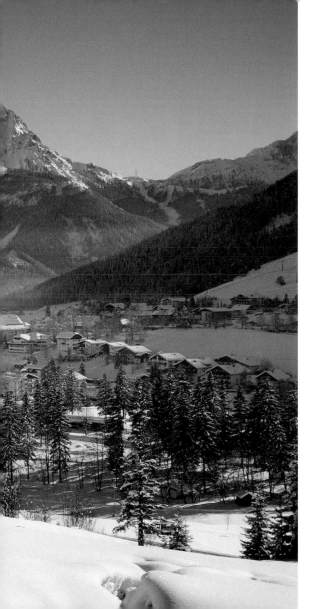

302-303 • Tyrolese Alps (Austria) - The village of Lermoos.

303 • Tyrolese Alps (Austria) - The Valley of Montafon, in the Voralberg.

304-305 • Graubunden (Switzerland) - A town in the area of Davos.

306-307 • Engandin (Switzerland) - A view of Tarasp and of the castle.

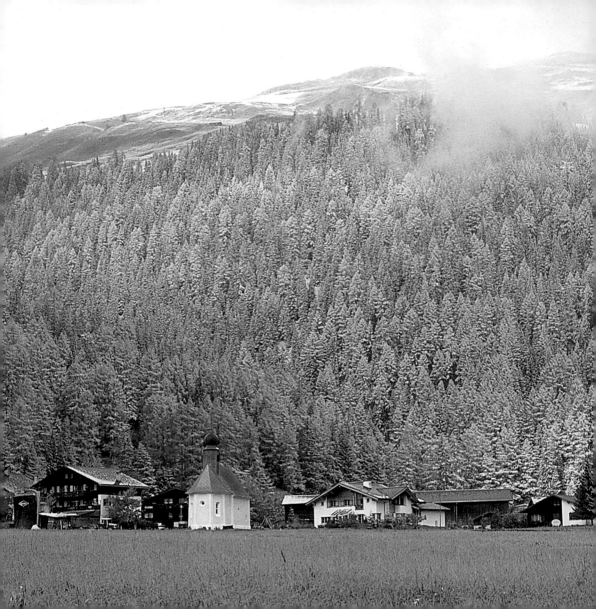

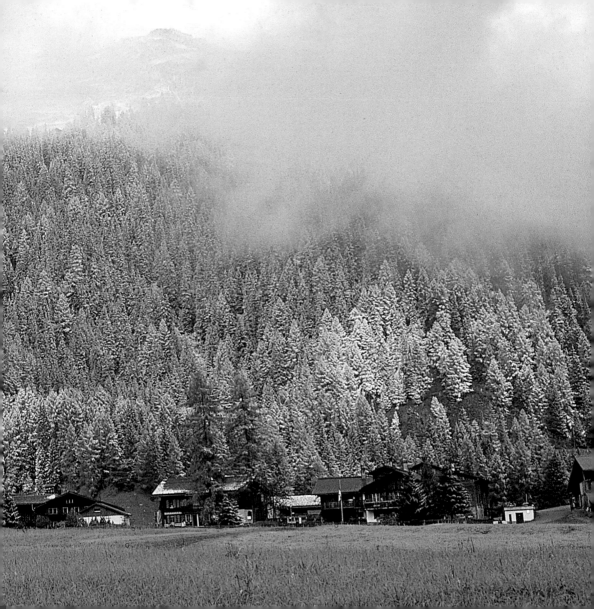

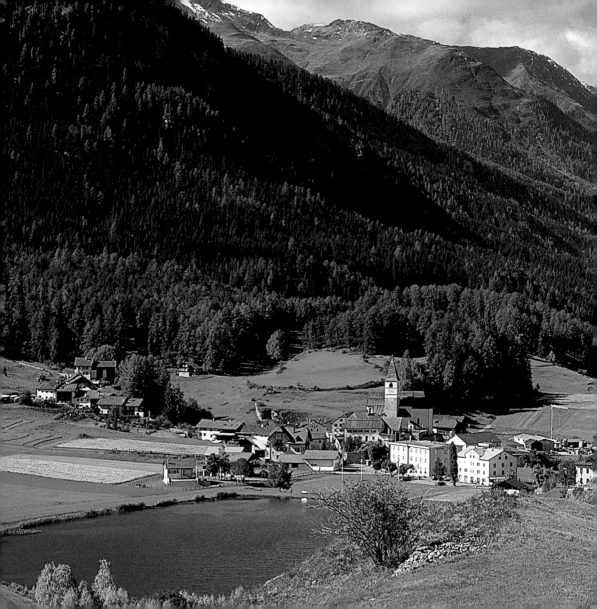

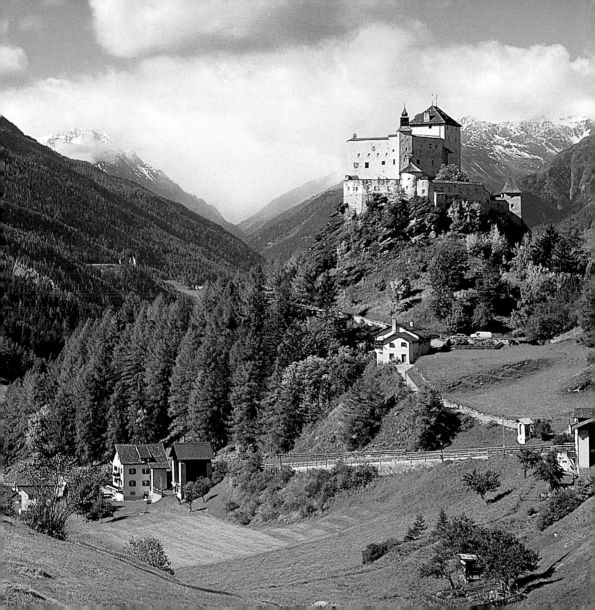

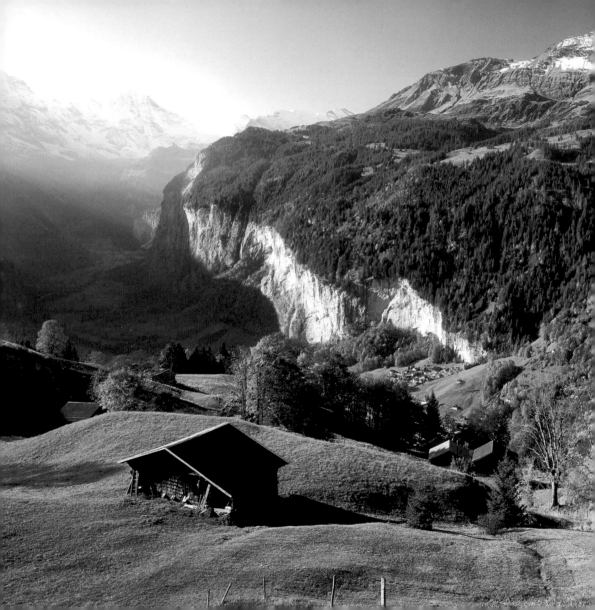

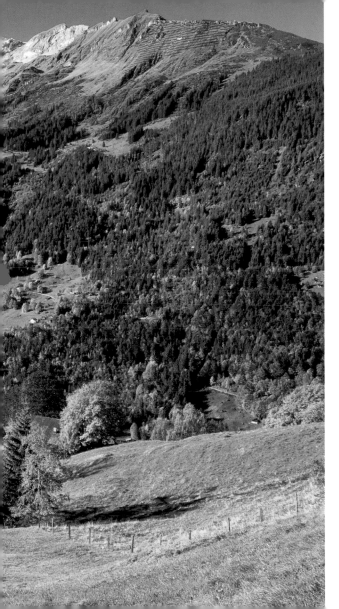

● Oberland (Switzerland) - The Lauterbrunnenthal seen from Wengen.

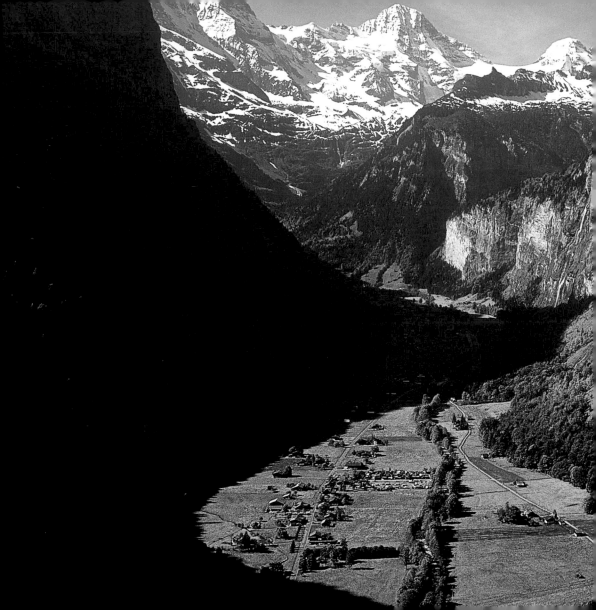

• Oberland
(Switzerland) -
A view of the
Lauterbrunnenthal.

312-313 ● Upper Pyrenees (France) - Pastureland in the area of Gavarnie.

314-315 ● Bavaria (Germany) - A meadow near the Karwendel Mountains.

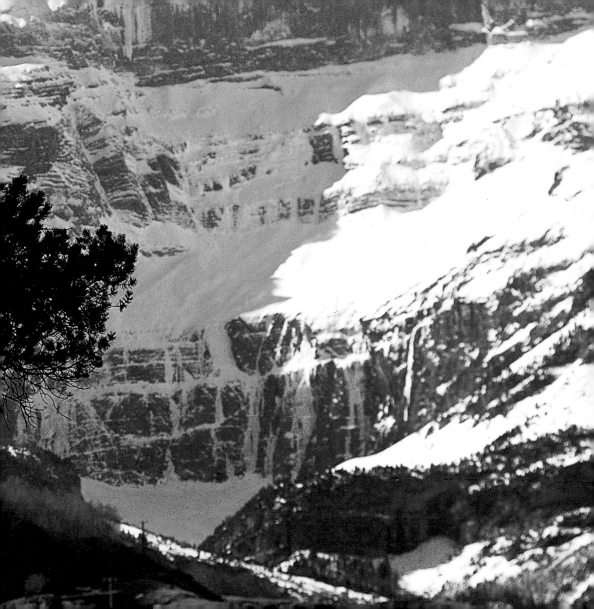

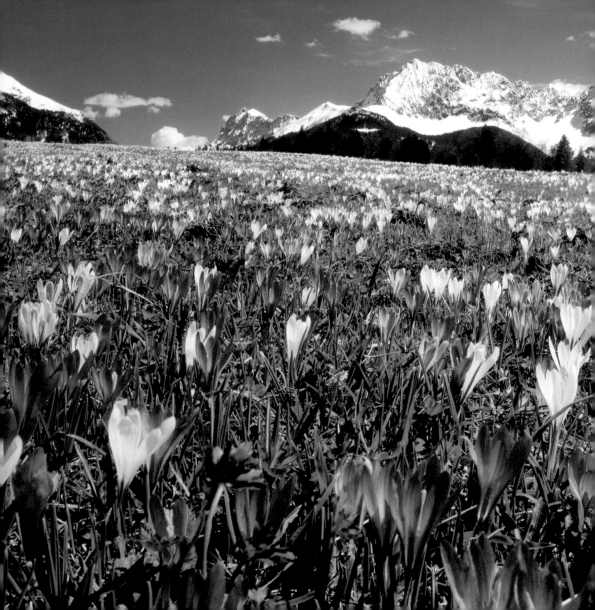

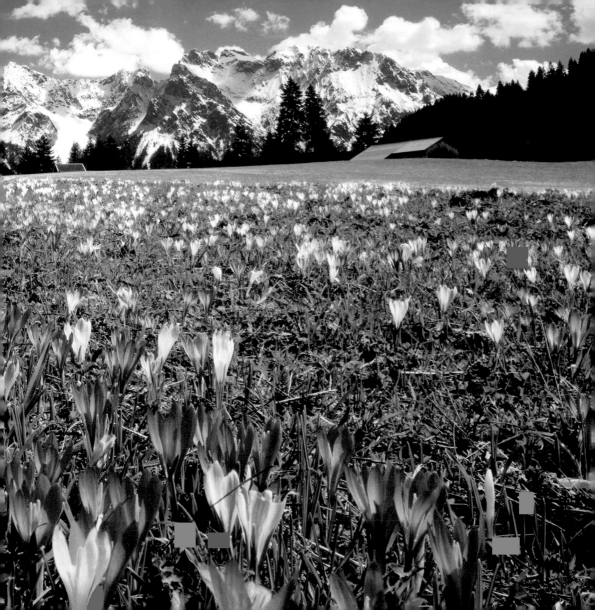

Asia

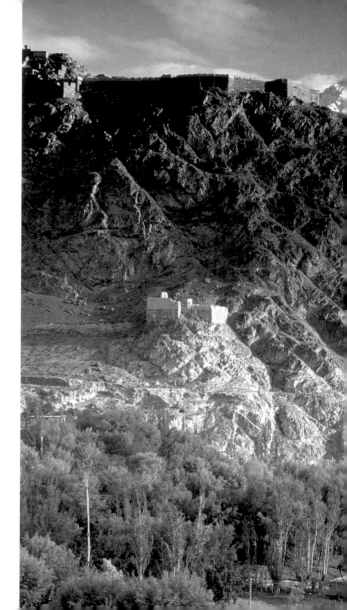

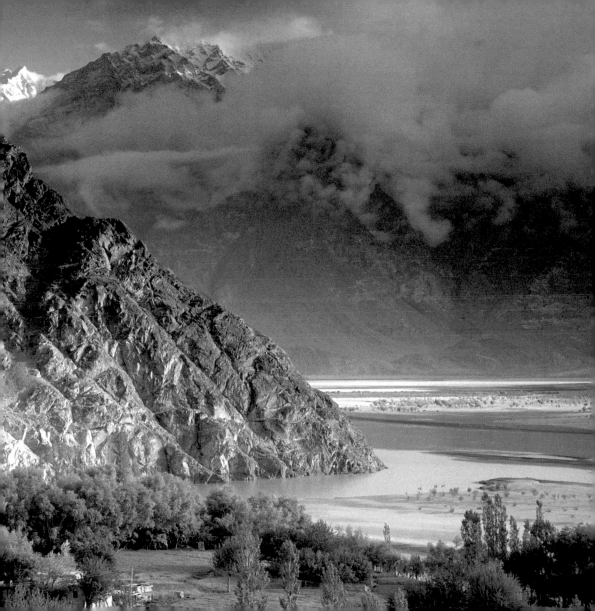

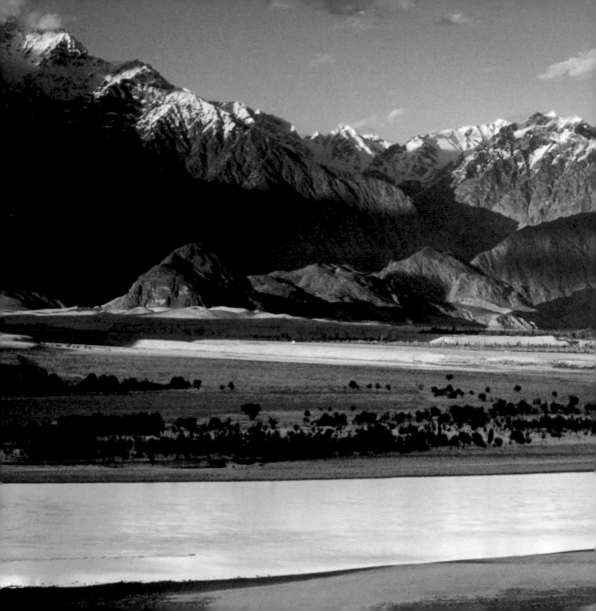

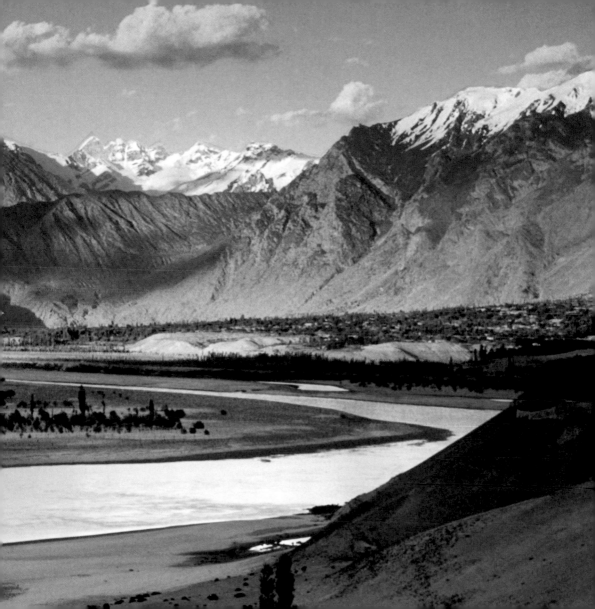

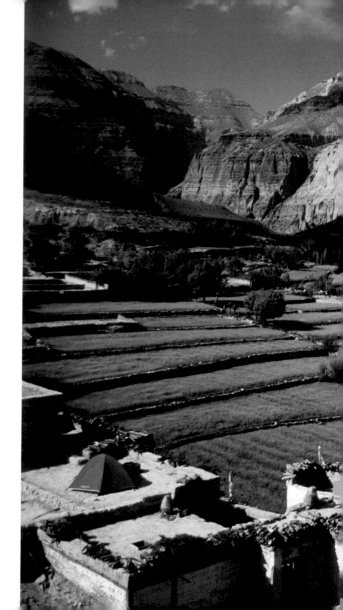

● Mustang (Nepal) -
A glimpse of the village
of Tsele and the pass of
the same name.

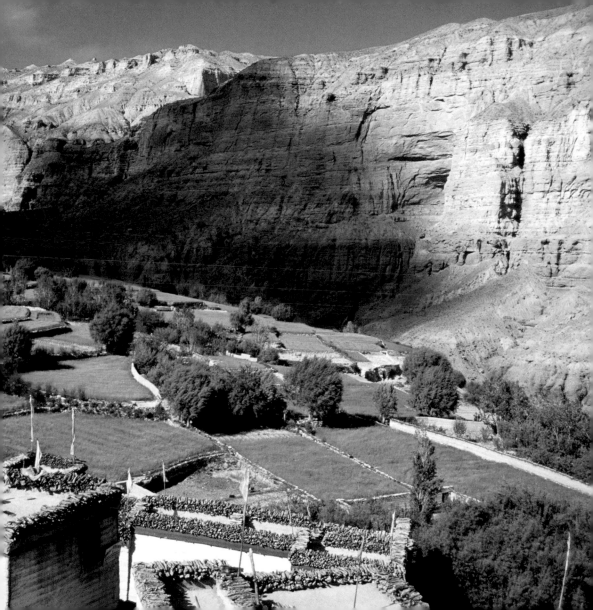

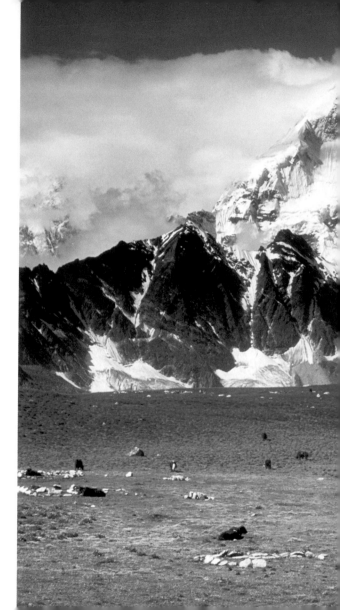

Kangshung (Tibet) -
A camp of nomads in
the Valley of Kama,
beneath Mount
Chomolonzo.

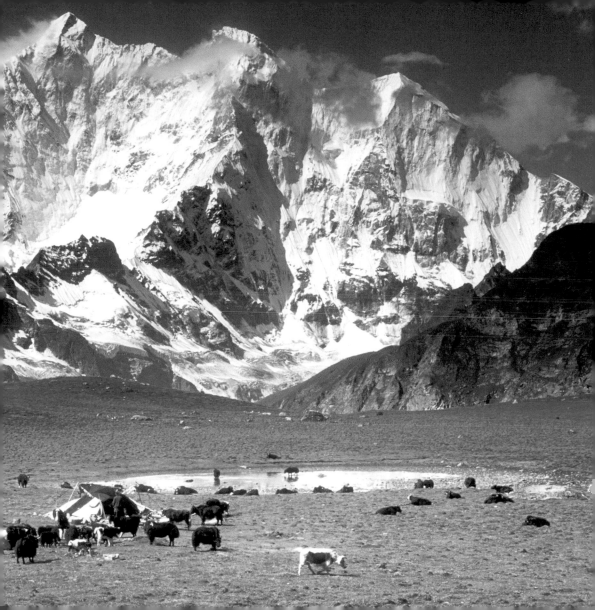

North America

- Alberta (Canada) -
A view of the lakes
region, in Jasper
National Park.

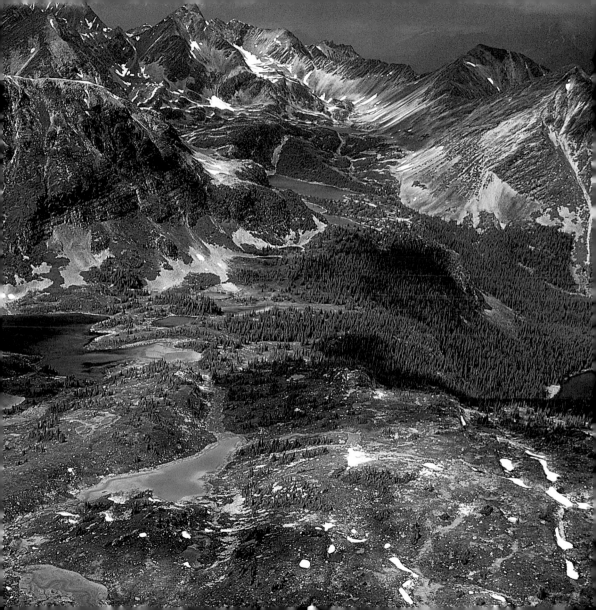

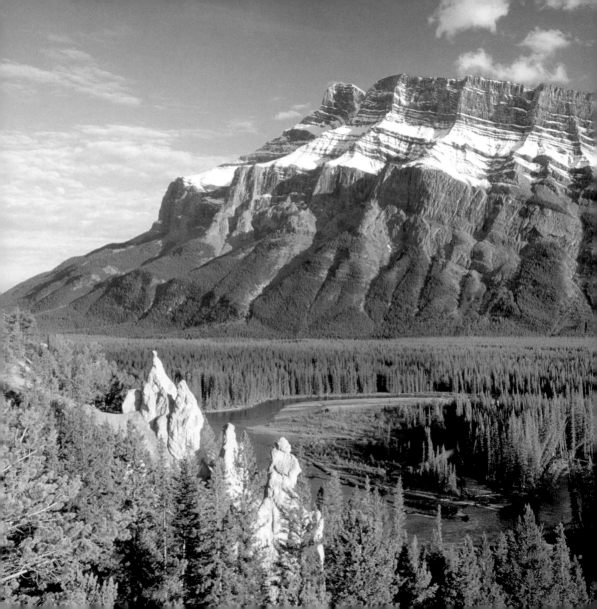

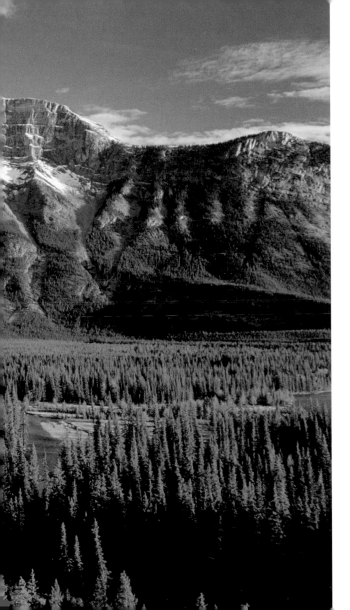

Alberta (Canada) - The Bow Valley and Mount Rundle, in Banff National Park.

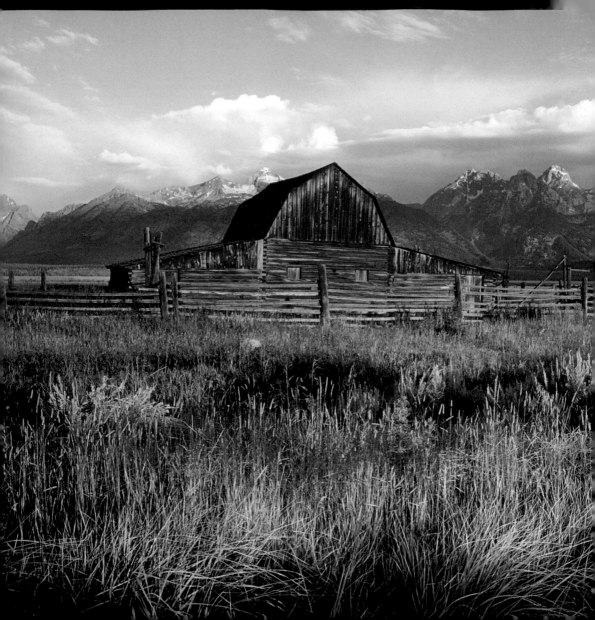

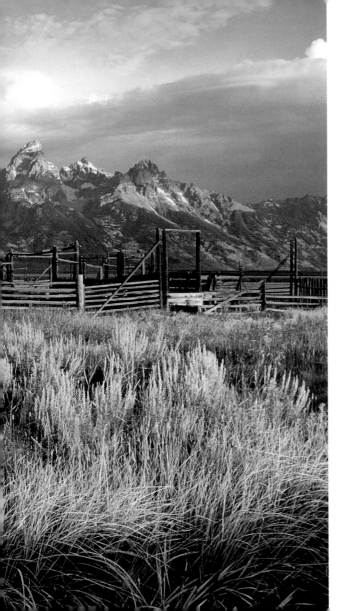

● Wyoming (USA) - A typical farm near the Teton Range.

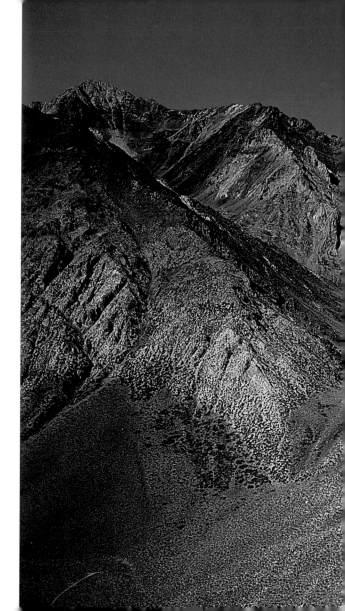

California (USA) -
The McGee Creek
Valley, with the Sierra
Nevada in the
background.

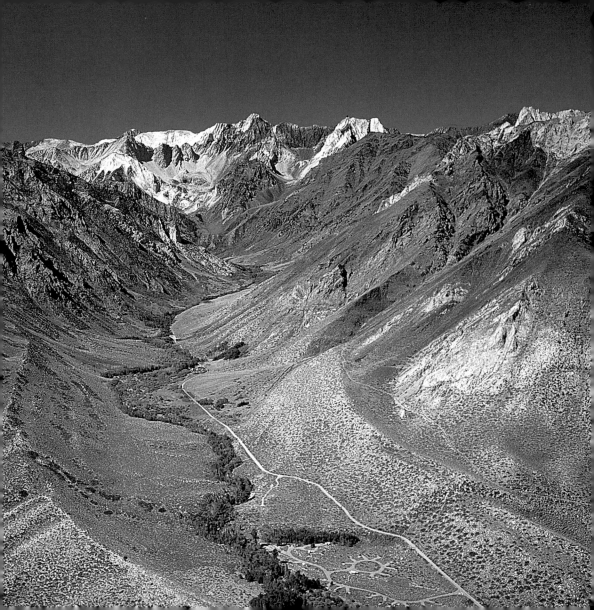

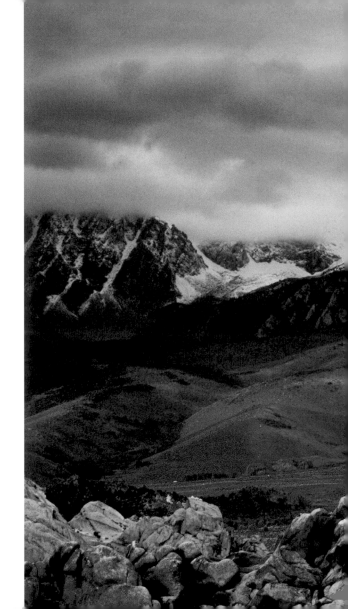

California (USA) -
A panoramic view of
Owens Valley, along the
Sierra Nevada.

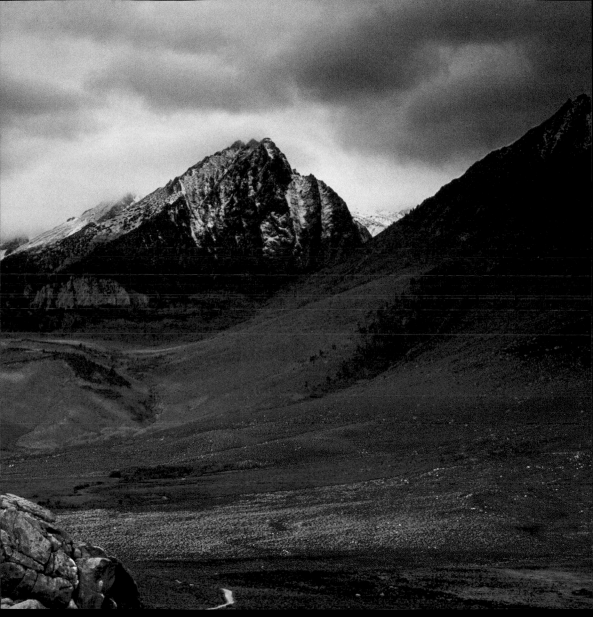

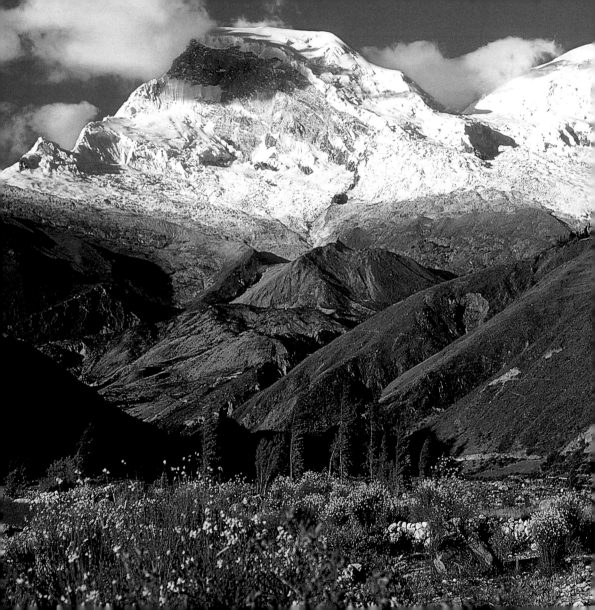

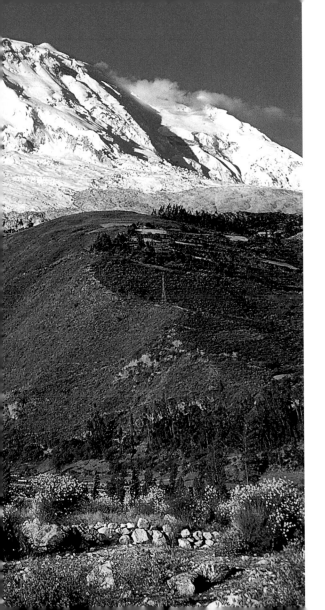

South America

336-337 ● Perù - A glimpse of the Cordillera Blanca.

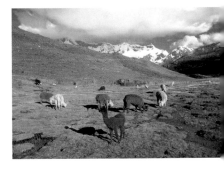

337 ● Perù - A group of alpacas at pasture along the Vilcanota Cordillera.

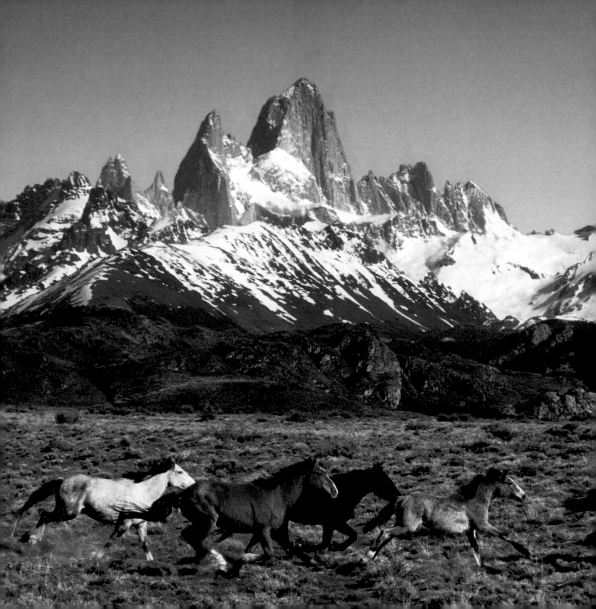

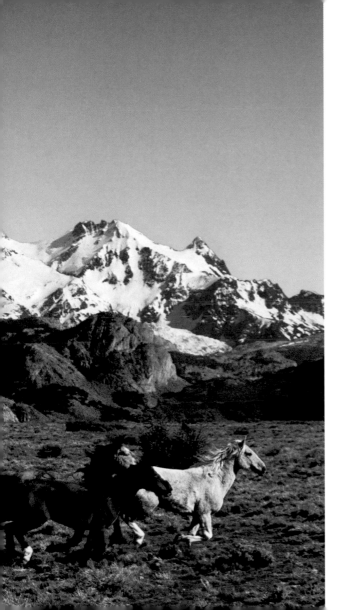

338-339 ● Chile -
A herd of horses
gallops across the
highlands at the base
of the Fitz Roy.

340-341 ● Bolivia -
The little city of
Achacachi and, in the
background, the Illimani
Mountains.

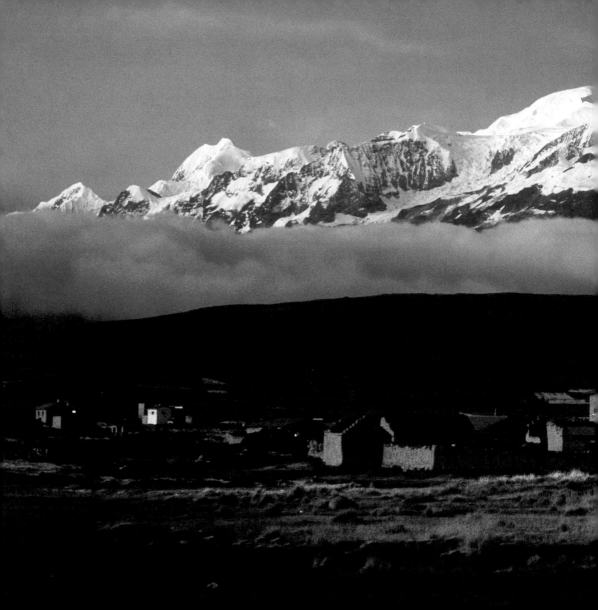

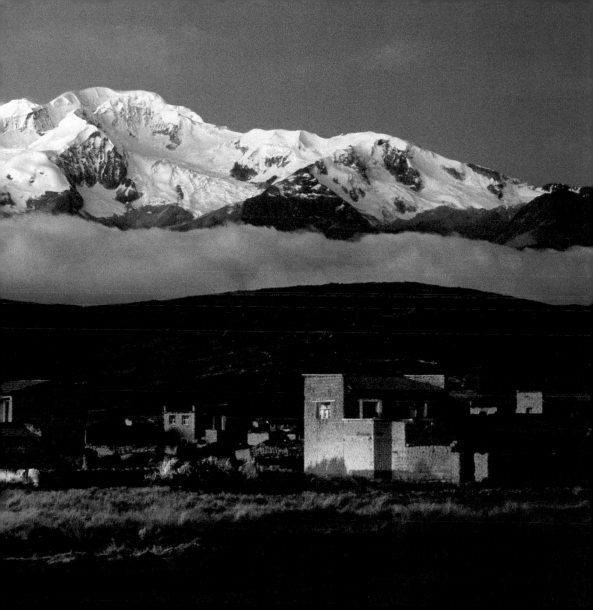

HIGH·ALTITUDE SPORTS

STEFANO ARDITO

- California (USA) - An expert free-climber climbs alongside the Upper Yosemite Falls. At his back is a rainbow.

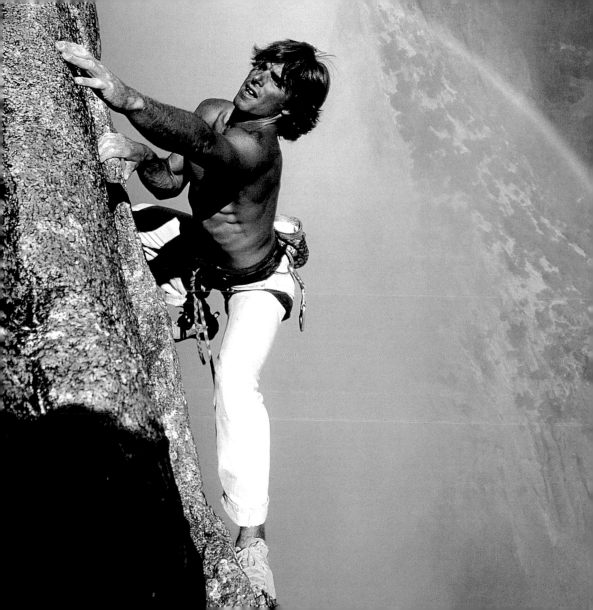

INTRODUCTION High-Altitude Sports

IN THE SECOND HALF OF THE TWENTIETH CENTURY, THE BOUNDARIES OF PHYSICAL VIGOR, RESISTANCE, AND SPEED WERE PUSHED TO UNTHINKABLE LIMITS. SPORTS MEDICINE HAS CONTRIBUTED TO MAKING THE HUMAN MACHINE A HIGHLY PERFECTED MECHANISM THAT RUNS LIKE CLOCKWORK. NUTRITION RESEARCH HAS MADE IT POSSIBLE TO UNDERSTAND HOW TO BALANCE DIETS ACCORDING TO THE REQUIRED PERFORMANCE. PREVIOUSLY UNEXPLORED TERRITORIES HAVE BEEN ACCESSED BY ADVENTURES IN THE UNKNOWN. THE HIGHEST MOUNTAINS ON THE EARTH HAVE BEEN CLIMBED, THE STEEPEST SLOPES, ENCROACHED. ALL THIS HAS CHANGED THE RELATIONSHIP BETWEEN MAN AND MOUNTAINS. FROM OMNIPOTENT DIVINITIES, RESPONSIBLE FOR IMMENSE HARDSHIPS, MOUNTAINS

INTRODUCTION High-Altitude Sports

HAVE BECOME PLAY COMPANIONS, PROPAGATORS OF EN-TERTAINMENT AND OPPORTUNITIES, AND PLACES WHERE TO SPEND ONE'S FREE TIME. NOT CONSIDERED SPORTS IN A STRICT SENSE, HIKING AND MOUNTAIN-BIKING HAVE ACQUI-RED A SOCIAL VALUE: CONTACT WITH NATURE AND ITS RE-FLECTIVE HEALTH BENEFITS HAVE LED A MASS OF ENTHU-SIASTS TO DON HIKING BOOTS (OR CLIMB INTO A SADDLE) IN ORDER TO ADVENTURE UP THE STEEPEST SLOPES, DOWN LONG PATHS, ALONG CRESTS, AND THROUGH WOODS, DRAWN BY THE DESIRE TO GET INTO THE GAME AND ATTAIN A PANORAMIC VIEWPOINT. IT IS A JOY FOR THE LEGS, LUNGS, AND EYES. AT A HIGHER LEVEL, MOUNTAIN CLIM-BING IS A TRUE SPORT, WITH A DIFFICULTY FACTOR PUSHED AT TIMES TO EXTREME LIMITS. THE PRIZE AT STAKE MIGHT BE

INTRODUCTION High-Altitude Sports

ONE'S LIFE, AND A ROPE CAN, IN A CERTAIN SENSE, TAKE ON ALL THE IMPORTANCE OF LIFE: FRIENDSHIP, COOPERATION, GENEROSITY, BUT ALSO FEAR, EGOISM, AND SELF-GRATIFICATION. FREE CLIMBING POSES FEWER ETHICAL PROBLEMS AND OFFERS LIMITED CHALLENGES: YOU CLIMB, WITHOUT EQUIPMENT, ESSENTIALLY USING YOUR BARE HANDS AND FEET, FIGHTING ONLY AGAINST YOURSELF AND THE FORCE OF GRAVITY. THERE ARE NO WEATHER ISSUES TO TAME OR PREDICT; PURE CHANCE WILL NOT BE KNOCKING AT YOUR DOOR. RELATIONSHIPS WITH MOUNTAINS CHANGE ACCORDING TO SEASON AS DO THE COLORS: FROM GREEN TO WHITE, FROM SUMMER TO WINTER. DOWNHILL SKIING IS SUNDAY'S SOLUTION TO CITY PEOPLE'S LAZINESS. WAKE-UP CALLS AT DAWN, LONG TRIPS, AND LINES AT THE TICKET

INTRODUCTION High-Altitude Sports

BOOTHS AND SKI LIFTS ARE THE INEVITABLE PRICE TO PAY TO ENJOY THE REFLECTION OF THE SUN OFF THE SNOW AND THE SOFT SWISH OF SKIS AGAINST THE WHITE POWDER. IN THE CROSS-COUNTRY VERSION, SKIING MEANS A LONG TRACK EXTENDING INTO THE WOODS, ONE'S BREATH FREEZING ON THE LIPS, A PUMPING HEART, RAYS OF SUNLIGHT FILTERING THROUGH THE TREES, AND THE SATISFACTION OF BEING ABLE TO OVERCOME THE FATIGUE. IN THE EXTREME VERSIONS, TOURING AND SKI MOUNTAINEERING, THE SPORT IS A CONFRONTATION WITH THE ABSOLUTE: DANGER, AN UNAVOIDABLE FACTOR, IS ADDED TO THE REQUIRED MUSCULAR STRENGTH, AND THE CHALLENGE EXISTS IN CONSTANTLY OVERCOMING ONE'S OWN LIMITS.

348-349 ● Scotland - A lone couple of climbers take on the icy conditions of Ben Nevis.

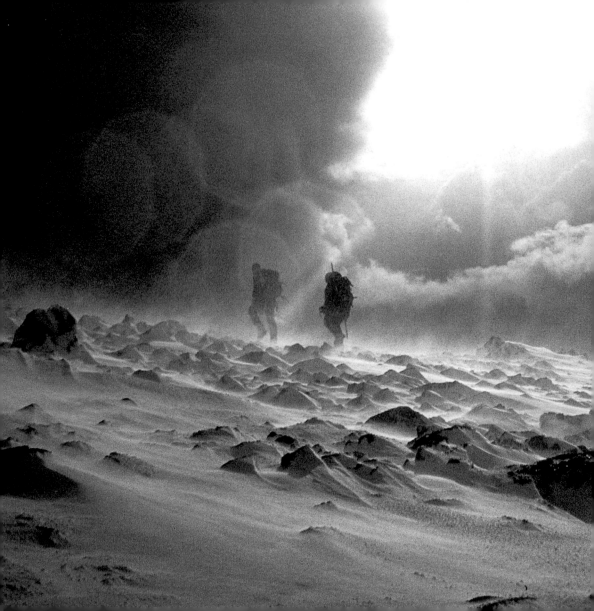

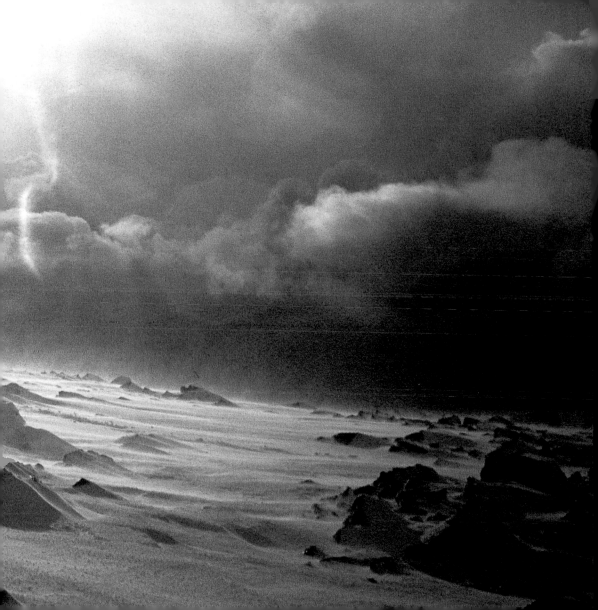

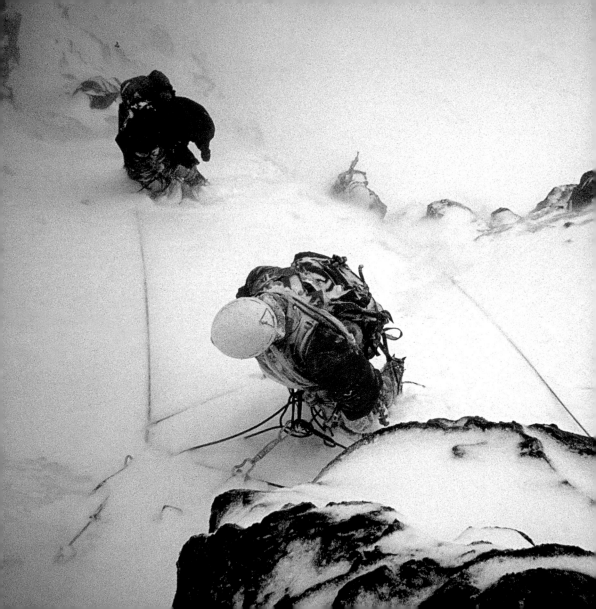

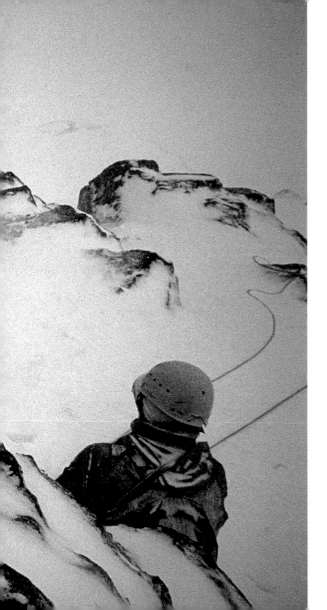

Mountaineering

350-351 • Scotland - A roped party climbs the frozen snow on Ben Nevis with difficulty.

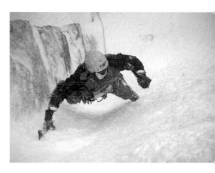

351 • Scotland - A mountaineer works hard on one of the most difficult passages on the North East Buttress on Ben Nevis.

352 ● Upper Savoy (France) - A hiker climbs Aiguille du Midi during an ice storm.

353 ● Upper Savoy (France) - The climber recomposes himself after having climbed Tour Ronde, the steep massif of Mont Blanc.

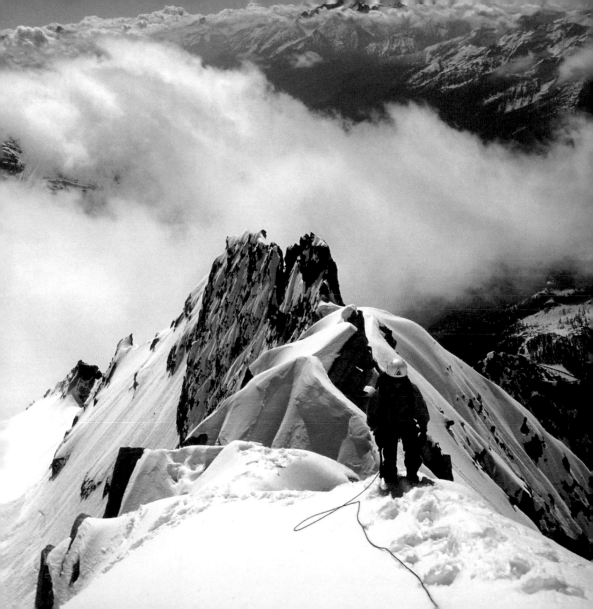

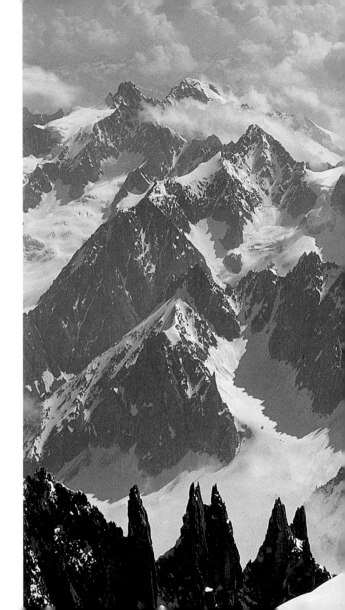

Val d'Aosta (Italy) - Two climbers at high altitude near Mont Blanc.

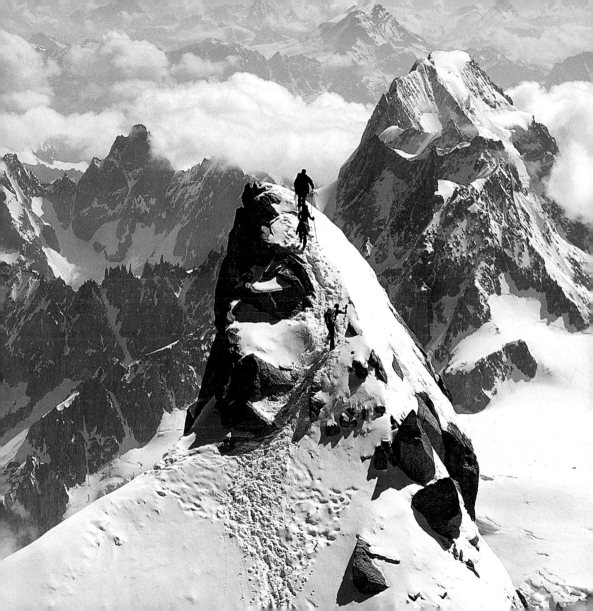

356 • Upper Savoy (France) - A hiking boot has trouble maintaining its grip on the ice.

357 • Upper Savoy (France) - The celestial panorama almost distracts from watching two hikers at high altitude.

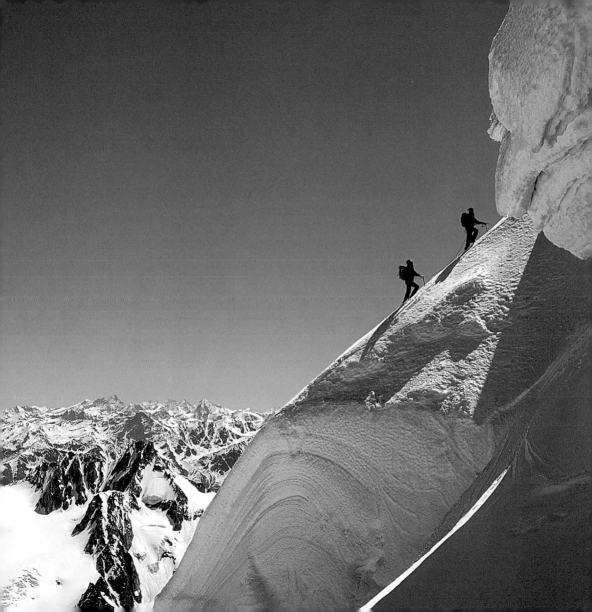

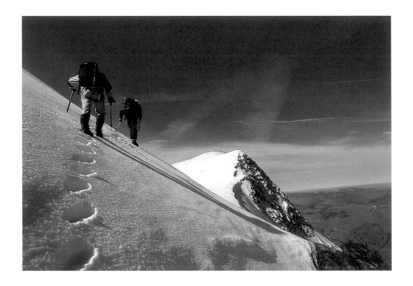

358 • Upper Savoy (France) - The line of tracks from two hikers marks their passage across the Dômes de Miage.

359 • The National Park of the Stelvio (Trentino, Italy) - Three climbers ascend towards the mighty and imposing dome of Ortles (12,812 feet).

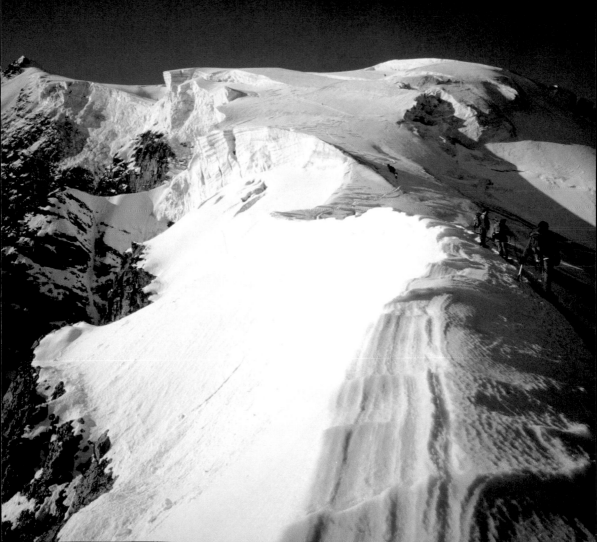

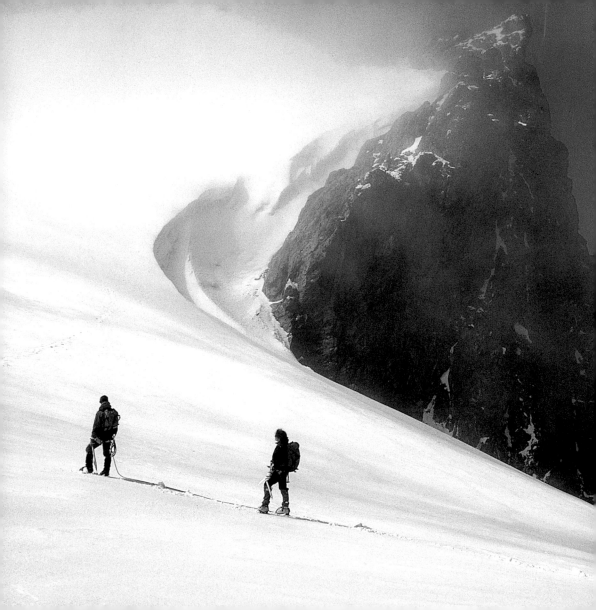

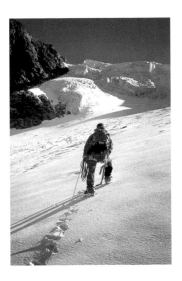

Canada - The adverse weather and the difficulties experienced do not halt the climb of these two mountaineers.

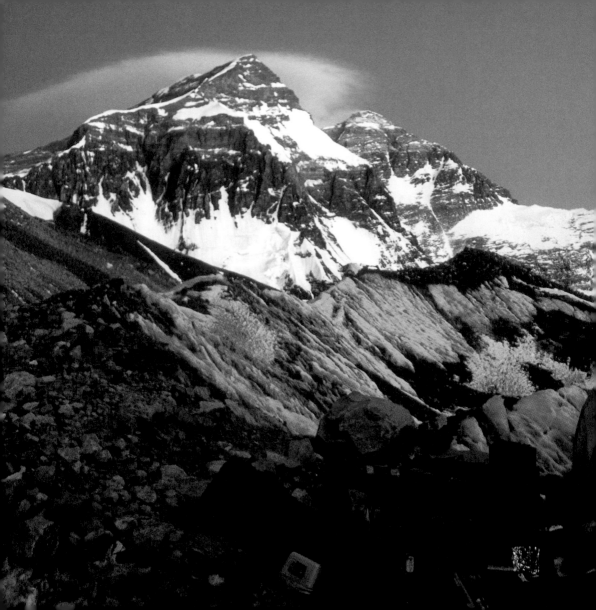

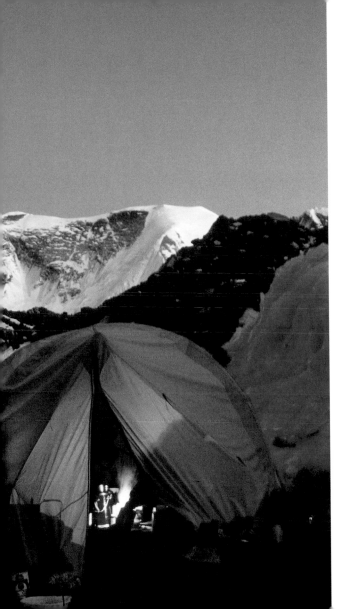

Tibet (China) - A faint lantern and a tent at a base camp near Mount Everest.

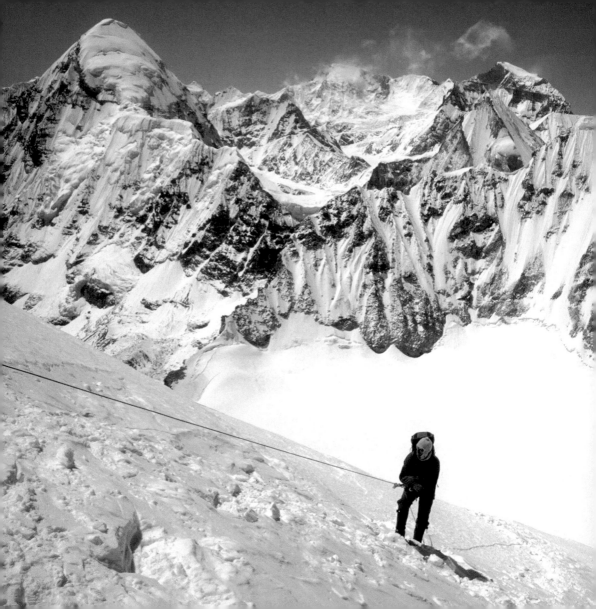

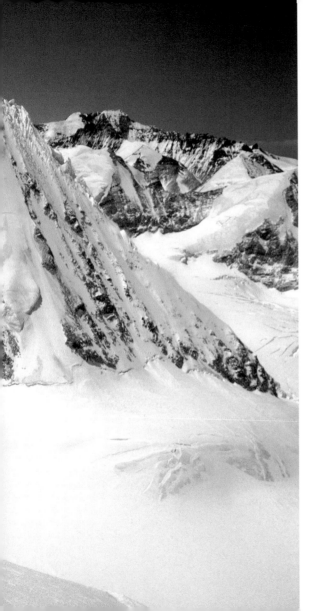

364-365 • Tibet (China) - A climber
is hard at work on a sheer face
on the slopes of Everest.

365 • Tibet (China) - Suspended from
a ladder, the climber defies obstacles
on Everest.

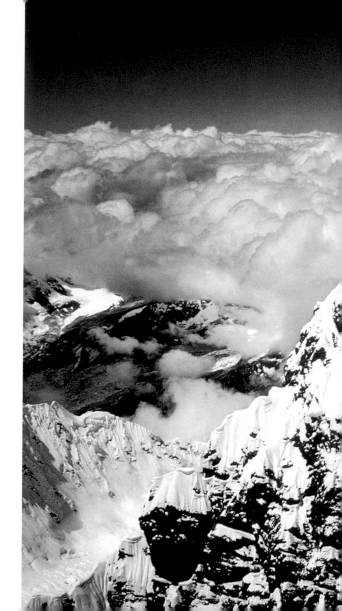

● Tibet (China) -
A climber on a
precipitous slope of
Mount Everest.

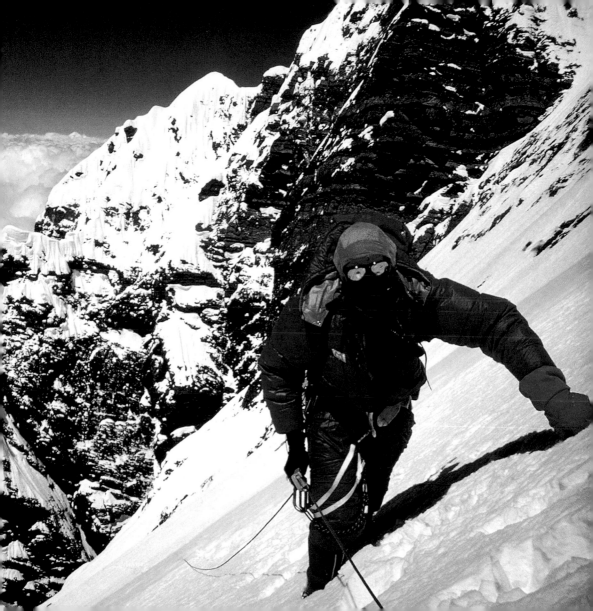

● Tibet (China) - This climber, on Mount Everest, defies a snow storm.
His hiking boots barely manage to grip the ice.

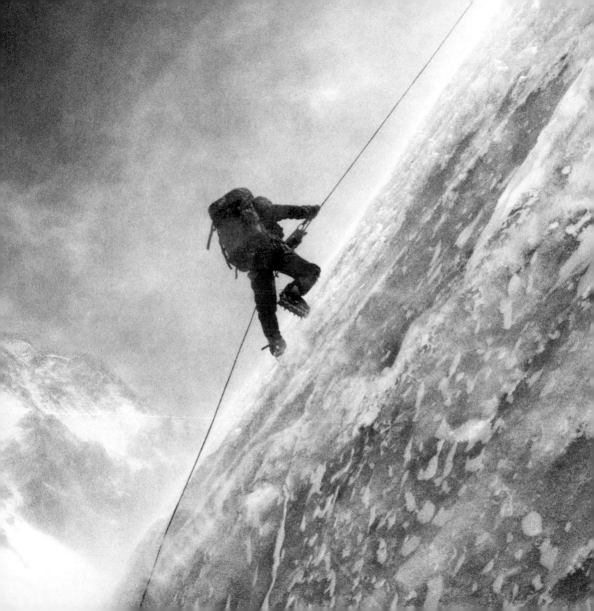

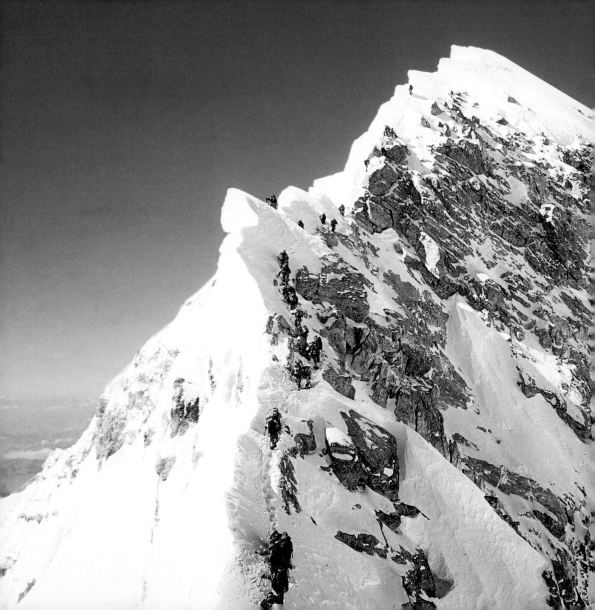

Tibet (China) - In a strict line, mountaineers follow the peak of the Second Step to reach the peak of Everest.

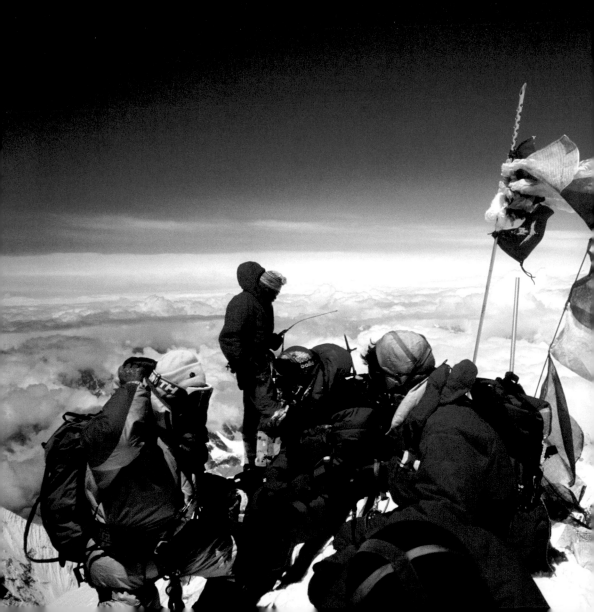

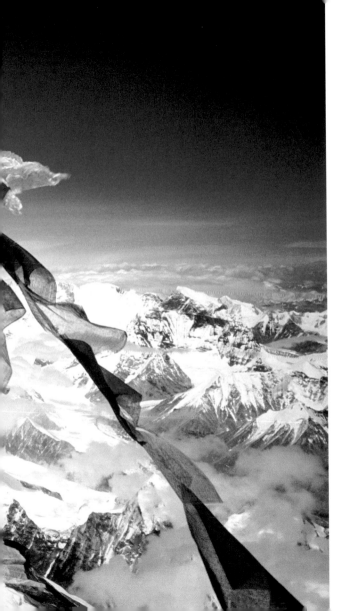

● Tibet (China) -
The panorama that
unfolds before this
group of hikers, at the
top of Everest, has no
equal.

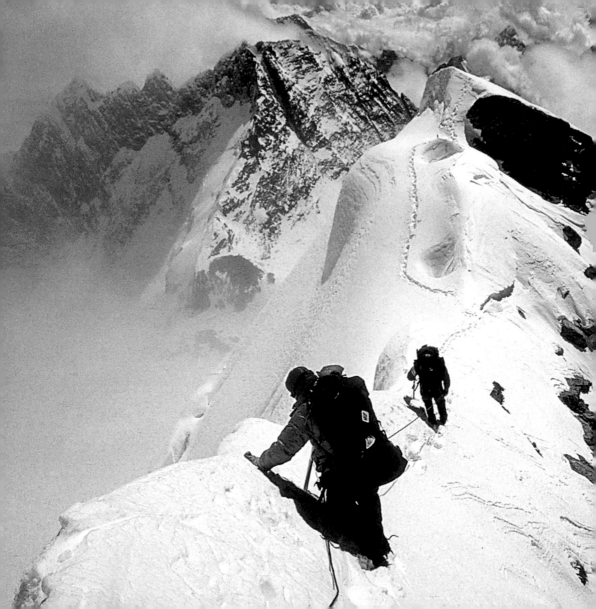

374-375 • Tibet (China) - The top crests of Everest are the most dangerous passages along the climb to the top.

375 • Tibet (China) - The climbing companions follow the tracks of the roped-party leader nearly to the top of Mount Everest.

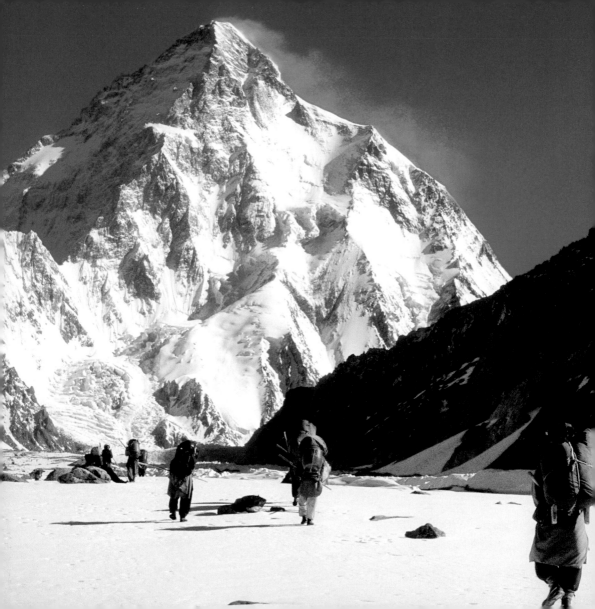

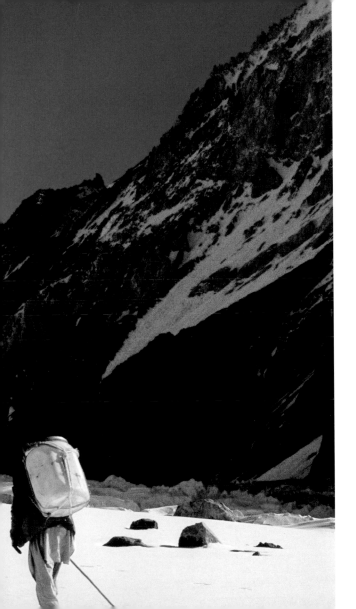

Himalayas (Pakistan) - A group of hikers headed towards K2.

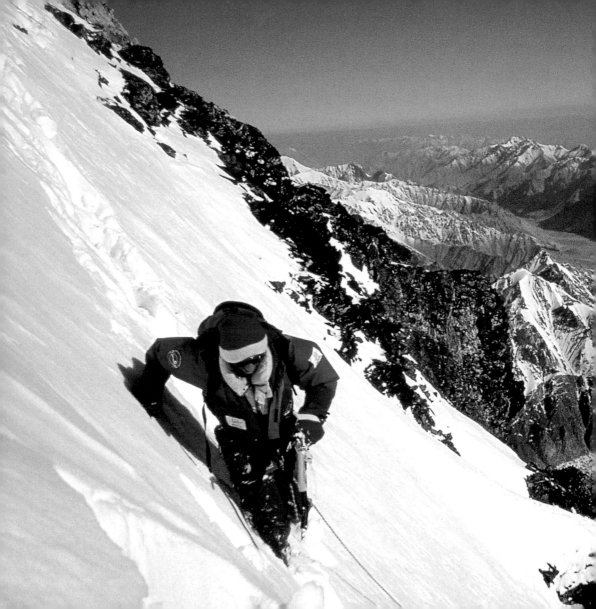

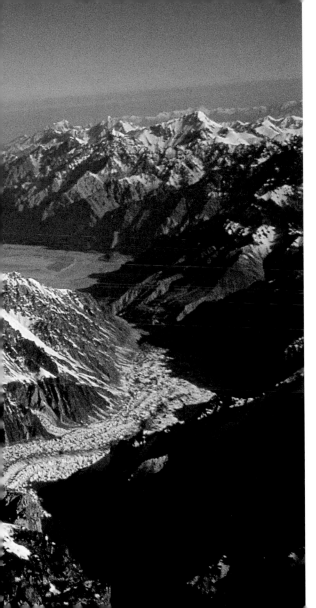

378-379 • Pakistan - This difficult path up the sides of K2 was laid by Frenchmen Pierre Beghin and Christophe Profit.

379 • Pakistan - The steep crossing of the northwest face of K2.

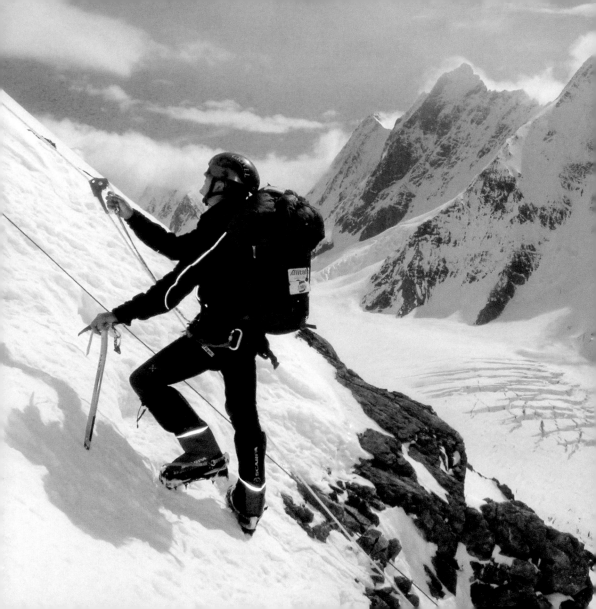

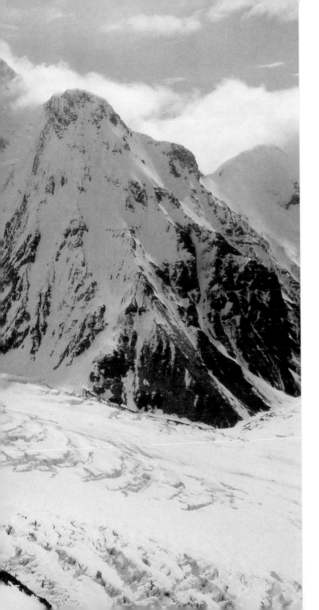

China, Pakistan - In 2004, a group of Italian climbers participated in the expedition to K2 commemorating the 50-year anniversary of the conquest of K2 by Desio, Compagnoni, and Lacedelli.

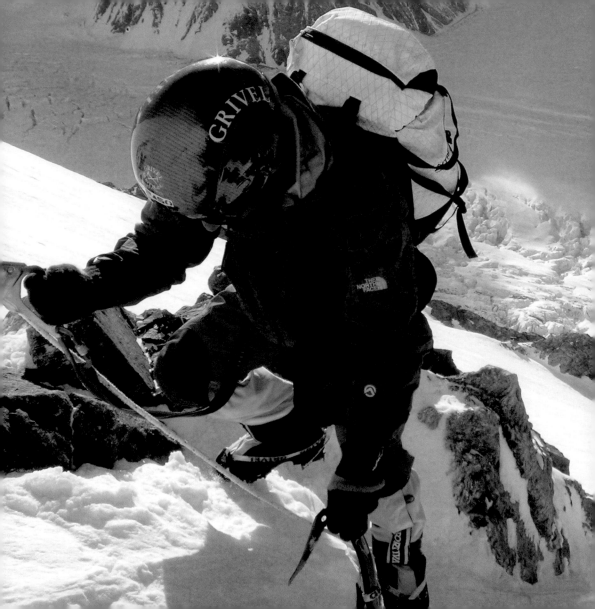

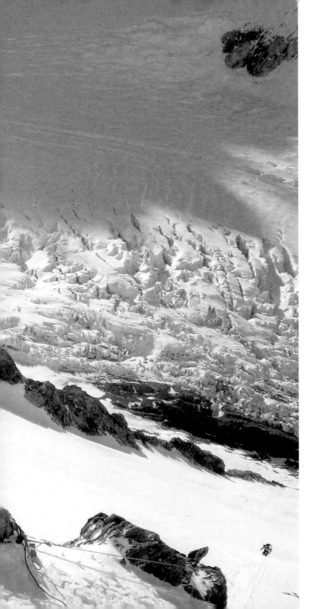

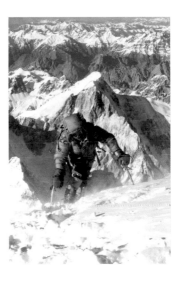

China, Pakistan - "K2 2004: 50 Years Later" wanted to commemorate an exceptional achievement and was crowned with a total success.

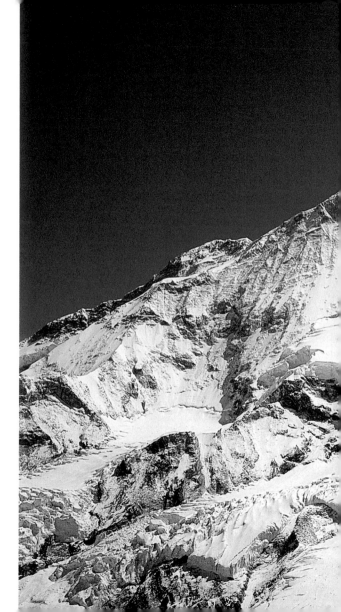

Nepal - The Makalu (27,767 feet) is the fifth tallest mountain in the world and was conquered for the first time by a group of French climbers.

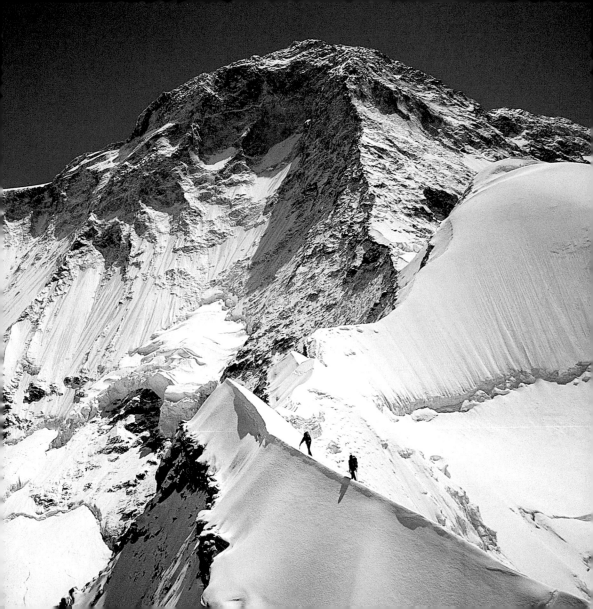

386-387 • Pakistan - Two mountaineers seem to disappear among the ice blocks of the Himalayas.

388-389 • Tibet (China) - Climbers maintain a delicate balance on the peak of Mount Anye Machin.

390-391 • West Coast (New Zealand) - On the Franz Josef Glacier, three sportsmen at high altitude laboriously drag their sleds.

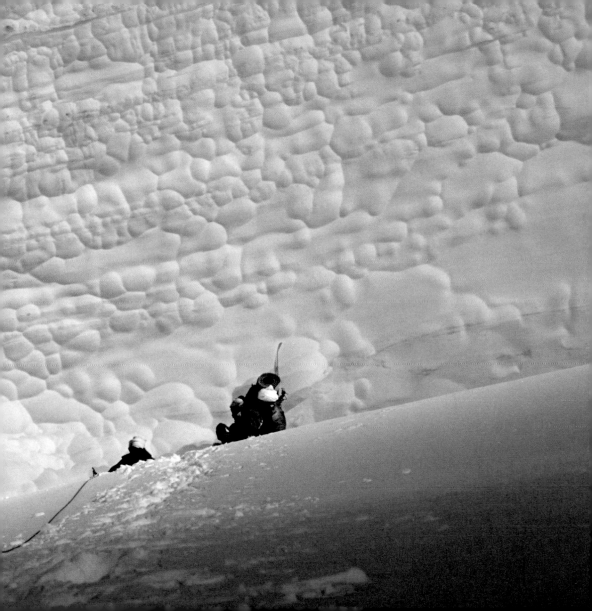

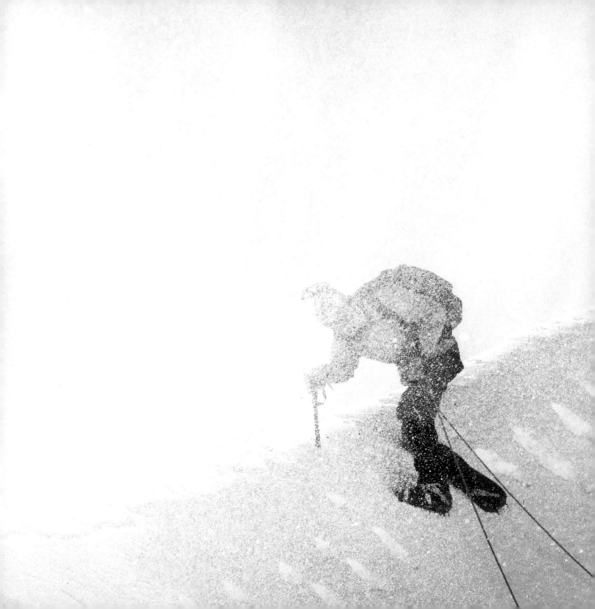

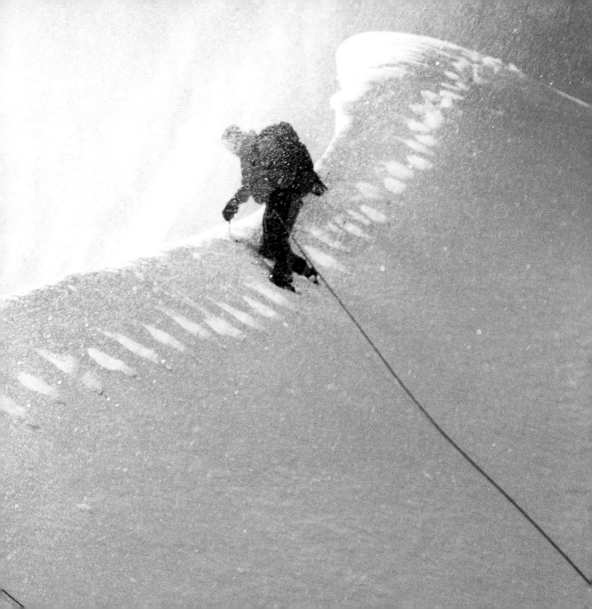

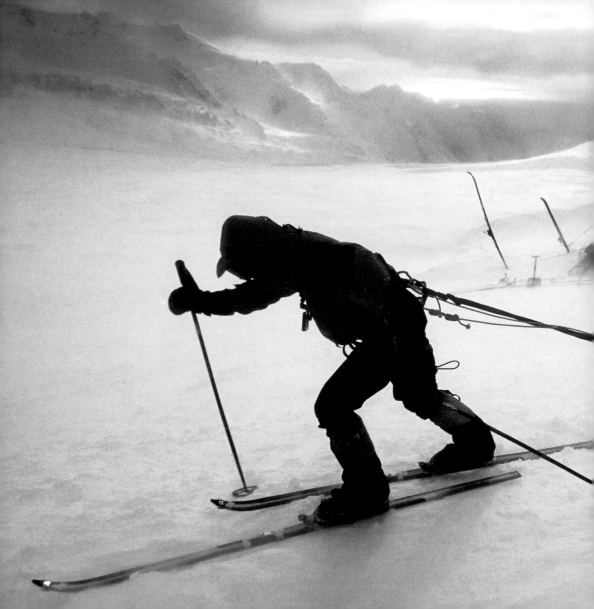

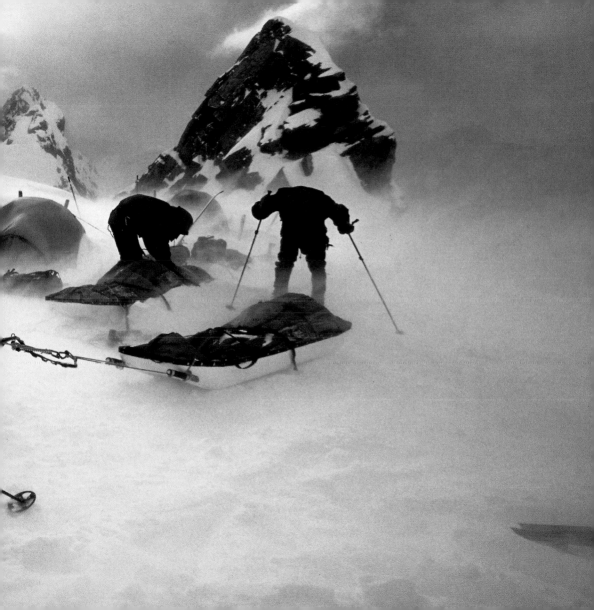

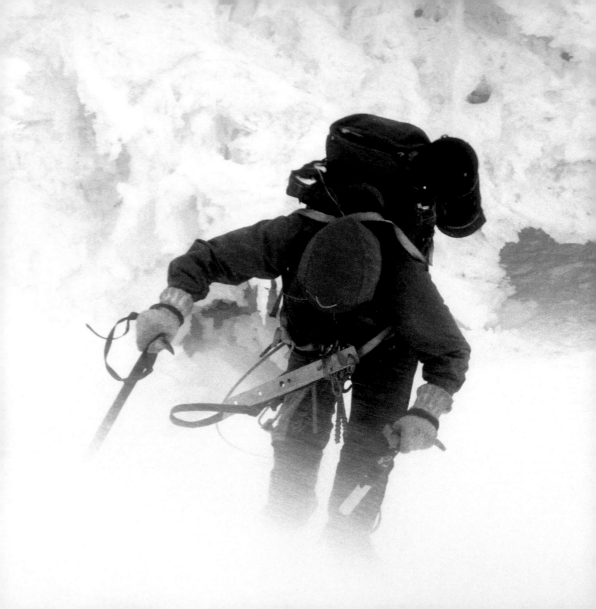

392-393 •
MacKenzie (New Zealand) - Fighting the wind, a climber aims for the peak of Mount Cook.

394-395 •
MacKcnzie (New Zealand) - This woman forcefully crams her pick into the ice on Mount Cook.

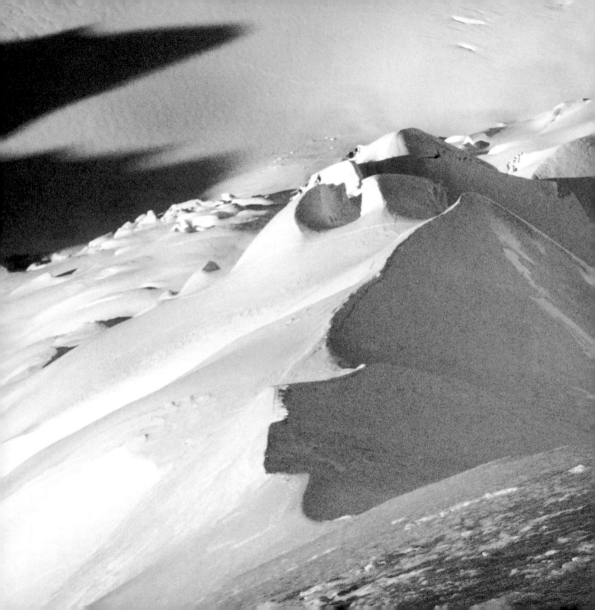

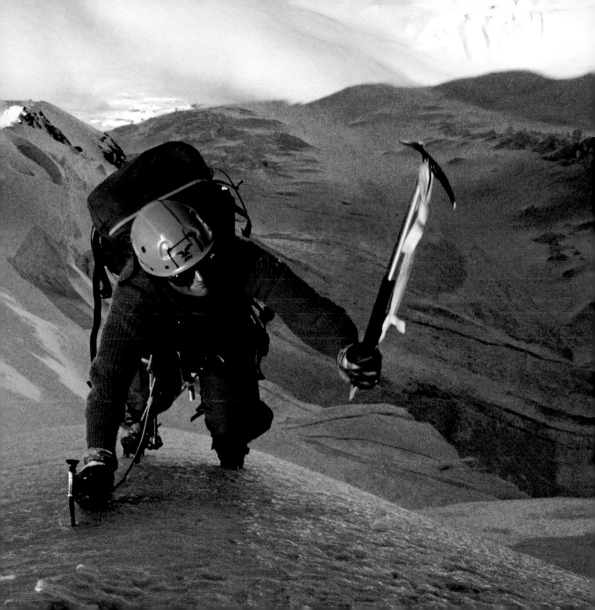

Ice-Climbing

● Veneto (Italy) -
In recent years, climbing
frozen waterfalls has
had a great following.

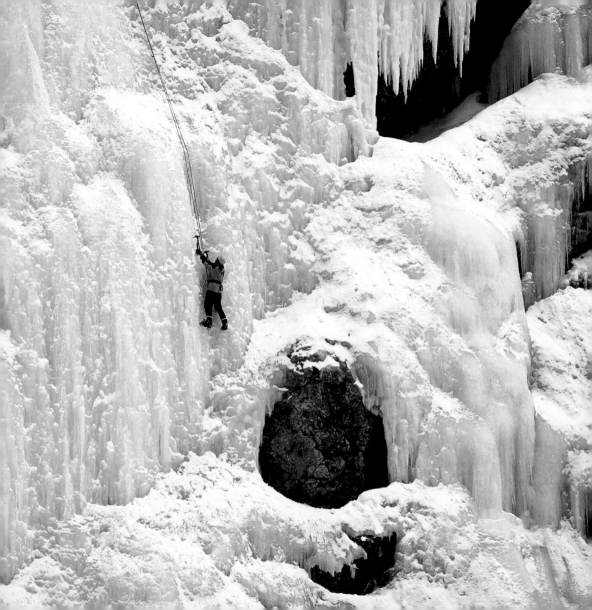

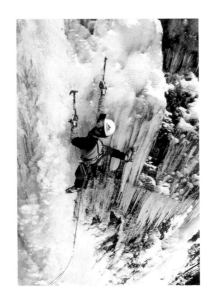

● Upper Savoy (France) - A pair of sharp ice axes and some crampons
on the feet are enough to ensure a climb up these ice floes.

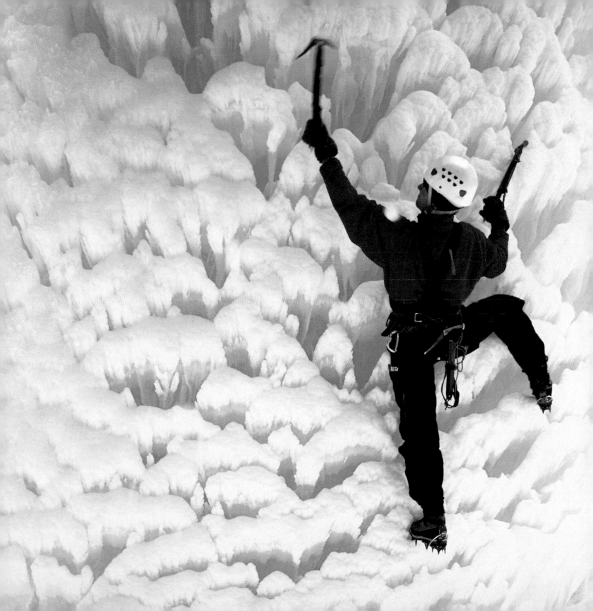

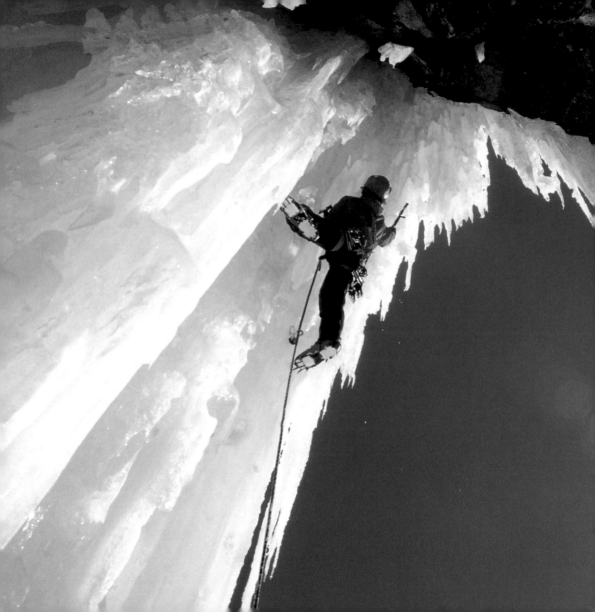

● Upper Savoy (France) - The dizzying spectacle of a sheer, frozen mountain face towers before a climber.

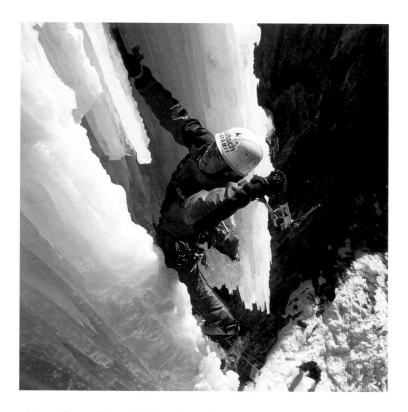

• Upper Savoy (France) - The strength, momentum, and passion of these climbers is expressed by these shots.

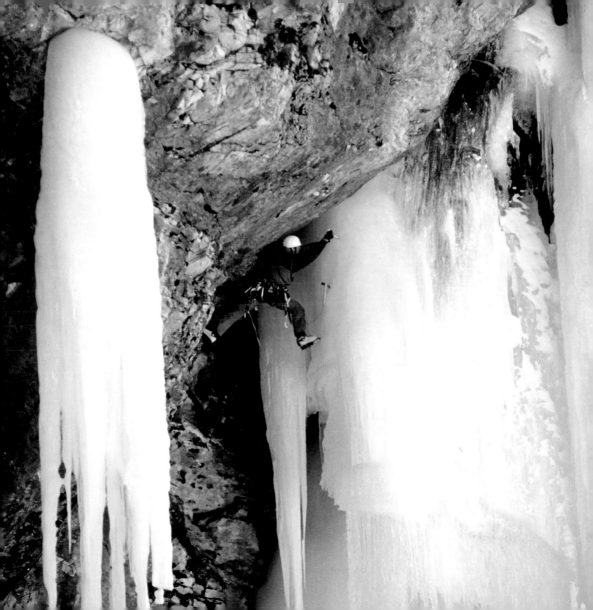

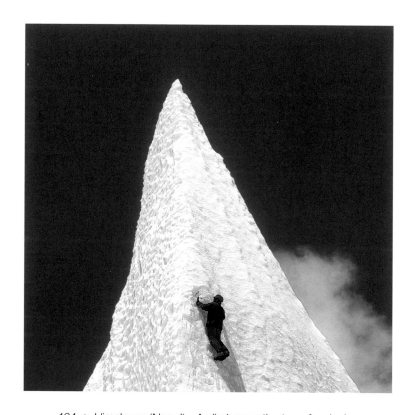

404 • Himalayas (Nepal) - A climber on the top of a glacier.

405 • Trentino (Italy) - In ice, the claw-like ice axes act as supports for climbers.

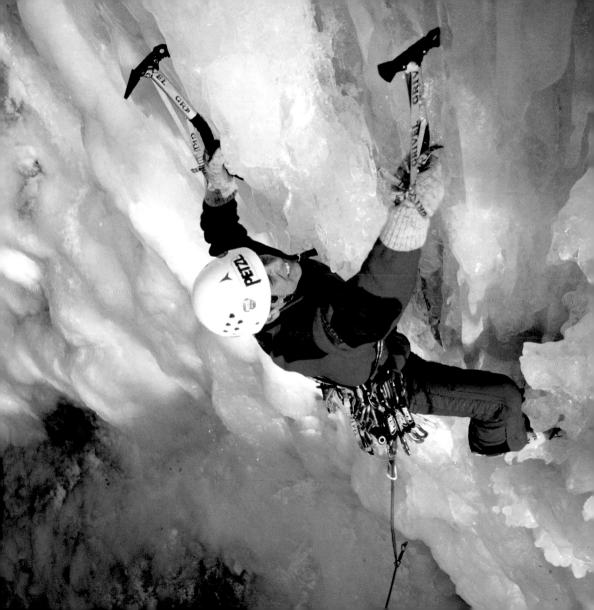

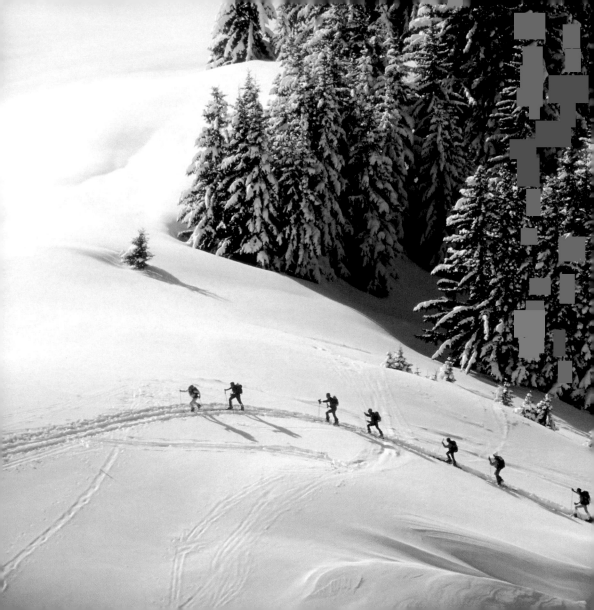

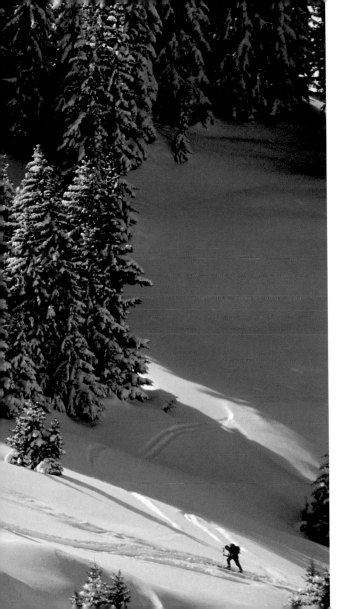

Mountaineering skiing

406-407 • Upper Savoy (France) - A group that goes touring hikes up a slope. When it is particularly steep, they use crampons.

408-409 • Upper Savoy (France) - Two mountaineer skiers go touring at the top of Tardevant.

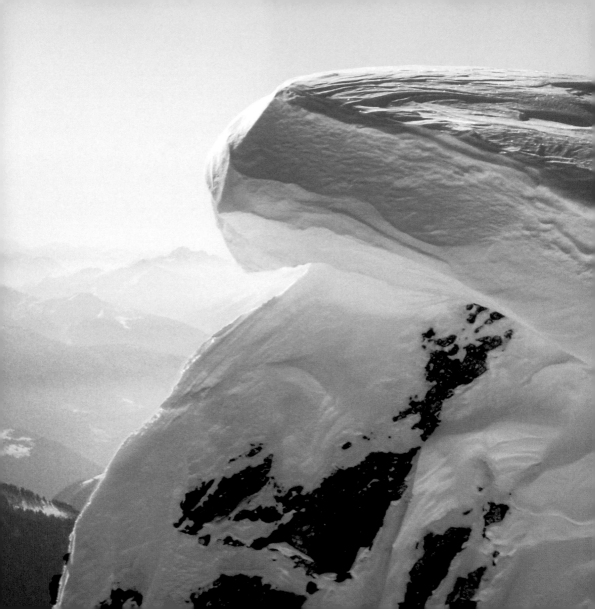

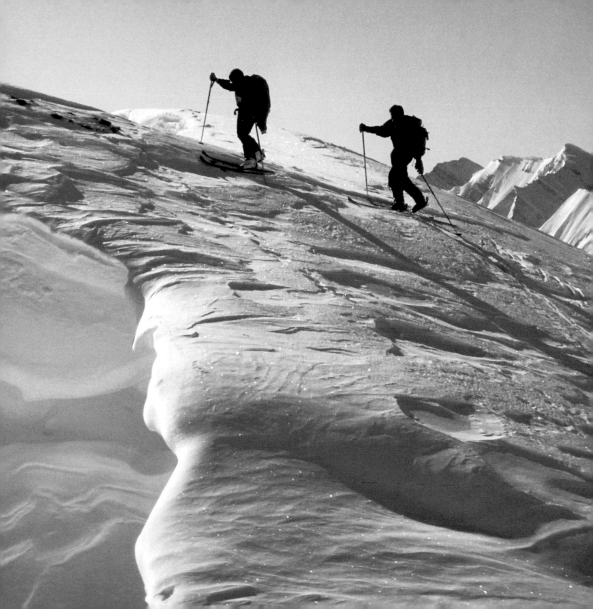

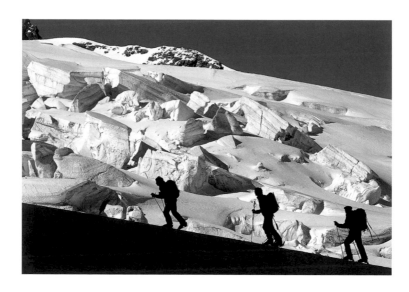

410 • Italy - The white and sky-blue backdrop emphasizes the outline of a group of mountaineer skiers.

411 • Upper Savoy (France) - Four mountaineer skiers climb the Alp d'Huez.

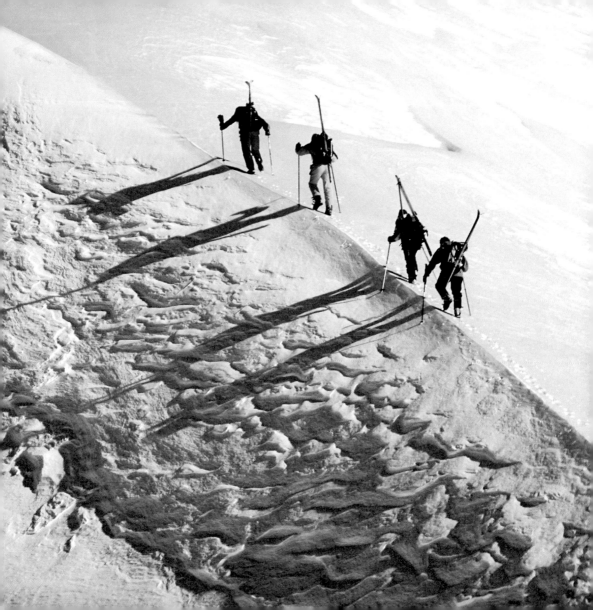

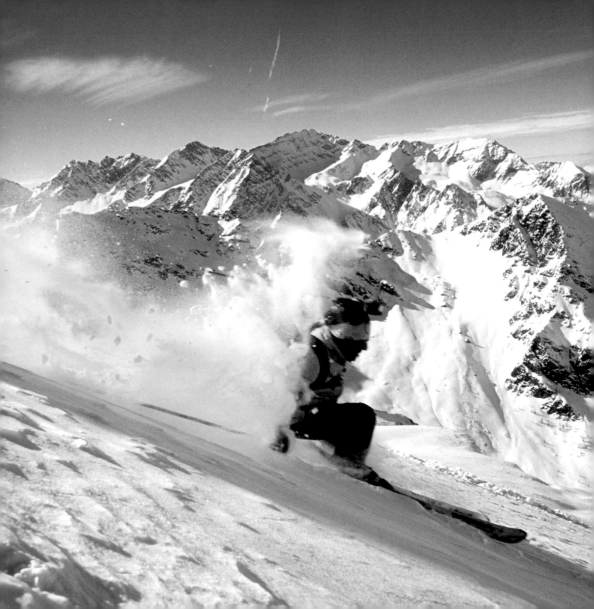

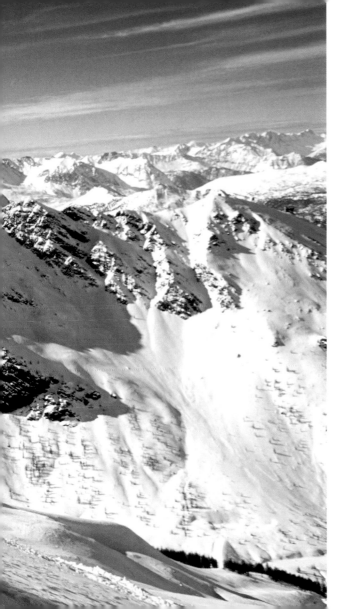

Off-trail skiing

- Piedmont (Italy) - The French Alps make a great setting for this sportsman.

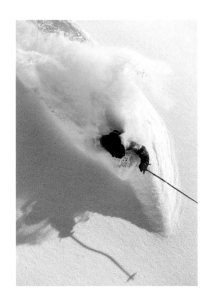

414 • Utah (USA) - A skier on fresh snow.

415 • Alaska (USA) - The fast descent of a snowboarder.

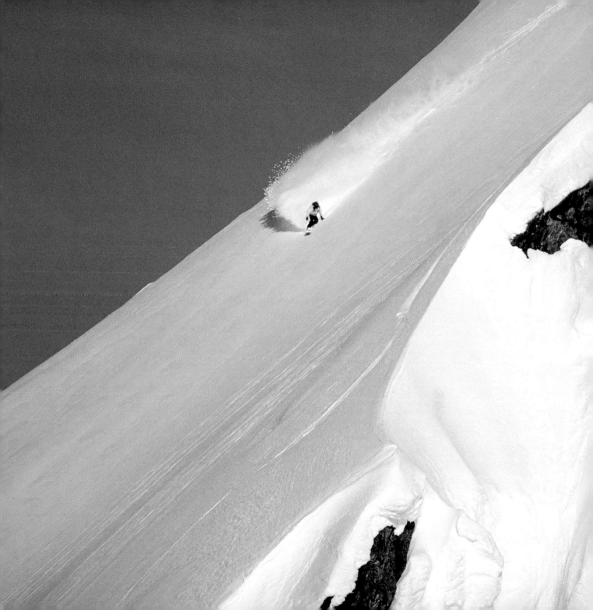

- Upper Savoy (France) - Off-trail skiing in Vallée Blanche is a breathtaking spectacle.

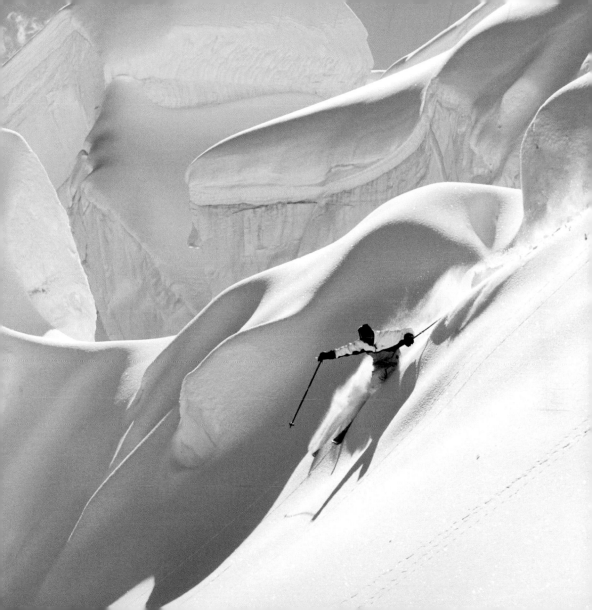

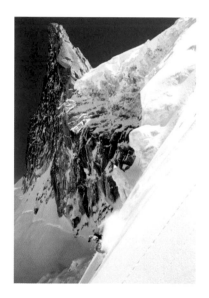

● Upper Savoy (France) - Vallée Blanche is one of the longest off-trail slopes.

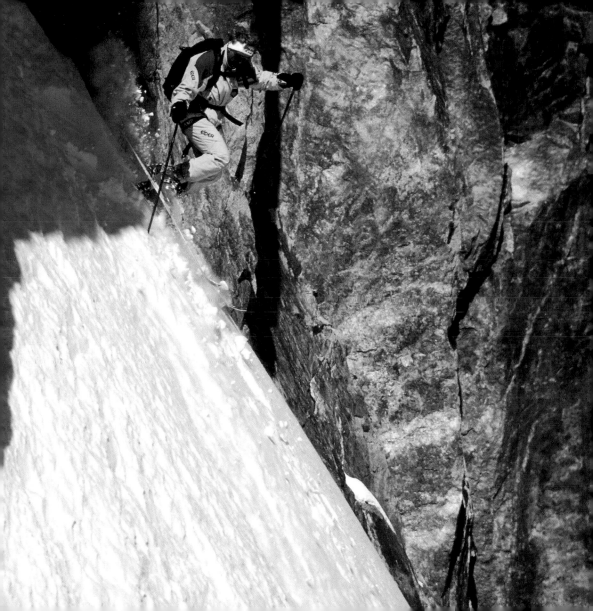

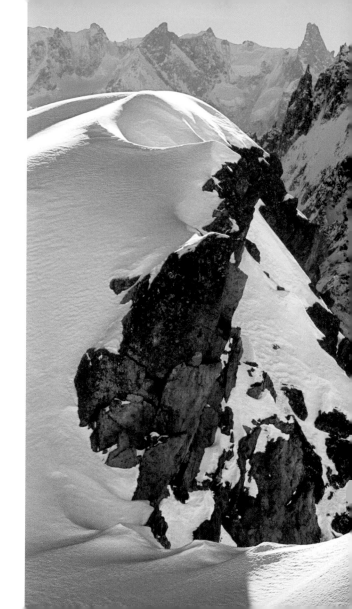

Upper Savoy (France)
- The Flegere, one of
the prettiest off-trail
sites in the French Alps.

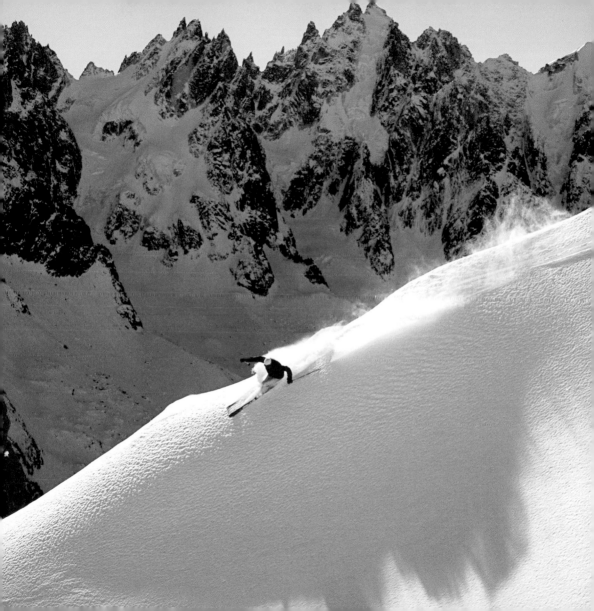

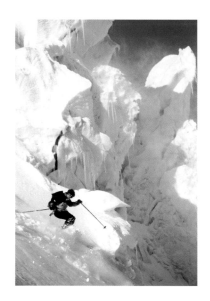

• Utah (USA) - The fresh snow seems to bend around this fearless skier.

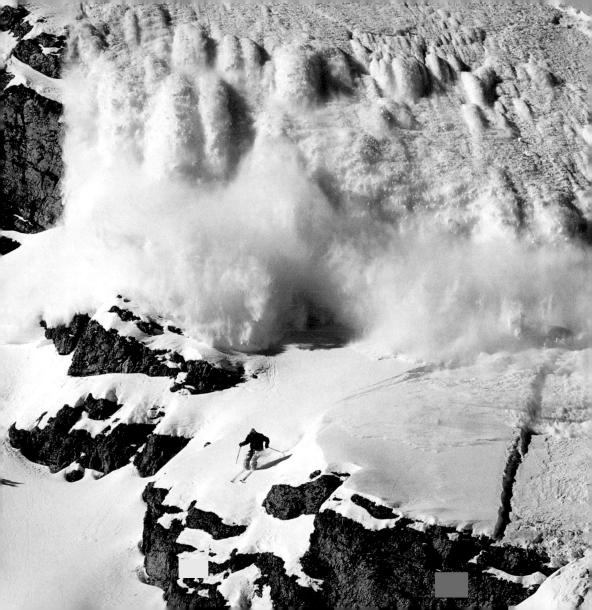

Valais (Switzerland) - Working hard on an off-trail descent, the skier seems to sink into a cloud of snow.

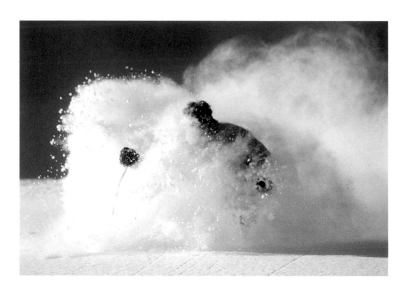

Valais (Switzerland) - Good skiers know how to "float" on fresh snow.

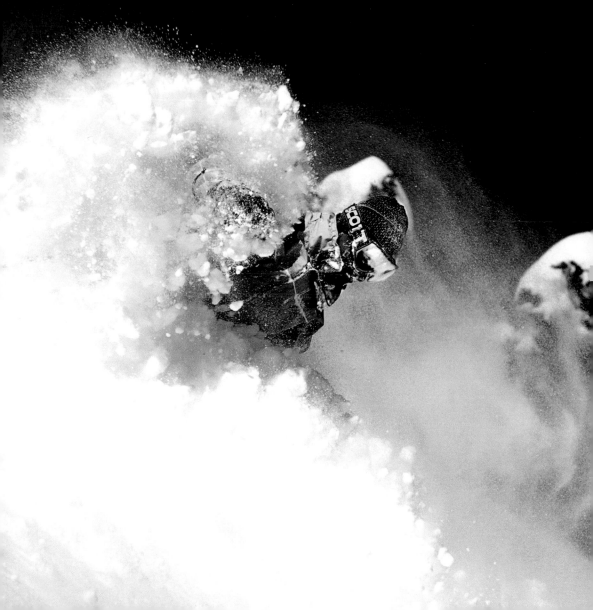

Freestyle

Styria (Austria) -
Three extreme skiers
measure their strength
in free-riding.

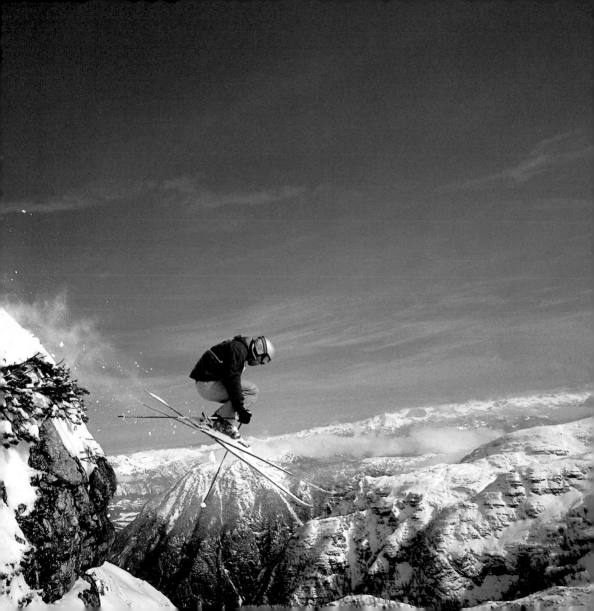

430 • Valais (Switzerland) -
A spectacular jump in the Verbier area.

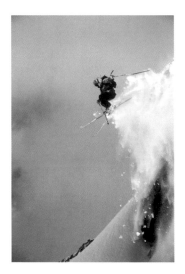

430-431 • Washington (USA) -
A fearless skier jumps from the cliff of
Alpental, in King County.

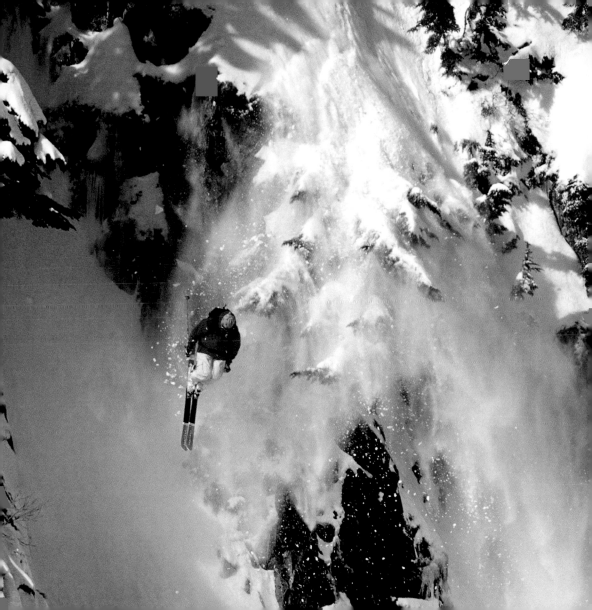

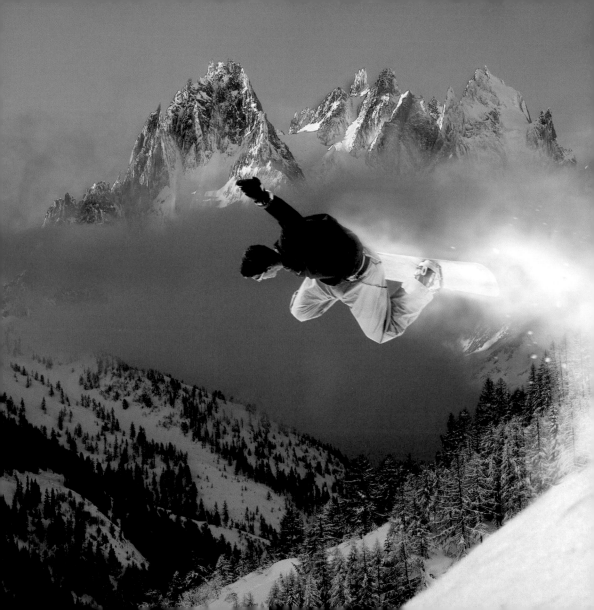

Snowboard

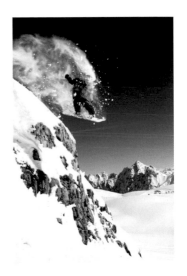

432-433 ● Upper Savoy (France) - A risky snowboard jump off Aiguille Verte, on Mont Blanc.

433 ● Upper Savoy (France) - Enveloped by a cloud of snow, the snowboarder seems to fly.

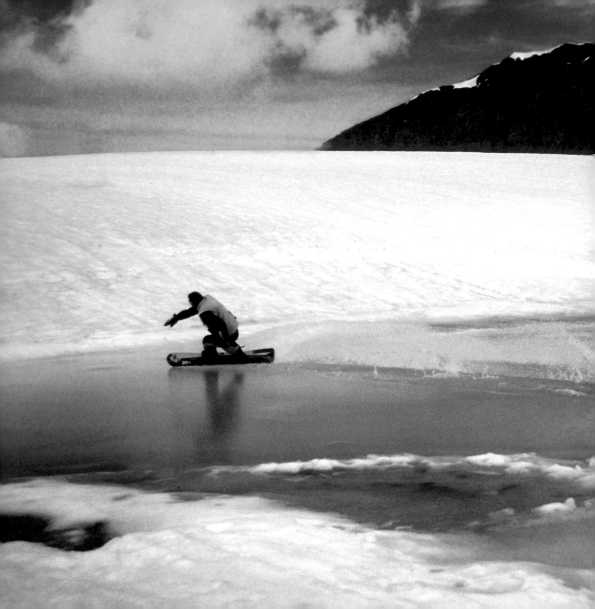

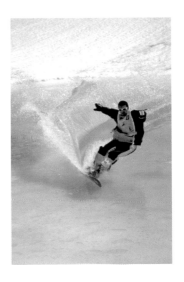

434-435 and 435 • Upper Savoy (France) - A brave show of skill by a snowboarder in Val d'Isère.

436-437 • Chamonix (France) - A snowboarder busy descending the Grands Montets.

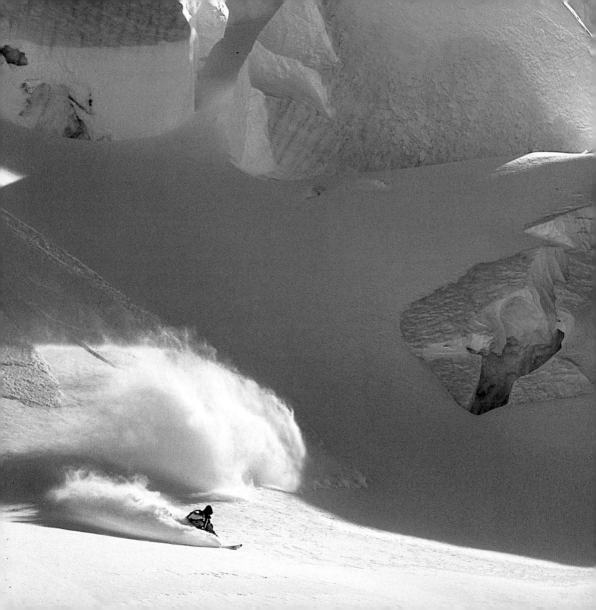

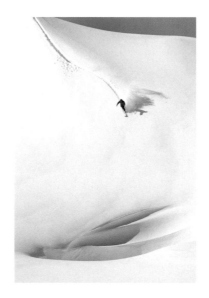

438 • Upper Savoy (France) - This snowboarder paints his trajectory on the fresh snow, like a kind of "dune."

439 • Upper Savoy (France) - Freestyle descent on snowboards for two friends.

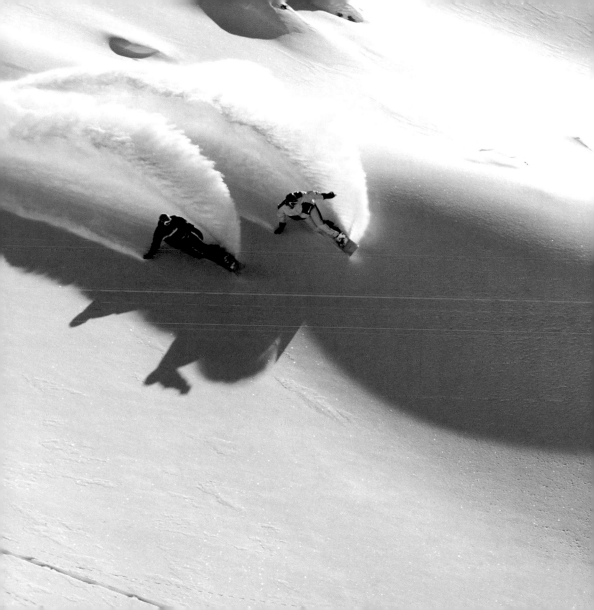

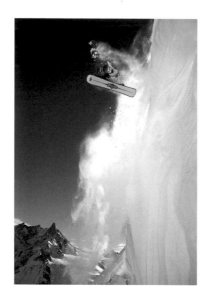

440 • Upper Savoy (France) - A jump with a snowboard from a serac near the Giant's Tooth (Dent du Geant) on Mont Blanc.

441 • Styria (Austria) - A snowboarder's jump from a cliff near Sankt Anton.

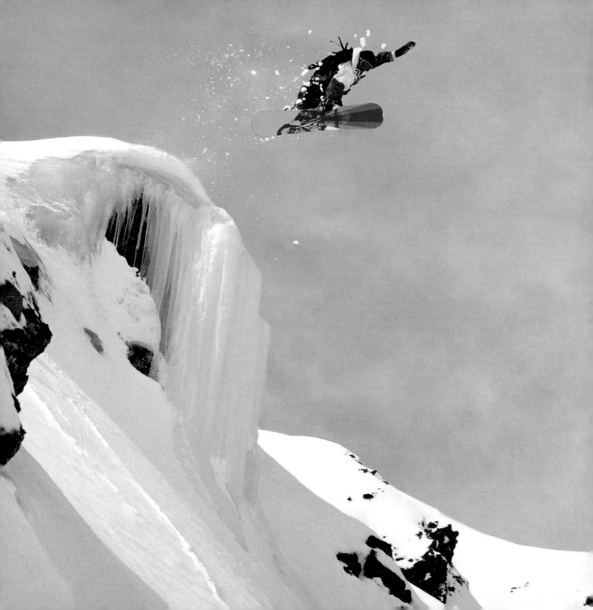

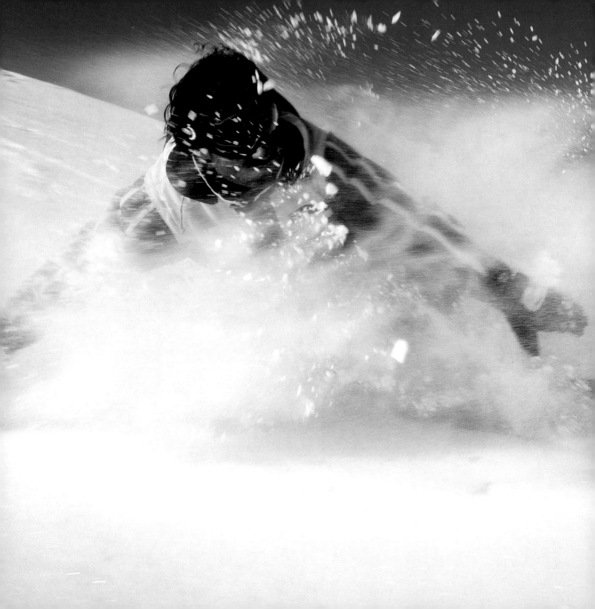

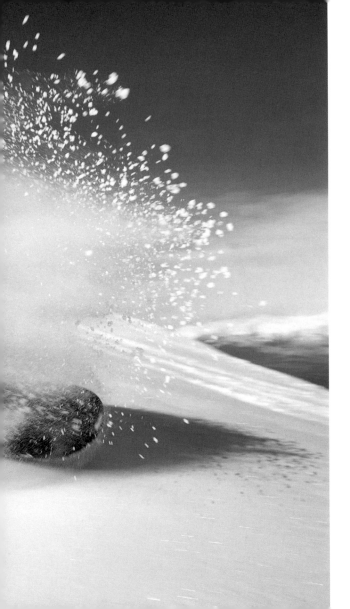

● Styria (Austria) -
Surrounded by a
blanket of snow, a
snowboarder goes
downhill fast.

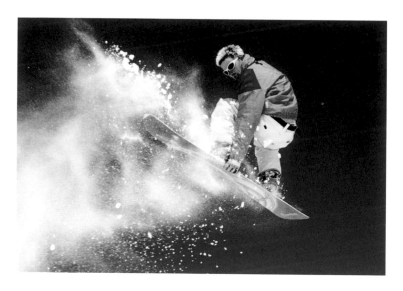

444 • Upper Savoy (France) - Jumping with a snowboard demonstrated by a true professional.

445 • Valais (Switzerland) - A pirouette in the snow.

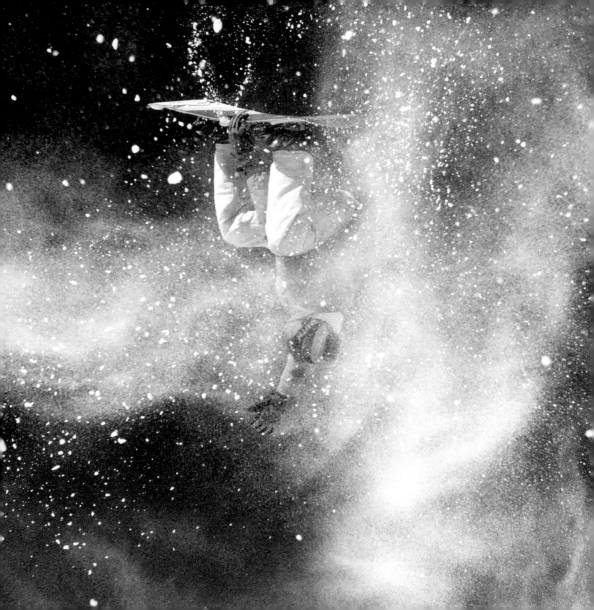

Cross-country skiing and snow-shoes

- Upper Savoy (France) - A woman that goes touring with a pack on her back and snowshoes crosses Vercors, in Val d'Isère.

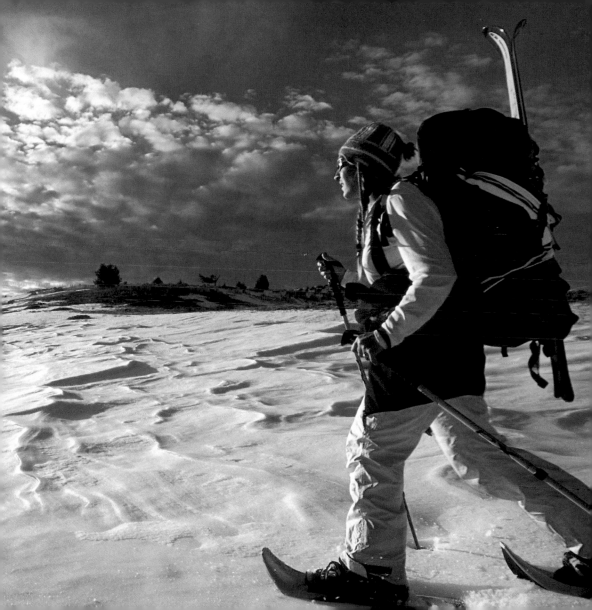

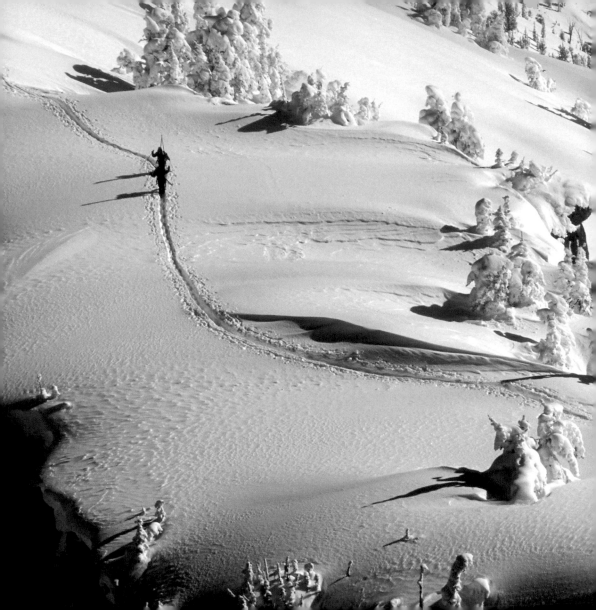

448-449 • Wyoming (USA) - A tough descent with snowshoes does not distract from the magical landscape of Grand Targhee.

450-451 • Alaska (USA) - A skillful skier prepares to pass through this gorgeous snowy forest.

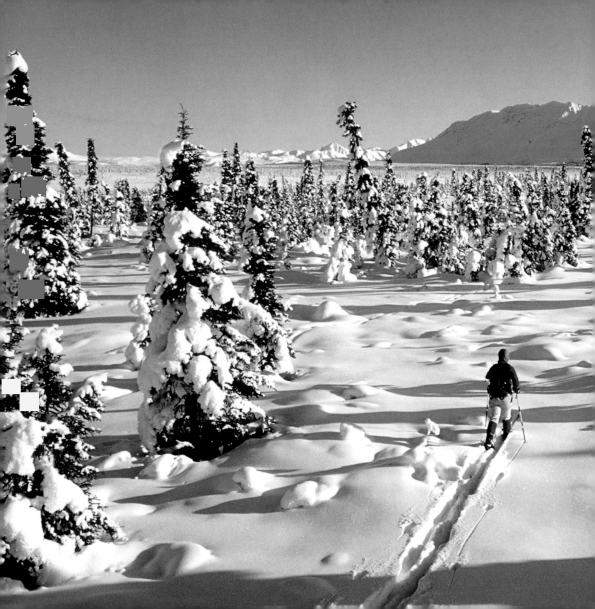

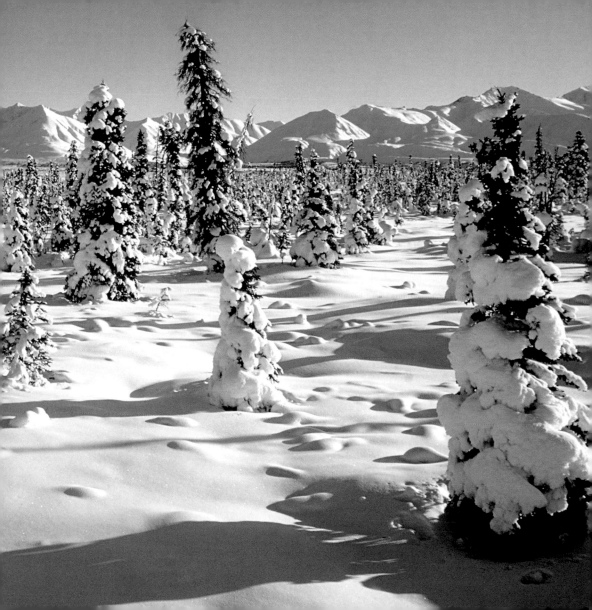

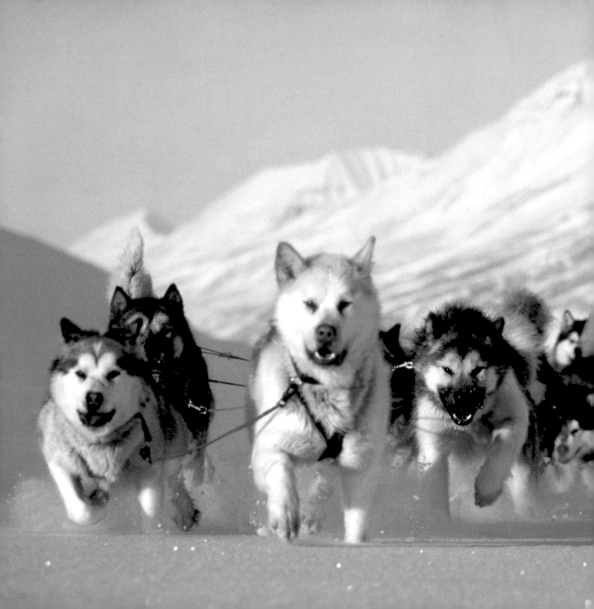

Sleds

452-453 ● Svalbard (Norway) - The strength of a group of dogs is apparent as they pull a sled and defy the cold and snow.

454-455 ● Svalbard (Norway) - Dogs pull a sled through the Norwegian Mountains.

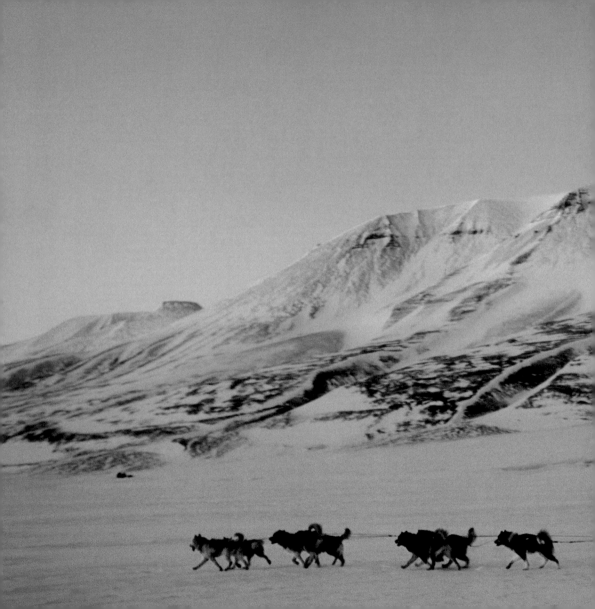

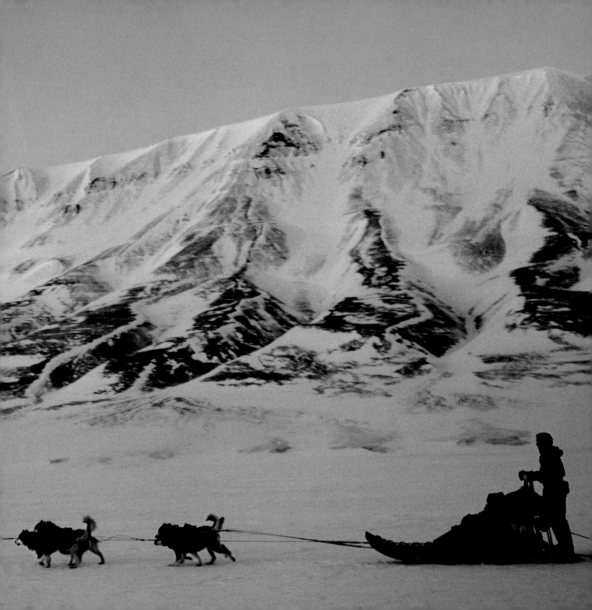

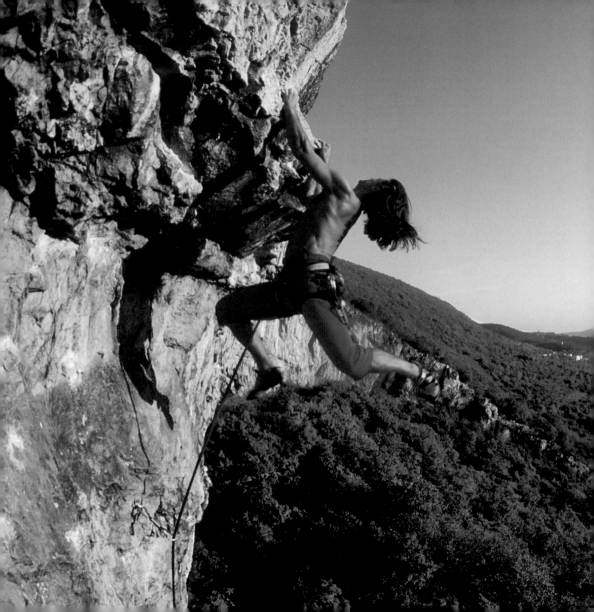

Free-climbing

- Slovenia - Tense muscles and concentration are indispensable to overcoming this difficult passage.

458 • Upper Savoy (France) - A climber seems to effortlessly climb up "Supreseme Calvaire 7b" at La Balme de Silligy.

459 • California (USA) - A free-climber hauls himself up a sheer cliff next to Yosemite Falls, in Yosemite National Park.

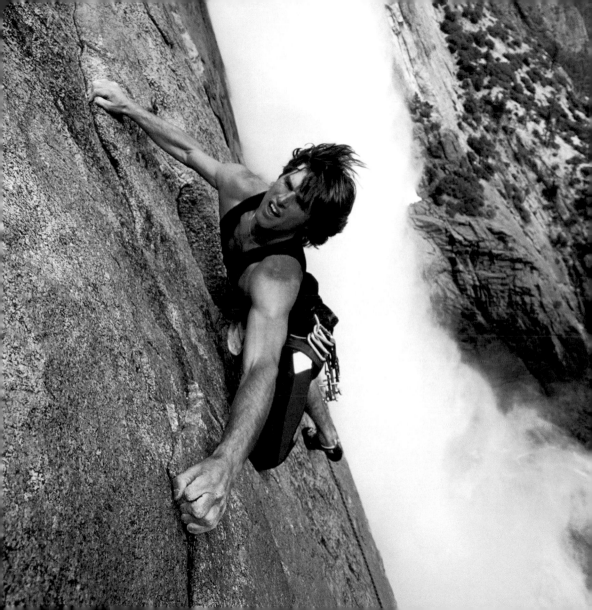

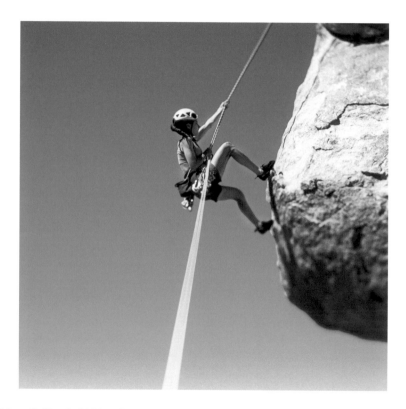

460 • California (USA) - Only courage and hard training can make this girl an expert free climber.

461 • Corsica (France) - Wind erosion on this rock wall at Roccapina seems to make climbing it easier.

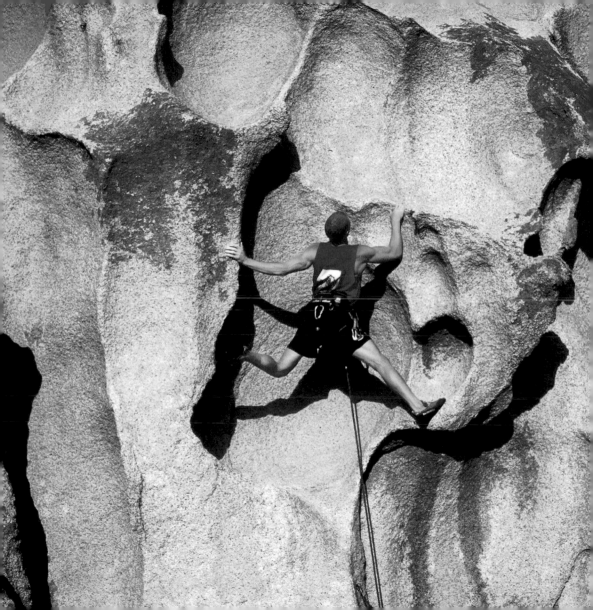

● Australia - A climber considers his next move on a wall in Simpson Desert.

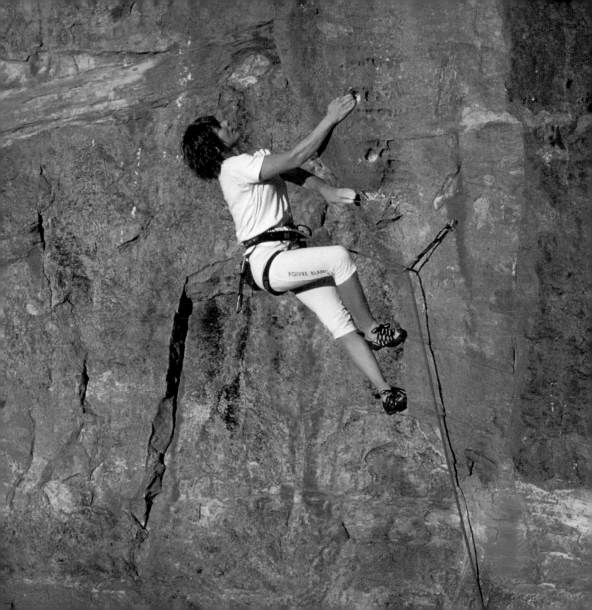

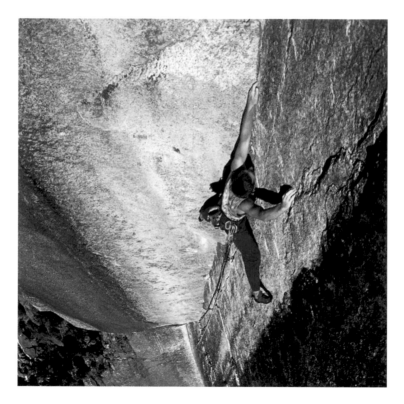

464 • Australia - A climber making a move on a wall in Mount Buffalo National Park.

465 • Australia - Free climbing at the limits of human endurance in Mount Arapiles State Park.

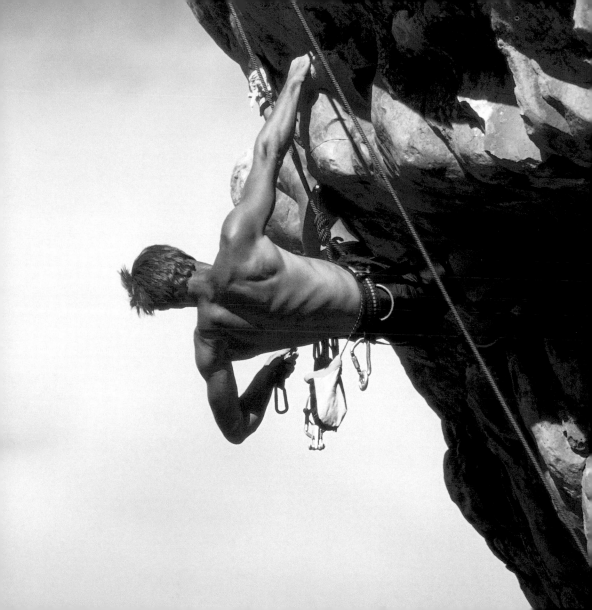

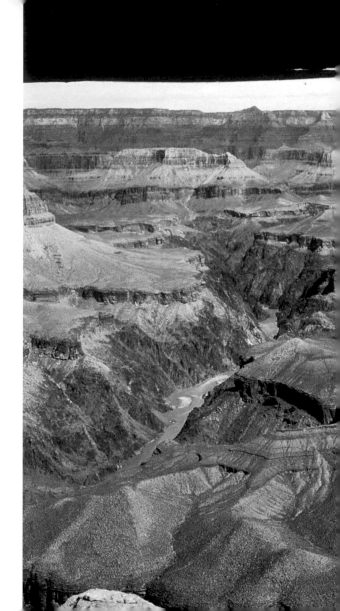

Arizona (USA) -
A skilled rock-climber
gripping the rocks in the
Grand Canyon.

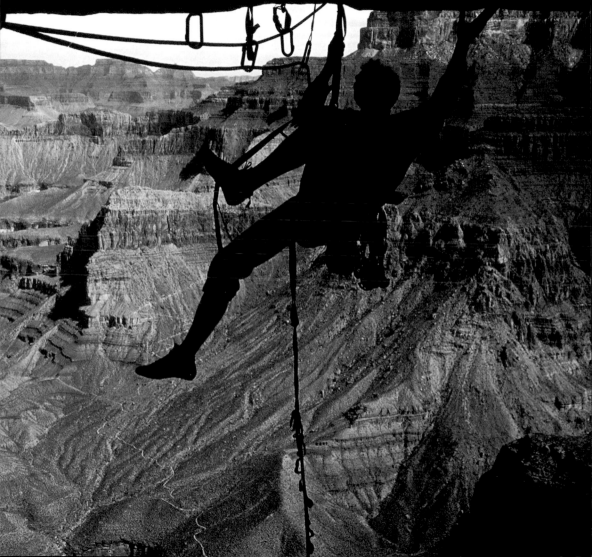

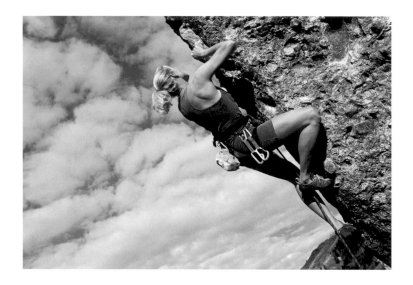

468 • California (USA) - Important for climbers is to choose good cliffs on which to put their bravery into practice.

469 • Australia - The skill and daring of a climber suspended in the void are tested in this passage.

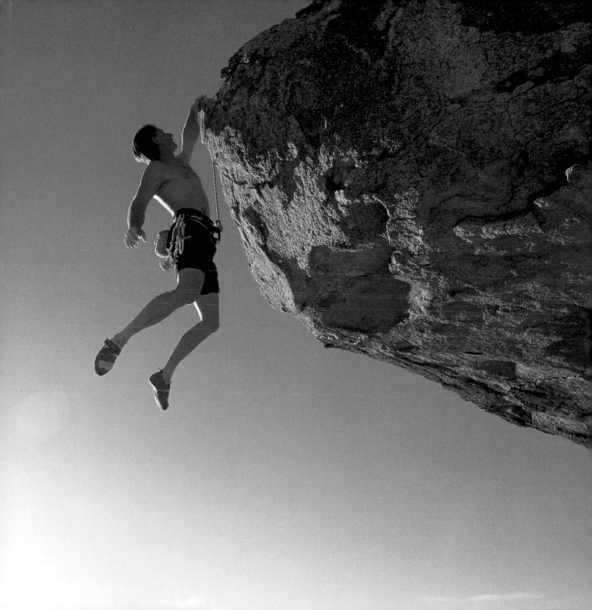

California (USA) - This athlete performs a "Tyrolese cross" between two sides of Basin Mountain in the Eastern Sierra Nevada Range.

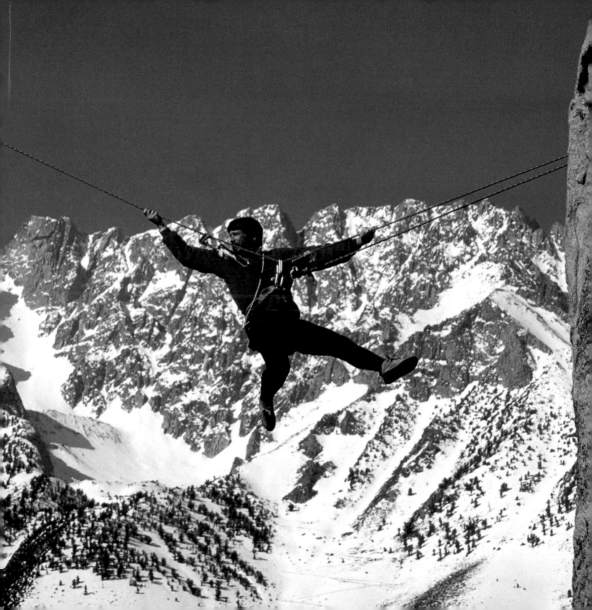

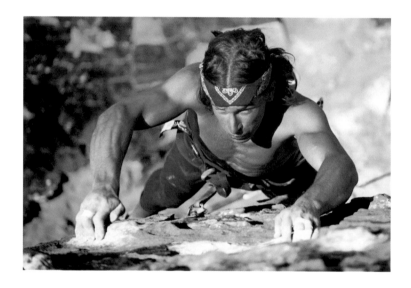

472 • California (USA) - The objective of free-climbers is to overcome increasingly difficult routes up rocks without the aid of any artificial means.

473 • Australia - Free-climbing can be a fascinating and athletic vertical dance, extreme and immaculate.

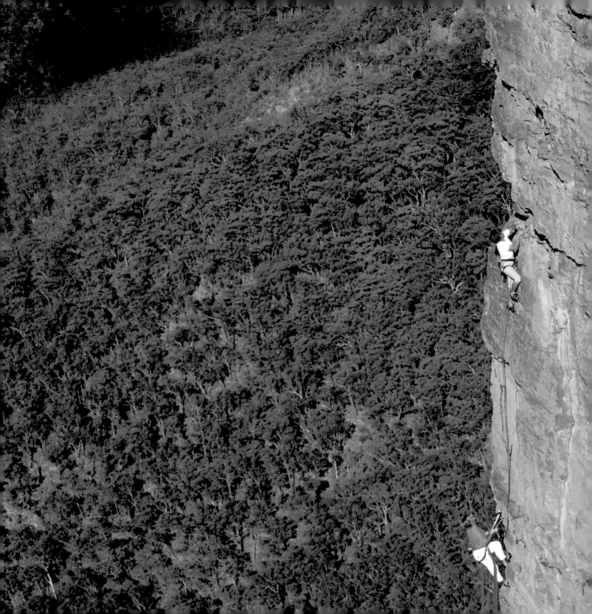

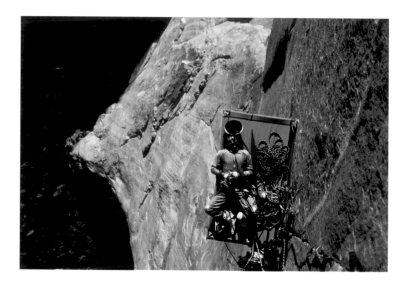

474 • California (USA) - A moment of rest for this climber on El Capitan in Yosemite.

475 • California (USA) - This climber admires the panorama from "The Prow" in Yosemite.

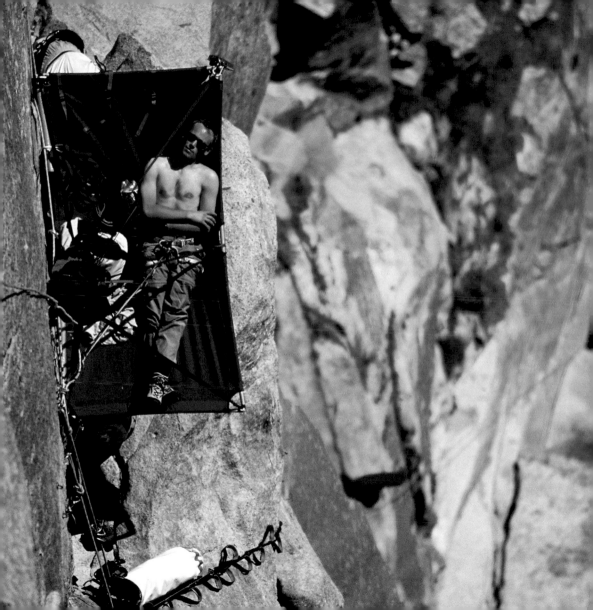

Hiking

476-477 ● Upper Savoy (France) - On a hike, a splendid view of the Matterhorn opens before two trekkers.

478-479 ● Upper Savoy (France) - A foot path on Aiguille Rouge.

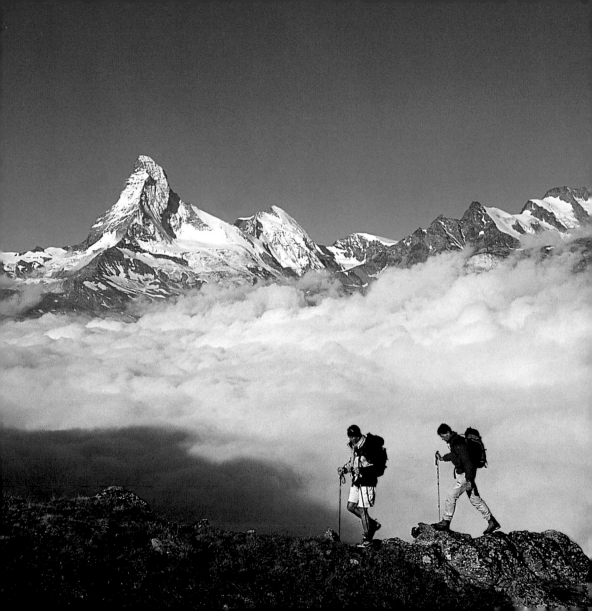

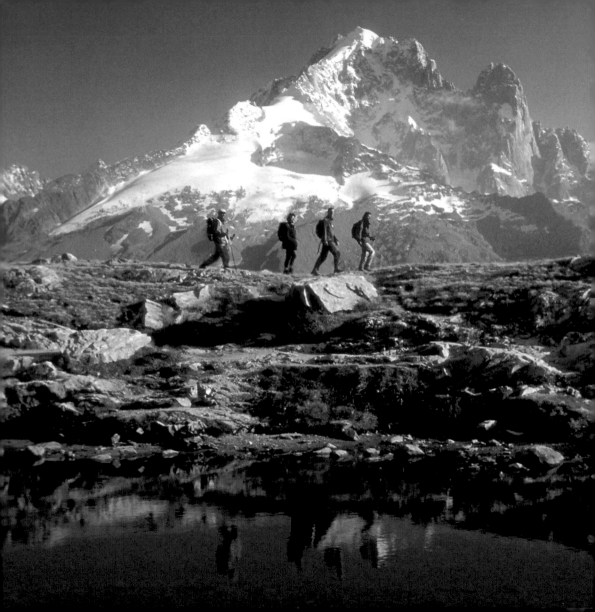

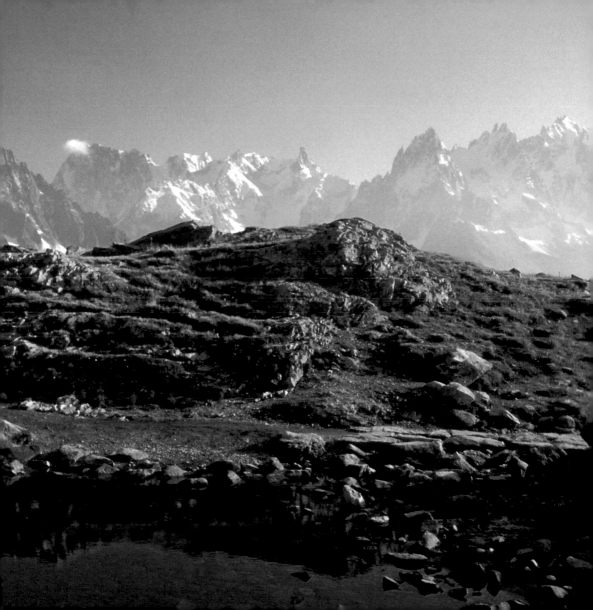

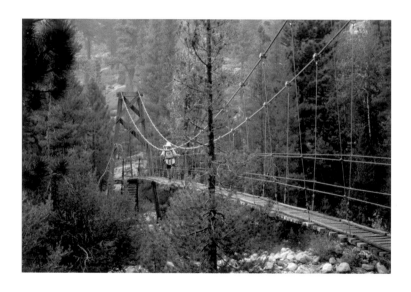

480 ● California (USA) - An excursionist on a wooden bridge over Woods Creek (Sierra Nevada).

481 ● Alto Adige (Italy) - A suspended bridge makes it possible to continue a walk in the Dolomites.

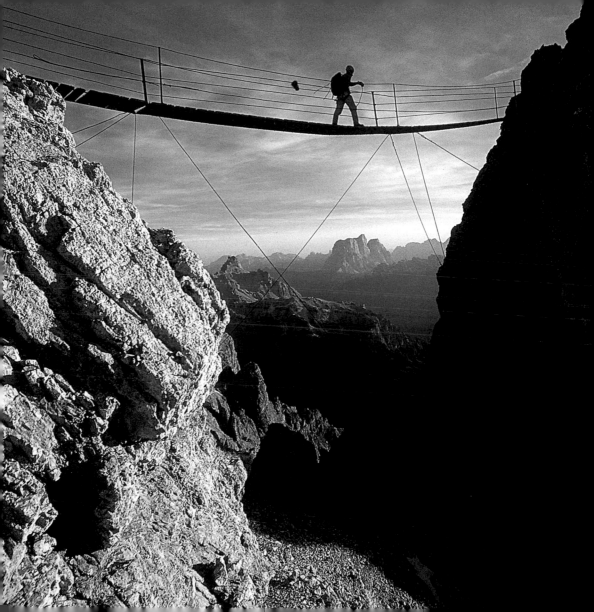

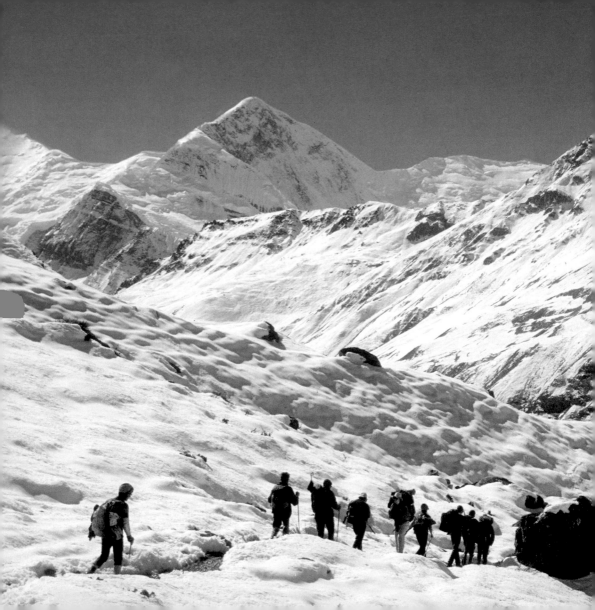

● Annapurna (Nepal) -
Trekkers on an alpine
pass in the area of
Thorung La.

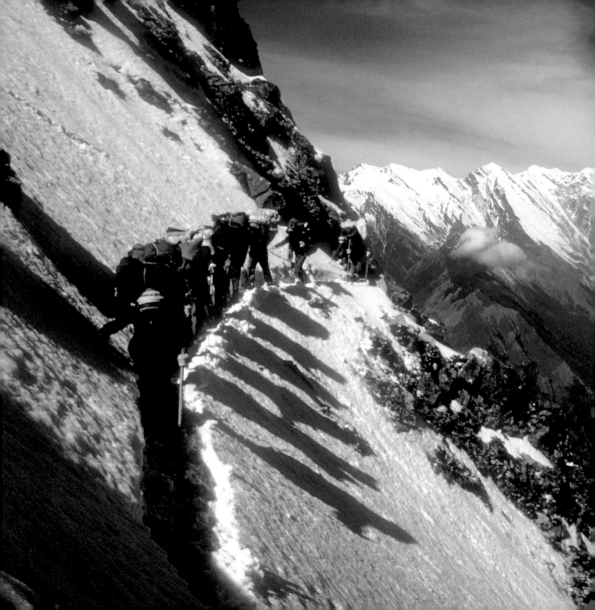

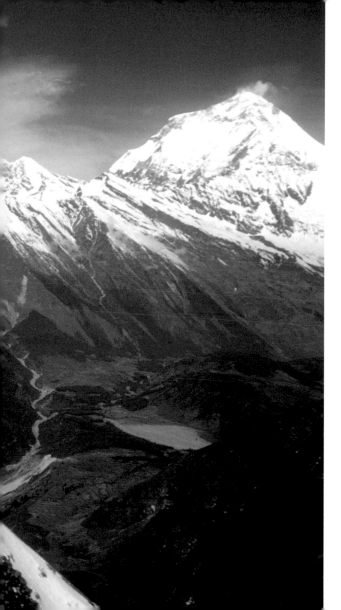

● Annapurna (Nepal) - Mountaineers loaded with packs reach camp past Dhaularigi.

Himalaya (Nepal) - Some men walk in the rain in the Khumbu Valley.

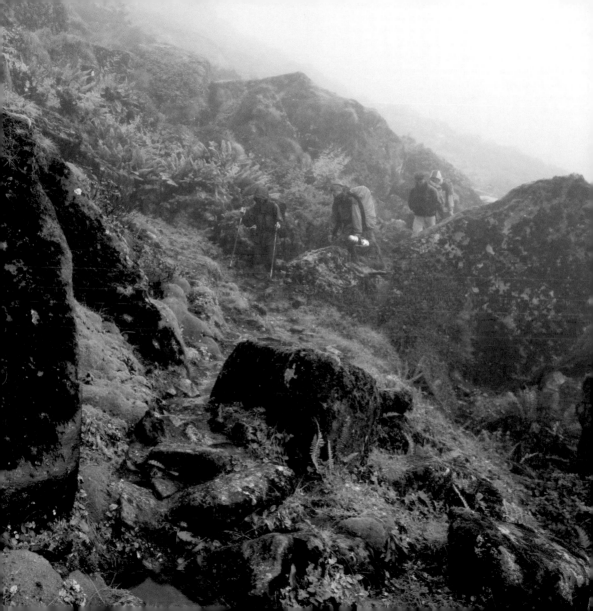

488-489 ● Aomori (Japan) - Hikers on Mount Shirakami.

490-491 ● Otago (New Zealand) - Hiking on the Cascade Saddle Route on Mount Aspiring National Park.

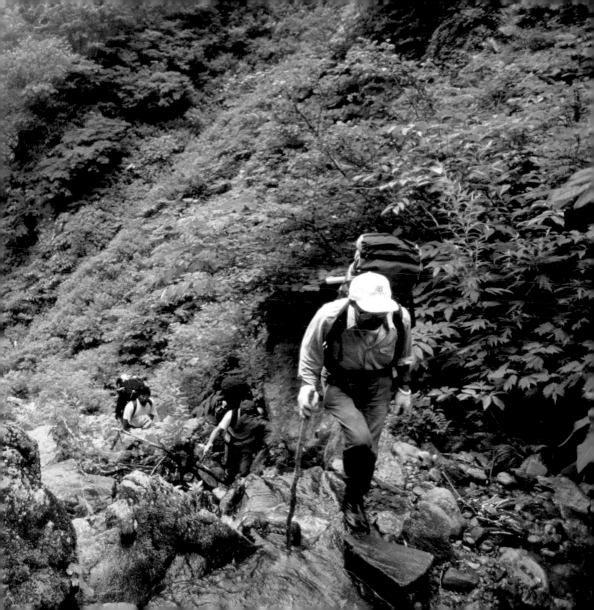

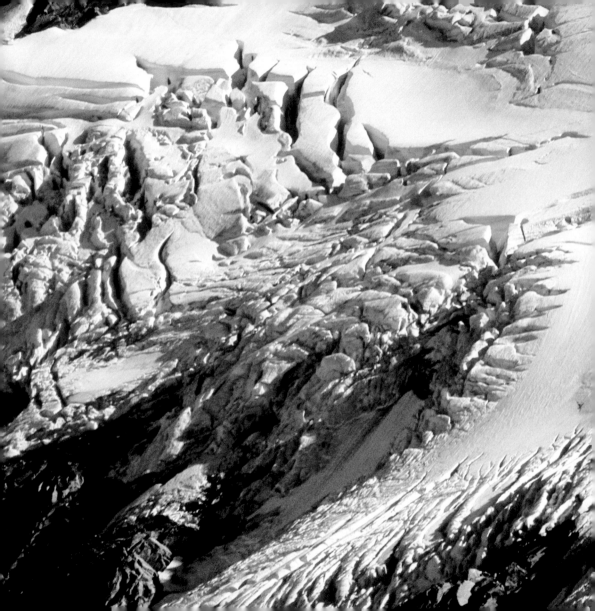

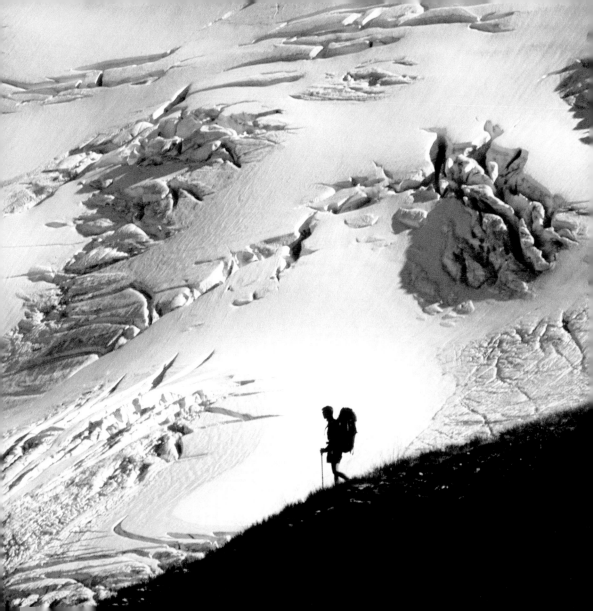

The PEOPLE Of the MOUNTAINS

LUIGI ZANZI

- Piedmont (Italy) - A group of young Walser in traditional costumes in Alagna, in Valsesia.

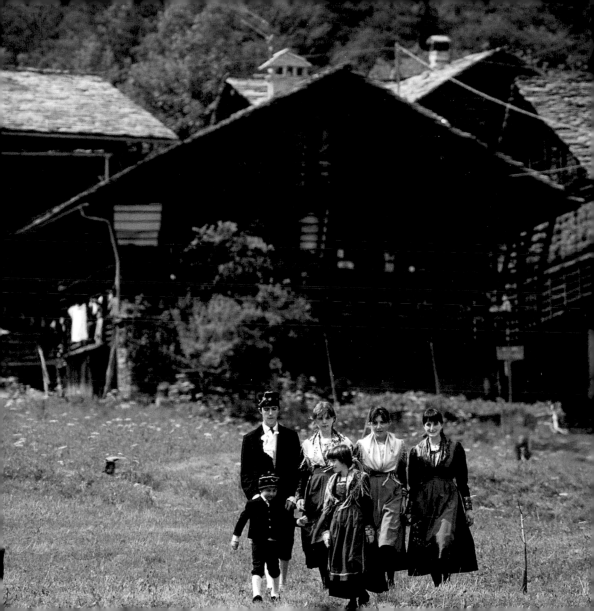

INTRODUCTION The People of the Mountains

The "invention" of living on "tall" mountains is among the most admirable creative initiatives of humanity: some peoples have made themselves into "mountaineers," actually choosing to survive at high altitudes, where survival is an adventure, where just walking is a work of art, where it is necessary to devise new farming techniques and invent new plant species and animal breeds that can be brought to pastures extracted from the rocks and glaciers in order to make a special "lifestyle" possible. This is a situation characterized by an increased cultural intensity that makes these high-altitude mountain-dwelling people some of the earliest protagonists among people in the natural-living environmental

INTRODUCTION The People of the Mountains

MOVEMENT. THIS KIND OF ADVENTURE INTO THE HIGH-ALTI-TUDE CULTURE SURPRISINGLY ENCOUNTERS SIMILAR SITUA-TIONS AMONG DIFFERENT MOUNTAIN GROUPS OF THE WORLD. THE WALSER PEOPLE OF THE ALPS AND THE SHERPA PEOPLE OF THE HIMALAYAS ARE THE MAIN PARADIGMATIC EX-AMPLES OF THIS EXPERIENCE. AROUND THE THIRTEENTH CENTURY, SOME OF THE WALSER PEOPLE LEFT THE UPPER VALLESE REGION (WALSER MEANING "PEOPLE FROM THE VALLESE") TO CLIMB TO THE HIGH ALTITUDES ALL AROUND MOUNT ROSA, CHOOSING MAINLY THE SOUTHERN SLOPES OF THAT MOUNTAINOUS REGION FOR WHERE TO SETTLE THEIR COLONIES. THERE, IN THE PRESENCE OF THE MATTERHORN-CERVINO, MOUNT ROSA (*ROISA* MEANING ICE), AND THE FLETSCH-HORN, BETWEEN SAAS FEE, ZERMATT, GRESSONEY,

INTRODUCTION The People of the Mountains

ALAGNA, MACUGNAGA, SIMPLON DORF, AND OTHERS, THE WALSERS UNDERTOOK A LONG MIGRATION, ALWAYS AT HIGH ALTITUDES, FROM WEST TO EAST, ACROSS MULTIPLE SLOPES OF THE CRESTS OF THE ALPS, ACROSS THE GRIGIONI, REACHING AS FAR AS THE VORARLBERG IN AUSTRIA. THIS WAS THE LAST GREAT COLONIAL MIGRATION OF A PEOPLE IN EUROPE'S HISTORY. FOR SCENERY, IT HAD THE UPPER ALPS AND IGNITED A COMPLETELY NEW "LIFESTYLE," FORGED IN A CHAOTIC ENVIRONMENT IN AN INCESSANTLY PRECARIOUS STATE OF TRANSFORMATION. SUCH CONDITIONS WOULD CONTINUOUSLY CHALLENGE THE MOUNTAIN PEOPLE TO INVENT NEW METHODS TO ENSURE THEIR SURVIVAL AND TO CLEARLY DEFINE THEIR IDENTITY THROUGH DISTINCTIVE CUSTOMS MAINTAINED OVER TIME THANKS TO INTENSE CONSERVATION EFFORTS.

INTRODUCTION The People of the Mountains

COMPLETELY ANALOGOUS WAS THE MIGRATORY VENTURE UNDERTAKEN BY THE SHERPA PEOPLE FROM THE EIGHTEENTH CENTURY ON, WHO MADE THEIR MOVE FROM EAST OF TIBET TO NORTH OF MAKALU, FROM EVEREST, AND FROM CHO OYU. THIS EVENT WAS THE FIRST OF A GREAT MIGRATION LASTING OVER A CENTURY TO COLONIZE SOME REMOTE, UNINHABITED HIGHLANDS SOUTH OF THE HIMALAYAS IN THE KHUMBU REGION. THEY WERE ABLE TO ACCESS THE AREA THROUGH HIGH-ALTITUDE GORGES CROSSED BY SEVERAL ADVENTUROUS NOMADIC GROUPS THAT TOOK UP RESIDENCE HERE AND THERE, ONE "CLAN" AFTER ANOTHER, IN VARIOUS INHABITABLE NOOKS ON THE MOUNTAINS AT THE FARTHEST REACHES OF HUMAN SURVIVAL (BETWEEN 13,000 AND 16,000 FEET ABOVE SEA LEVEL).

498-499 ● Oberland (Switzerland) - A horn player in Interlaken.

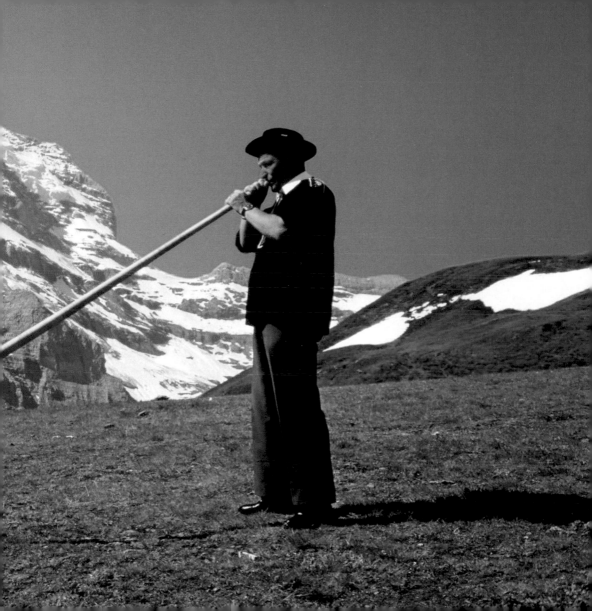

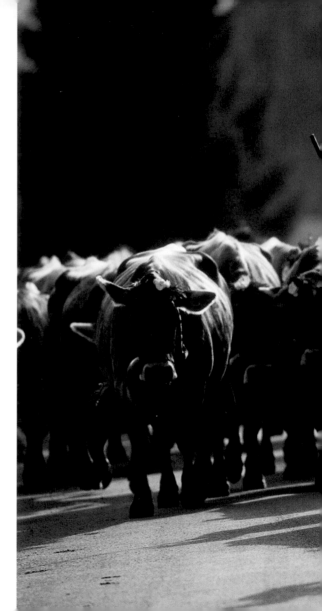

500 ● Voralberg (Austria) - A typical Alpine head covering, in Bregenzerwald.

500-501 ● Voralberg (Austria) - A group of shepherds in Voralberg with their cows, descending into the pasture.

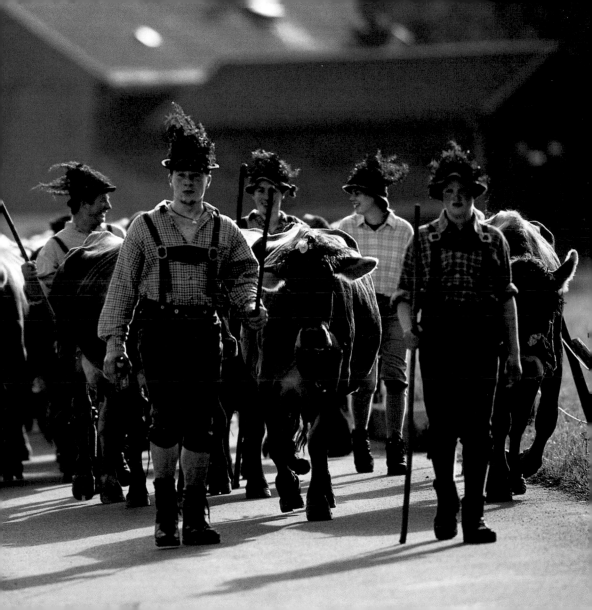

502 ● Piedmont (Italy) - Women in traditional costumes in Alagna in Valsesia.

502-503 ● Piedmont (Italy) - Geranium blossoms fill the trellises of Walser homes with color.

504 • Alto Adige (Italy) - Men walk in a parade for the feast of the Sacred Heart of Jesus in Val Badia.

505 • Alto Adige (Italy) - Some women accompany the statue of Christ during the parade of the Sacred Heart of Jesus in Val Badia.

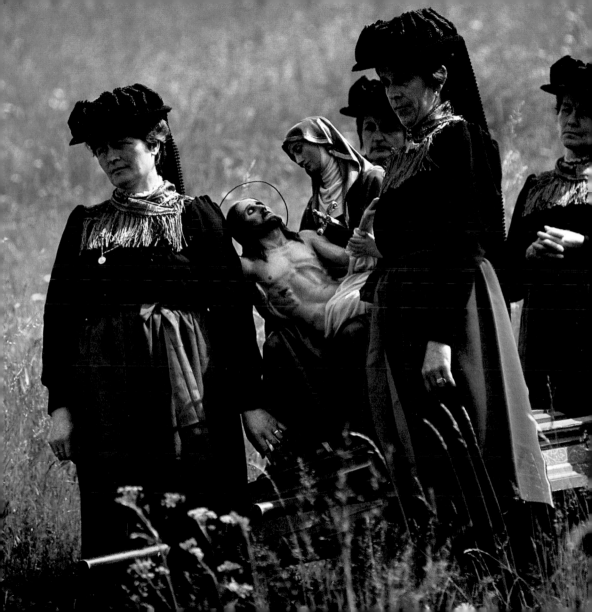

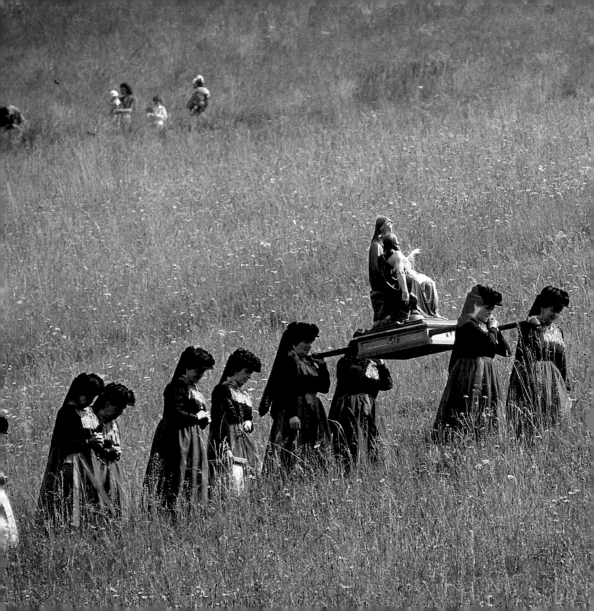

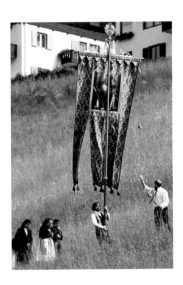

506-507 • Alto Adige (Italy) - Women carry the statue of Mary with Jesus Christ on their shoulders during another moment in the parade.

507 • Alto Adige (Italy) - A banner bearing the image of Jesus Christ, in Val Badia.

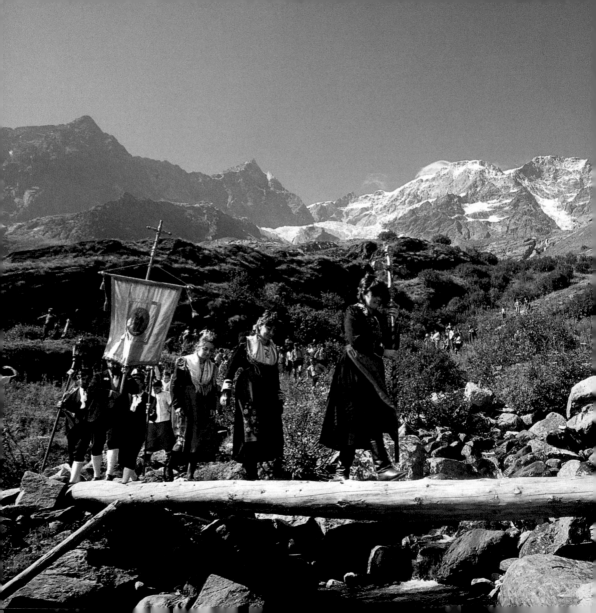

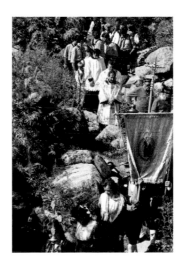

Piedmont (Italy) - The Procession of the Flower Rosary in Alagna, in Valsesia.

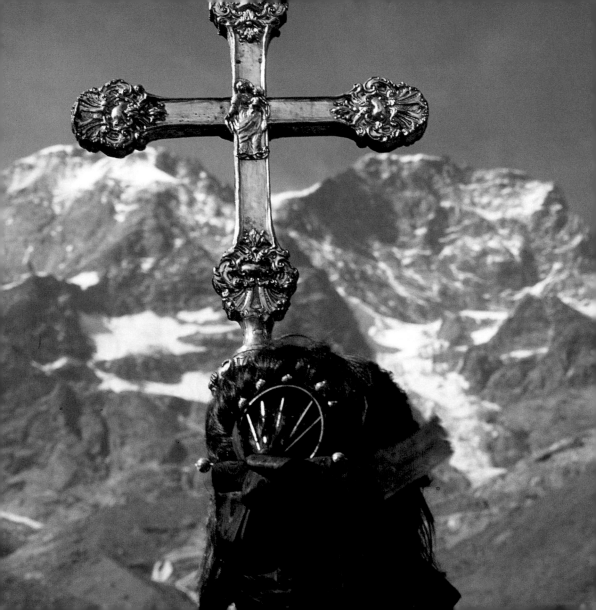

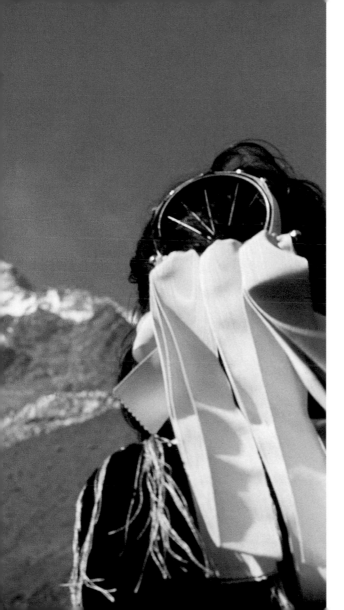

Piedmont (Italy) - Thanking the Virgin Mary during the procession of the Flower Rosary in Alagna, in Valsesia.

512 • Val d'Aosta (Italy) - The finely worked costume of an elderly Walser woman in Gressoney.

513 • Val d'Aosta (Italy) - Lively colors in a traditional costume from the Gressoney Valley.

Val d'Aosta (Italy) - A victorious cow (left) after the "battle of the queens" in the Croix Noire Arena in Aosta.

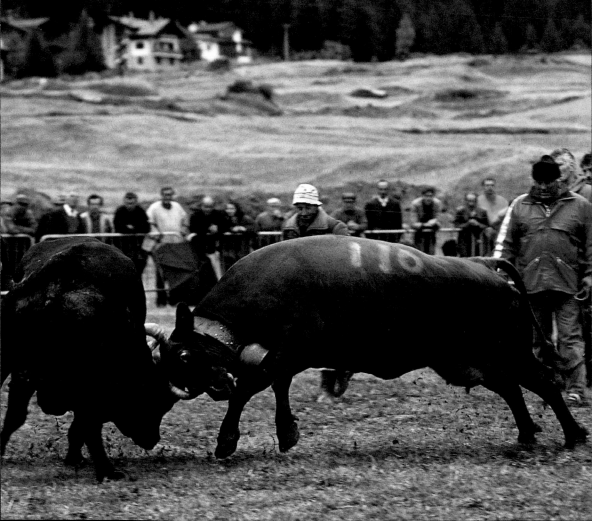

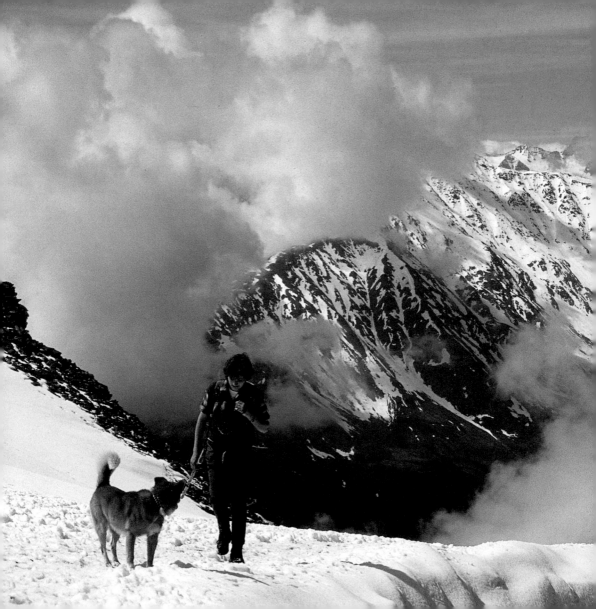

Alto Adige (Italy) - Taking herds of sheep to pasture from Italy to Austria across the Similaun Glacier in Val Senales.

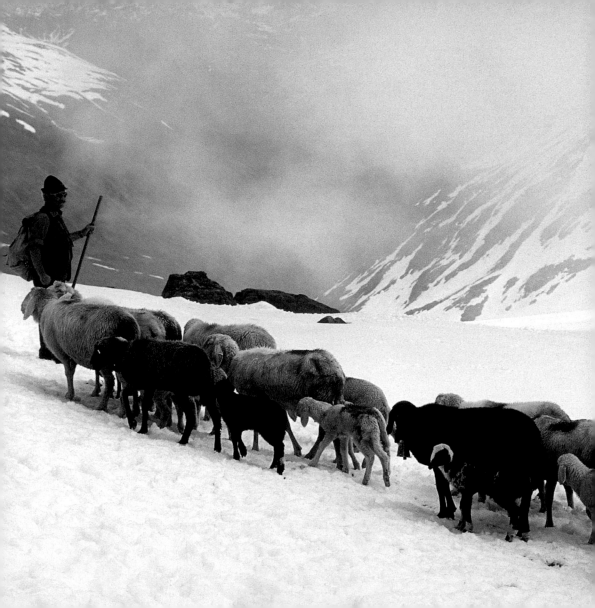

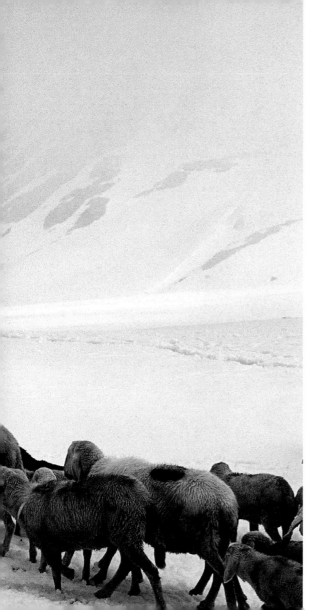

● Alto Adige (Italy) -
Sheepherding across the Similaun
Glacier, in Val Senales, is an
ancient tradition born of a pastoral
culture still active here as in other
regions of Italy.

Africa

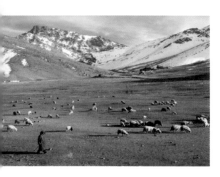

520 ● Atlas Mountains (Morocco) - A flock of sheep at pasture, in the highlands of Oukaimeden.

520-521 ● Morocco - A woman with two children in a village in the Upper Atlas Mountains.

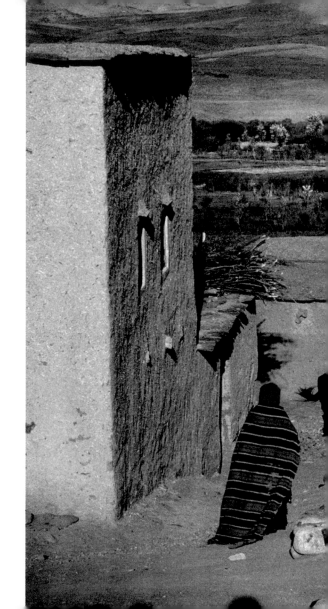

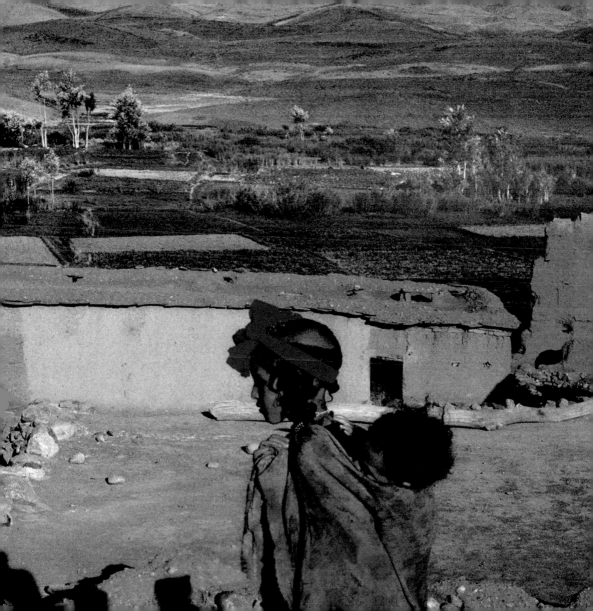

Asia

- Himalaya (Nepal) -
A Sherpa woman at
work in a village in the
Khumbu Valley.

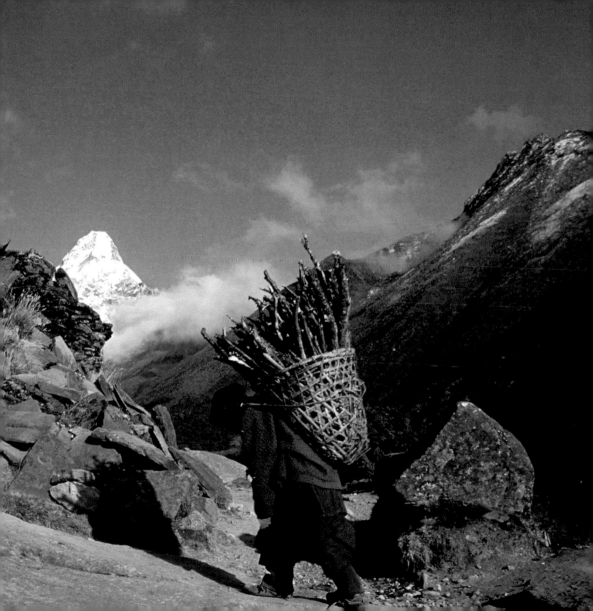

524 • Himalayas (Nepal) - A Sherpa boy carries a load of logs.

525 • Himalayas (Nepal) - Yaks help inhabitants in the Khumbu Valley with their work.

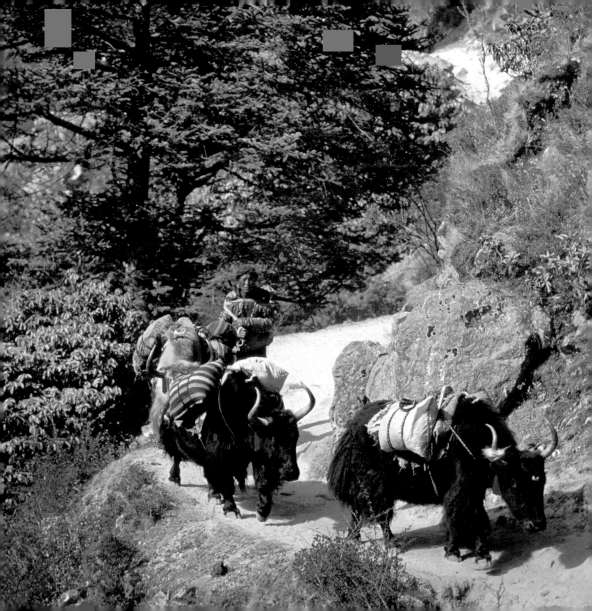

● Himalayas (Nepal) - Two children of the
Sherpas, a people that descended from
Tibet to the Khumbu Valley about 300
years ago.

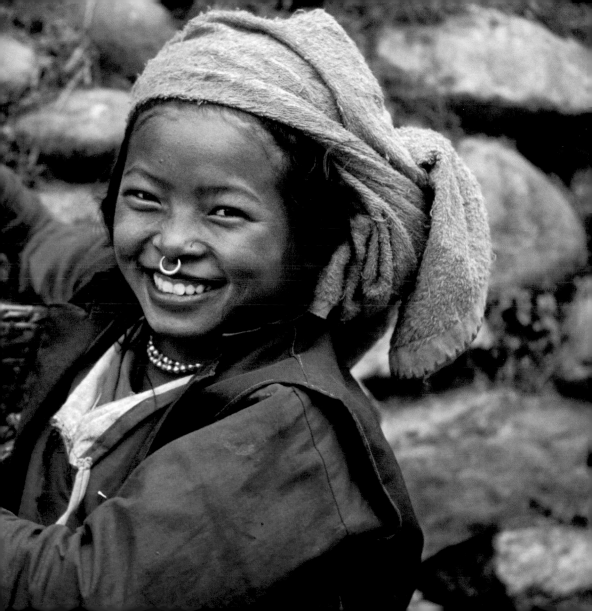

Himalaya (Nepal) -
Porters cross a
suspended bridge.

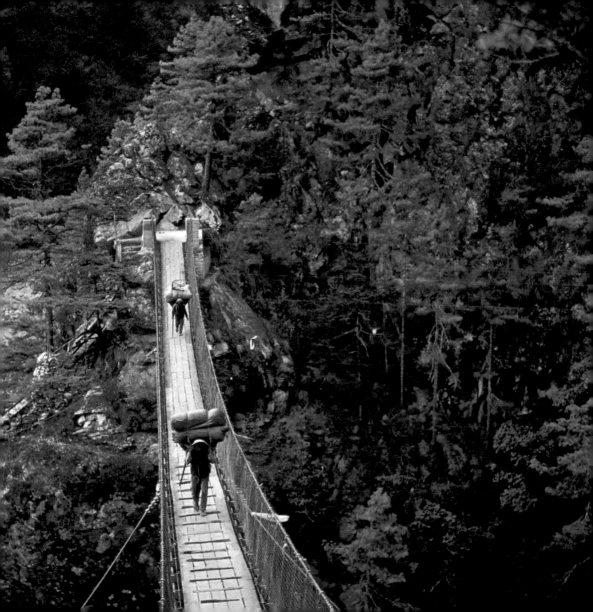

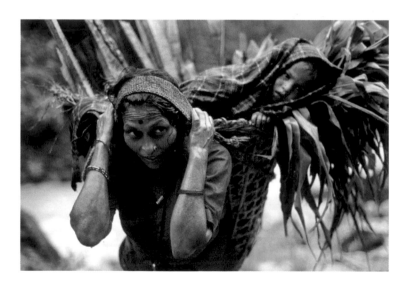

530 • Himalaya (Nepal) - A mother packs her baby onto her shoulders and walks in the rain near Muktinath.

531 • Himalaya (Nepal) - The lined face of a Sherpa man in the village of Sotan.

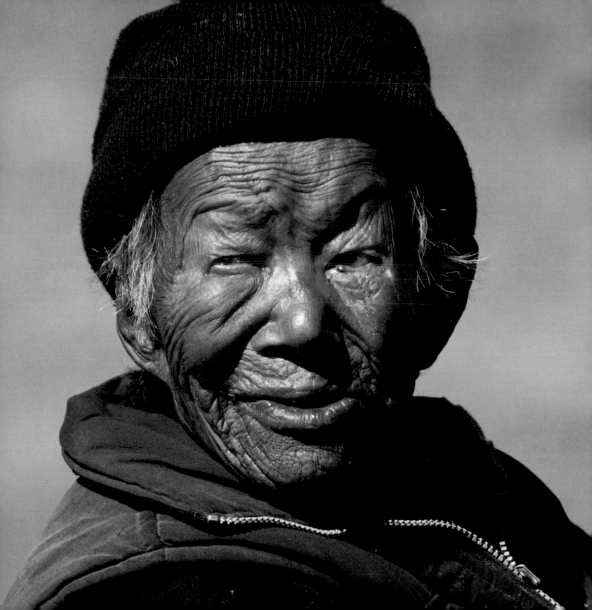

Karakoram (Pakistan)
- Two Balti men carry
heavy bags towards the
Baltoro Glacier.

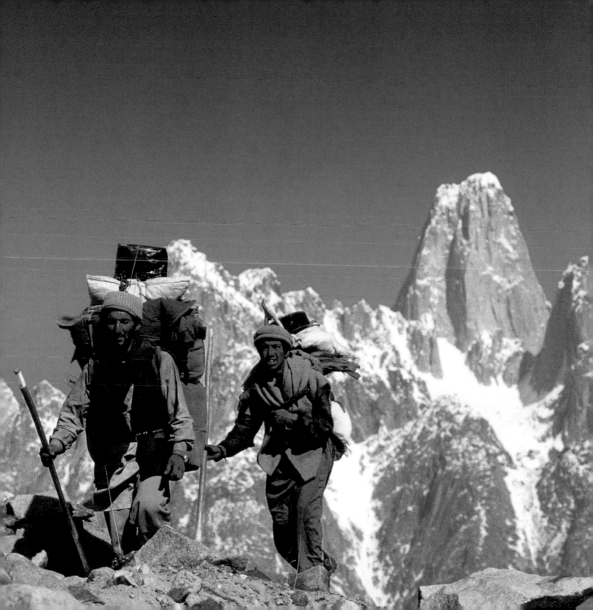

South America

- Ecuador - A man riding his mule fords a mountain river.

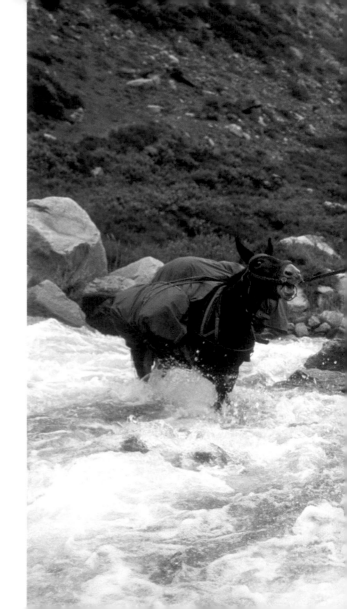

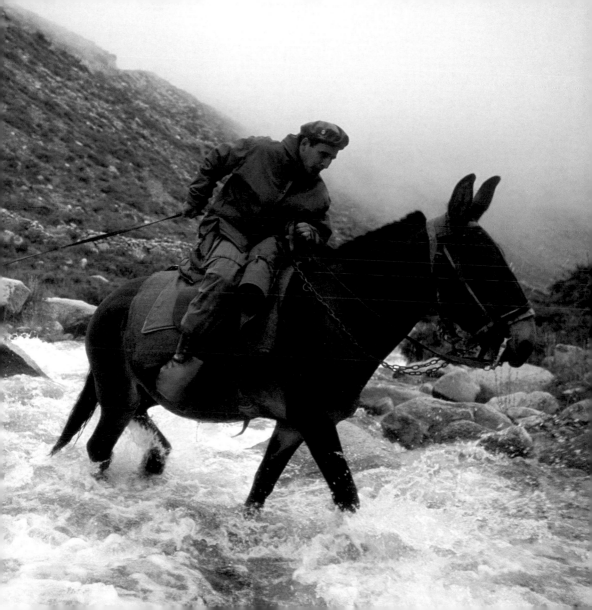

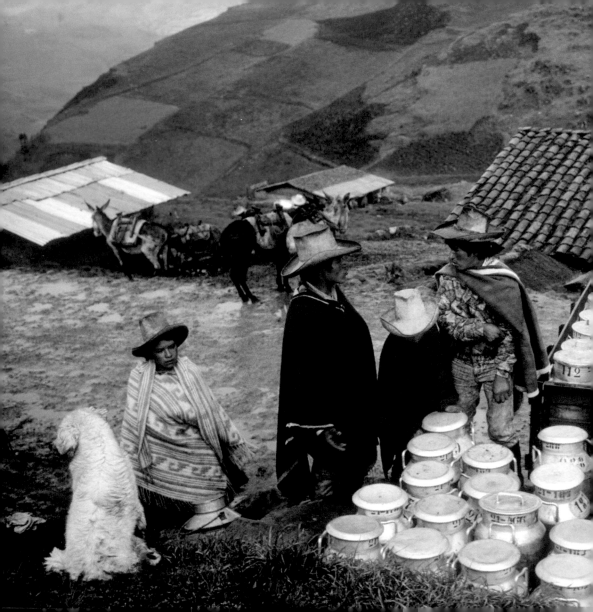

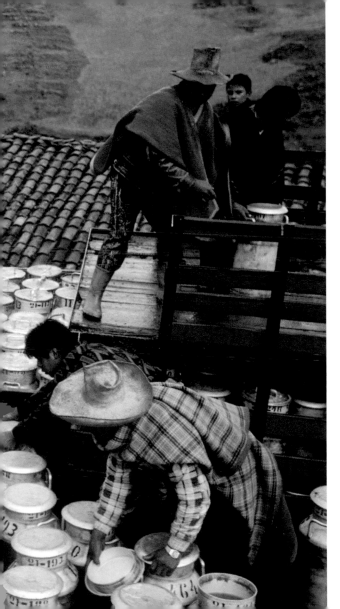

Ecuador -
Shepherds selling milk
at the market.

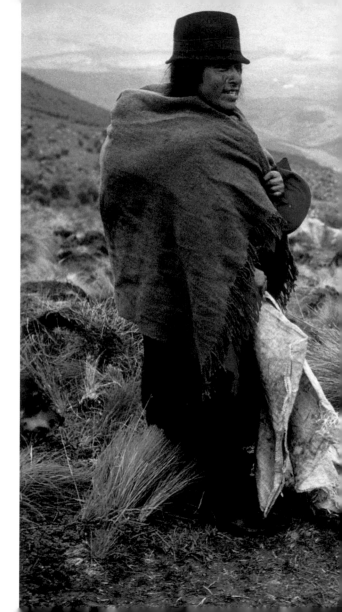

● Ecuador - A few men
load their bags onto the
back of a their mule.

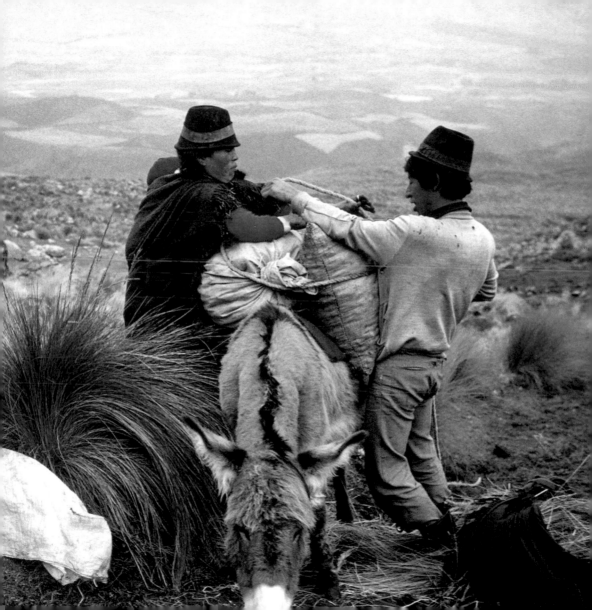

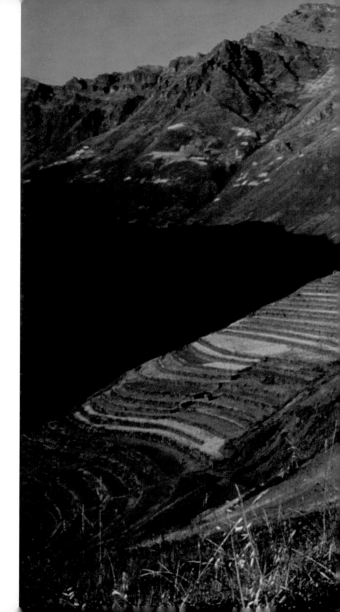

● Perù - Two men work
in the fields of the
Sacred Valley of Cuzco.

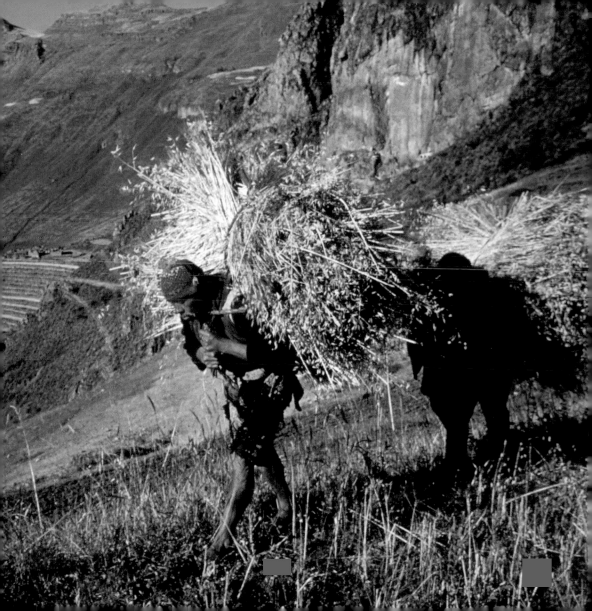

542 • Peru - Sunny colors for the head covering of this Peruvian baby, in Cuzco in the Vilcanota Cordillera.

543 • Peru - A man who takes part at the dance festival in Raqchi, in Sicuani.

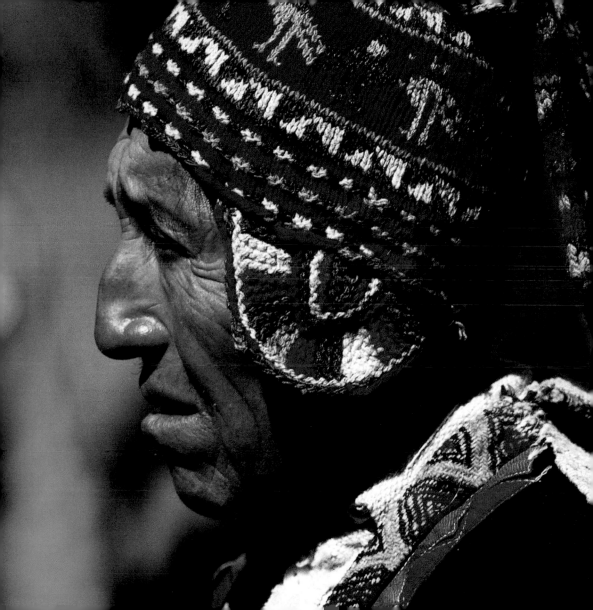

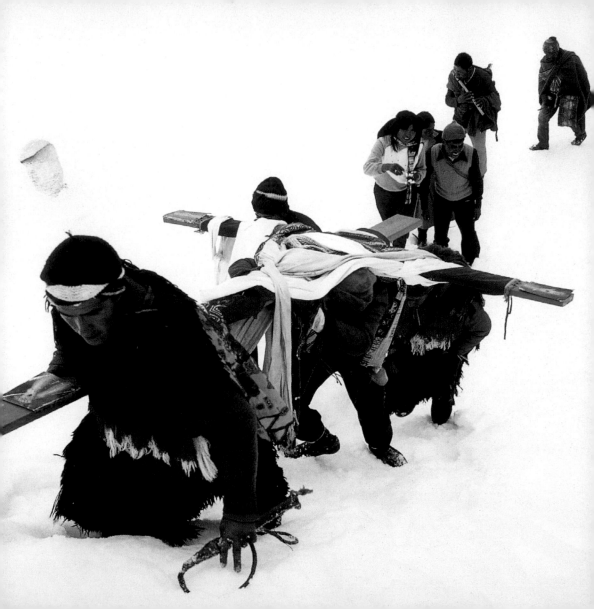

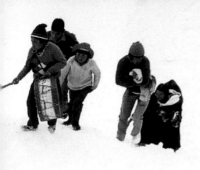

544-545 • Peru - A procession over the snow, during the Qoyllur Rit'i, in the Vilcanota Cordillera.

545 • Peru - Prayer before a crucifix during the Qoyllur Rit'i, in the Vilcanota Cordillera.

546 ● Peru - The rite of the candles in the snow on the Colquepunku Glacier, during the Qoyllur Rit'i, in the Vilcanota Cordillera.

546-547 ● Peru - A moment during the Qoyllur Rit'i, in the Vilcanota Cordillera.

548-549 ● Peru - The long serpent of pilgrims returning from Ukuku, during the Qoyllur Rit'i, in the Vilcanota Cordillera.

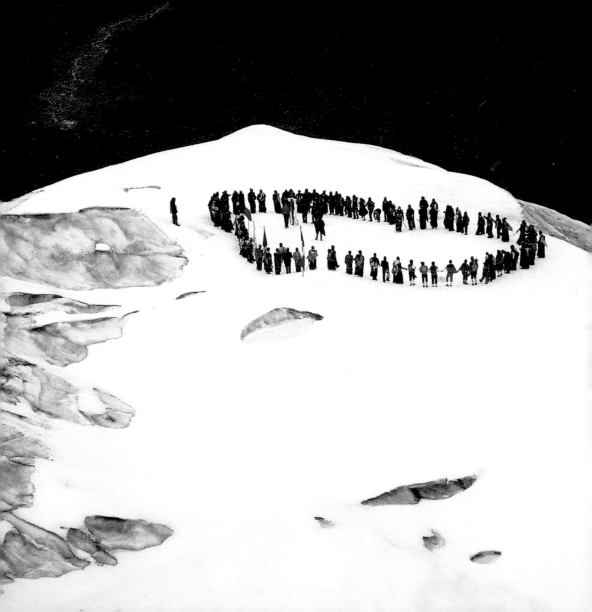

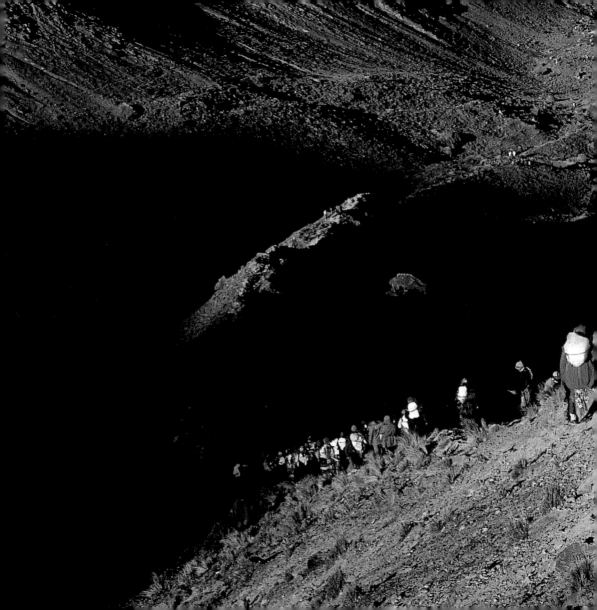

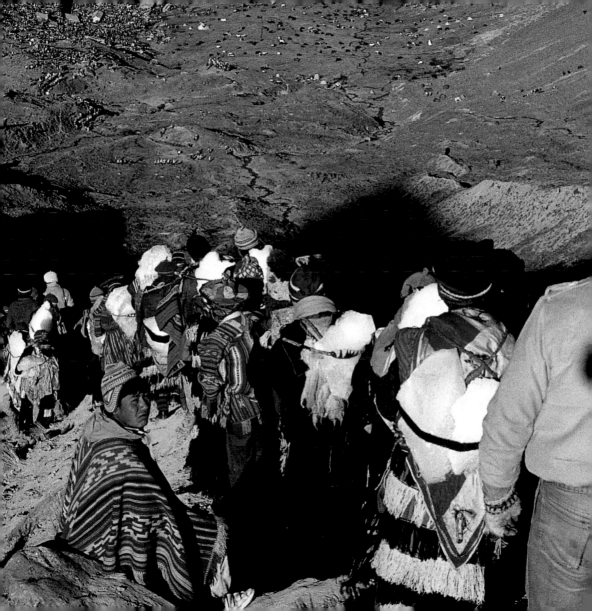

CREATURES Of the WOODS

FRANCESCO PETRETTI

- Val d'Aosta (Italy) - A fight between two ibex in Gran Paradiso National Park.

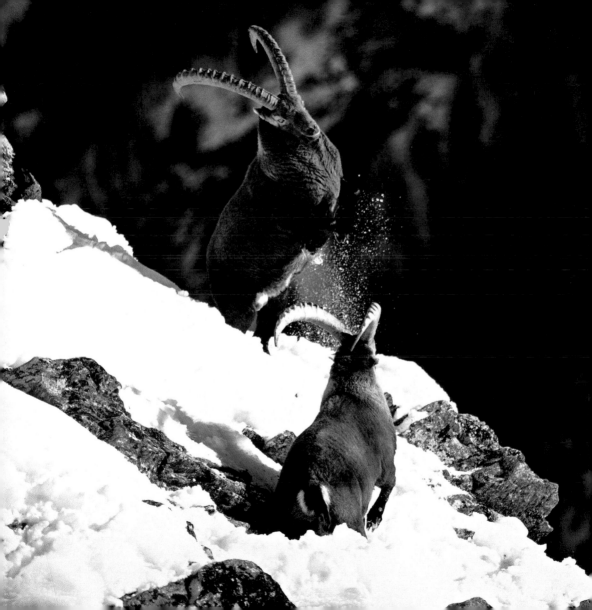

INTRODUCTION Creatures of the Woods

A NOT FAR FROM THE EQUATOR, I FELT LIKE I WAS IN THE ALPS. LIKE LITTLE CHAMOIS, THE KLIPSPRINGER ANTELOPES RAN ON VEINS OF BLACK LAVA. ABOVE THEM, THERE WAS ONLY THE PEAK OF MOUNT BATU, 14,100 FEET HIGH, THE SECOND TALLEST MOUNTAIN IN ETHIOPIA. THERE, THE TEMPERATURE ALMOST ALWAYS FALLS BELOW FREEZING AT NIGHT, WHEREAS DURING THE DAY, THE SUN SHRIVELS THE ARTEMISIA BUSHES AND THE BIG LOBELIAS. ON THE SMALL, COBALT-COLOR LAKES, THERE WERE FAMILIES OF SKY-BLUE-WINGED GEESE. THEIR GOSLINGS TODDLED AFTER THE ADULTS WALKING WITH THEIR WADDLING GAIT, WANDERING OFF ON FOOT WITHOUT HASTE. THERE ARE WOLVES IN THESE MOUNTAINS, BUT THEY ARE A BIT SPECIAL: ABYSSINIAN WOLVES WITH LONG PAWS AND TAWNY COATS. NOT MUCH FURTHER DOWN, THE

INTRODUCTION Creatures of the Woods

CLOUD-SHROUDED FOREST OF HAGHENIAS AND PODOCARPS BEGIN: THREE MEN ARE NOT ENOUGH TO COMPLETELY EMBRACE SOME TRUNKS. THE FOG MOVED AMONG THE TREE TRUNKS, CONDENSING IN TINY DROPS. TUFTS OF DENSE BAMBOO OBSTRUCTED THE VIEW; VINES AND TENDRILS CONNECTED THE PLANTS INTO AN INEXTRICABLE WEB. I THEN UNDERSTOOD THAT MOUNTAINS ARE ALL UNIQUE, BUT THAT IN THE END, THEY ALL RESEMBLE EACH OTHER: HARD WORK, SOIL AND BARE ROCK, WIND, AND ABOVE ALL, COLD. A COLD THAT IS BARELY MITIGATED BY A WARM SUN THAT CAN BE FELT WHEN THE CLOUDS DISPERSE AND THE SKY BECOMES SO BLUE IT SEEMS BLACK. THE ANIMALS OF THE MOUNTAINS ARE PART OF A BIG FAMILY: THE IBEX OF THE ALPS AND THE WOLF OF ABYSSINIA, THE WILLOW PTARMIGAN OF ALASKA AND THE

INTRODUCTION Creatures of the Woods

SNOW LEOPARD OF THE PAMIR, THE BIGHORN SHEEP OF THE ROCKY MOUNTAINS AND THE CONDOR OF THE ANDES ALL SPEAK THE SAME LANGUAGE. THEY ALL MUST EQUALLY RESIST SNOW AND ICE STORMS AND HAVE TO FIND FOOD IN A BARREN MINERAL LANDSCAPE. THEY DO THIS AS ONLY THEY KNOW HOW: THE FIELD-MOUSE, WEIGHING ABOUT ONE OUNCE, DIGS ITS DEN INTO THE GLACIERS OF THE ALPS, THE BEARDED VUL-TURE CIRCLES THE PEAK OF EVEREST WITHOUT AN OXYGEN TANK, THE ALPINE ACCENTOR HATCHES ITS EGGS AMONG THE ROCKS OF THE HIMALAYAS, A DELICATE BUTTERFLY SPREADS ITS WINGS ON THE TOP OF KINABALU IN BORNEO. THE MOUN-TAINS CAN HAVE THEIR BASE IN THE DESERT OR THE TROPICAL FOREST BUT THEIR HEAD IS ALWAYS IN THE ARCTIC. EVEN AT THE TOP OF THE MAIELLA IN THE MEDITERRANEAN, IT SEEMS

INTRODUCTION Creatures of the Woods

TO BE THE TUNDRA: A VAST BOWL OF TINY PEBBLES, ALMOST BARE. THERE ARE ONLY A FEW BUDS OF ANDROSACE AND SAXIFRAGE AS TIGHT AS A STONE. WHEN THIS MOUNTAIN IS COVERED BY SNOW, THE CHAMOIS GO INTO HEAT AND CHASE EACH OTHER UNTIL THEIR HEARTS ARE READY TO BURST. THE GRIP OF THEIR HOOVES ON THE ICE AND ROCKS IS EXTRAORDINARY, AS EXTRAORDINARY AS THEIR RESISTANCE TO THE CLIMATE. AT THE END OF THIS EXTENUATING CHASE, THE STRONGEST CHAMOIS HAS THE RIGHT TO MATE WITH THE FEMALES OF THE PACK, ALTHOUGH IT IS NOT A GIVEN THAT HE WILL SURVIVE THE WINTER. MORE THAN A FEW EXEMPLARS FIND DEATH ON THE BY-NOW SILENT AND SNOWBOUND MOUNTAIN ONCE THEY HAVE PERFORMED THEIR REPRODUCTIVE DUTIES.

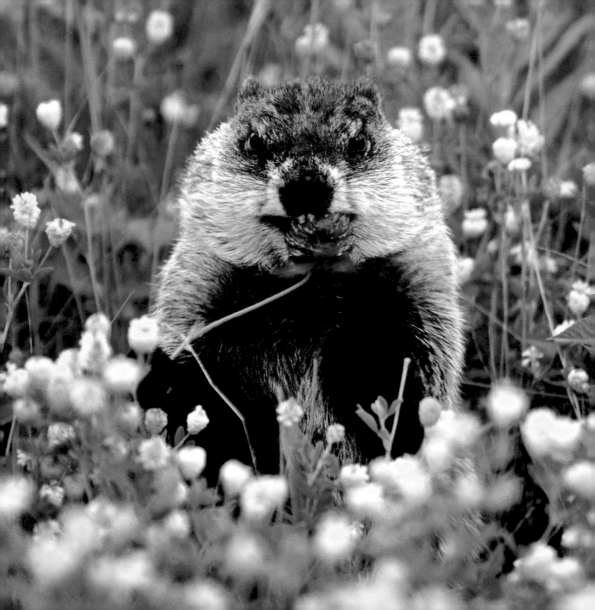

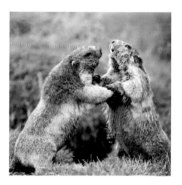

556-557 • Minnesota (USA) -
A groundhog eats a wild flower in the
mountains of Minnesota.

557 • Val d'Aosta (Italy) - Two European
marmots play in a meadow.

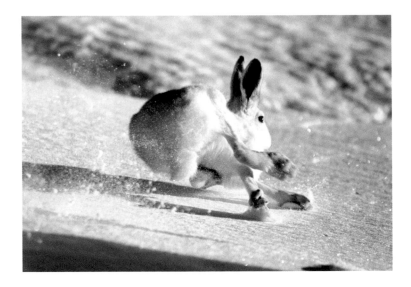

● Scotland - In the cold Scottish winter, a hare first runs across the fresh snow then stops to scan the horizon.

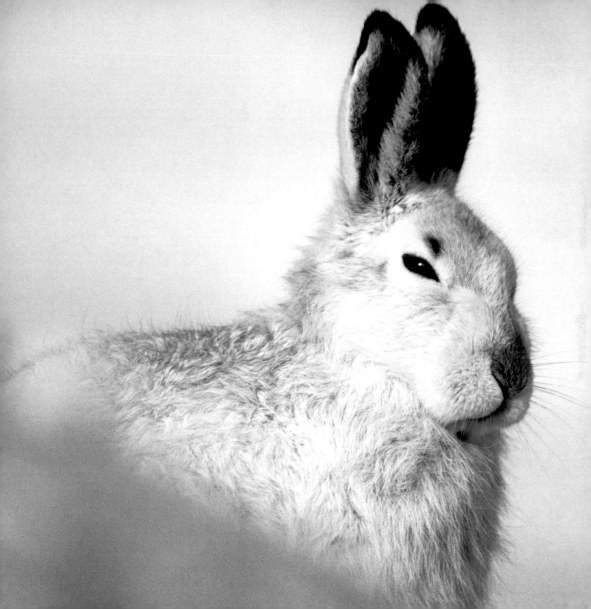

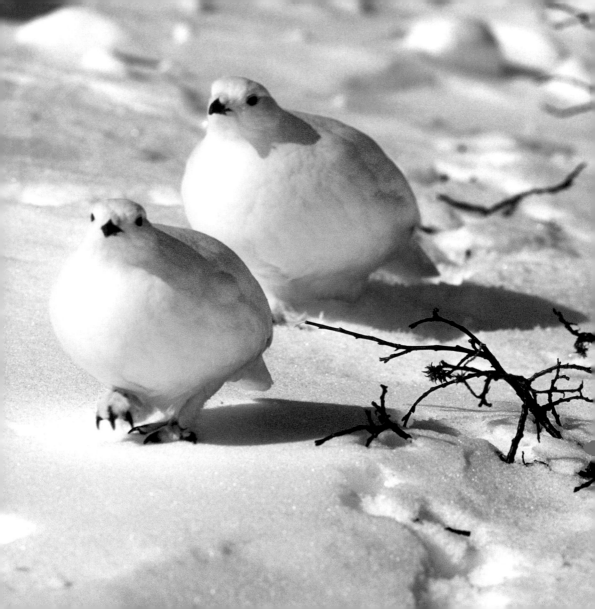

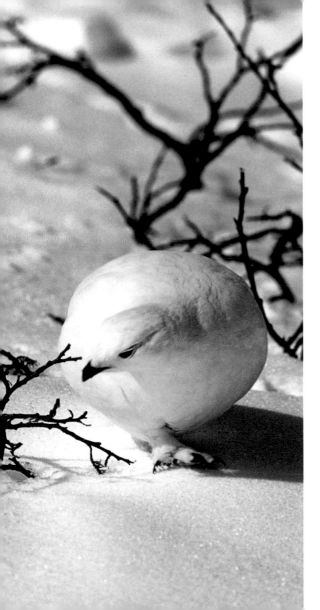

560-561 ● Colorado (USA) -
Three partridges with the typical
white winter plumage.

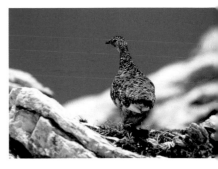

561 ● Colorado (USA) -
A partridge during a warmer
period of the year.

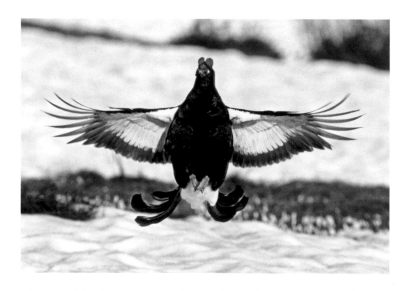

● Lombardy (Italy) - A male pheasant shows the red caruncles above the eyes (left) and the white subcaudal feathers (right).

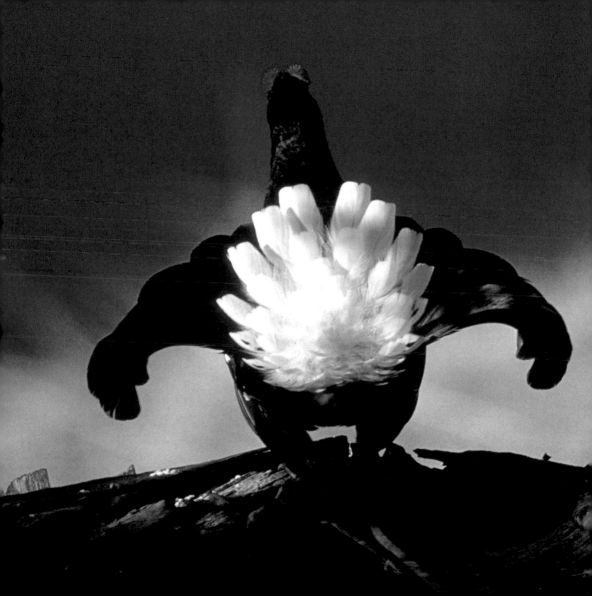

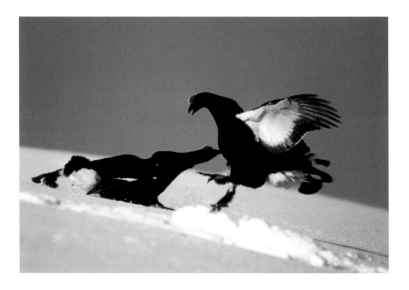

564 and 565 ● Lombardy (Italy) - Two male black grouse (*Tetrao tetrax*) challenge each other.

566-567 ● Patagonia (Chile) - The granite columns of Torres del Paine compose the backdrop to a copious group of llamas.

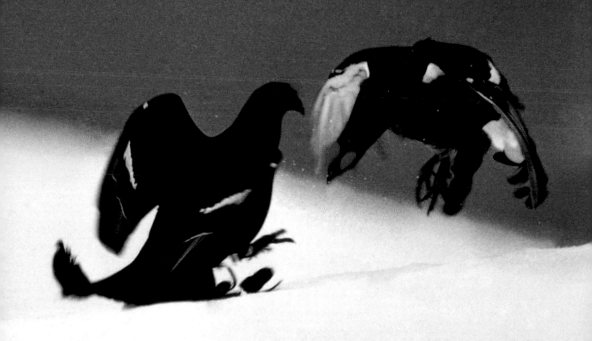

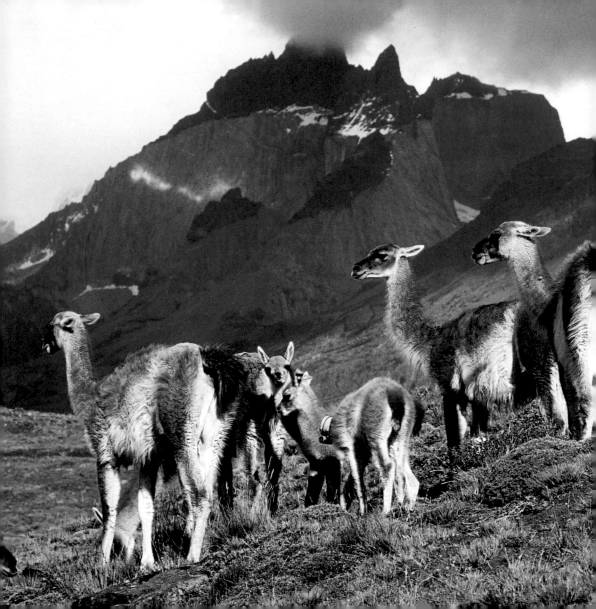

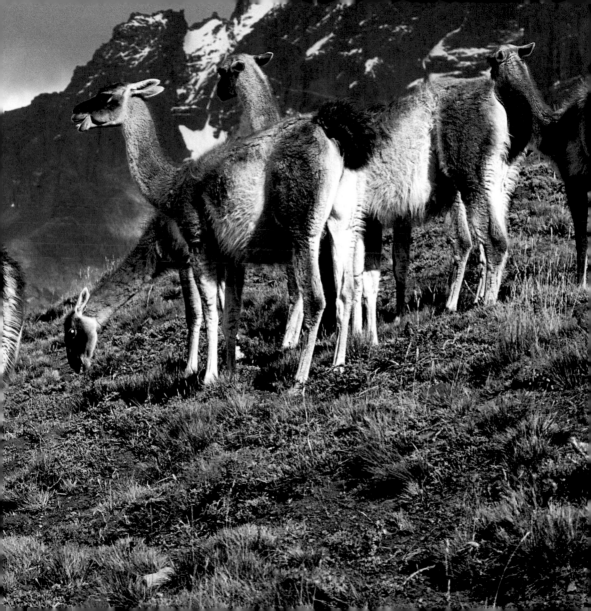

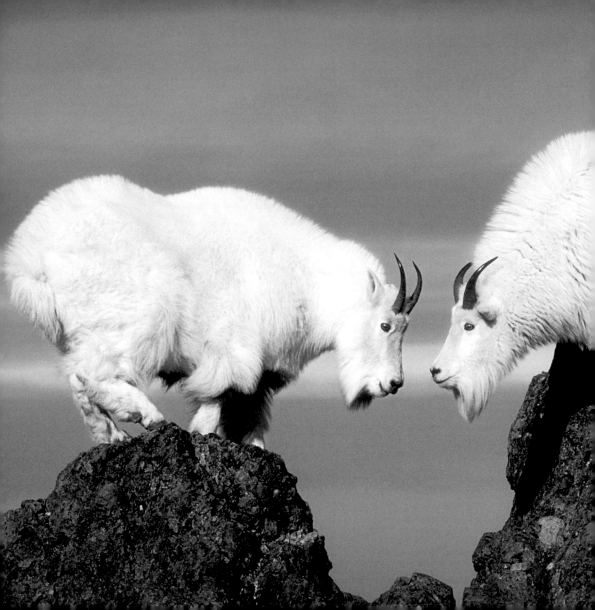

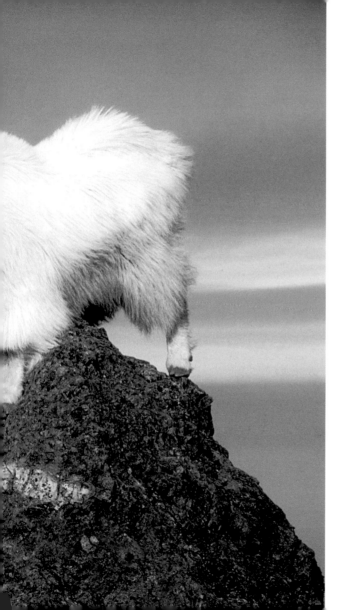

568-569 ●
Washington (USA) -
Two mountain goats
clash in Olympic
National Park.

570-571 ● Idaho,
Montana, Wyoming
(USA) - Two Rocky
Mountain sheep, in
Yellowstone National
Park.

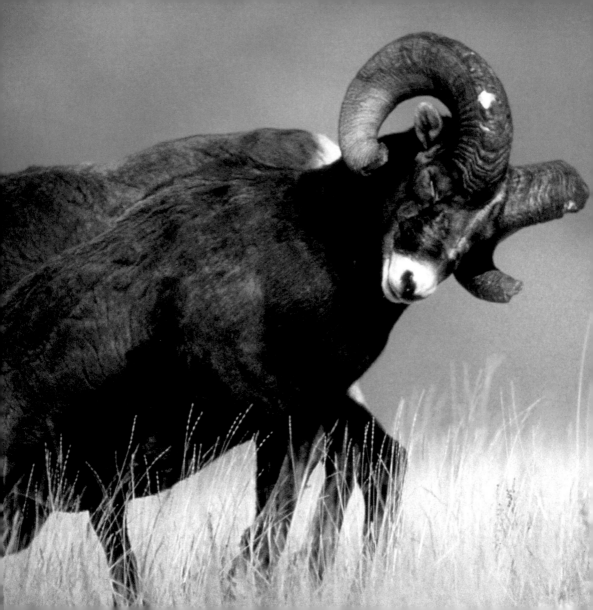

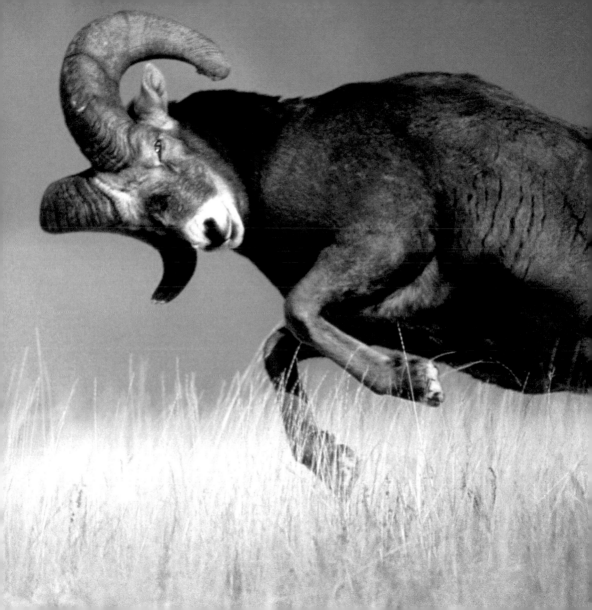

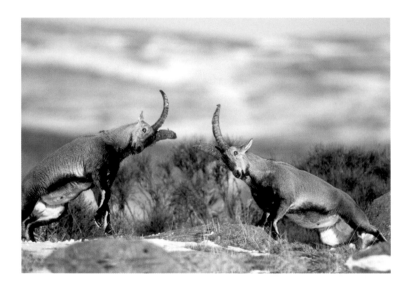

● Spain - Two adult ibex (*Capra pyranaica victoriae*) clash for possession of the herd's females.

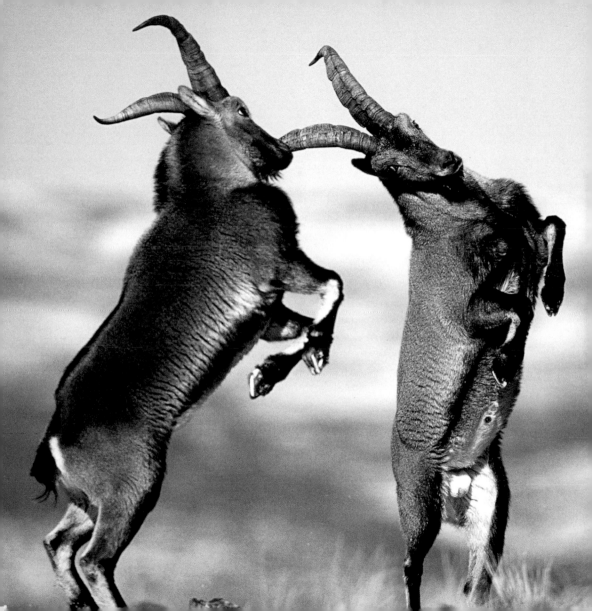

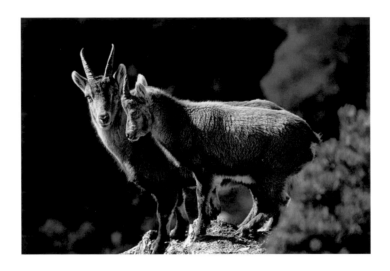

574 • Trentino Alto Adige (Italy) - A couple of ibex at the edge of an embankment in the Dolomites.

575 • Trentino Alto Adige (Italy) - This female ibex seems to have noticed the presence of the photographer and poses, looking directly into the lens.

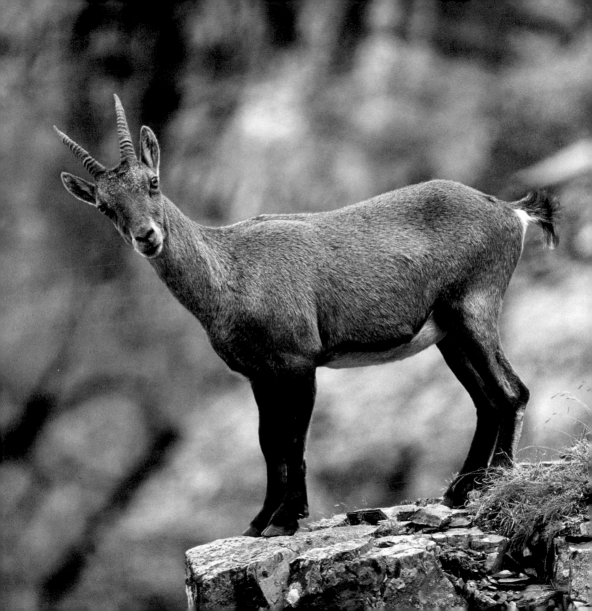

576 • Val d'Aosta (Italy) - A couple of ibex at high altitude, in Gran Paradiso National Park.

576-577 • Val d'Aosta (Italy) - A solitary ibex, seen here alone among the highest peaks in the Alps.

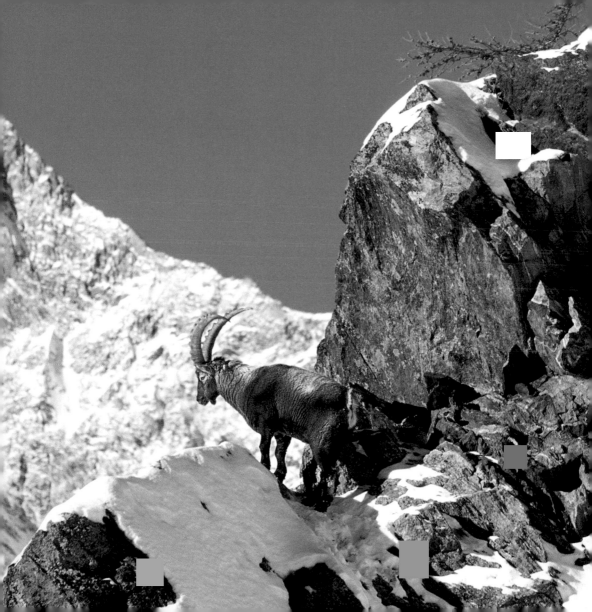

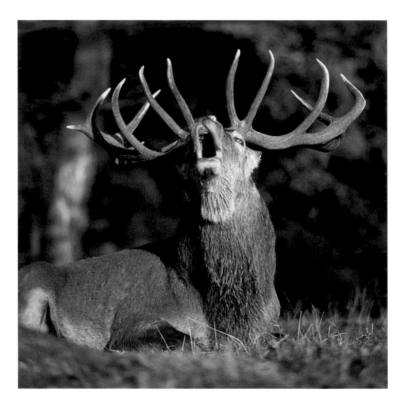

578 and 579 ● Sweden - Two adult deer (*Cervus elaphus europaeus*) photographed in summer (left) and late autumn (right).

580-581 ● Alaska (USA) - A North-American deer is silhouetted on the Rocky Mountains.

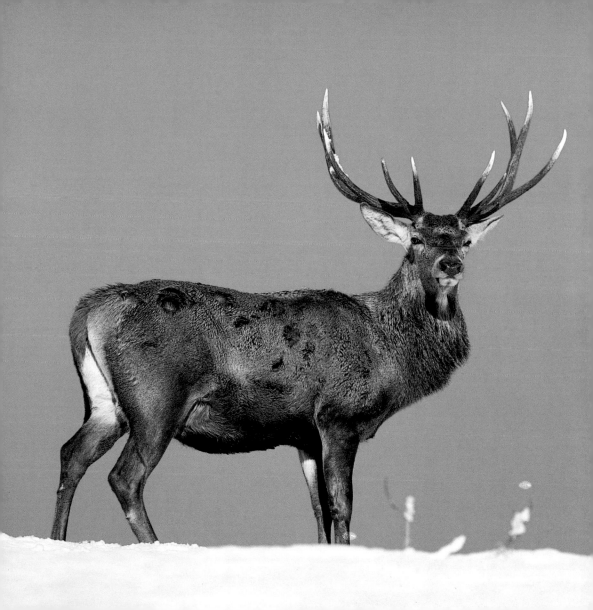

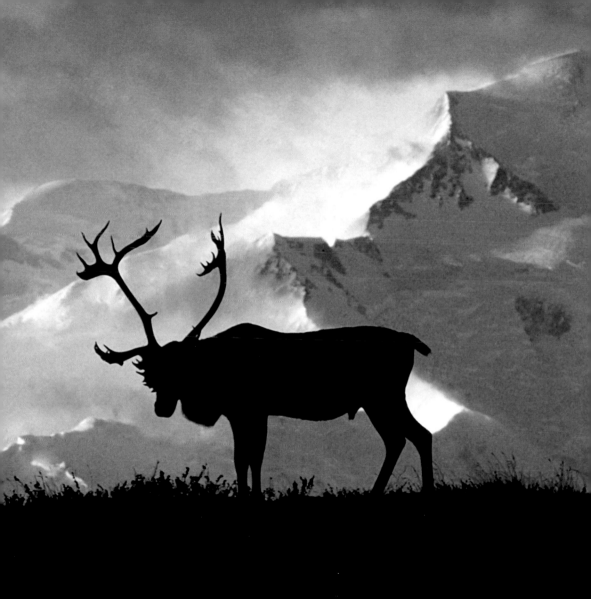

582-583 ● Val d'Aosta (Italy) - Two Alpine chamois (*Rupicapra rupicapra*) chase each other on the snow.

584-585 ● Val d'Aosta (Italy) - A male chamois, appearing to enjoy the breathtaking panorama, pops up from the rocks and snow of the Alps.

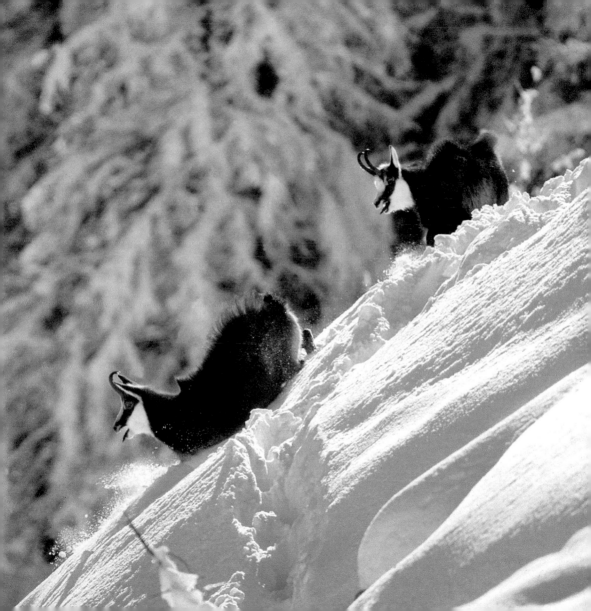

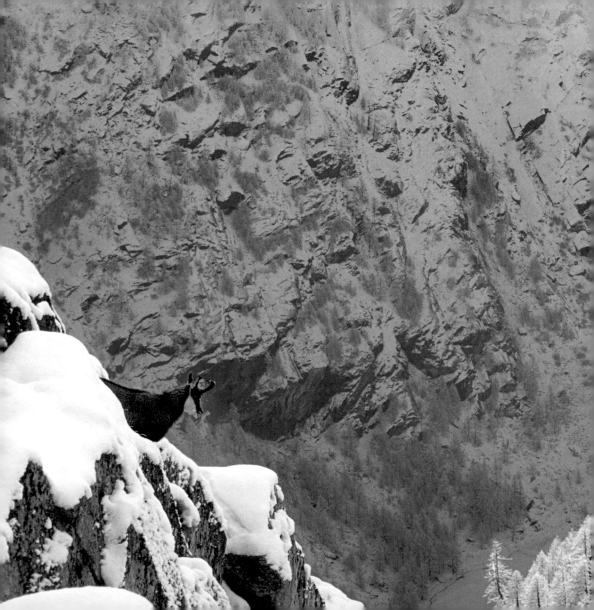

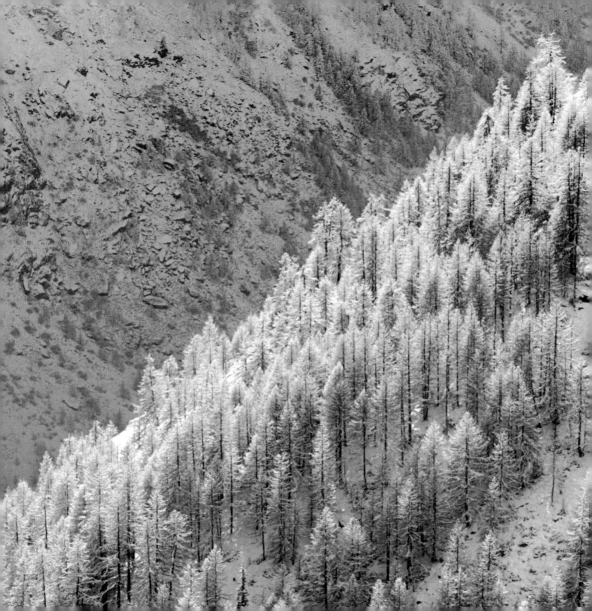

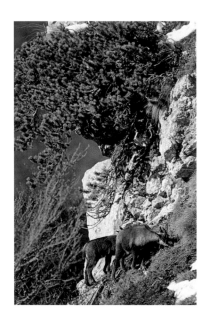

586 ● Abruzzo (Itay) - A couple of chamois are intent upon grazing among the steepest rocks.

587 ● Abruzzo (Itay) - A chamois agilely overcomes a rough rocky wall.

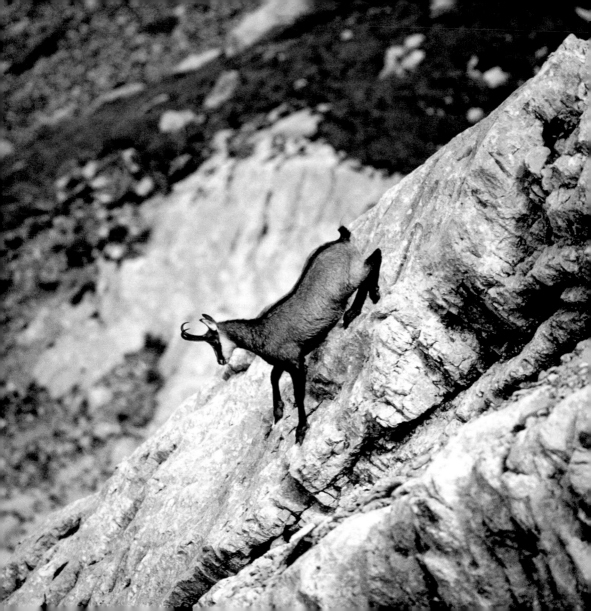

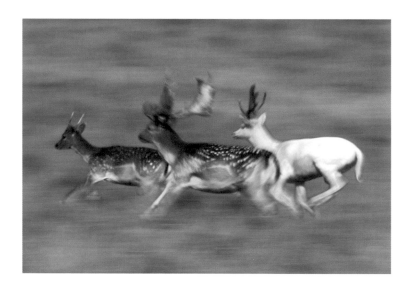

588 • Lombardy (Italy) - Three roe deer run about the meadows.

589 • Lombardy (Italy) - A mother roe deer (*Capreolus capreolus*) with her little one.

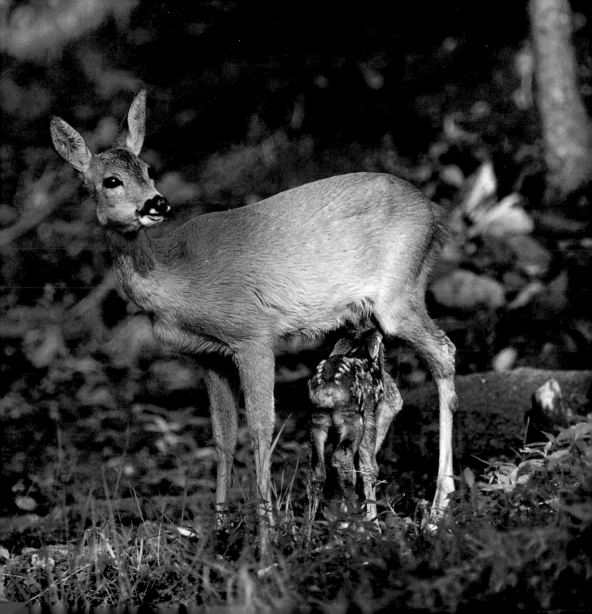

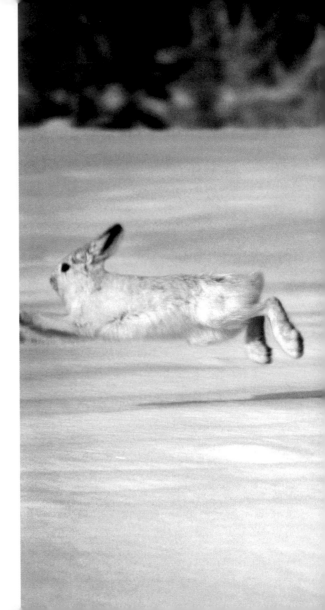

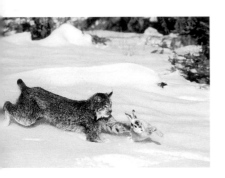

● Friuli Venezia Giulia (Italy) -
A European wild cat *(Felis sylvestris)* chases a hare across the snow at great speed.

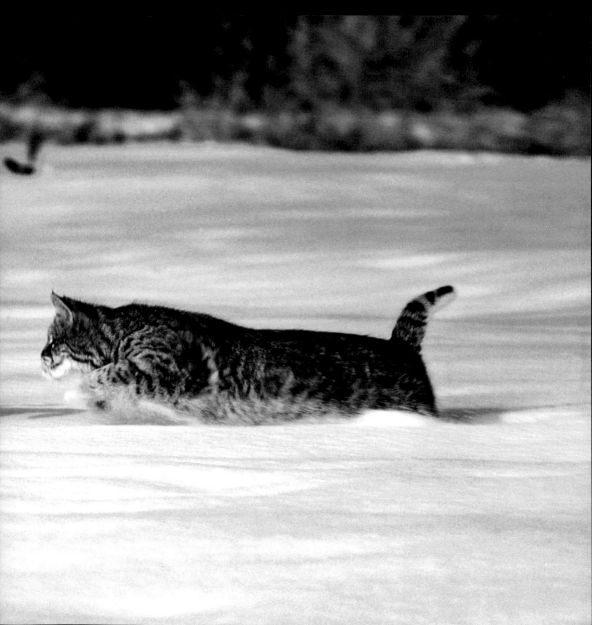

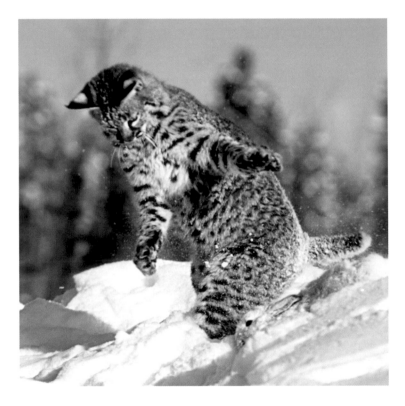

592 • Friuli Venezia Giulia (Italy) - A young wild cat plays in the snow.

593 • Canada - The leap of an adult lynx.

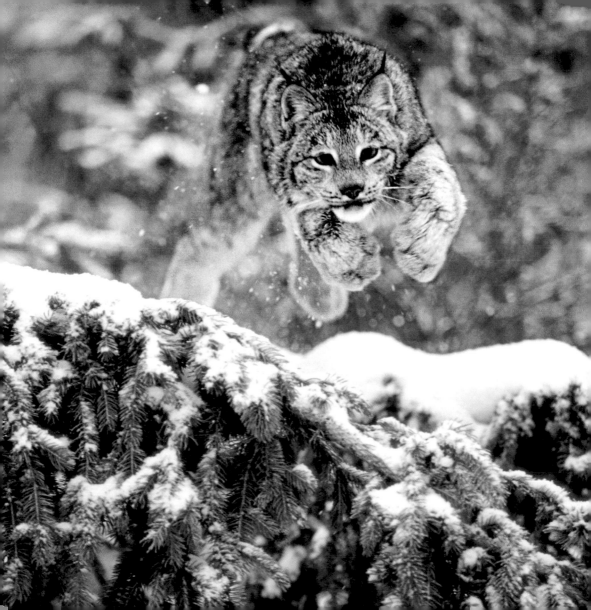

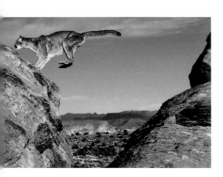

● Utah (USA) - A puma, also called a cougar or mountain lion (*Felis concolor*), leaps between two boulders near Zion National Park.

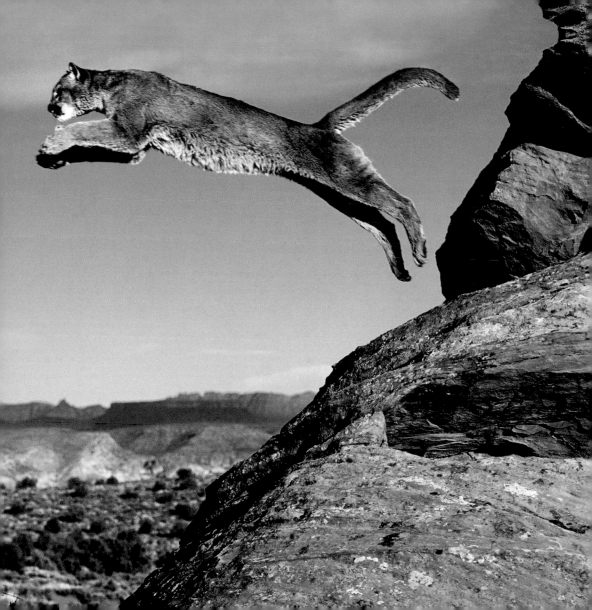

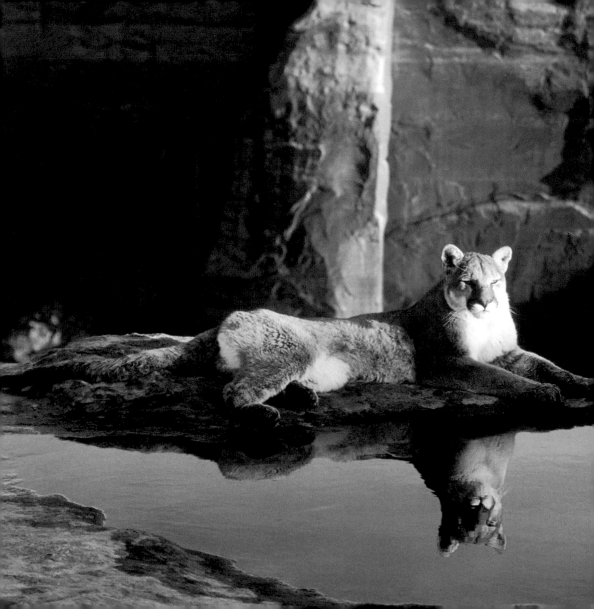

596-597 • Utah (USA)
This adult puma looks
almost like he is dozing.

598-599 • Utah (USA) -
An adult puma (*Felis
concolor*) runs in the snow.

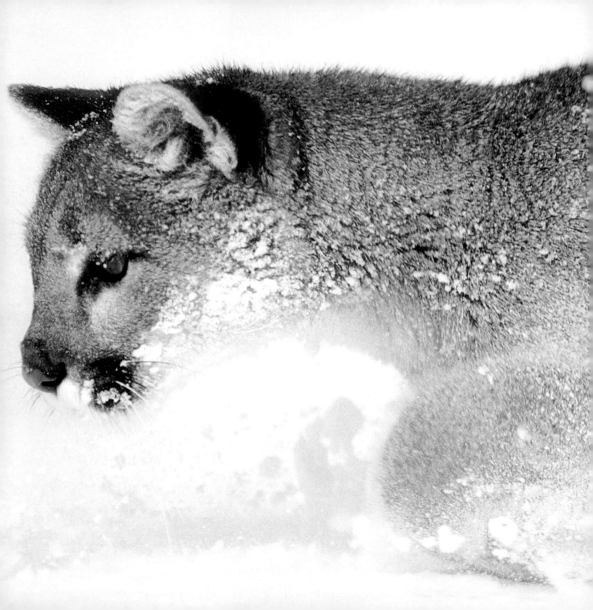

600 and 600-601 • Altai Mountains (Mongolia) -The snow leopard (*Panthera uncia*) usually lives at altitudes above 10,000 feet

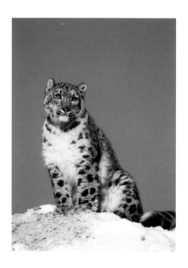

602-603 • Altai Mountains (Mongolia) - The leopard's coat affords it perfect camouflage.

604-605 • Montana (USA) - A puma confronts two wolfs over the carcass of a deer.

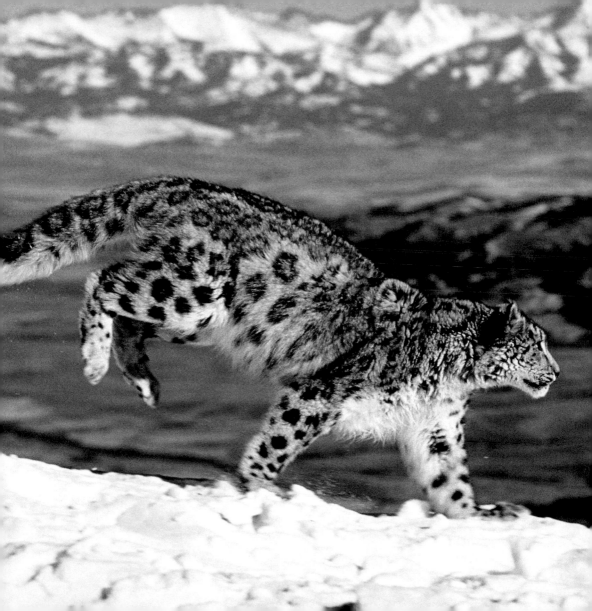

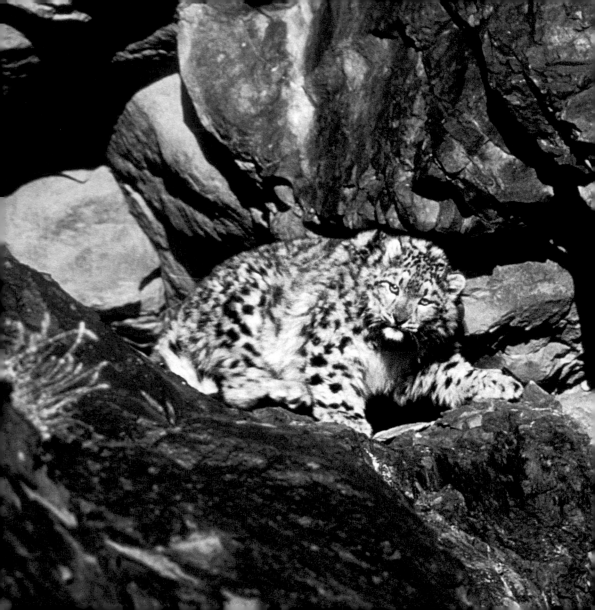

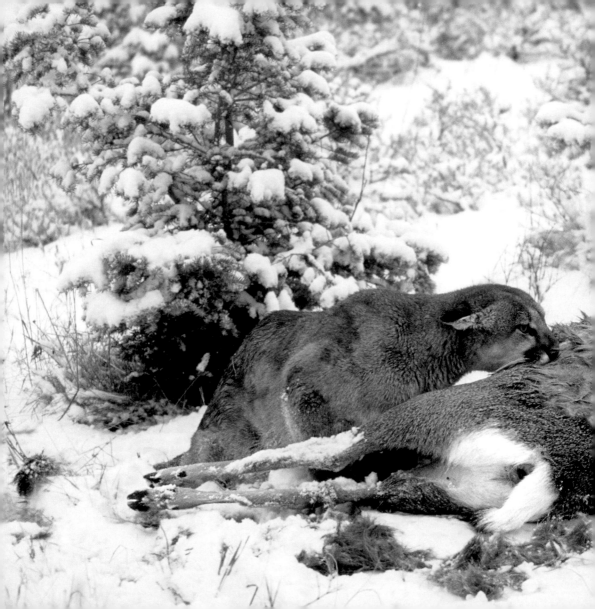

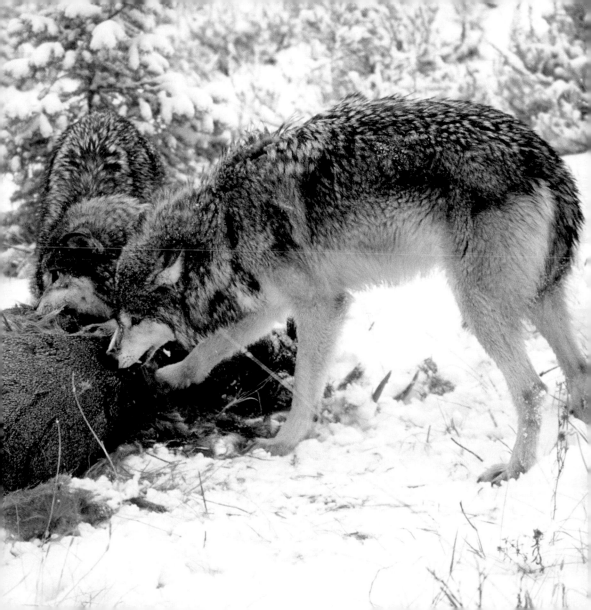

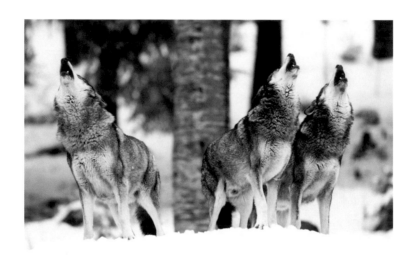

606 • Montana (USA) - The wolf, a social animal, lives in packs. Here, we see three wolves call the pack with howls.

607 • Umbria (Italy) - A young European wolf plays in the snow.

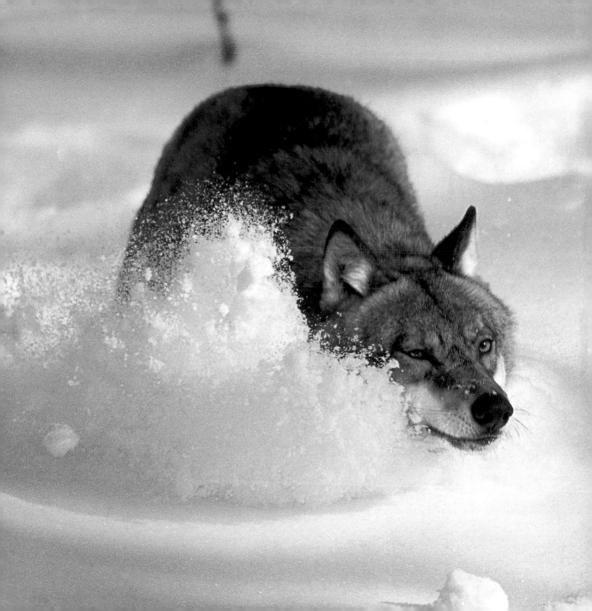

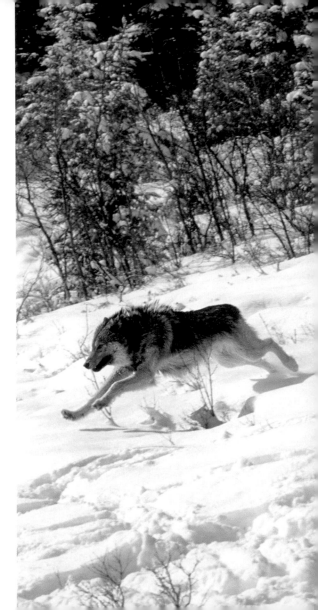

608 ● Montana (USA) - A wolf
leaps across to the opposite side
of the river.

608-609 ● Montana (USA) - A
group of three young wolves play
and chase each other on the
snow.

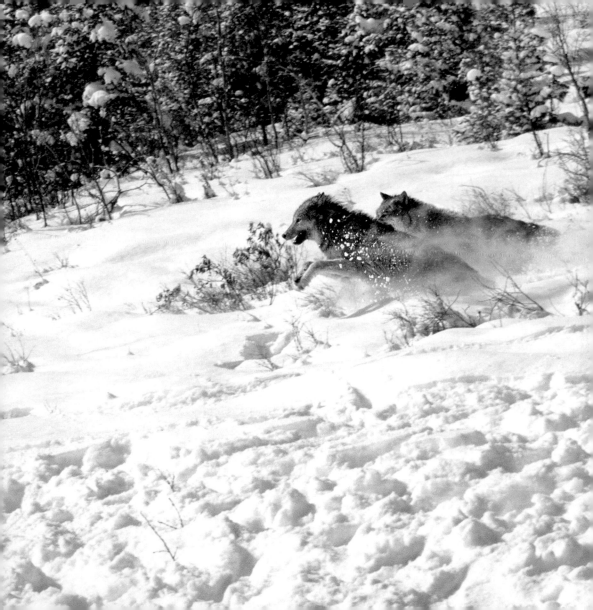

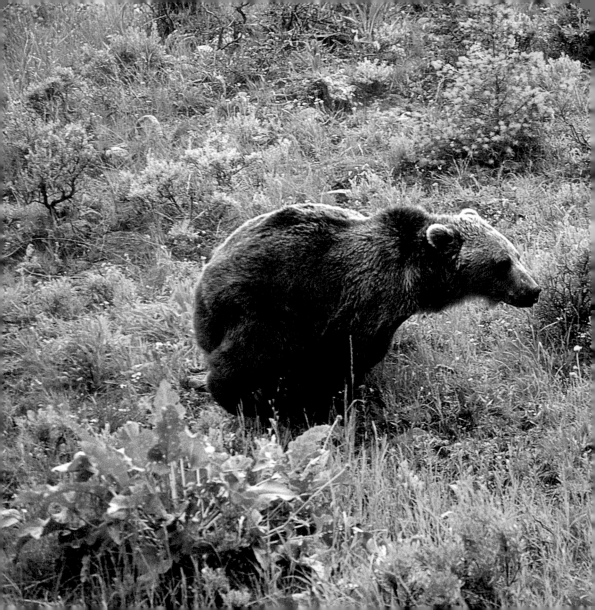

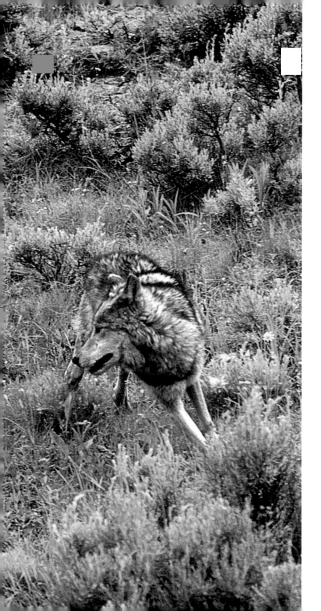

610-611 and 611 • Alaska (USA) - A North American brown bear *(Ursus arctos horribilis)*, otherwise known as a grizzly, chases a wolf.

612-613 • Alaska (USA) - In an enchanting snowy landscape in North America, two fox play and chase each other.

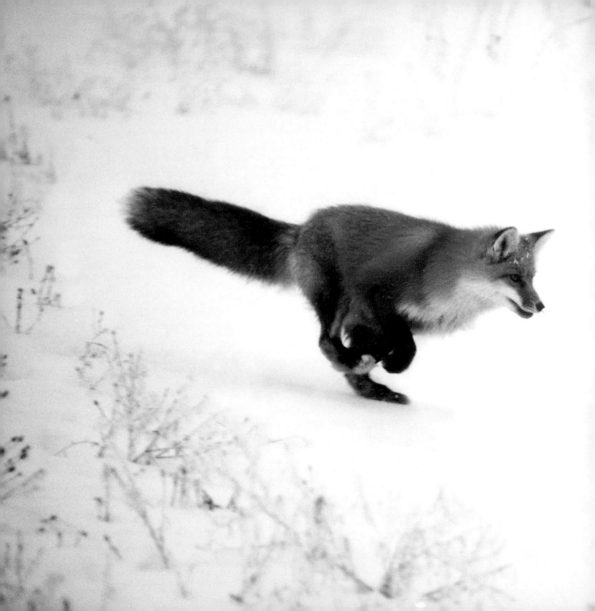

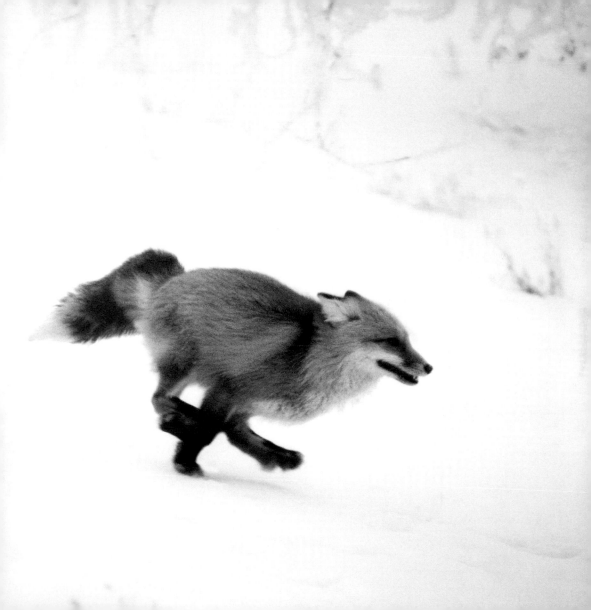

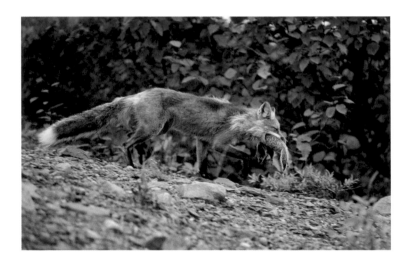

614 ● Alaska (USA) - This fox carries off its prey, held tightly in its teeth.

615 ● Alaska (USA) - Two young fox practicing for future battles through play.

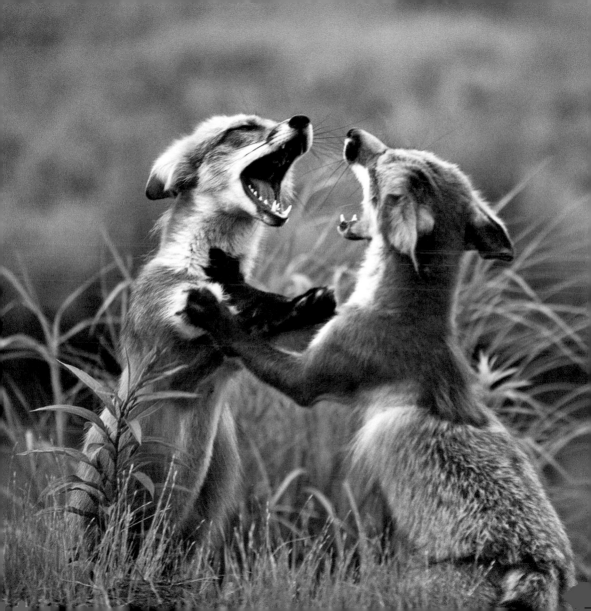

616 • Colorado (USA) - An adult grizzly rears up on its hind legs in a threatening posture.

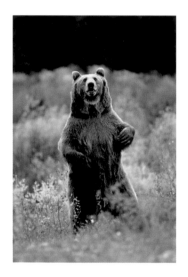

616-617 • Canada - A grizzly bear defends its territory with a challenging grimace.

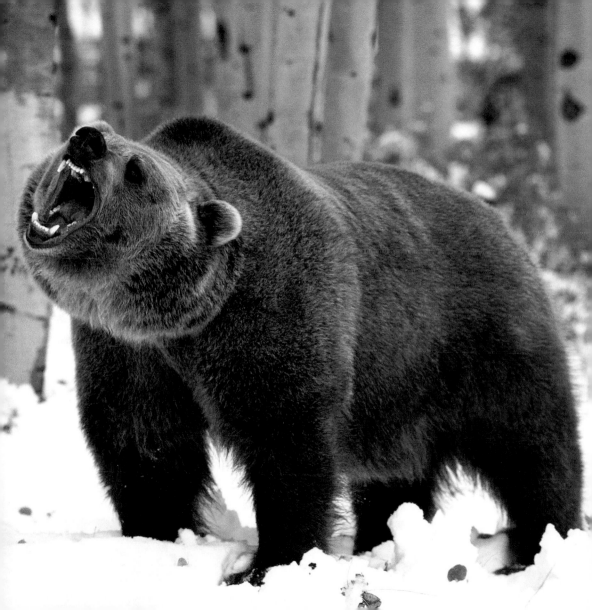

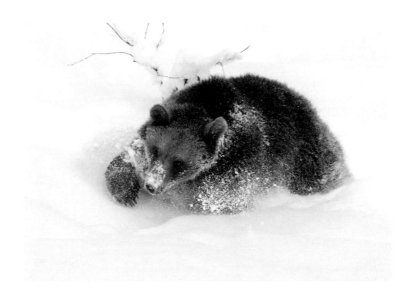

618 and 619 • Alaska (USA) - A young brown bear plays in the snow.

620-621 • Finland - A female brown bear *(Ursus arctos)* is closely followed by her two cubs.

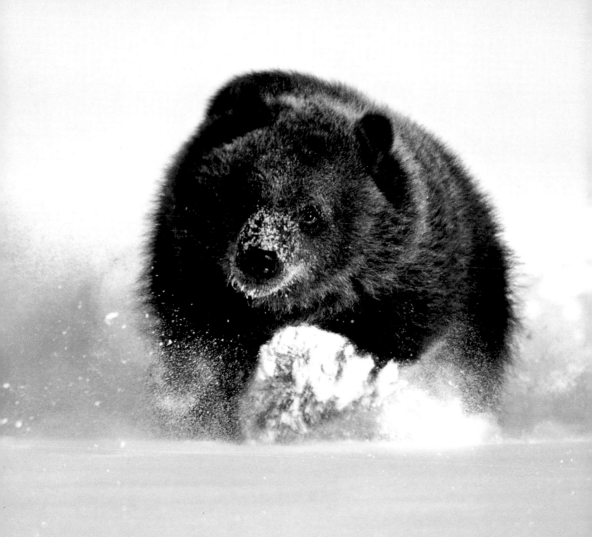

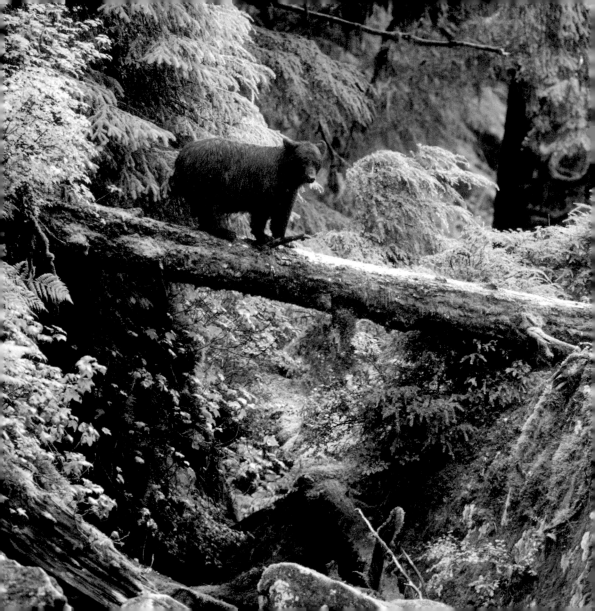

622-623 • Tenessee (USA) - An American black bear, of impressive size, maintains its balance on a tree trunk.

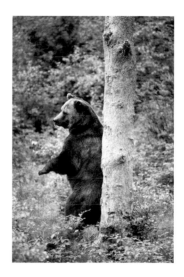

623 • Tenessee (USA) - A brown bear takes advantage of a tree to scratch its back.

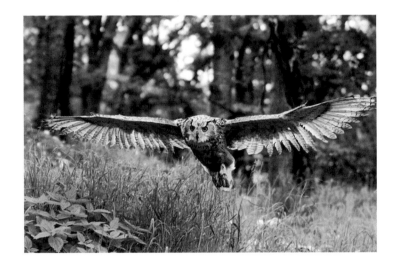

624 ● Baviera (Germany) - A tawny owl surveys the territory from above.

625 ● Baviera (Germany) - The eagle owl *(Bubo bubo)* can reach one foot long and have a wingspan of up to six feet.

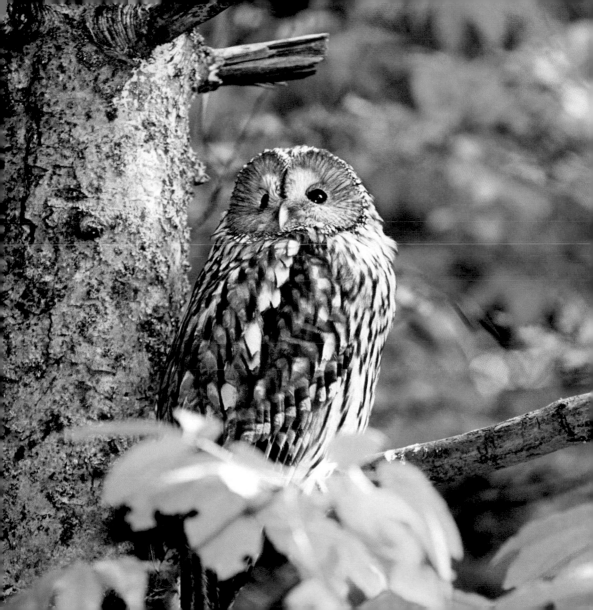

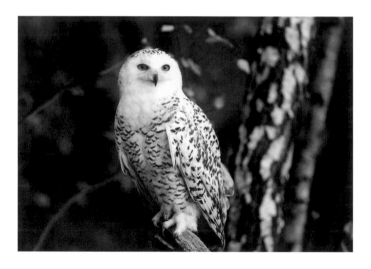

● Baviera (Germany) - The snow owl possess an austere nobility of which it almost
seems aware.

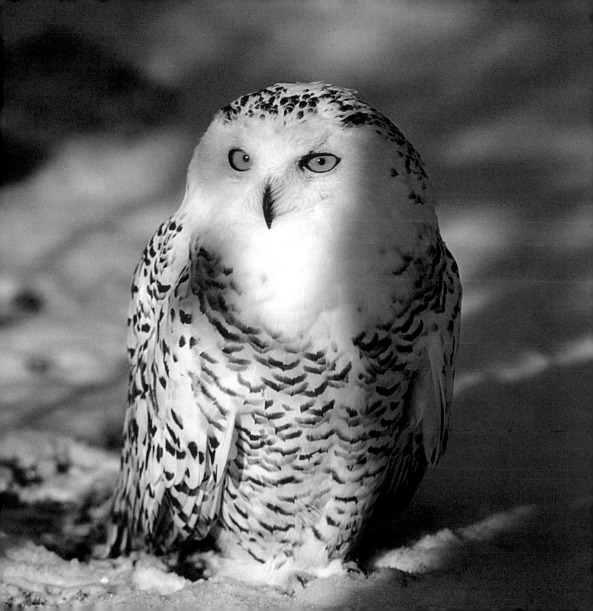

Peru - An Andean condor (*Vultur gryphus*) exploits rising air currents to fly above Colca Canyon.

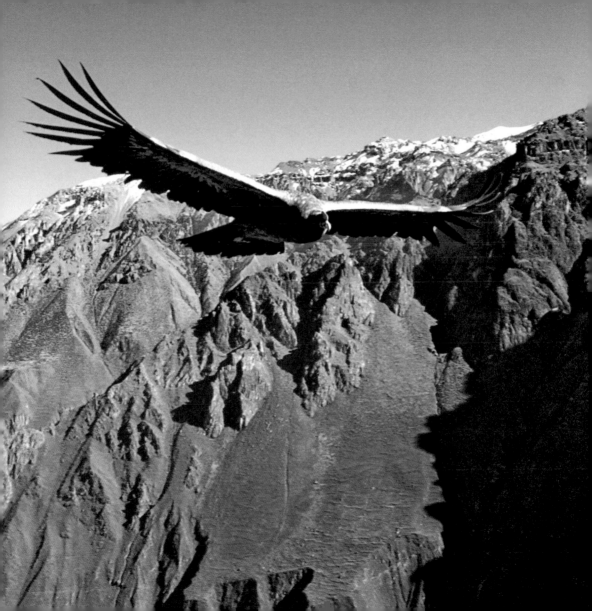

630 • Cevennes (France) - A vulture glides over the green of a mountain landscape.

631 • Cevennes (France) - Perched on a tree, a vulture watches over the surrounding territory.

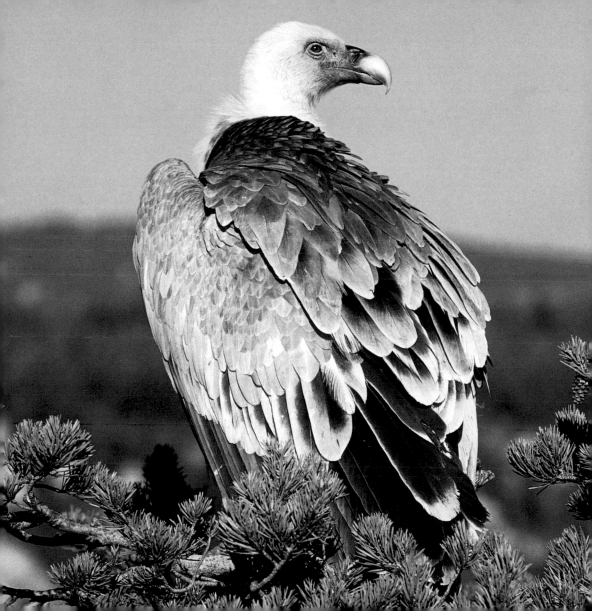

● Alaska (USA) - The heavy snow does not disturb the eagle, first in flight and then perched.

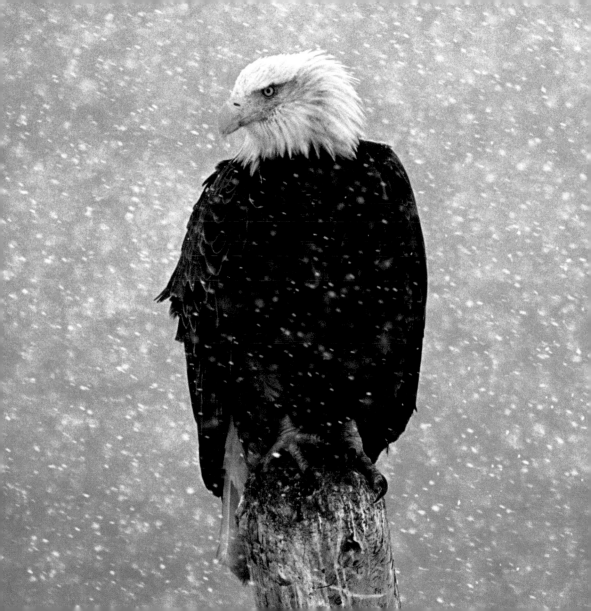

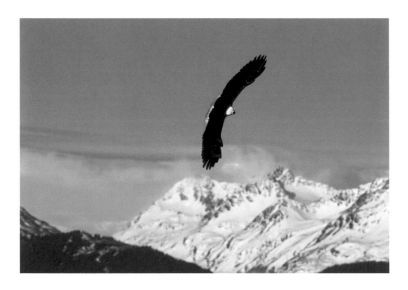

● Alaska (USA) - From far away, the symbol of the United States, the bald eagle, or the white-headed sea eagle *(Heliaeetus leucocephalus)*, seems to fly above the clouds.

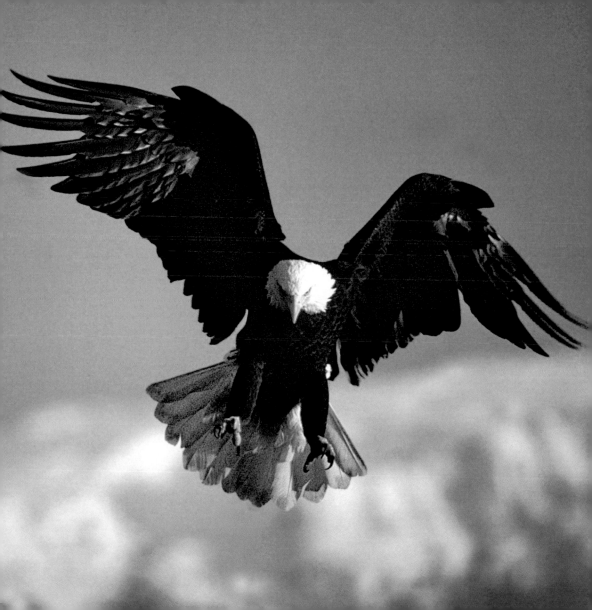

● Lombardy (Italy) - A golden eagle *(Aquila chrysateos)* lands in attack on its prey.

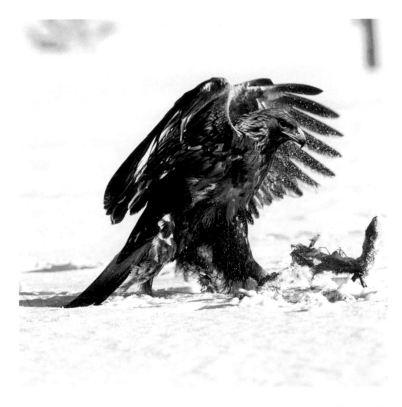

Lombardy (Italy) - This golden eagle seems to be showing off its trophy.

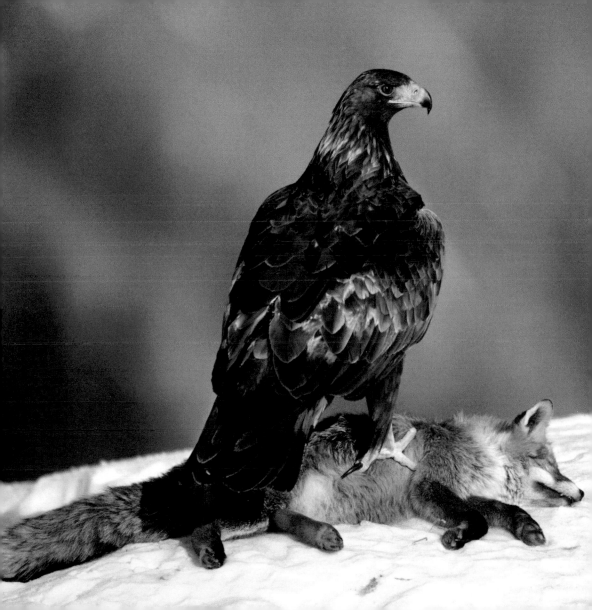

MIRRORS

Among the

CLOUDS

ERMINIO FERRARI

• Veneto (Italy) - The Tre Cime di Lavaredo, Misurina Lake.

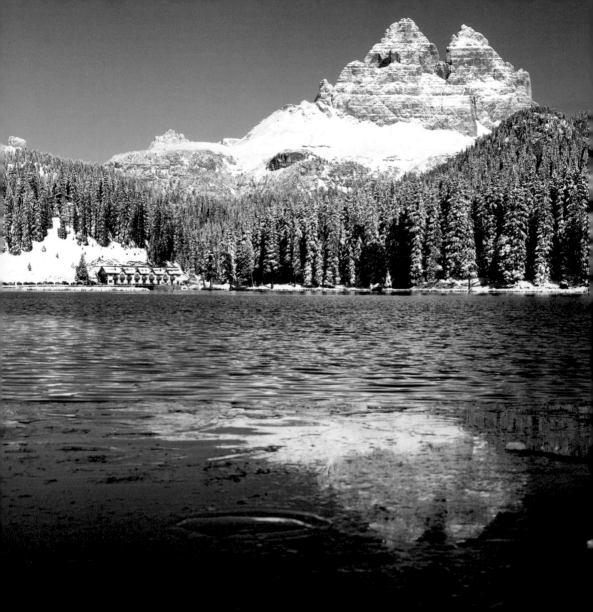

INTRODUCTION Mirrors among the Clouds

I REMEMBER ONE, WHEN I WAS HALF DEAD FROM THE COLD, ON A LATE-AUTUMN MORNING, AT 5,900 FEET HIGH, IN A RECESS IN THE LEPONTINE ALPS IN THE AREA OF THE VAL GRANDE. IT WAS CAST IN AN OPAQUE LIGHT THAT REVEALED A REEF OF ROCKS THAT THE SUN WOULD OTHERWISE REMAIN FAR AWAY FROM FOR THE ENTIRE SEASON. THERE WAS ANOTHER, BUT THIS ONE HAD BEEN ARTIFICIALLY CREATED BY A DAM THAT HAD RAISED THE WATER LEVEL. ON AN OPPRESSIVELY CLOUDY DAY, ITS IMMOBILE WATERS (ON WHICH ONLY AN UNATTRACTIVE OILY RESIDUE CIRCULATED) REFLECTED THE PEAKS OF THE ANTRONA VALLEY, HIDDEN BY THOSE DARK VAPORS TO WHOMEVER LOOKED UP TO FIND THEM. LAKES: THERE ARE PEOPLE WHO SPEND YEARS TRYING TO BE ACCEPTED INTO THEIR MYSTERIES, TO STUDY THE ROCKS THAT BORDER AND

INTRODUCTION Mirrors among the Clouds

TINT THEM, TO INVESTIGATE THE GLACIERS THAT HOLD THEM AS IF IN THE PALM OF A HAND. SPECIAL PLACES: OF A FISHERMAN AND HIS SOLITUDE; OF TWO YOUNG PEOPLE AND A SONG, AS IF IT BELONGED ONLY TO THEIR LOVE; OF A PAINTER AND HIS SUNDAY INSPIRATION; OF A TIRED CLIMBING PARTY. THE REMNANTS OF TIME, THE INVENTION OF FORMS, REVIVALS, LIFE BEFORE LIFE. THE SWISS-FRENCH WRITER MAURICE CHAPPAZ CALLED THEIR LIQUID AND TRANSITORY NATURE AMNIOTIC. SOME LAKES EXIST ONLY IN ONE SEASON: JUST A CRACK IN THE ICE AND THE SKY THAT WAS REFLECTED THERE A MOMENT AGO IS SWALLOWED UP. OTHERS ARE SO TRANSPARENT, OVERFLOWING WITH LIGHT, THAT FOR A MOMENT, IT IS POSSIBLE TO FORGET THAT IN THAT CLARITY IS DEATH, FALLEN DROP BY DROP FROM A SKY THAT DUMPS ACID RAIN. YET, IT IS SAID THAT THIS IS THEIR

Mirrors among the Clouds
Introduction

BEAUTY. IT IS EASY TO BECOME INFATUATED, EASY TO BELIEVE THAT THERE IS AN ESTHETIC CANON IN THE NATURE OF THINGS. THIS NAÏVE AND INNOCENT GAME OF MIRRORS DOES NOT REFLECT OUR FACE, BUT OUR MINDS, TO THE EXTENT THAT EVEN WHEN WE AGE, THE REFLECTIONS DO NOT SHOW OUR WRINKLES. IT MAY BE BECAUSE THE MIND DOES NOT REALIZE THAT WHAT LAKES SHOW US DOES NOT APPEAR TO THE NAKED EYE. ON THE WAY BACK FROM A TREK, I STOPPED ON THE BANKS OF THAT LEPONTINE LAKE. I WALKED THE SHORT PERIMETER OF GRASS AND ROCK UNTIL I SAW THE IMAGE OF MOUNT ROSA, OF ITS FAR AND SPARKLING EASTERN FACE, FORM IN THE WATER THAT A SUDDEN RAY OF SUN SEEMED TO BRING BACK TO LIFE.

- Washington (USA) - Mount Rainier is mirrored in Lake Eunice.

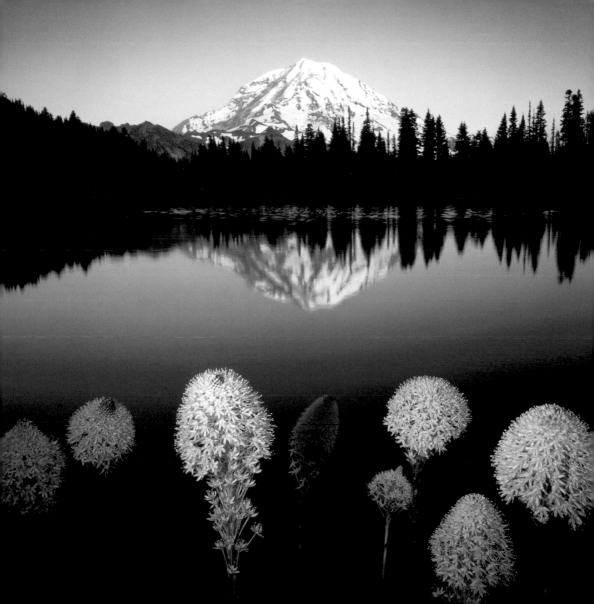

Europe

- Val d'Aosta (Italy) -
This alpine lake is found
in the massif of Mont
Blanc.

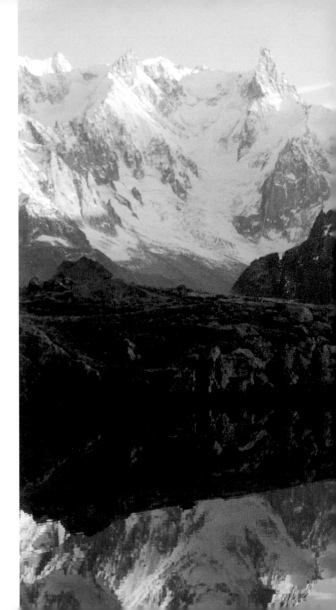

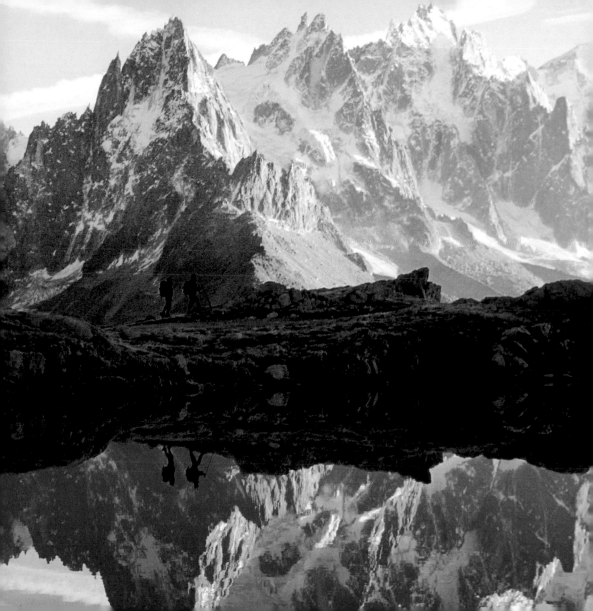

● Upper Savoy
(France) - The Lac Noir,
near Chamonix.

● France - Two excursionists go along a small mountain lake by the Central Pyrenees.

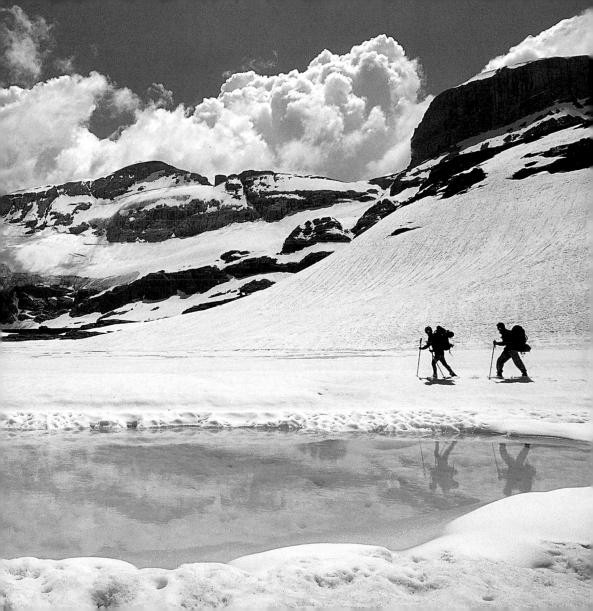

652-653 • Piedmont (Italy) - The hill of Nivolet and the Seru and Agnel lakes are in the Gran Paradiso National Park.

654-655 • Switzerland - The Matterhorn is reflected in the waters of Lake Blu.

656-657 • Tyrol (Austria) - An alpine lake by the Simmingjochl Pass in the Stubai Alps.

658-659 • Trentino Alto Adige (Italy) - The Brenta Massif towers above a small seasonal lake.

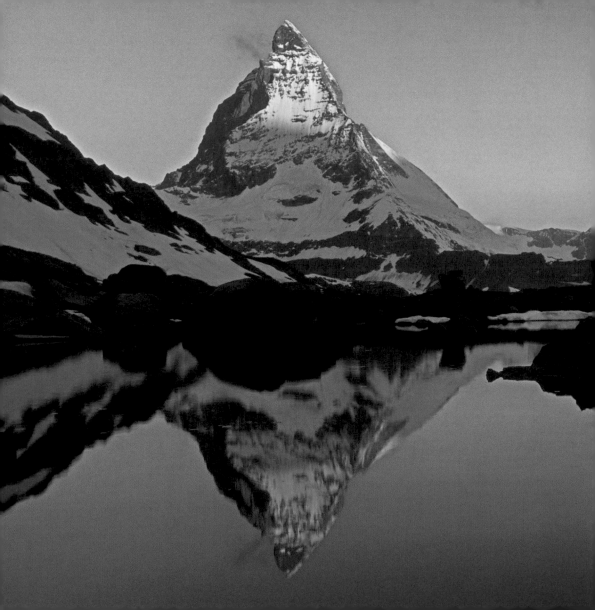

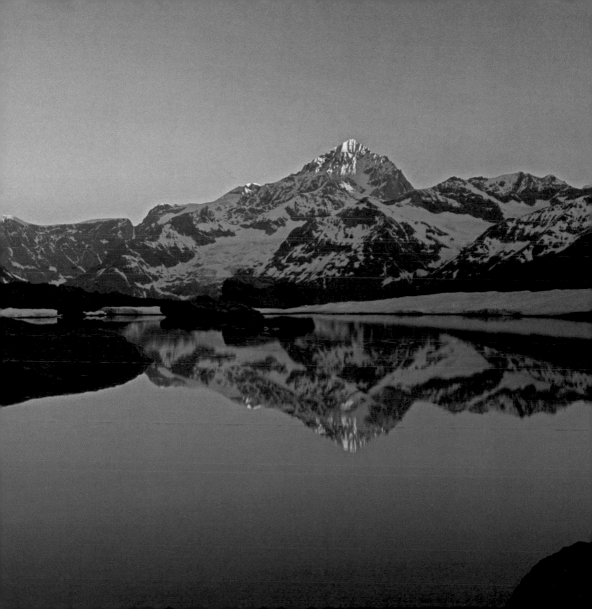

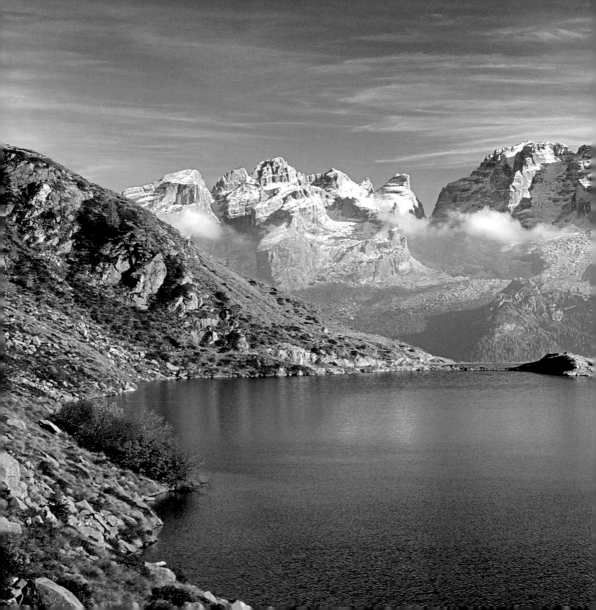

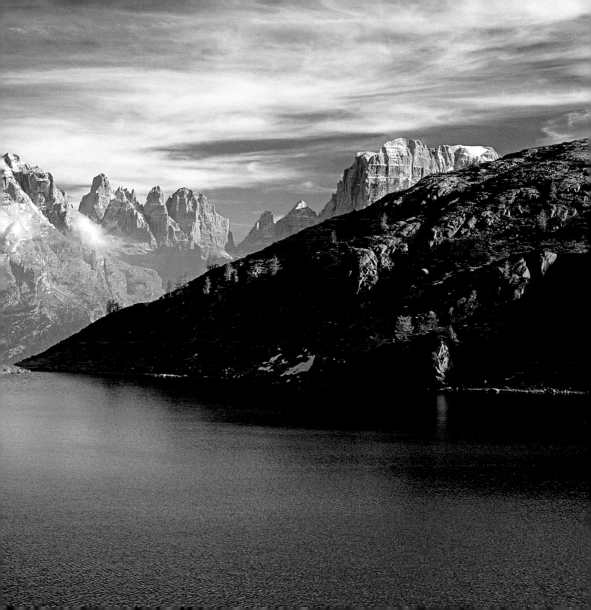

Africa

660-661 ● Kenya - An aerial view of the
Oblong Tarn.

661 ● Kenya - The Lewis Glacier
ends in a tiny lake.

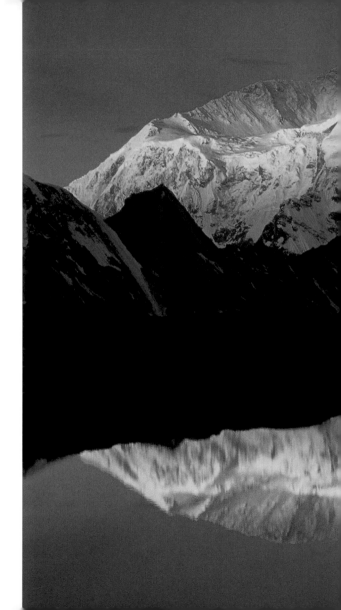

Asia

● Tibet (China) -
Mounts Makalu and
Chomolonzo are
reflected in a little pond
in the Kama Valley.

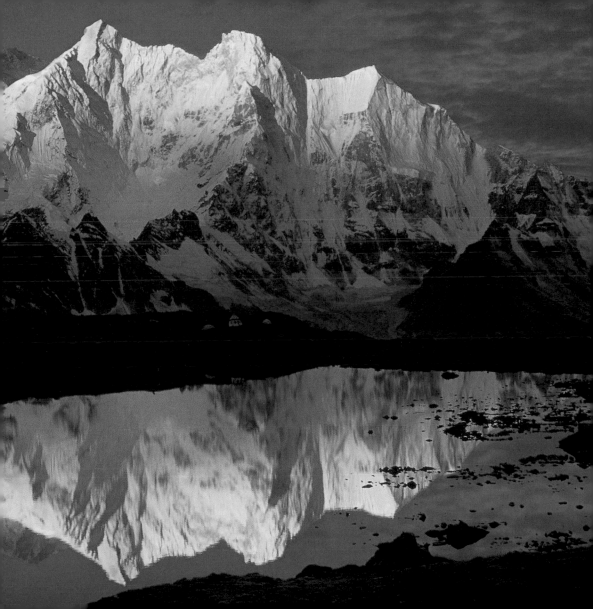

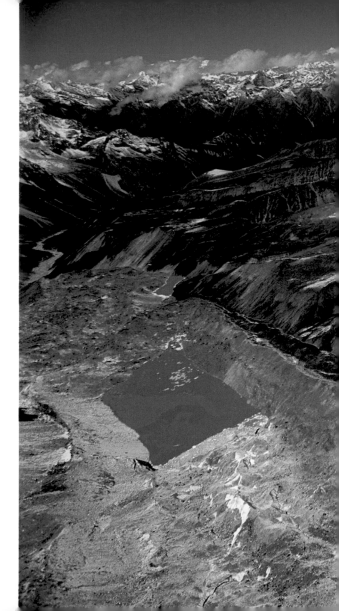

- Himalayas (Nepal) - Lake Tsho Rolpa is found at a remarkable altitude.

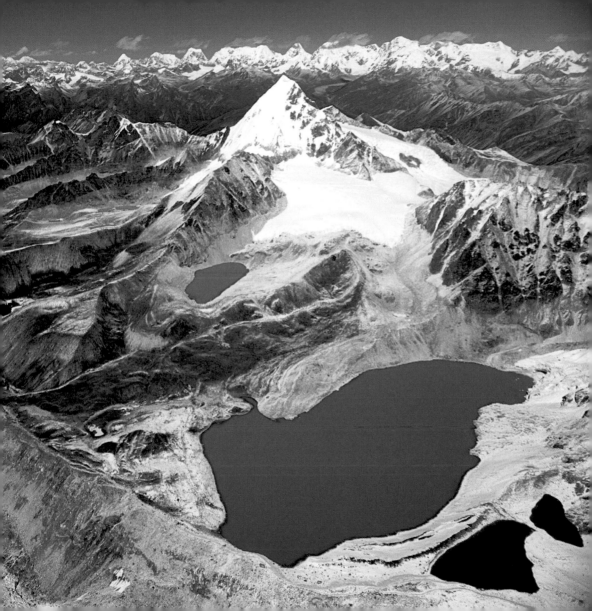

666-667 ● Kamchatka (Russia) - Lake Blu developed in the crater of a volcano.

668-669 ● Canterbury (New Zealand) - Snowy mountains reflected in Lake Heron.

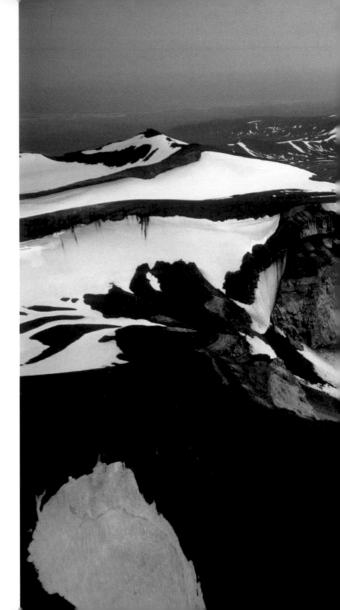

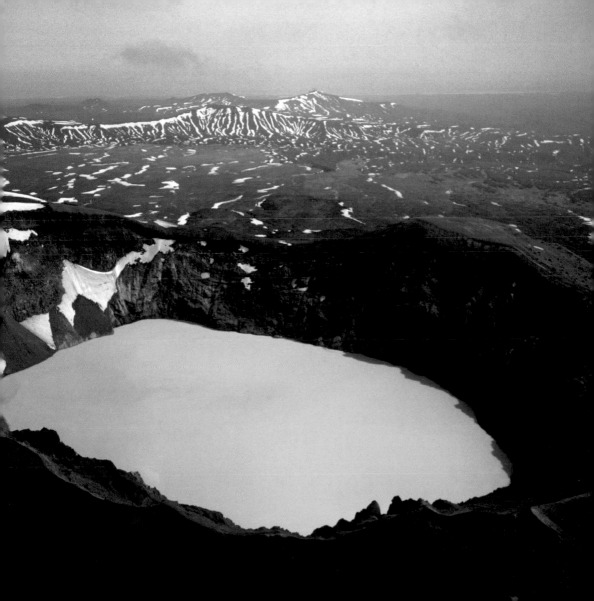

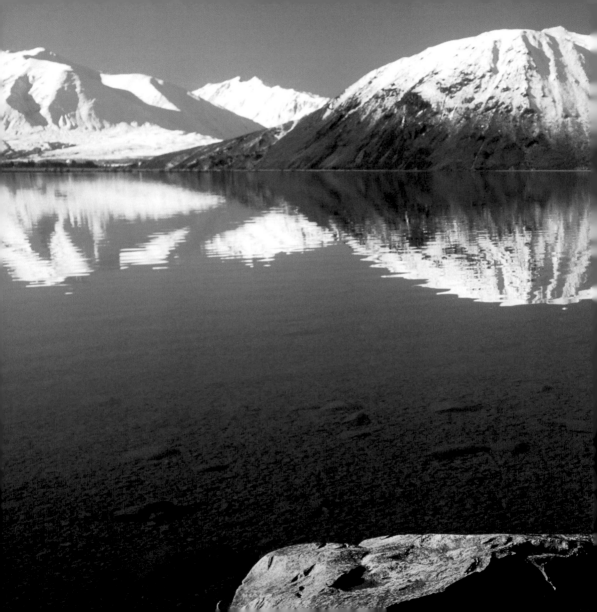

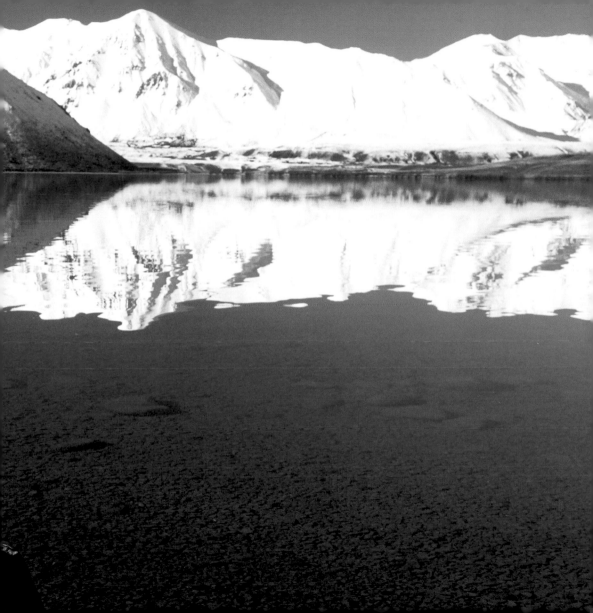

America

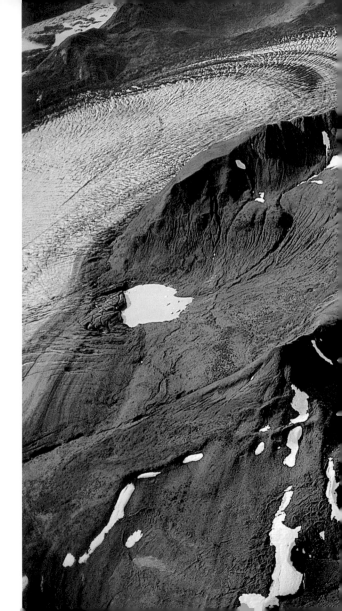

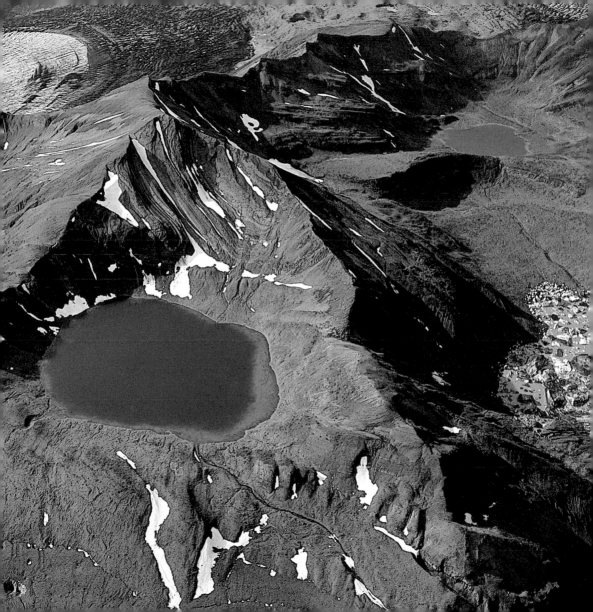

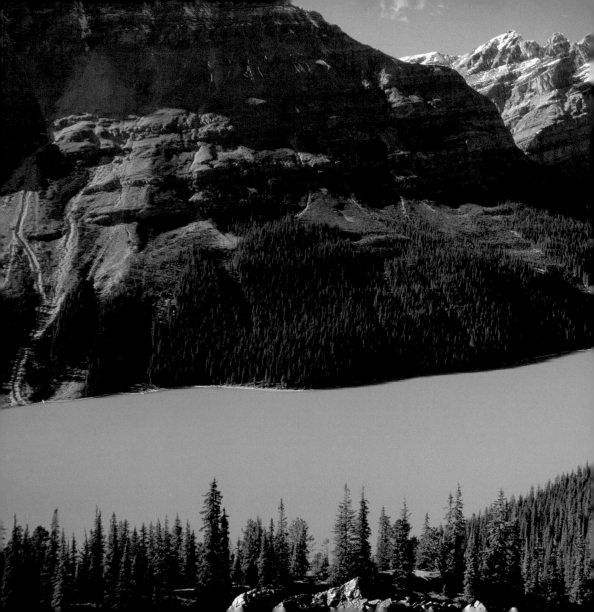

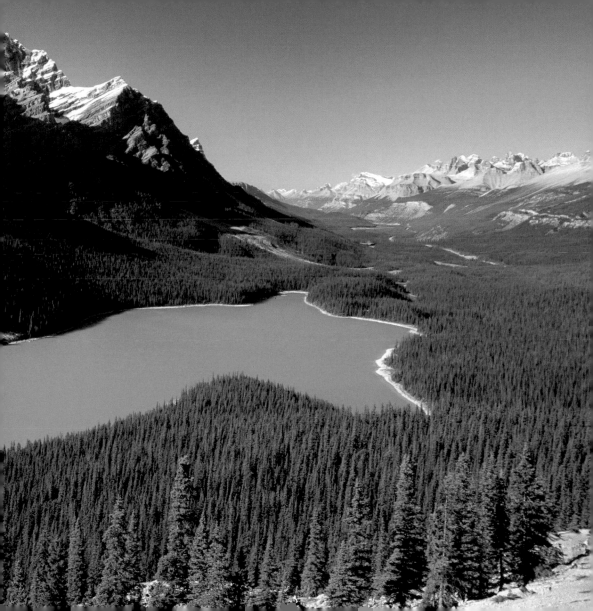

674-675 ● Alberta (Canada) - Mount Edith Cavell towers over Angel Lake in Jasper National Park.

676-677 ● Oregon (USA) - Crater Lake is famous for its blue waters and breathtaking view.

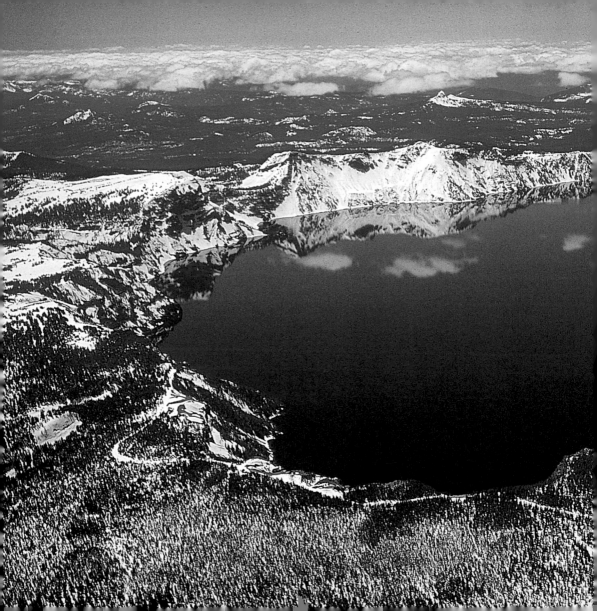

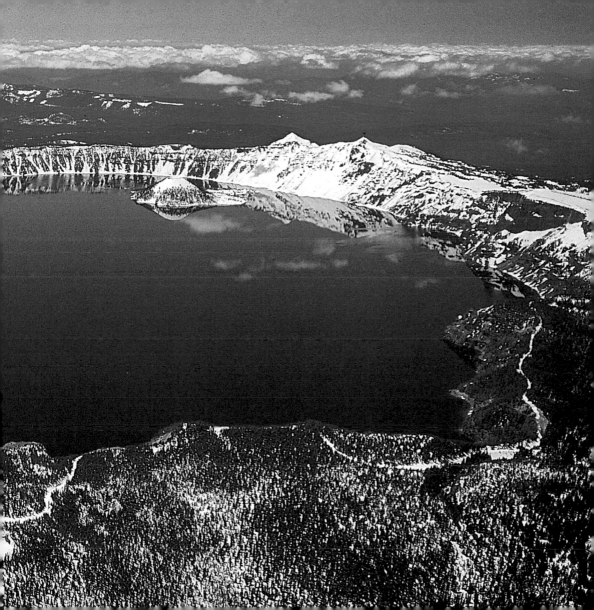

Oregon (USA) -
A high-altitude pond in
the Walloma County.

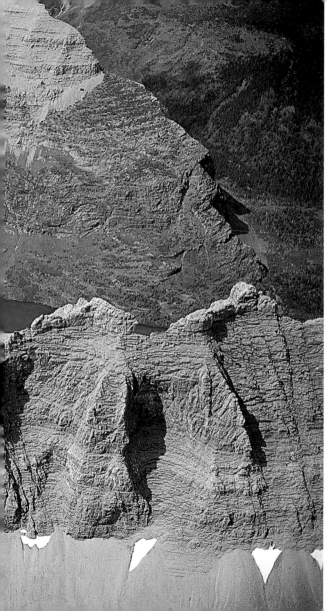

680-681 • Montana (USA) - A small lake of glacial origin collects thaw waters in Glacier National Park.

682-683 • Chile - Lake Herbert, in the Torres del Paine National Park, at sunset.

684-685 • Santa Cruz (Argentina) - Mount Fitzroy and Laguna de Los Tres are in Los Glaciares National Park.

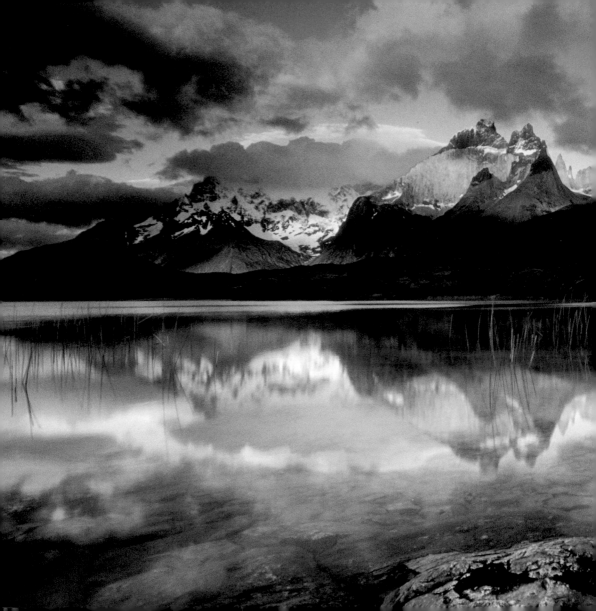

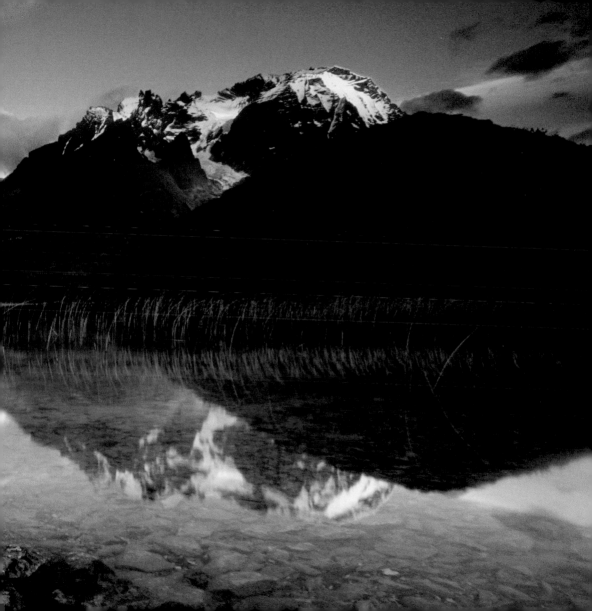

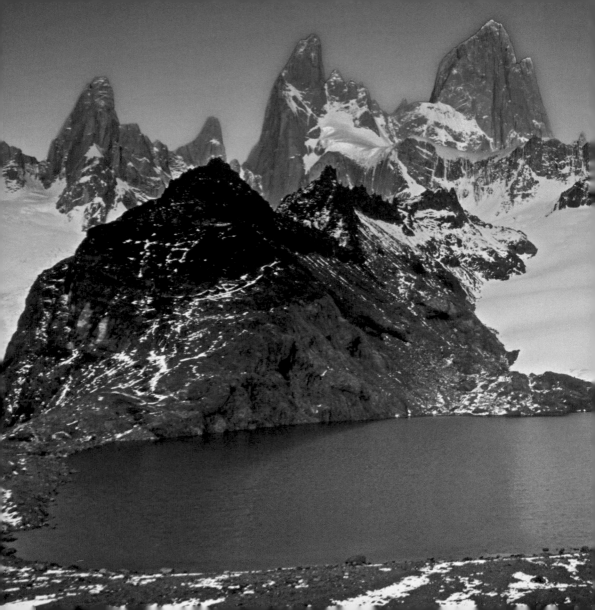

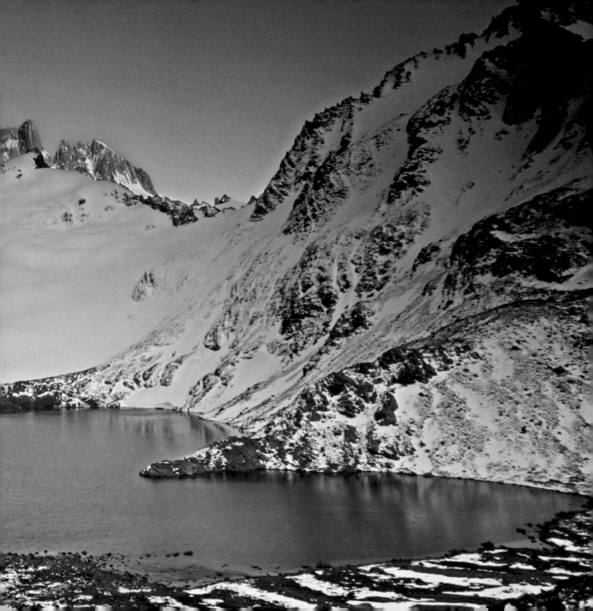

ENCHANTED FORESTS

STEFANO ARDITO

- Washington (USA) - This conifer forest climbs up the slopes of Mount Steele in Olympic National Park.

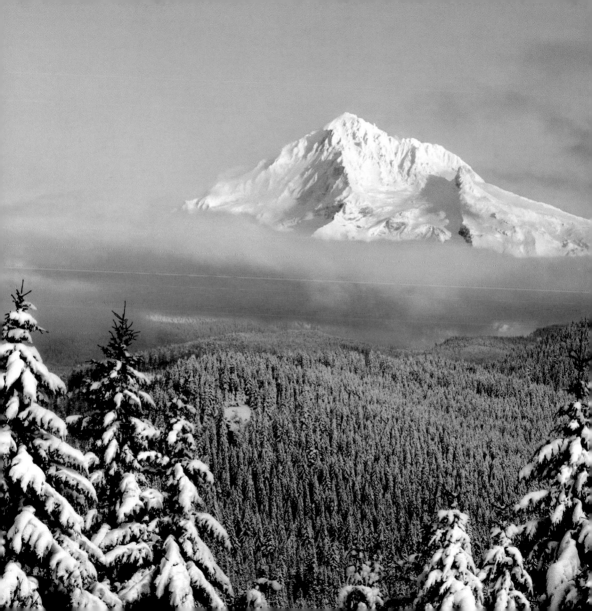

INTRODUCTION Enchanted Forests

THE MOUNTAINS OF THE WORLD SHELTER EAGLES, IBEXES, AND VULTURES. BEARS, LEOPARDS, AND PUMAS WILL VENTURE TO HIGH ALTITUDES. HOWEVER, THE SYMBOL OF THE MOUNTAINS IS A WHITE FLOWER WITH THICK PETALS, WHICH NEVER GROWS OVER FOUR INCHES HIGH. SPREAD OVER THE ARC OF THE ALPS, PRESENT FROM THE PYRENEES TO THE BALKANS, THE WHITE ALPINE FLOWER, KNOWN AS THE "ALPINE STAR," APPEARS ON STAMPS, COINS, AND TOWN EMBLEMS. AT HOME ON STEEP AND ROCKY GROUND, THE ALPINE STAR CAN LIVE AT OVER 10,000 FEET HIGH AND APPEARS EVEN ALONG THE PATHS OF THE DOLOMITES AND THE VALAIS. THE WHITE ALPINE FLOWER IS BY NOW A SPECIES AT RISK. AN IDEAL SYMBOL, THEREFORE, FOR THE NATURAL ALPINE ENVIRONMENT THAT IS UNDER ASSAULT FROM FOOT TRAFFIC AND SKI SLOPES. ON ALL

INTRODUCTION Enchanted Forests

THE CONTINENTS, TINY PLANTS – SAXIFRAGES, BUTTERCUPS, CURRY PLANTS, AND EVEN MORE MOSSES AND LICHENS – GROW UP TO THE EDGES OF THE GLACIERS (ON THE HIMALAYAS AND ANDES, PLANTS EVEN GROW AT OVER 16,000 FEET). FURTHER DOWN, THE DIFFERENCES INCREASE AND THE PLACE OF JUNIPERS AND SWISS-MOUNTAIN PINES IS TAKEN, IN AFRICA, BY GROUNDSELS AND LOBELIAS AND, IN THE HIMALAYANS VALLEYS, BY GIANT RHODODENDRONS. THE MOUNTAINS WOULD NOT BE THEMSELVES, THOUGH, WITHOUT THE GREAT FORESTS ENVELOPING THE SLOPES. IF THE FIRS, STONE PINES, AND LARCHES HAVE MADE A CONTRIBUTION TO THE ECONOMY OF THE ALPS, OTHER CONIFEROUS SPECIES – DEODAR CEDARS, LEBANESE CEDARS, LORICATE PINES, SEQUOIAS – PLAY AN ANALOGOUS ROLE IN THE HIMALAYAS AND ON THE AMERICAN

Enchanted Forests

Introduction

MOUNTAINS. MANY OF THESE SPECIES, THREATENED BY THE LUMBER INDUSTRY, HAVE BEEN SAVED BY ENVIRONMENTAL BATTLES AND THE CREATION OF NATIONAL PARKS. OTHER HIGH-ALTITUDE WOODS REMAIN PART OF THE WILD WORLD. THE MACARANGAS AND PODOCARPS OF THE RUWENZORI AND MOUNT KENYA HOST ELEPHANTS AND GORILLAS; THE FORESTS OF THE ANDES CONTINUE TO PRODUCE BIOLOGICAL SURPRISES. NOTHING IS MORE ROMANTIC, THOUGH, THAN THE FORESTS OF PATAGONIA. THE LENGAS LINED BY MOSS, THE ÑIRES THAT TURN RED IN AUTUMN, AND THE COIHUES WITH THEIR SLENDER TRUNKS FORM A UNIQUE AND WILD WORLD, WHICH THE INCESSANT WIND SHAKES BUT CANNOT DAMAGE. HERE, EVERY NATURE ENTHUSIAST IS RIGHT AT HOME.

• Abruzzo (Italy) - Sangro Valley, in the Abruzzo National Park.

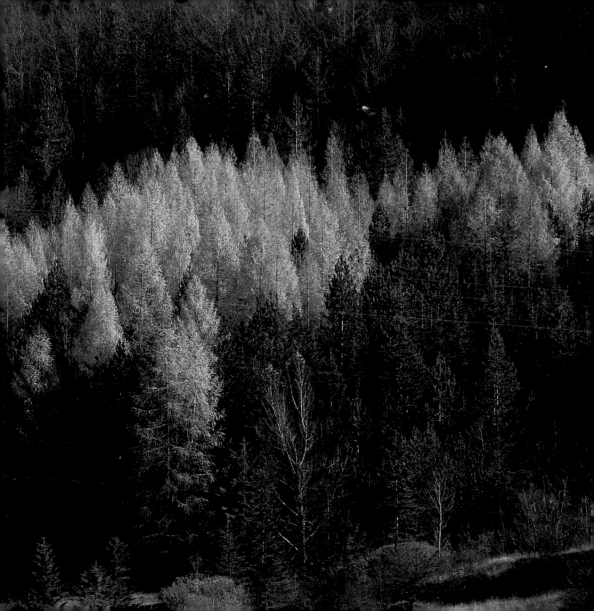

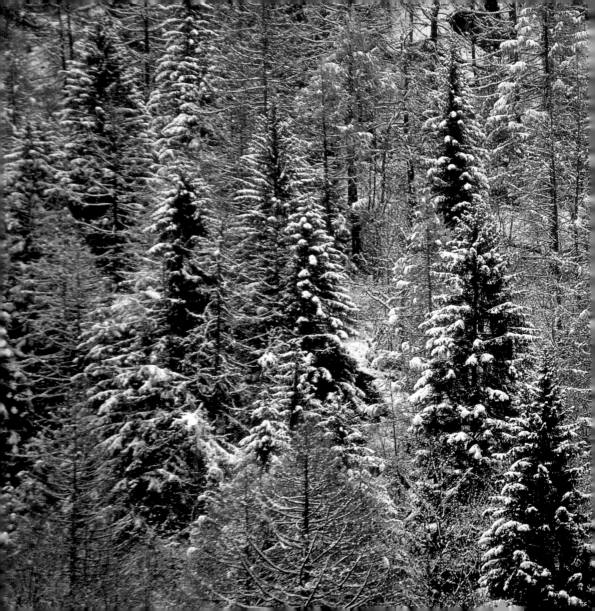

Europe

- Val d'Aosta (Italy) - Savarance Valley is in the Gran Paradiso National Park.

Friuli Venezia Giulia (Italy) - The Tarvisio Forest covers part of the Carnic Alps.

Friuli-Venezia Giulia (Italy) - Low clouds encumber this tract of the Tarvisio Forest.

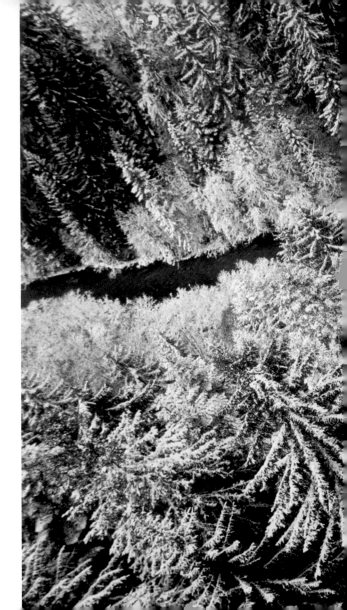

698-699 • Trentino Alto Adige (Italy) - A conifer forest in the National Park of the Stelvio.

700-701 • Austria - These woods were photographed right after a heavy snowstorm.

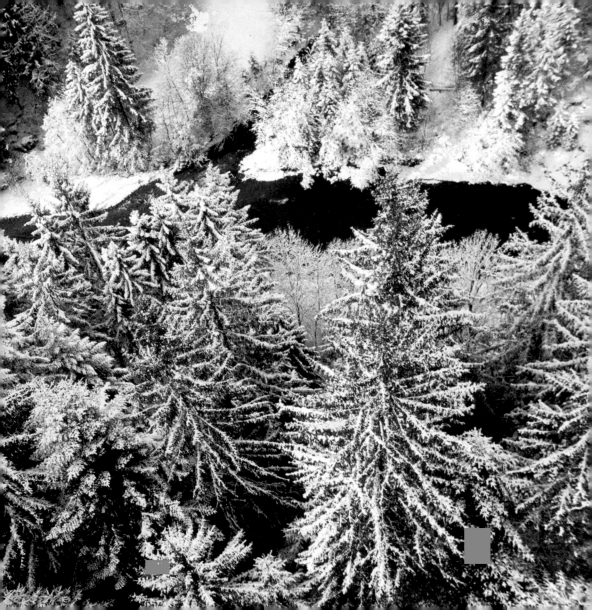

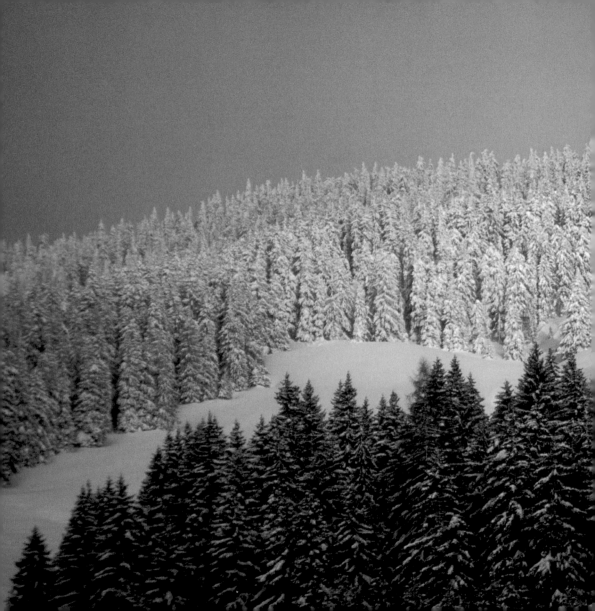

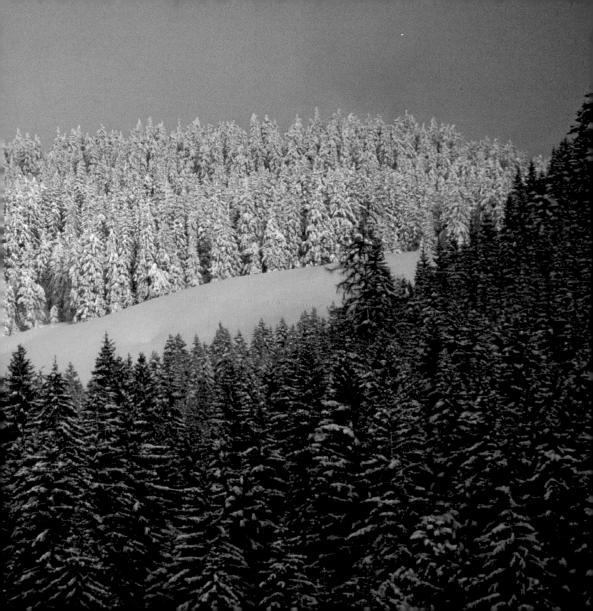

● Eastern Pyrenees (France) - The territory of Pyrenees National Park is mostly covered by trees with tall trunks like beeches, Scotch pines, and silver firs.

" THE FORESTS ARE THE WITNESSES OF MYSTERIES THAT ESCAPE US. SMALL POPULATIONS LIVE THERE, HUMANS AND NON-HUMANS. THEIR LIFESPAN COVERS DOZENS OR EVEN HUNDREDS OF OUR GENERATIONS: MUCH LONGER THAN OUR LIMITS. YET, THEY SPEAK TO US, THEY SING TO US IN THE WIND, "AS IF THE PINE NEEDLES ON THE HORIZON WERE THE STRINGS OF A HARP." "

DAVID THOREAU *Walden*

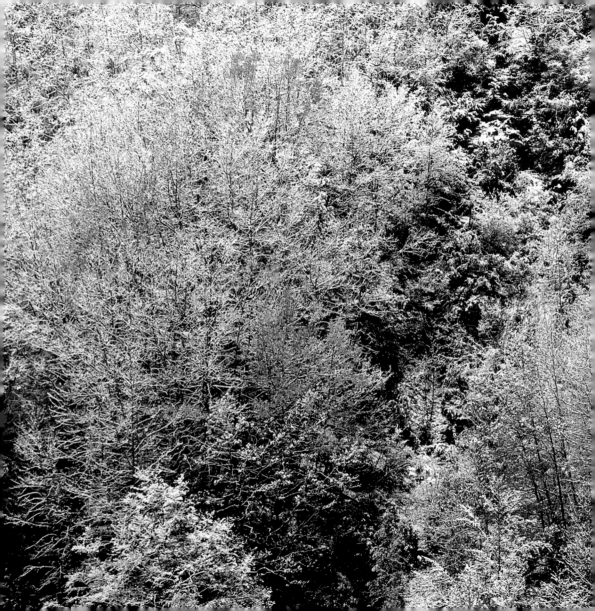

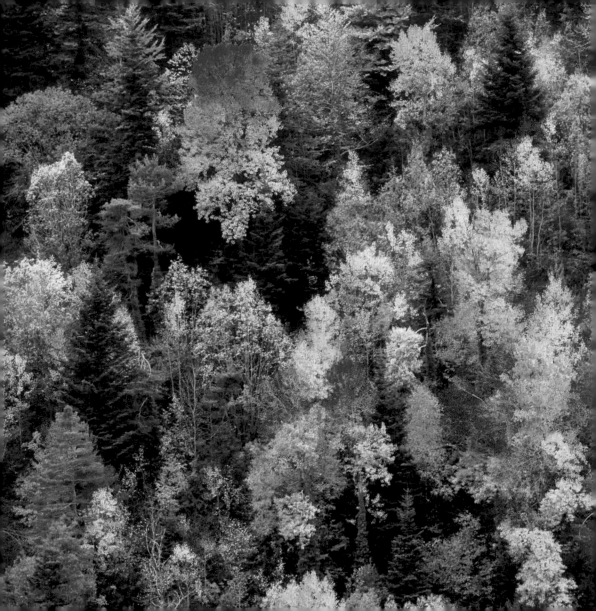

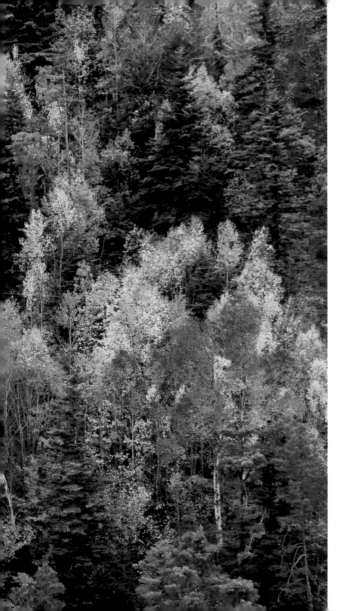

704-705 • Pyrenees
(Spain) - The forest
splashed with autumn
colors.

706-707 • Eastern
Pyrenees (France) -
This mountain stream
crosses green woods.

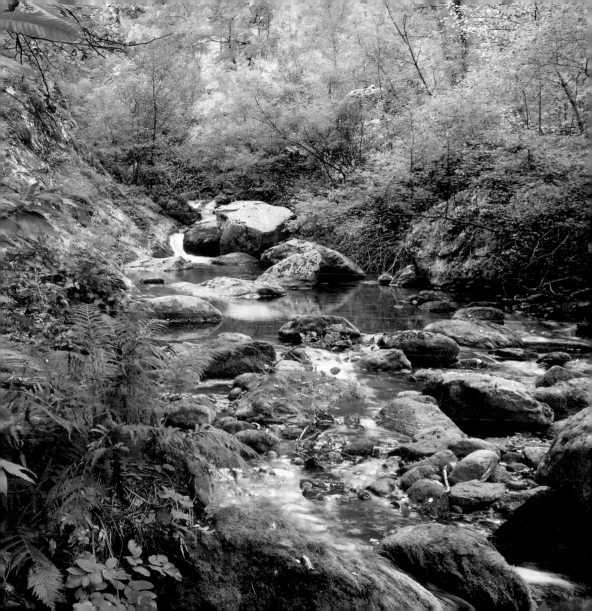

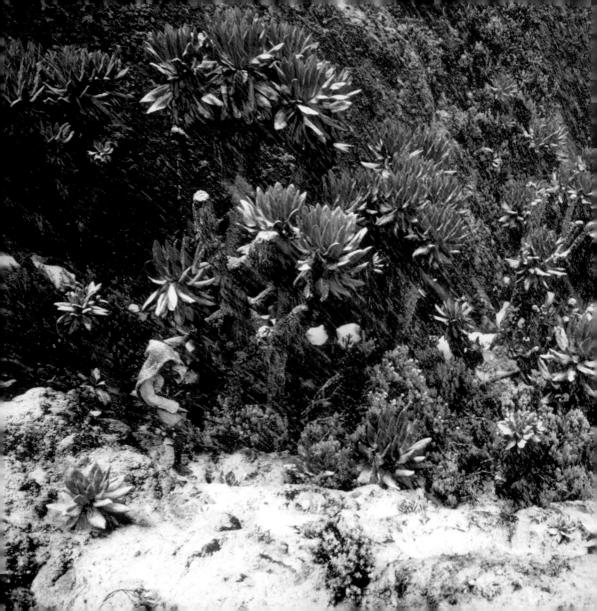

Africa

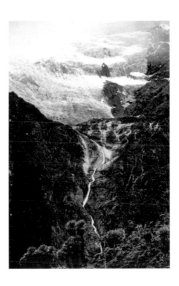

708-709 • Uganda - Abundant vegetation characterizes the slopes of the Ruwenzori.

709 • Uganda - A brook that winds its way into the subtropical forest descends from the Ruwenzori Glacier.

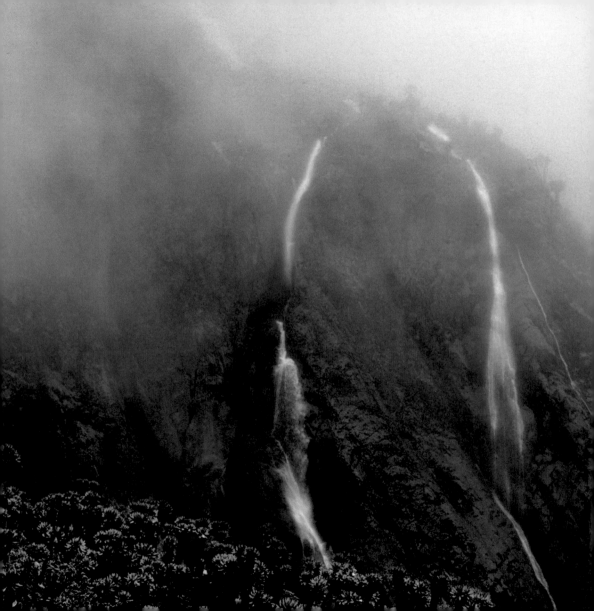

710-711 ● Uganda - This stream becomes a waterfall that branches off onto a face of Mount Ruwenzori.

711 ● Uganda - Dense vegetation grows at low altitudes around the Ruwenzori.

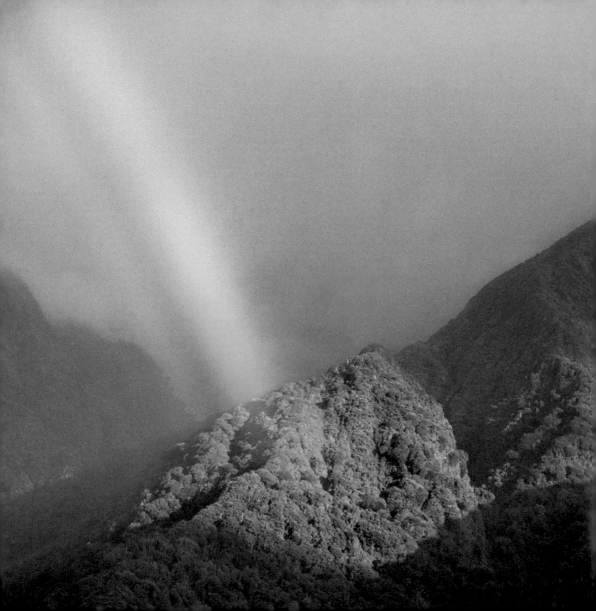

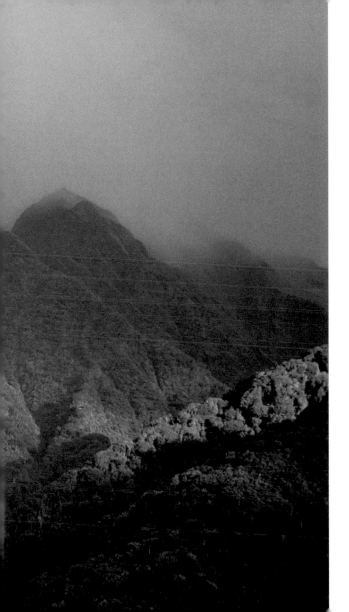

Oceania

New Zealand - A rainbow above the pristine forests and hills of Green Hills, near the Fox Glacier, in the New Zealand's Westland National Park.

America

714-715 ● Alaska (USA) - A forest of conifers in winter.

716-717 ● Wrangell National Park, Alaska (USA) - Conifer forests in the taiga, lapped by the Copper River at the base of the Wrangell Mountains.

718-719 ● Colorado (USA) - The forest on the slopes of Mount San Juan, in the Archuleta County.

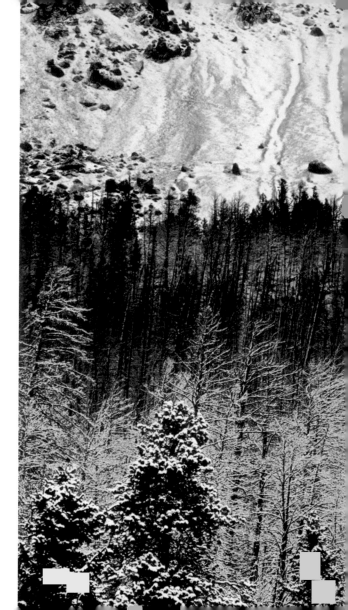

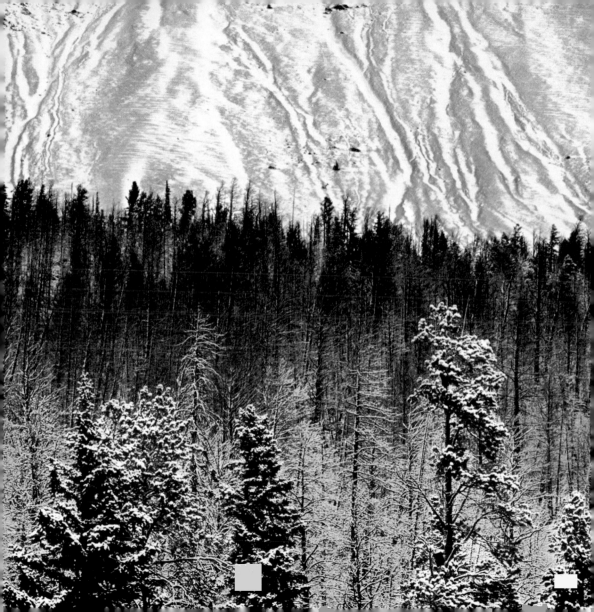

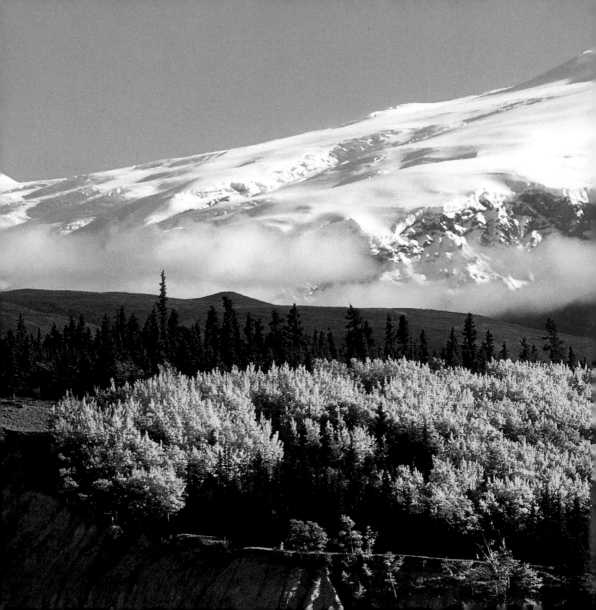

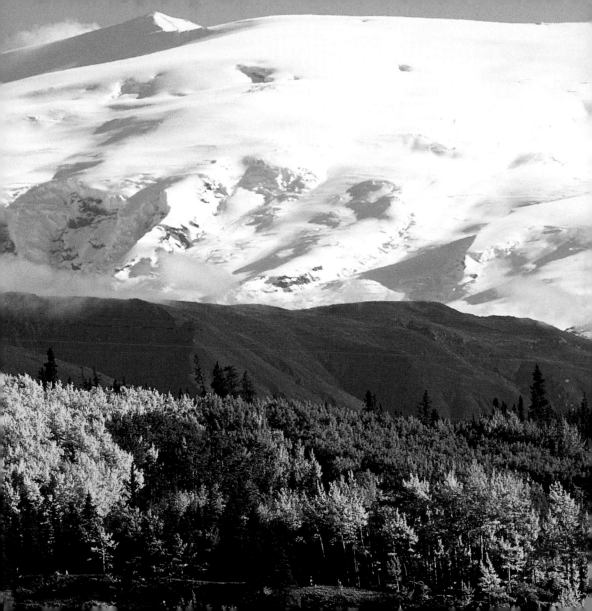

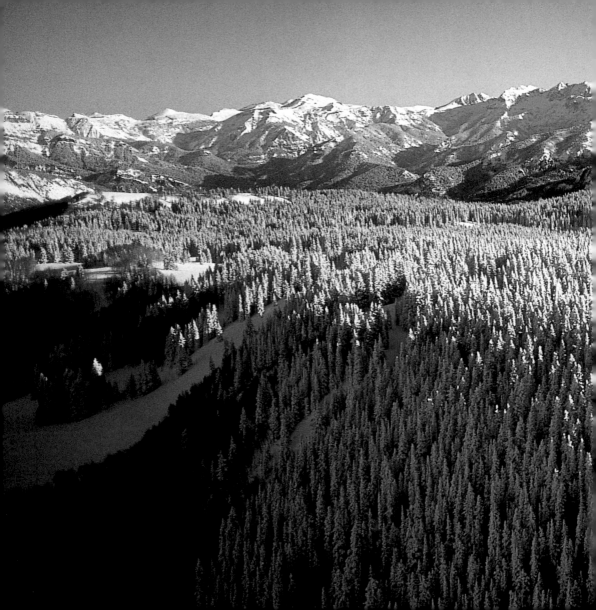

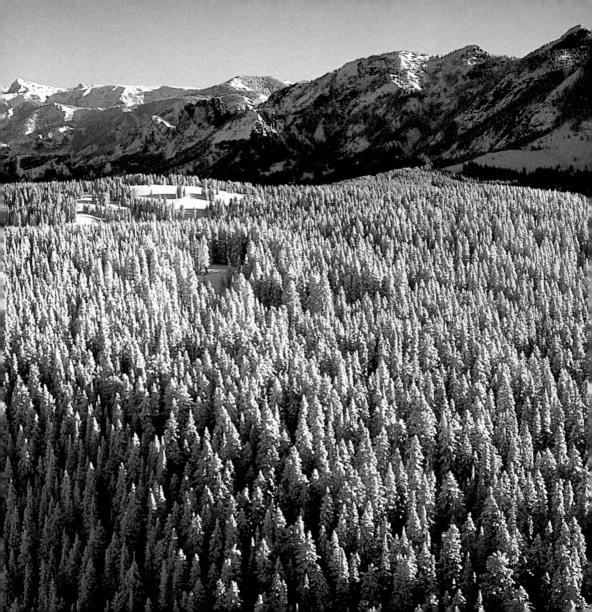

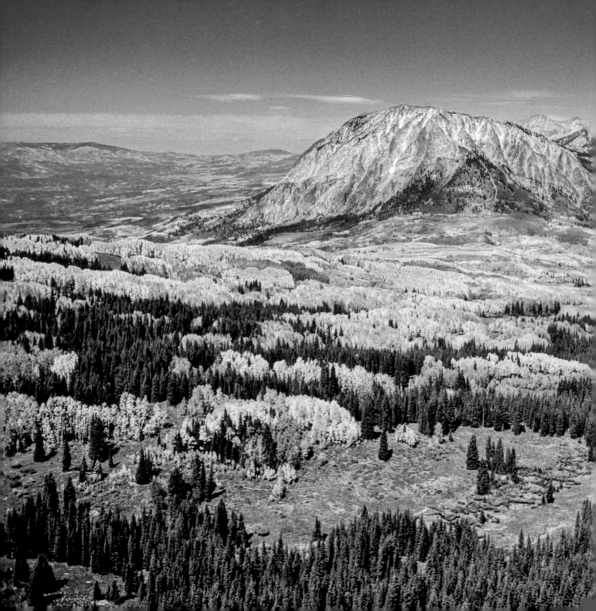

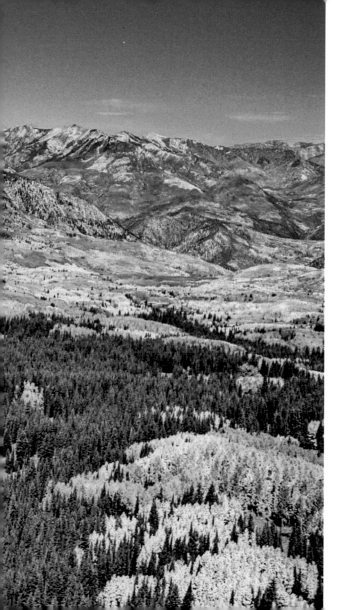

● Colorado (USA) -
View of Kebler Pass
and Mount Marcellina in
Gunnison County.

New England (USA) - The forest during the period of "Indian Summer" at the base of Mount Green in the Appalachian Mountains.

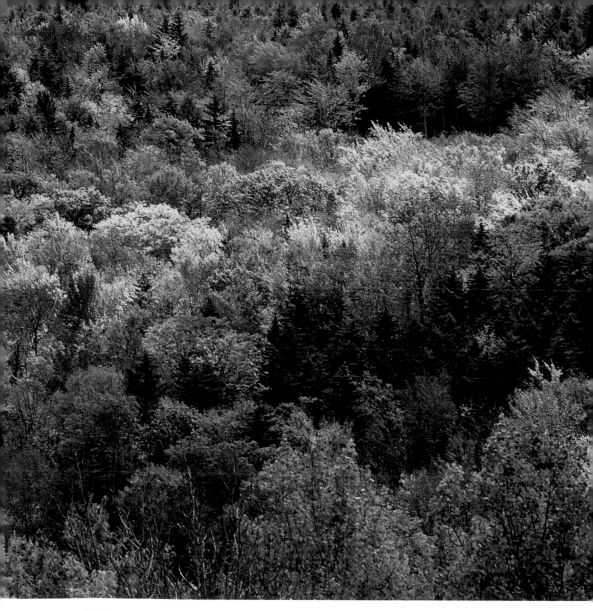

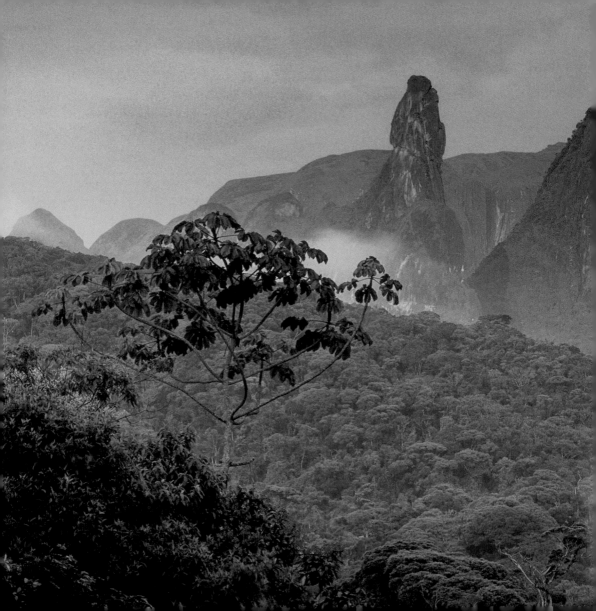

Brazil - The tropical rain forest in the Serra dos Orgaos National Park.

AUTHORS Biographies

STEFANO ARDITO

Journalist, photographer, writer, and documentary-maker, Ardito specializes in nature, mountains, adventure, hiking, and travel and has worked with several periodicals and written about 70 books. As a director, he has done about 30 documentaries about nature, mountains, and travel. He was one of the founders of the Mountain Wilderness Association (which he left in 1995) and one of the creators of the Sentiero Italia, a path that covers Alps and Apennines.

ENRICO CAMANNI

Born in Turn in 1957, a historian and teacher of Alpine subjects, he was chief editor of the *Rivista della Montagna* for 7 years, and in 1985, he founded the publication *Alp*, which he ran for 14 years. Today, he runs the magazine of mountain culture *L'Alpe* in collaboration with the Musée Dauphinois of Grenoble. He has published about 20 books on the Alps and mountaineering.

ERMINIO FERRARI

Born in 1959, he is a journalist and works for the Swiss newspaper, the *Regione Ticino*, for whom he edits the foreign policy section, and with the monthly publications *Alp* and *Rivista della Montagna*. For *Regione Ticino*, he covered the war in ex-Yugoslavia as a foreign correspondent. He also spends much time covering the people, the places, the history, and, preferably, the silences of the mountains. He has published several volumes, both photographic and not.

ROBERTO MANTOVANI

A professional journalist, for years Mantovani has written about mountaineering and alpine culture, the Himalayans, and mountain expeditions. He runs the *Rivista della Montagna* and has written many books on mountains. He has published several books and has also produced, for various publications (book and periodicals), essays and articles on the history of mountaineering, alpine skiing, and adventure travel. In the past, he worked for five years at CISDAE, the Italian Center for the Study and Documentation of Non-European Alpinism at the National Museum of the Mountain. He regularly works for periodicals and newspapers.

LUCA MERCALLI

Born in Turin in 1966, he is president of the Italian Meteorological Society and has run the meteorology magazine *Nimbus* since 1993. He is the author of 80 publications and over 500 articles published in the newspaper *La Repubblica* and magazines (*Alp, L'Alpe, Rivista della Montagna*). He has held teaching positions in climatology and glaciology at the University of Turin. He is director of the Meteorological Observatory of Real Carlo Alberto and a member of the scientific committee of the Club Alpin Français and the WWF Italia. He coordinated the *Climatic Atlas of the Val d'Aosta* and published *I tempi sono maturi* (The Times are Ripe) and *Le mucche non magiano cemento* (Cows Do Not Eat Cement).

FRANCESCO PETRETTI

After receiving his degree in biology, Francesco Petretti undertook a specialization in zoology, conducting research on birds of prey and the environment of the steppes. He then became a teacher of the management of animal resources at the University of Camerino. Since 1983, he has worked in the environmental sector, with particular emphasis on the planning and running of programs for the protection of natural resources, responsible for technical, administrative, and personnel direction on the part of both public and private entities and environmental associations. He is a member of the WWF Italia Scientific Committee and of the Species Survival Commission of the International Union for Nature Conservation (UICN). Since 1990, he has been involved in communicating and teaching the general public about environmental issues through television, radio, and editorial productions.

LUIGI ZANZI

Professor Luigi Zanzi is a teacher of the methodology of the historical sciences at the University of Pavia and the University of Insubria. On the history of mountain civilizations, he has written *The Walser in the History of the Alps*, 1988; *Dolomieu: An Explorer in the History of Nature*, 2003; *The Alps in the History of Europe*, 2004; and, A *Mountain Man's Mind: The Philosophy of Reinhold Messner*, 2004.

INDEX

INDEX

PHOTO CREDITS

PHOTO CREDITS

Veneto Region (Italy) - The Marmolada (10,968 feet), the tallest mountain in the Dolomites.